D0074932

# The American Political Party System

Books in the **Contemporary World Issues** series address vital issues in today's society such as genetic engineering, pollution, and biodiversity. Written by professional writers, scholars, and nonacademic experts, these books are authoritative, clearly written, up-to-date, and objective. They provide a good starting point for research by high school and college students, scholars, and general readers as well as by legislators, businesspeople, activists, and others.

Each book, carefully organized and easy to use, contains an overview of the subject, a detailed chronology, biographical sketches, facts and data and/or documents and other primary source material, a forum of authoritative perspective essays, annotated lists of print and nonprint resources, and an index.

Readers of books in the Contemporary World Issues series will find the information they need in order to have a better understanding of the social, political, environmental, and economic issues facing the world today.

# The American Political Party System

## A REFERENCE HANDBOOK

Michael C. LeMay

ABC-CLIO™

An Imprint of ABC-CLIO, LLC

Santa Barbara, California • Denver, Colorado

**Library of Congress Cataloging-in-Publication Data**

Names: LeMay, Michael C., 1941– author.
Title: The American political party system : a reference handbook / Michael C. LeMay.
Description: Santa Barbara, California : ABC-CLIO, [2017] | Series: Contemporary World Issues | Includes bibliographical references and index.
Identifiers: LCCN 2017006961 (print) | LCCN 2017007905 (ebook) | ISBN 9781440854118 (alk. paper) | ISBN 9781440854125 (ebook)
Subjects: LCSH: Political parties—United States—History. | Two party systems—United States—History. | Political culture—United States—History. | United States—Politics and government.
Classification: LCC JK2261 .L45 2017 (print) | LCC JK2261 (ebook) | DDC 324.273—dc23
LC record available at https://lccn.loc.gov/2017006961

ISBN: 978-1-4408-5411-8
EISBN: 978-1-4408-5412-5

21  20  19  18  17      1  2  3  4  5

This book is also available as an eBook.

ABC-CLIO
An Imprint of ABC-CLIO, LLC

ABC-CLIO, LLC
130 Cremona Drive, P.O. Box 1911
Santa Barbara, California 93116-1911
www.abc-clio.com

This book is printed on acid-free paper ∞

Manufactured in the United States of America

This book recounts the historical development of the American two-party system. It analyzes why and how two major parties have dominated that system since the early 1800s. In discussing more than 200 years of American history focusing on the dynamics of the two-party system, it is useful to categorize that long-term history into periods of time to better discuss those developments. Several methods have been used by historians and political scientists to do so. I herein use six such periods marked by the presidential election of six transformative presidents and close the discussion of current political party developments with the question: do the 2008 and 2012 elections of President Barack Obama demarcate a lasting change in the party coalitions or does the 2016 election of Donald Trump signal a shift to Republican dominance with an appeal to national populism?

There is disagreement among historians and political scientists over concepts and dates of party systems. I find it useful to break up the discussion of more than 200 years of political party and electoral developments by using demarcation elections that many scholars identify as critical elections, each identified by six transformative presidents: Thomas Jefferson, 1800; Andrew Jackson, 1828; Abraham Lincoln, 1860; William McKinley, 1895; Franklin Roosevelt, 1932; and Ronald Reagan, 1980 (Aldrich 1995; Burnham, 1970; Clubb et al. 1990; Gerring, 1998; Key, 1955; Lichtman, 1983; Manza and Brooks, 1999; Rosenof 2003; Schlesinger 1973; Sundquist 1983; Williams 2010). Each party

system era begins and ends with the election of a transformative president or, in Skowronek's terms, a reconstituting president.

*The American Political Party System: A Reference Handbook* follows the format of the ABC-CLIO series of Contemporary World Issues.

Chapter 1 presents the background and history of the American political party system, from the founding to present time. It aims to provide the reader with the basic information needed to understand the subject, key contemporary issues, and different points of view. Chapter 2 is an analysis of problems, controversies, and possible solutions of the current American political party system up to and including the presidential election of 2016. It acknowledges all sides of the issue in a balanced, unbiased treatment of the topic.

Chapter 3 presents 10 original essays by scholars and activists involved in the issue, offering voices that supplement the expertise and perspective of the author. They are contributed by other scholars and by political activists on the front line of political party competition today, narrating their personal activism and motivation. Chapter 4 provides profiles of key organizations and people involved in the political party and elections discourse. It describes more than 60 such organizations and provides brief bio-sketches of 70 persons who are major actors in American elections and the political party competition over them. Chapter 5 presents annotated tables, graphs, and figures and annotated synopses of primary source documents, such as laws and court cases, which have impacted political party competition and party development in America. Chapter 6 is a resource chapter, divided into print and nonprint sources for further research: academic books, films, videos, and relevant scholarly journals. Chapter 7 lists a chronology of key moments in the history of American elections and political party development. The book closes with a glossary providing easy access to definitions of the key terms related to the topic, followed by a comprehensive index.

## References

Aldrich, John. 1995. *Why Parties? The Origin and Transformation of Political Parties in America*. Chicago: University of Chicago Press.

Burnham, Walter D. 1970. *Critical Elections in the Mainsprings of American Politics*. New York: W. W. Norton.

Clubb, Jerome M., William Flanigan, and Nancy Zingale. 1990. *Partisan Realignments: Voters, Parties, and Government in American History*. Berkeley Hills, CA: Sage.

Gerring, John. 1998. *Party Ideologies in America, 1828–1996*. Cambridge: Cambridge University Press.

Key, V. O. "A Theory of Critical Elections," *The Journal of Politics*, 17 (1955): 3–18.

Lichtman, Allen J. "Political Realignment and 'Ethnocultural' Voting in Late Nineteenth Century America," *Journal of Social History*, 16 (Spring, 1983): 55–82.

Manza, Jeff, and Clem Brooks. 1999. *Social Changes and Political Change: Voter Alignments and U.S. Party Coalitions*. New York: Oxford University Press.

Rosenof, Theodore. 2003. *Realignment: The Theory That Changed the Way We Think About American Politics*. Lanham, MD: Rowman and Littlefield.

Schlesinger, Arthur M., Jr., ed. 1973. *A History of U.S. Political Parties*. New York: Chelsea House Publishers.

Sundquist, James L. 1983. *Dynamics of the Party System: Alignment and Realignment of Political Parties in the United States*. 2nd ed. Washington, D.C.: The Brookings Institution Press.

Williams, R. Hal. 2010. *Realigning America: McKinley, Bryan, and the Remarkable Election of 1896*. Lawrence: University Press of Kansas.

# The American Political
# Party System

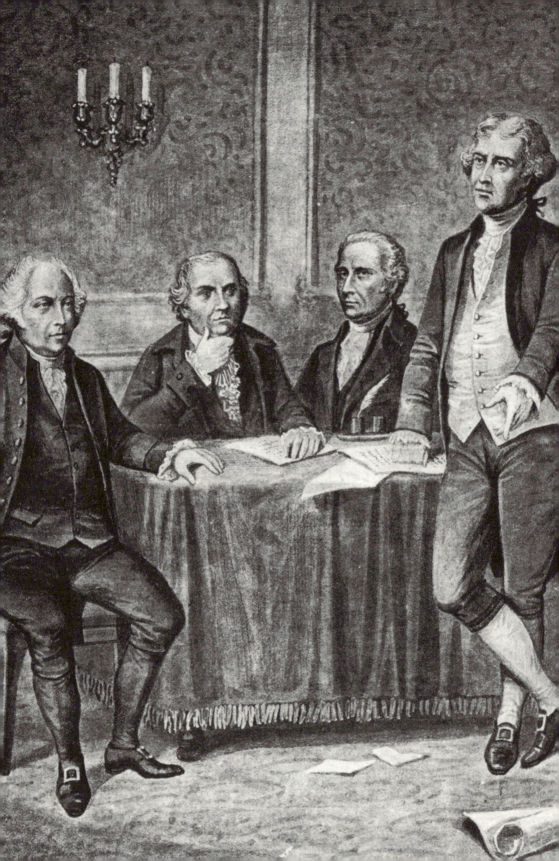

## Introduction

For much of American history, there has been antipathy toward partisanship. The first two presidential elections were consensus elections, of George Washington, in which political parties as we know them today were not yet formed. While president, Washington warned against the dangers of party opposition to the government, fearing that factionalism and demagoguery could destroy the republic. Washington thought that once a government is duly elected, it is inappropriate for citizens or officials to criticize it since such criticism amounted to disloyalty. Many, maybe even most, Americans agreed.

Today, it seems odd to think that partisan conflict can be avoided. Most liberal democracies throughout the world have competitive party systems. For the Founders, though, the Constitution itself was considered the principal expression of popular consent. Criticism of the government could be disloyal since that government was appointed according to the Constitution. To oppose the government was to oppose the constitutional order.

---

This lithograph image depicts four of the Founding Fathers at the Continental Congress: John Adams, Robert Morris, Alexander Hamilton, and Thomas Jefferson. Adams, Hamilton, and Jefferson went on to become leaders of the Federalist Party and the Jeffersonian Democratic-Republican political parties. (Library of Congress)

In the new nation, government was viewed as a social compact. Many public documents of the time, as well as numerous letters, editorials, and sermons, refer to the social compact theory (Hyneman and Lutz 1983). It holds that government emerges out of a pre-political state of nature, where all human beings are free and equal and where no human being rules any other. This state tends to be chaotic because there is no rule, no law and order. To avoid chaos, a given group of humans join together and form a distinct society. This first stage of the social compact rests on the *unanimous* consent of each and every member of society. The second stage of the compact is the creation of the government by a *majority* of the members of the now-extant society. In America, this second stage is formalized in a written constitution. A majority is necessary because unanimity cannot be achieved on every societal decision.

The Constitution is supposed to be consistent with the rights and freedoms of all; the majority is only a substitute for the unanimous consent that otherwise would have to be obtained to be consistent with the doctrine of the rights of every individual member. If the government fails to protect rights, then the members of the society may change and even abolish it and establish a new one to do so.

Most of the Founders believed in a republican form of government, a system of representation with regular elections. The Founders did not anticipate any of the profound problems of nominations and elections that later emerged. It is striking that during the framing and ratification of the Constitution, there was so little discussion of just how elections for federal offices would be conducted.

The question of factions emerged during the debates over the framing and ratification of the Constitution. The new government was intended to blunt or control, rather than enhance or direct, the spirit of parties. In *Federalist* 10 and 51, James Madison argues that factional strife would be rendered benign by competition among a multitude of groups. Compared with state legislators, members of the new federal Congress would

have to account for so many different interested and passionate groups that they would be compelled to pass laws and policies more conducive to the general interests rather than the particular interests of local factions (Hamilton 2003: 71–79, 320–22).

## The Rise of National Parties

Policy making took an unexpected turn from the outset of Washington's administration. Treasury Secretary Alexander Hamilton advocated policies to increase the scope and power of the central government: federal assumption of state debts, a national bank, and laws to develop manufacturing, secure the public credit, and bind the states into a single commercial nation (Hamilton 1985: 248–75, 277–317, 331–34). He thought energetic and proactive leadership from the executive was necessary. Congress was to be led by the president, with Hamilton acting as a kind of prime minister.

As the "father of the Federalists," Hamilton was a leading force in organizing, within the Washington administration, the nucleus of the Federalist Party. His influence was paramount in the first two presidential administrations (Witcover 2003: 8). Several Federalists led state organizations that were quasi-party organizations. John Adams became the most noted Federalist politician, the only man ever to be elected president under the party's banner. He was opposed to partisanship and antagonistic to Hamilton both personally and politically.

Hamilton's policies soon generated opposition, notably from Secretary of State Thomas Jefferson. Jefferson saw that the formation of legislative majorities amenable to his views would require more than the deliberative process anticipated in *The Federalist*. He began leading a broad public movement to stop Hamilton's program, which involved the formation of democratic societies critical of the government and the creation of newspapers advocating limited federal power. It came to be called the Jeffersonian Republican Party, the first concerted national party in American history.

To form the nascent party, Jefferson sought allies in local political clubs whose leaders could be recruited as foot soldiers in a national republican movement (Witcover 2003: 25). Begun in 1800, his presidential administration can be viewed as the first transformative presidency.

James Madison and Thomas Jefferson were the chief architects of the new party (Witcover 2003: 111). Madison had warned of factions but came to realize the need for a national majority through party leadership. He had earlier argued that majorities would indeed form, but as coalitions within the national legislature. He had not fully anticipated the problem of energy and leadership in policy making. By 1791, he realized that the coalescing of interests within the legislature was not occurring as predicted. He argued that Congress had become captive to Hamilton's agenda (Zvesper 1984). He feared the Federalist plan would result in consolidation of all governments in the union under a quasi-monarchical president. To counter that, a national coalition of interests by a "republican" party was needed (Madison 1981: 181–83).

It is striking that the Constitution did not provide for a mechanism to identify candidates for the presidency (Ceaser 1979). In Article II, it describes the Electoral College, whose members were to be selected by state legislatures and who would meet and vote on nominees for the office. While that appears odd from our modern standpoint, it reflected the Framers' antipathy to organized political action within the mass of the citizenry. The Electoral College was intended to serve as a buffer between the people and president and was designed to blunt tendencies toward partisanship and demagoguery in presidential selection.

The procedure never worked that way. It seemed to do so only in the first two presidential elections because Washington was the overwhelming choice for president. The presidency was *contested* for the first time in 1796, when Jefferson opposed Vice President John Adams. In 1796, congressional party caucuses

were significant in the identification of candidates. There would be no national party conventions linking the federal and state parties together until the 1830s. Instead, party caucuses in the Congress assumed this role. "King Caucus" signified a principal difference between the organization of the first parties and that which would emerge in the mass party system of the Jacksonian era (Aldrich 2012). The caucus was considered "king" in the sense that it implied an undemocratic, non-republican system in which elites (the members of Congress) in their party caucuses selected national party nominees. There was a need to organize parties for the sake of winning elections and passing legislation but not yet for a defense of a *system* of political parties to organize the polity for democratic self-rule.

## Party Principles

The people who opposed Hamilton understood their opposition in terms of *regime* principles. Madison argued that Republicans were moved by more than opposition to a narrow set of public policies. The party was moved by a specifically *republican*, as opposed to a monarchical, set of principles. He argued all societies tended to divide into two groups: those who are more and those who are less confident in the capacity of the people to self-govern. Federalists adhered to a different conception of citizenship (Madison 1981: 189; Reichley 1981).

For Madison, the Federalists betrayed an appreciation of monarchical forms contrary to genuine republicanism. For him, the two political parties represented regime types, one more democratic, the other more aristocratic, though each claimed to be the embodiment of republicanism (Gerring 2001: 257–59, 263). Republicans routinely accused Federalists of favoring monarchy; Federalists accused Republicans of being Jacobites (named after the French Revolution's radical democrats). The party struggle began to resemble a cold war between two opposing nations, and party conflict intensified with foreign

policy issues in the 1790s (Jefferson 1944: 512–13, 126–29; Hofstadter 1969: 88).

In 1794, the Washington administration negotiated the Jay Treaty with Great Britain. Orchestrated by Hamilton, it resolved several disputes with the British and established smoother trade. Jefferson and Madison opposed it. Ratified by the Senate in 1795, the treaty contributed to the growing agitation for war between France and the United States. Formal war was never declared, but tensions with France continued. Congress passed the Act of January 29, 1795, that increased residency requirement from two to five years and required applicants for citizenship to affirm allegiance to the United States and renounce allegiance to their former sovereigns and hereditary titles of nobility—a provision aimed at French immigrants (see LeMay and Barkan 1999, Document 8: 12).

Federalists proposed a ban on all but native-born Americans from holding public office or even voting (Witcover 2003: 57). They considered the 1798 Irish Rebellion, inspired by the French and American Revolutions, a threat. Federalists feared that Catholic refugees might find their way to America, and many Federalists viewed Catholics as unfit for membership in the republic.

Federalists won the midterm elections of 1798 and then passed in quick succession the Alien and Sedition Acts and the Naturalization Act of 1798, laws intended to control enemy aliens and seditious citizens and to restrict or deport immigrants who might be hostile to the United States (see LeMay and Barkan 1999, Documents 9 and 10: 13–16). But they had overreached. These laws resulted in the landslide Republican victory of 1800. The laws reflected Federalist fear of an effort by citizens and aliens to support the Republican cause, which they associated with France (Pickus 2005: 41).

The partisan struggle resulted in the Virginia and Kentucky state legislatures condemning the Alien and Sedition Acts, which became an important part of the 1800 election, the

first national election that was an unabashed two-party battle (Witcover 2003: 65). Madison argued that "interposition," whereby a state's sovereignty was placed between its citizens and the federal government, was a legitimate constitutional means open to them (Madison 1981: 230; Zentner 2005). He saw political parties as justifiable vehicles to watch over and to warn governments not to overstep their proper bounds.

## One-Party Rule

Conflict between Federalists and Republicans stopped short of revolution or civil war. The threat to the United States from France waned in 1800 as Napoleon Bonaparte consolidated power. President Adams achieved a formal peace with the French with the Treaty of Mortefontaine, superseding treaties with France that had lasted since the time of the Revolution. Throughout the tumultuous 1800 election campaign, Adams declined to align openly with the Federalist Party, attempting to maintain the non-partisan bearing of Washington. His personal aversion to partisanship helped avoid a more incendiary political climate in 1799 and 1800. Adams's attempt to rise above parties represented the kind of nobility many thought necessary in republican government, but it also showed him to be a naïveté about the realities of partisanship extant in the new republic.

In 1800, the Jeffersonian Republicans defeated the Federalists in a close election. The results were lasting, amounting to what some political scientists call a partisan realignment, a decisive national shift in party preference and allegiance (Sundquist 1983). The Jeffersonian realignment was distinctive as the first of its kind. With Jefferson's election, the egalitarian and republican side of American politics prevailed.

The partisan divide had become intense, but the Federalists soon ceased to exist as an organized force. Jeffersonian Republicans led a one-party rule lasting until 1828.

## The Jacksonian Transformative Election and Period, 1828–1860

In 1824, four men seriously contended for the presidency, none of whom won an Electoral College majority. There was no competitive party system to select nominees and provide a clear choice in the popular election. The plurality winner in the Electoral College, Andrew Jackson, was passed over in the House of Representatives. They chose John Quincy Adams, the runner-up in the College. J. Q. Adams, like his father, was a Federalist in principle and sentiment. Jackson was the more obvious heir to Jefferson's political legacy. This confusion was bred by the very success of the Republicans: with only one party, it was difficult to discern who was or was not the more republican candidate.

Jackson's election to the presidency signaled the dawn of the mass party system and the rise of the first truly national two-party system. The most important development was the transformation of the rather loosely knit Republican Party, forged by Thomas Jefferson among party organizations in the various states, into the more national coalition of the Democratic Party, led by Andrew Jackson and organized by Martin Van Buren.

The allegiance of immigrant groups to the Democratic Party was an important component of the coalition of the majority political party from 1828 through the outbreak of the Civil War in 1860. The Whig Party and the Anti-Masonic Party were less open to naturalized citizens of immigrant groups pouring into the country. Partly for this reason, they were unable to obtain majority party status (LeMay 1987).

Immigration policy was largely unrestricted. Immigrants were needed to increase the American population precisely when Europe needed to reduce its overcrowded nations and reduce pressures from social and economic changes. The Democratic Party viewed immigrants as a vital buffer against Native American Indian resistance to the Euro-American expansion across the

continent. By the 1850s, this expansion was seen as the newly burgeoning nation's *Manifest Destiny*, a term coined by John O'Sullivan in 1845 (LeMay 1987, 2006; Widmer 1999).

### Extension of the States

The American population tripled between 1820 and 1860, from fewer than 10 million to more than 30 million. Steam-driven river traffic and the railroads opened the interior as six new states were added to the union.

States sought immigrants to increase their populations. Some allowed resident aliens, with some qualifications, to vote in elections. In 1846, Wisconsin extended the franchise to aliens who intended to be naturalized and who had lived in the state for a year. Michigan, in 1850, adopted a similar law. By the late 19th century, 18 states allowed aliens to vote (Ueda 1980: 737, 740).

Population expansion coincided with the expansion of the *presidential* franchise, as more states adopted the popular vote for the Electoral College, as opposed to appointment by state legislatures. In 1796, only 7 of 16 states had popular selection of electors. By 1824, presidential electors were chosen by popular vote in 18 of the 24 states. In 1832, only 1 of the 23 states, South Carolina, used its state legislature to selected Electoral College members. This meant an enormous increase in the number of ordinary voters who had to be mobilized in a national presidential election (Busch 2001).

### The Rise of the Mass Party

The new form of party that emerged came to be called the "mass party." The national party organization was no longer centered in elites in the capital. Rather, the party emphasized participation in politics throughout the country. This extension of the party corresponded with the steady expansion of the electorate in the first decades of the 19th century.

What some call the second party system (Kleppner et al. 1983) emerged in 1828 with Jackson's presidency. The Democratic Party emerged out of the remnants of Jefferson's Republican Party to distinguish itself from "Republicans" like Adams. For a time, Adams and others were called "National" Republicans. Their label followed from their preference for an energetic national government, embodied in Henry Clay's famous "American System," which called for federal funding of internal improvements, tariffs to spur industry, and continued support of a national bank. Jackson and his supporters accepted the "Democratic" label to distinguish themselves from the Nationalists.

The Democrats comprised a new coalition crafted by New Yorker Martin Van Buren. He led the effort to elect war hero Andrew Jackson, the inspirational head of the Democratic Party. Jacksonian Democrats dominated American politics and civic culture until 1860 and shaped a party system by setting forth the methods and means of the modern mass party. The Whig Party, which grew out of the National Republicans, served as the Democrats' main opposition (Kleppner et al. 1983; Wilentz 2005, 2007).

Van Buren saw that a disciplined national system of two parties permanently competing with one another would be "highly useful" and even "inseparable from free governments" and a check on the "disposition to abuse power, so deeply planted in the human heart" (Van Buren 1867: 125). He aimed to prevent corruption and tyranny by means of the political party, properly organized and maintained.

The party system in New York, known as the Albany Regency, provided a model for the country. Its leader, Martin Van Buren, helped organize what became known as the Democratic-Republican Party, designed to battle the Federalist Party (Witcover 2003: 133, 151). The Regency was a disciplined organization defined by the subordination of the interests of individual politicians to the interests of the party.

This new party "would create opportunities for nominations, patronage, careers, in return for the loyalty it demanded

of its members" (Hofstadter 1969: 244). Van Buren, and other prominent Albany Regency men, believed that party discipline was necessary to check the abuses of personal power (Garraty 1949: 40; Van Buren 1867: 125).

In 1827 and 1828, as the de facto chairman of the emergent national Democratic-Republican Party, Van Buren set about transforming the party system. He brought various state and local organizations and groups broadly dedicated to Jeffersonian principles under the umbrella of the Democratic Republican label by calling a national convention for the nomination of General Jackson (Van Buren 1867). The various state organizations coalesced, following promises of local autonomy in exchange for support of the broad agenda of the national party (Aldrich 1995: 106–19). In 1828, the Democrats did not have a convention in the modern sense, but in the decades that followed, the national conventions, made up of delegates from the state and local parties and whose main task would be the nomination of the national party's presidential candidate, replaced the congressional party caucuses in presidential nominations. The decentralized, local party organizations became the source of political power.

An Anti-Masonic Party, the first "third party" in the United States, emerged from a social movement strongly opposed to Freemasonry as a single-issue party that aspired to national major party status. It lasted a decade. It was the first party to hold a modern nominating convention and introduced the adoption of party platforms (Epstein 2012; Holt 1984; Vaughn 1983). The National Republicans, the Anti-Jackson faction, were a feeble organization. Several political leaders seized upon anti-Masonic feeling to create a party to oppose the rising Jacksonian Democrats, as Jackson was a high-ranking, well-known Mason. By 1832, the movement lost its singular focus on Masonry and spread from its base in New York to neighboring states (Raybeck 1959).

The party conducted the first presidential nominating convention, in 1831 in Baltimore, and polled almost 8 percent of

the popular vote in the 1832 general election. The convention format was adopted by the National Republicans in December of that year and by the Democrats in May 1832. The Whigs, the successors to the National Republicans, held their first national convention late in 1839. The Anti-Masonic Party was waning by then and made no alternate nominations and soon vanished. But it had played an important role in the evolution of party practices and structure.

For Van Buren, Jackson was useful because of his popularity and even more useful because his views were ideologically indistinct, allowing the party to give meaning to Jackson's candidacy and administration (Remini 1972: 72–73). The national party "required only that a state grouping be sufficiently organized to pick a slate of presidential electors, ensure that they would cast their votes for Jackson if called on to vote, and agree to call itself the Democratic Party" (Aldrich 2012: 121).

The Democratic Party used a party caucus in Washington (later the national committee, appointed by the national convention) to act as the coordinating body across the country to serve as the national arm of the new party-as-organization, raising resources, coordinating efforts, and overseeing investment in building state- and local-level organizations for mobilization in 1828 and thereafter (Aldrich 2012: 116). While not all of the states were fully organized under the party label in 1828, the result nevertheless was a dramatic increase in voter turnout—from 26.5 percent in 1824 to 56.3 percent in 1828. In the next few election cycles, voter turnout remained strong. Once the Whig Party had developed by the late 1830s, following the model of the Democrats, the mass party system had matured, resulting in greater democratization of the country.

## The Party Spoils System

To wed voters and politicians to the party, patronage and other material incentives became the guiding principle of partisanship: "to the victor belong the spoils of the enemy" (Spencer 1959: 60). This later resulted in party "machines,"

organizations that emphasized incentives as much as ideological prescriptions. Incentives would become particularly important in the 19th century. The seeds for the machines were laid in the trend toward urbanization that was already begun by the 1830s (Bayor and Meagher 1995, Ch. 3; LeMay 2013, Vol. 1: 54–56).

Party organizations in many cities became essentially adjuncts to the government. Party "bosses," as they came to be called, would control to a degree the levers of government power, often without holding official positions in government. This "party-in-control" dominated American politics for more than a century after Jackson's presidency. Urban machines, such as Tammany Hall in New York City, were criticized for their tendency for graft and corruption. But the decentralized party structure, not the government, would be the locus of political and even social activity.

Ordinary citizens benefited from the largesse of the political party. Party leaders used their connections in government, business, and churches to provide benefits for, and induce loyalty from, citizens who would be rank-and-file members. The party became a principal source of social assistance to the poor and dispossessed (McSweeney and Zvesper 1991: 108–111).

This welfare component of the mass party was crucial. Compared with modern American government, the national government of the 1800s had a very slight role in matters of public welfare. For Jackson and Van Buren, *democracy* meant limited, local government. The mass party system of the 19th century, like the formal institutions of government, was highly decentralized (Higham 1981: 13).

The structure of the mass party system was not direct democracy, having no measures like the initiative or the recall most often associated with the Progressive reformers of the early 1900s (Ceaser 1979). Nor did it advocate constitutional reforms, such as direct election of U.S. senators.

The Jacksonian era parties are called "mass" parties because party organizers reached out to constituents and encouraged

their support of the party ticket. This meant the development of party rallies to rally support and mobilize voters on election day. Party organizations, through caucuses and conventions, played that role. The emphasis in the mass party was that the political party would become a medium through which the ordinary citizen would engage in civic life through material assistance, parades, and holiday celebrations that emphasized broad participation in politics rather than passive deference to an elite or indifference to politics altogether (Aldrich 1995: 97–98).

## Democratic Superiority

The new Democratic Party was a great success. It took several election cycles for their opponents to form themselves into a similarly organized party: the Whigs. The Democrats were a coalition of farmers, city dwellers, laborers, and Irish Catholics. The party advocated free trade, social reform, expansion southward into the territories, and a foreign policy that supported republican, anti-aristocratic movements abroad. It was urban and middle class and appealed to the burgeoning European immigrant population, especially Irish Catholics (Widmer 1999). The party sought the expansion of popular modes of electioneering based on optimism about the common person's capacity for sound judgment and rational choice.

The Whigs more or less continued the original Federalist positions on law and policy, emphasizing energetic national government. They tended to be of Anglo stock, situated in New England. Protestantism and traditional morality were important elements of Whig sensibility. The Whigs stressed virtue ethics, the need for habitual formation of moral character (Howe 1984). The first truly contested presidential election between the Democrats and the Whigs was not until 1840, which the Whigs won.

Van Buren was the Democratic nominee who lost that election. He won the presidency in 1836. He served only that one term because the Panic of 1837 (a recession in today's terminology) struck almost as soon as he took office. Whig nominee

General William Henry Harrison served one term. The other Whig victory was that of General Zachary Taylor in 1848. Still, the dominance of the Democrats was evident in the fact that Harrison and Taylor were successful because they were war heroes, not dogmatic Whigs.

A central theme of the Democratic Party in the 1840s was aggressive westward expansion, Manifest Destiny. They pursued expansion despite the risk of war with Mexico over the annexation of Texas and increased tension with Great Britain over control of the Oregon Territory. The Whig Party opposed Manifest Destiny and particularly the Mexican-American War (Hofstadter 1969; Nichols 1967; Wilentz 2005).

In 1848, the Democratic Party established the Democratic National Committee at its national convention. This completed the mass party structure. The Whigs won the presidency due to the split from the Democratic Party by the Free Soil Party, which opposed the expansion of slavery. These changes prefigured the political upheaval and emergence of a new party in 1858. Southern Democrats, as well as many Northern Whigs, opposed the Compromise of 1850, a bundle of laws intended to sort out the issues related to slavery following the acquisition of new territory after the Mexican war. The Whig Party began to collapse in 1852 over its divisions on slavery and nativism. The Democrats won back the White House in 1852, with the election of Franklin Pierce, and held it again with James Buchanan in 1856 (Schlesinger 1973). The Whigs were associated with the privileged class of the wealthy elite (Widmer 1999; Wilentz 2004). But once slavery became the central national political issue in 1854, the Democrats became the de facto proslavery party. In the 1850s, the Democrats were more open to immigrants and became their natural political home (Zolberg 2006: 139). An imperative of the mass party was to increase voter turnout, which sometimes led to abuses of the franchise. Voter fraud was not uncommon. Immigrants were sometimes used by the parties, especially the Democrats, to rig elections (Myers 1971: 90–91; Reichley 2000: 84).

Ties between immigration and the mass party organization took on greater significance as the 19th century progressed. More people came to the United States in the decade from 1845 to 1855 than in the previous seven decades combined (LeMay 1985: 33). Between 1840 and 1854, Irish and Germans dominated the flow to the United States and were well-known Democratic supporters.

The Whig Party was the primary home of Puritan Protestants, particularly in New England. In response, the Irish gravitated to the Democratic Party, in keeping with its greater openness to immigrants (LeMay 1987: 25). In 1848, revolution hit central Europe and the German states. Many German intellectuals fled to America. They became known as the "Forty-Eighters." They provided important leadership in the early development of unions and were involved in the anti-slavery movement (LeMay 1985: 36–37; Rippley 1973). Many German immigrants and their descendants aligned with the Republican Party after 1854.

## The Know Nothings

The rapid increase in immigration in the mid-1840s triggered a sharp nativist reaction (Zolberg 2006: 140–53), leading to a significant third party movement. Catholic immigrants coming in ever-larger numbers set off a dramatic antiforeign reaction. Immigrants were blamed for the problems facing a rapidly changing society extensively urbanizing and industrializing. Social reformers and Protestant evangelicals sought to save the nation's purity, and helped form an anti-immigrant association, the Secret Order of the Star Spangled Banner, which evolved into the American Party, more commonly known as the Know Nothings (because it was a secret organization, so when asked about it, members would "know nothing") (LeMay 1987: 10).

The slavery issue loosened ties to the major parties, and many voters unwilling as yet to cast their lot with either found a temporary home among the Know Nothings. The movement

attracted parts of the working class fearful for their jobs and what they perceived as the undermining of society by the vast influx of immigrants. They feared an increasing political threat as the electoral clout of the immigrant bloc vote became evident with beginnings of the urban political machines. They felt that large-scale immigration led to low wages and deplorable working conditions. They advocated restrictive immigration policies and stringent naturalization laws—for example, a 21-year waiting period for citizenship, up from the 5 years adopted in 1795; the idea was that since a native-born citizen could not vote or hold office until age 21, immigrants should not be able to participate in politics for the same length of time (Anbinder 1992: 121). At the state level, they advocated literacy tests and language qualifications for voting (Zolberg 2006: 160).

The transformative election of Abraham Lincoln saw the emergence of a new party, formed in opposition to slavery. As an intersectional party vying to be competitive in the North and the South, Whigs found it difficult to negotiate the political waters regarding slavery. As the issue of slavery became more divisive, the incentive for the parties to become sectionalized increased (Holt 1999). This eventually happened with the Democratic Party, which by 1860 became the party of the South and of slavery. The new Republican Party would become the party of the North and antislavery.

## The Transformative Election of Lincoln and the Parties, 1854–1896

Political party development was shaped by the slavery issue and the Civil War. The Whigs dissolved. The Democrats changed from the dominant majority party to the minor one of the two-party system, dependent on its southern regional base. The newly formed Republican Party rose to the status of dominant majority party, resulting from dramatic shifts in the coalition of interests affiliated with the two major parties (Gould 2003;

Marcus 1971; Rutland 1996). Party organizations became more complex and developed grassroots organizations at the precinct level in the growing number of large cities (Greenstein 1970; Jenson 1971, 1983; Litt 1970). New third party movements and organizations also formed during this era—some to relatively long-term life, others single-issue oriented with brief political existence.

The Civil War caused a shift in the nation's economy from agricultural to industry centered in cities and from the east to the mid-west. In 1860, 80 percent of the population was rural. There were only 392 cities. By 1900, a majority of the population lived in cities (LeMay 2013, Vol. 1: 53, Vol. 2: 123).

The Republican Party platforms in 1868 and 1872 advocated continued immigration. Enacted by the Republican Congress, the most significant national policy to attract new immigrants was the Homestead Act of 1862 (see LeMay and Barkan 1999: 29–30). The act gave 160 acres of land to anyone who worked it for 5 years. The decision to build the transcontinental railroad had a similarly profound impact on attracting new immigrants. It granted two companies each 10 to 20 acres of land for each mile of track built. The Central Pacific hired more than 7,000 Chinese laborers to construct the line from Sacramento eastward. The Union Pacific hired thousands of Irish immigrants to do so from the east westward (LeMay, 1987: 35). By the early 1870s, agricultural devices such as the gang plow and reapers, mechanical threshers, and well-drilling equipment and windmills to supply water opened the Plains states, and settlers flooded in, fueled by population from the east and the millions of immigrants arriving to American shores (LeMay 1987: 34–35).

A number of big cities saw urban political machines develop (organized to appeal to ethnic voting blocs) and running slates of candidates, many of whom were naturalized citizens. This led to anti-immigrant sentiment among those who favored restriction. "Boss Tweed" organized the Tweed Ring which captured control of Tammany Hall and plundered millions

of dollars from New York City's treasury from 1865 to 1871. Anti-machine reformers called for restriction of immigration (Allen 1993; Dinken 1989).

From mid-1870 to mid-1880, restrictionists targeted the Chinese. Anti-Chinese sentiment began in California in the 1850s. In 1867, the Democratic Party swept state offices running on an anti-Chinese platform, and the Workingmen's Party won control of San Francisco. The Panic of 1873 spurred fears of "the Yellow Peril." By 1880, anti-Chinese sentiment was so strong on the West Coast that it was virtual political suicide to support Chinese immigration (LeMay 1987: 53). Congress passed a Chinese Exclusion Act in 1879, vetoed on the grounds that it violated the Burlingham Treaty of 1868 (Bennett 1963: 16). A new treaty was ratified in 1881, and a new law suspended Chinese immigration for 20 years. President Arthur, however, vetoed that bill. Congress passed a second bill in May 1882 (22 Stat. 58), which came to be known as the Chinese Exclusion Act (LeMay and Barkan 1999: 51–54). It stopped virtually all Chinese immigration for 10 years: Chinese immigrants dropped from 12,000 in 1880 to a mere 23 by 1885 (LeMay 1987: 54–55). The law expressly prohibited their naturalization (Bennett 1963: 17).

## Developing Political Parties and the Modern Two-Party System

The American party system is currently characterized as a two-party system dominated by the Democratic Party and the Republican Party. One of these two major parties has won every presidential election since 1852 and controlled Congress since 1856. Since the Civil War, they competed in status as to which one was the dominant and which the minority of the two and witnessed the organization and dissolution of several third parties (Gillespie 1993; Haas 1994; Jenson 1983; Witcover 2003: 3). They saw the dissolution of the Free-Soil Party (1848–1854), a single-issue anti-slavery party which splintered from the Whigs and the Liberty Party. The American Party,

distinctly anti-immigrant, emerged and ran candidates for the presidency in 1876, 1880, 1884, and 1888.

The Workingmen's Party was a labor organization that became a third party, the first Marxist-influenced party in American history and a forerunner of the Socialist Party of America. It was strong in Kentucky, California, Washington, and Oregon (Foner 1977).

The Greenback Party (1874–1884) was a single-issue party. An agrarian-based reaction to the Republican Party's hard-money policies, it advocated use of paper currency. It ran candidates in 1876, 1880, and 1884, but withered when the recession ended. It had close ties to the Grange. Another single-issue party was the Silver Party (1892–1911). Similarly, the Prohibition Party (1869–1884) ran presidential candidates in 1872, 1876, 1880, and 1884 but never attained 1 percent of the popular vote.

The Equal Rights Party, founded in San Francisco in 1884, advocated suffrage for women, equal property-owner rights for women, a moderately protective tariff policy, prohibition of the sale of alcohol, civil service reform, and the sale of public lands only to actual settlers. It also won less than 1 percent of the popular vote (Hoogenboom 1961; McMath 1993; Williams 1978). The Socialist Labor Party (1876–1890) used immigrants as its grassroots shock troops (Draper 1957: 31–32; LeMay 2009: 62).

Arguably the era's most successful third party was the People's Party (1876–1896). It was a coalition of farmers, laborers, and middle-class activists who fought the growing corporate power that then controlled the economy (Clanton 1991). It advocated direct election of senators, the initiative, and referendum. The initiative allowed voters to put an issue on the ballot to become law without the legislature enacting it. The referendum was a direct vote on a proposed law, again allowing citizens to bypass the legislature. The Democrats and Republicans eventually adopted many of its programs and ideas: the federal income tax, direct election of senators, initiative and

referendum (at the state level in some states), and banking reform (Clanton 1991; Kazin 1995; Lester 2007).

By 1881, high tariffs generated a large surplus for the federal government; the Republican-controlled Congress used those tariff revenues to fund pensions to Civil War veterans and a variety of pork barrel projects. Democrats, and the agrarian movement, opposed the burdensome "tax." Monetary policy instilled more emotional reactions than tariffs. Farmers supported silver coinage or cheap paper currency (greenbacks), while creditors favored a stable money supply backed by gold. Creditors and big-business interests essentially won the debate when Congress passed the Species Redemption Act of 1875, putting the country back on hard money.

Closely aligned to monetary policy was civil service reform. The major parties favored the spoils system, in which a successful political party rewards its activists with jobs. Between 1865 and 1896, the size of the federal bureaucracy rose from 53,000 to more than 166,000. Lucrative salaries for elected and appointed officials resulted in kickbacks that filled party coffers. Abuses led to the formation of the National Civil Service Reform League, in 1881, and resulted in the Pendleton Civil Service Act of 1882, which, however, covered only about 10 percent of federal jobs and was not applicable to state and local governments (Greenstein 1970).

More important than third parties were developments in the two major parties: the decline of the Democratic Party from dominant to minority status and the emergence of the Republican Party to dominant major party status.

Between 1860 and 1896, the Democrats elected only Grover Cleveland as president (in 1884 and 1892). They were split between two wings: the Bourbon Democrats supporting Eastern business interests and the agrarian wing comprising small farmers in the South and West. The agrarian wing captured control of the party in 1896, on the issue of "free silver," when it nominated William Jennings Bryan (Williams 2010). The Democrats used grassroots party organization and patronage

to finance their party operations and big-city machines. They were proponents of farmers, urban workers, new immigrants, Manifest Destiny, and greater equality among all white men, and they opposed a national bank (Ashworth 1983).

During Reconstruction, the Democratic Party benefited from resentment among white Southerners. The depression of 1873 allowed Democrats to take control of the House of Representatives in 1874; by 1877, Democrats controlled every Southern state. From 1880 to 1960, the Southern states that had joined the Confederacy voted Democratic in nearly every presidential election. Democrat Grover Cleveland, the reform governor of New York, won the White House in 1884 and again in 1892, having lost in the 1888 contest. He led the Bourbon Democratic wing of the party representing business interests, supported banking and railroads, and espousing laissez-faire capitalism. In power during the Panic of 1893, the Democrats were blamed for causing it, setting off a battle for control of the party between its bourbon and agrarian factions.

The Republican Party emerged in Ripon, Wisconsin, in 1854, organized to oppose the Kansas Nebraska Act to extend slavery into the territories. It held its first national convention in Pittsburgh, in 1856, and its first national nominating convention that summer, in Philadelphia (Gould 2003). In 1858, in the North, the party attracted former Whigs and former Free-Soil Democrats. It formed a majority party in nearly every Northern state with the election of President Abraham Lincoln in 1860. The party included northern white Protestants, businessmen, professionals, factory workers, farmers, and African Americans. It was pro-business, supporting banks, hard money (the gold standard), railroads, and high tariffs to protect industrial workers and industry. It supported giving free western land to farmers ("free soil"), expanded banking, and more railroads and factories (Foner 1995).

Republicans established a coalition of ethnic and religious groups that set moral standards for their members and

advocated carrying those standards into politics. The pietistic and evangelical churches gave politicians access to social networks that became voting blocs. They advocated purging sin from society: alcoholism, polygamy, and slavery (Kleppner 1979). Geographically, they dominated New England, upstate New York, and the upper Midwest. Religiously, they received strong support from Congregationalists, Presbyterians, Methodists, Scandinavian Lutherans, and Quakers.

In 1868, Republican Ulysses S. Grant won the White House. The party's radical wing had full control of Congress, the party, and the army. It attempted to build a base in the South using freedmen, scalawags (white Southerners who voted with black freedmen), and carpetbaggers (Northerners who moved to the South during Reconstruction), supported by army detachments and local clubs, called Union Leagues (Gould 2003).

The party grew so large that factionalism became evident, perhaps inevitable. Grant tolerated high levels of corruption. The pietistic/moralistic wing of the party began to abstain from elections, and the Depression of 1873 energized the Democrats, who won control of the House. Reconstruction came to an end in the highly contested 1876 election. A special electoral commission, convened due to electoral disputes in Florida, Louisiana, South Carolina, and Oregon, awarded the presidency to Rutherford Hayes, a Republican, who promised to withdraw federal troops from the southern states, which soon became the "Solid South," giving overwhelming majorities of electoral votes and congressional seats to the Democrats (Remini 2006).

The Republican Party, nicknamed the GOP (short for Grand Old Party), developed factions: the stalwarts (in favor of the spoils system), the half-breeds (against the spoils system), and the mugwumps (against machine politics). When the half-breeds pushed for civil service reform against the spoils system, the mugwumps broke rank and helped elect Democrat Grover Cleveland in 1884 (Gould 2003; Sibley 1991).

Cultural issues were highly salient during the Gilded Age of 1877–1890 (Marcus 1971). The Republicans supported pietistic Protestants (Methodists, Congregationalists, Presbyterians, and Scandinavian Lutherans) in their demands for Prohibition. That position angered "wet Republicans," especially German Americans, who broke ranks in 1890–1892, enabling the Democrats to win (Kleppner 1979: 182).

In response to a new immigrant flow, a plethora of nativist groups emerged after 1880 to agitate to restrict immigration. Organized labor, the Workingmen's Party, the Chinese Restriction League, the Asian Exclusion League, the Ku Klux Klan, the People's Protective Alliance, the Japanese Exclusion League, the Order of American Mechanics, the American Protective Association, the 100 Percenters, and the Immigration Restriction League all arose between 1890 and 1930. They wanted to close the open door by instituting first a literacy test, and then the quota system, to stem what they viewed as an unwanted "flood" of immigration (Hoerder 1982; LeMay 2013, Vol. 2: 10–11). A coalition of business and ethnic groups sought to keep the doors open (LeMay 1987: 63–66, 2006: 95–105).

## The Transformative Election of McKinley and the Progressive Era, 1896–1932

Political scientists and historians refer to American political history from 1896 to 1932 as the Progressive Era, dominated by the Republican Party. The concept of party systems was introduced by E. E. Schattschneider in 1960; later, several political scientists began numbering them as the first, second, third, fourth party system, and so on (Chambers and Burnham, 1967, Kleppner 1987; Link 1972; Lipset and Rokkan 1967; Sarasohn 1989; Schattschneider 1960). During the Progressive Era, Democrats won the White House for only eight years, 1912–1920, when a split in the Republican Party enabled Woodrow Wilson's two terms.

The Progressive Era began with a depression in 1896 and ran through World War I and into the start of the Great Depression. A number of domestic issues were central to the era: (1) the regulation of railroads and large corporations, then called "trusts," (2) gold versus silver as the base for American currency, (3) the degree to which a protective tariff was used, (4) the role of labor unions and child labor in the economy, (5) the need for a new banking system, (6) reform of corruption in party politics and electoral structural reforms such as primary elections, direct election of senators, and the initiative and referendum, (7) racial segregation, (8) government efficiency and civil service reform, (9) women's suffrage, and (10) control of immigration. Issues central to foreign policy during the Progressive Era were as follows: (1) the Spanish-American War, (2) imperialism, (3) the Mexican Revolution, (4) World War I, and (5) the creation of the League of Nations.

The dominant political leaders of the era were presidents William McKinley (R, 1896–1901), Theodore Roosevelt (R, 1901–1908), and Woodrow Wilson (D, 1912–1920). Two other Progressive leaders were unsuccessful candidates for president: three-time presidential candidate of the Democratic Party, William Jennings Bryan, and Wisconsin's Progressive Republican senator Robert M. La Follette (Sanders 1999).

In 1896, McKinley won overwhelmingly and won again in 1900 (Williams 2010). The 1896 election restored business confidence and long-term prosperity. McKinley's election swept away many of the issues and personalities that had dominated the previous era. It retained the basic voting blocs but realigned some of their coalition. Republicans dominated the industrial Northeast, most of the Midwest, about half of the West, and found new electoral success in the border states. The Democrats were strongest in the South and Plains states. McKinley's two elections (he was assassinated early in his second term) set the stage for the Progressive movement, a new

way of thinking about politics and the role of government and a new agenda for politics (Williams 2010).

### Major Party Developments: The Republicans

William McKinley's campaign manager, Senator Marcus Hanna (R-OH), structured a new party finance system, relying heavily on revenue from railroads and industry (Williams 2010). McKinley was the first president to actively promote pluralism. He campaigned on the idea that prosperity should be shared by all ethnic and religious groups (Shafer and Badger 2001; Williams 2010). The party's reputation as the party of business, however, was mitigated by Theodore Roosevelt, who succeeded as president after McKinley's assassination and who emphasized "trust-busting." Within the Republican Party, Roosevelt contested Hanna in the 1904 convention, secured the nomination, and won the election campaigning on continuing McKinley's policies. In pushing a progressive agenda, Roosevelt scored modest legislative gains with railroad regulation and pure food laws. He won critical Supreme Court decisions, bringing antitrust suits that broke up the Northern Securities Company and the Standard Oil Trust. In the final two years of his term, he had less success, with enactment of legislation he coined "the Square Deal." As the sitting president, his control in the party enabled him to name his successor, Secretary of War William Howard Taft, who defeated Democrat William Jennings Bryan in the 1908 election (Harbaugh 1963; Morris 2001, 2002).

Tariff policy strained the Republican coalition. Eastern conservatives wanted high tariffs on manufactured goods. Midwesterners wanted low tariffs favored by farmers. This rift helped the Democrats win control of the House in 1910 (Gould 2003).

Roosevelt tried to win back the Republican Party nomination for president in 1912. Taft, the sitting president seeking a second term, won the nomination. Roosevelt bolted, led his

delegates out of the convention, and created a new party, the Progressive (or "Bull Moose") Party. The split enabled Democrat Woodrow Wilson to secure a decisive win, and his two terms interrupted the Republican era (Cooper 2009; Gould 2008; Link 1972; Morris 2001).

Republicans controlled the White House throughout the 1920s, running on platforms that opposed entrance into the League of Nations, supported high tariffs, and promoted business interests. Republicans Warren Harding, Calvin Coolidge, and Herbert Hoover won in 1920, 1924, and 1928, respectively. In 1924, the Progressive wing of the party broke away to support Senator Robert La Follette, but La Follette failed to stop Coolidge, who won by a landslide, and La Follette's movement fell apart. The Teapot Dome Scandal hurt the Republican Party, but when President Harding died, Coolidge blamed everything on him, and the opposition splintered in 1924, enabling Coolidge's win (Shafer and Badger 2001).

The policy agenda of the Republican Party throughout the 1920s seemed to produce an unprecedented prosperity that lasted until the Wall Street Crash of 1929, which precipitated the Great Depression. It was not until FDR crafted his New Deal Coalition, in 1932, that Democrats achieved their stronghold on big cities (Gould 2003; Shafer and Badger 2001).

### Major Party Developments: The Democrats

In the 1904 Democratic Party Convention, conservatives controlled the convention against the Bryan wing. The Democrats' in-party rift helped Roosevelt win by a landslide. Bryan then dropped his free silver and anti-imperialism rhetoric and embraced mainstream progressive issues: a federal income tax, antitrust legislation, and the direct election of senators. Bryan endorsed and supported the nomination of Woodrow Wilson in 1912. In turn, Wilson appointed Bryan secretary of state, a highly coveted cabinet position (Kehl 1981; Neal 1983; Sarasohn 1989).

The Democrats took control of the House and nominated and elected Princeton University alumni Woodrow Wilson as president in 1912 and 1916 (Blum 1980; Cooper 1983, 2009; Daniels 1946; Gerring 1998, 2001; Gould 2008; Link 1972).

Wilson and congressional Democrats passed a series of progressive laws: a reduction in tariffs, stronger antitrust laws, new programs to aid farmers, hours-and-pay benefits for railroad workers, and outlawing child labor (Cooper 2009). Wilson led America into World War I and to its successful conclusion. He represented the United States at the 1918 Peace Conference in Versailles. His vision for peace, known as his "Fourteen Points," was idealistic and helped secure adoption, at the peace conference, of the Covenant of the League of Nations. He was awarded the Nobel Peace Prize in 1919 (http://www.nobel prize.org/nobel_peace?...?laureates/1919/Wilson-acceptance .html) (Cooper, 2001).

A war-weary country was gripped by isolationism, and the Senate rejected Versailles and the League of Nations. A worldwide pandemic, known as the Spanish Influenza, 1918–1919, caused upwards of 650,000 deaths in the United States and an estimated 50 million worldwide (LeMay 2006: 88–89). In the postwar years, a nationwide wave of violent, unsuccessful strikes and race riots and social turmoil and unrest shook American politics. Voters blamed the Democrats, since they were the party in power (Cooper 2001).

At the 1924 Democratic National Convention, Al Smith, governor of New York, led a wing of the party to introduce a resolution denouncing the Ku Klux Klan. The deep split in the party over cultural issues such as Prohibition enabled Republicans to win. The 1928 nominee, Al Smith, built a strong Catholic base in big cities, but the party remained the minority party until Franklin D. Roosevelt of New York entered center stage in American politics, creating his New Deal Coalition that dominated national politics from 1933 to 1945 (Finan 2003; Slayton 2001).

## The Transformative Election of FDR, 1932–1980

Some political scientists categorize a Fifth Political System as occurring between 1932 and 1980, ushered in with the realigning election of Democratic president Franklin Delano Roosevelt and ushered out with the realigning election of Republican president Ronald Reagan (Barone 1990; Kleppner 1983; Ladd and Hadley 1978; Lawrence 1997; Sloan 2008). Democrats controlled the White House for 32 of those 48 years; a Republican president occupied the White House for only 16 of them. Democrats controlled the Congress for all but four years. The Republicans took control of the House of Representatives in 1946–1948 and 1952–1954. When the Democratic coalition divided over Vietnam War policy in 1968, Richard Nixon took the White House (Fraser and Gerstle, 1990; Lawrence, 1997; Ladd and Hadley, 1978).

The Democratic Party coalition, known as the New Deal, was comprised of Catholics, Jews, African Americans, white Southerners, urban machines, Progressive intellectuals, and populist farm groups (Chambers and Burnham 1967; Fraser and Gerstle 1990; Milkis 1993; Paulson 2007; Shafer and Badger 2001; Sloan 2008; Sundquist 1983).

Between 1932 and 1964, Democratic control of Congress was the norm; between 1968 and 1980, divided control of government was the norm. During this era, Republicans were often split between a conservative and moderate wing.

### FDR and New Deal Democrats

A major reason why many historians hold that FDR's 1932 and 1936 elections were realigning elections marking the beginning a new political party system is that FDR created a new party regime, the New Deal, that led to the political establishment of a recognizably modern bureaucracy and a distinguishing set of national welfare and economic programs, made possible by a new coalition of voting blocs giving his party

unprecedented dominance. His election ended the majority status of the Republican Party and signaled voting group realignment in an upheaval of the political landscape. The Great Depression sealed Roosevelt's election, led to a change in the rules of succession, and created a new coalition in Congress as well as among rank-and-file voters. The dominant Democratic Party, with a host of new Democratic senators and 118 freshman House Democrats, advocated and successfully adopted a major expansion of national power. In the process, it redefined American liberalism and conservatism (Safire 1978).

The Roosevelt New Deal defined liberalism as we know it today: a belief in activist national government to solve fundamental economic problems to ensure social welfare (Brinkley 1995: 10–11). Roosevelt's 1932 election was a sweeping victory. He won the popular vote by 57.4 percent to Hoover's 39.6 percent, 88.9 percent of Electoral College votes, 472 to 59, and 44 of the 50 states (www.uselectionatlas.org/). Hoover campaigned against the national government's assumption of relief for the distressed. Roosevelt campaigned on a platform of "Relief, Recovery, and Reform." In 1932, voters essentially "fired" the Republicans wholesale (Sundquist 1983: 209).

Roosevelt's sweeping victory enabled him to call a special session of Congress to address the economic crisis and failure of the banking system. It launched a fevered period of action— rapidly introducing and passing a succession of measures into law—that came to be known as the "First Hundred Days." These first New Deal policy changes were unprecedented. No period before or since has witnessed so hasty and such extensive enactment of so many pieces of legislation: bank closures, emergency farm relief, national government guarantees for bank loans, establishment of the Tennessee Valley Authority public power project, limits set on agricultural production, and a national industrial recovery policy (Freidel 1990: 95).

Roosevelt began another political innovation: addressing the public directly by radio broadcast, called a "fireside chat." He used the "bully pulpit" of the presidency to marshal public

opinion to pressure for legislative authority to deal with the bank crisis. He innovated in the legislative process, tying unrelated bills together to be passed as a package. In his first month in office (March 1933), he sent packages for farm relief, direct unemployment relief, securities regulation, mortgage foreclosure protection, the Tennessee Valley Authority, and the National Industrial Recovery Administration to the Congress. The chief executive became the chief legislator.

The New Deal coalition and public acceptance of large majorities in biennial elections determined a new and enduring realignment. By 1935, the Roosevelt administration's domestic policy moved firmly leftward. This shift attracted and kept the allegiance of former and current Republican Progressives (the Teddy Roosevelt/LaGuardia wing of the party), when FDR's New Deal policies demonstrated his reformist bent against corporate power (James 2000).

A Second New Deal began in 1935 with the 74th and intensely Democratic Congress. Strongly liberal, Congress moved policy from relief to structural reform. The Second New Deal cemented enduring loyalties to FDR and the Democrats from 1936 to his death in 1945. The most important such reform was the Social Security Act of 1935 (Barone 1990: 85; Freidel 1990: 155–57). FDR's support of the Wagner Act (1935) brought the firm allegiance of organized labor to the Democratic Party. Urban policy in the Second New Deal solidified support of cities, the big-city machines, and blacks. Blacks voted largely Democratic in 1936 for the first time ever. The 1936 electorate was six million voters larger than the 1932 electorate, and over five million of them voted for FDR.

By 1937, Roosevelt had the most one-sided party dominance of any single House or Senate of the two-party era. FDR kept the conservative South in the coalition with programs that appealed to its agricultural economic base: the Tennessee Valley Authority, the Rural Electrification Act of 1936, and agricultural price supports of southern crops. While it did not end the old politics of race, it did introduce a new dimension of

loyalty and adherence to activist liberal government. As long as economic benefits were concentrated among whites and not expressly for poor blacks, New Deal liberalism was acceptable to the South. FDR's First and Second New Deals comprised 14 major programs passed between 1933 and 1938 (Freidel 1990; Hamby 1992). By 1938, a "liberal" meant a supporter of the New Deal, and a "conservative" meant an opponent, no matter one's official political party label. Conservatives stressed long-term growth, support for entrepreneurship, and low taxes (Safire 1978).

A coalition of conservatives and rural southern Democrats and Republicans gained control in Congress in 1938, ending any more big New Deal domestic legislative initiatives (Brinkley 1995). But the New Deal programs established in 1932 to 1938 survived and flourished. The executive branch remained in Roosevelt's hands when he defied tradition to seek a third term—which he won—in 1940, and most of the New Deal programs became near-permanent. A majority of the electorate identified with the Democratic Party and continued to view the party as the better one to resolve the economic crisis and implement social welfare programs. A fundamental shift had reshaped American life. An enduring political coalition tied to activist and expansive central governance was assured, and lasted until 1964. Presidential executive powers and agencies grew, and the American public accepted a greatly expanded view of what the president could and should do (Barone 1990; Freidel 1990).

### Democratic Party Developments Post–World War II

Vice President Harry S. Truman assumed the presidency after Roosevelt's death in 1945, shortly after FDR's unprecedented election to a fourth term. (The Twenty-Second Amendment was passed shortly thereafter to limit the president to two consecutive terms.) The party experienced rifts and a spin-off splinter party as factional tensions, suppressed or papered over by Roosevelt and the need for cohesion during the war years, emerged.

Truman integrated the U.S. armed services, and the national Democratic Party attracted significant black support, which strained Truman's relations with the solid South segregationist wing. Some southern Democrats, known as the "Dixiecrats," bolted. Truman took advantage of strains in the Republican Party and pulled off a stunning surprise reelection in 1948. President Truman, in his first elected term, initiated a package of proposals he called "the Fair Deal." A conservative coalition of Democrats and Republicans in the Congress defeated most of the Fair Deal program, most notably universal health care. The Supreme Court reversed his order to seize the steel industry because labor strife and strikes were hampering transportation critical to the Korean War effort (Lawrence 1997).

Strains in the party developed over foreign policy: the Korean War, Truman's anti-Soviet programs, the Truman Doctrine, the Marshall Plan, and NATO. President Truman cooperated with the internationalist-leaning Republican establishment and defeated isolationists in his own party to push a Cold War program that dominated foreign policy until 1991, when the Soviet Union disintegrated. President Truman, under the aegis of a U.N. Resolution, had the United States enter the Korean War without congressional action or approval. The 1952 Democratic National Convention nominated Adlai Stevenson, who went down to defeat in two landslide wins by Republican General Dwight D. Eisenhower.

In Congress, factionalism was kept under control, and compromise with President Eisenhower was established as a norm under House Speaker Sam Rayburn and Senate Majority Leader Lyndon B. Johnson. Democrats, with strong union and ethnic group affiliations and electoral voting blocs, ensured Democratic majorities in the House for all but two elections (1946, 1952) from 1930 to 1992.

The election of Massachusetts senator John F. Kennedy in 1960 reinvigorated the Democrats. New programs, like the Peace Corps, won over the idealists. Kennedy picked Lyndon Johnson, his major opponent in the primary, as his running

mate in order to unify the party. Foreign policy issues and initiatives, like the failed Bay of Pigs invasion in Cuba, construction of the Berlin Wall, sending advisors to the burgeoning war in South Vietnam, the space race to the moon, and the Cuban Missile Crisis, dominated much of his brief presidency. After the Cuban Missile Crisis, Kennedy sought to de-escalate tensions with the Soviet Union.

Domestically, Kennedy pushed for civil rights and racial integration. His election marked the coming of age of the Catholic component of the New Deal Coalition, putting a strain on the party's segregationist southern wing. When Kennedy was assassinated in Dallas, Vice President Lyndon Johnson assumed the office. To the great surprise of the Conservative Coalition in Congress, of which he had been an integral part during the later Roosevelt and Truman years, Johnson pressed for and enacted a remarkable number of liberal laws, a program he labeled "The Great Society." He had attempted, and came close to matching, FDR's "First Hundred Days."

In the 1964 presidential election, Lyndon Johnson crushed Senator Barry Goldwater (R-AZ). The Democratic ticket won 486 Electoral College votes and 61.7 percent of the popular vote to the Republican's ticket receiving only 52 Electoral College votes and 38.5 percent of the popular vote (www.presidency.ucsb.edu).

An overwhelming majority in both the Senate and the House enabled Johnson to succeed in passing major civil rights laws, comprehensive immigration reform, and racial integration reform. In foreign policy, he escalated involvement in the Vietnam War. Those actions shattered party unity for the 1968 election.

African Americans, who prior to Kennedy's election had strongly supported the Republican Party, continued to shift to the Democratic Party, attracted by the economic opportunities of the New Deal programs, relief programs, party patronage, and Democratic Party support for civil rights. Their movement

to the Democratic Party coalition drove conservative Southern Democrats to the Republican Party in presidential contests.

The 1968 election was a year of crisis for the Democratic Party. Senator Eugene McCarthy (D-MN) rallied an intellectual and student antiwar movement to challenge Johnson in the early primaries. Senator Robert Kennedy (D-NY) broke with Johnson and entered the race as well.

Johnson bowed out on March 31, and Vice President Hubert Humphrey entered the race but did not run in any of the primaries. His base in the party was labor unions and big-city bosses. Robert Kennedy won several primaries, notably the California primary on June 4, but was assassinated two days later. The Democratic National Convention was held in Chicago in 1968, marked by street protests, a "police-riot," and continued antiwar protests. Governor George Wallace of Alabama bolted the party and launched a splinter third-party campaign.

Nixon won the Republican nomination. The Democratic Party was so deeply split that Nixon won the presidency, although Democrats retained control of Congress. Southern Democrats had so abandoned the party that Nixon's "Southern Strategy" paid off.

Following the turmoil of the 1968 Convention, the Democratic Party formed a commission that proposed extensive reforms of the presidential nominee selection process. In 1972, the party nominated Senator George McGovern (D-SD) on a platform of peace and a guaranteed minimum income for all Americans. Despite efforts at party unity, the ticket was defeated in a landslide election by incumbent Richard Nixon.

After a corruption scandal had forced Vice President Spiro Agnew's resignation, Nixon appointed Gerald Ford (R-MI) as vice president. Then the Watergate scandal forced Nixon to resign; Ford assumed the office and promptly pardoned Nixon. The Democrats used the corruption and scandals, the economic recession, and the high rate of inflation (known as "stagflation") to win back the White House. After an extensive

nomination contest, the party nominated Georgia governor Jimmy Carter, who defeated Gerald Ford.

President Carter established a new energy policy and a consolidation of governmental agencies. Two new cabinet-level departments were created: the Department of Energy and the Department of Education. The Department of Health, Education, and Welfare became the Department of Health and Human Services. Carter's domestic policy successes included deregulating the trucking, airline, rail, finance, communication, and oil industries; bolstering the social security system; appointing a record number of women and minorities to government and judicial offices; enacting environmental protection laws; and expanding the National Park Service.

In foreign policy, Carter's major accomplishments were the Camp David Accords, the Panama Canal Treaty, establishment of full diplomatic relations with mainland China, and the Salt II Treaty with the Soviet Union. He championed civil rights throughout the world, emphasizing human rights as the center of his foreign policy. For these efforts, he was awarded the 2002 Nobel Peace Prize—up to that time only the third president to be so awarded. (The others were Theodore Roosevelt in 1906 and Woodrow Wilson in 1919.)

Carter attempted comprehensive health care reform but failed to get it passed. He also failed to get comprehensive tax reform. With stagflation once again arising, a failed attempt to use the military to rescue Americans held hostage by Iran for 444 days, and the Soviet Union's invasion of Afghanistan, Carter's popularity plunged. He defeated Senator Edward Kennedy (D-MA) to gain nomination for reelection but lost to California's Republican governor, Ronald Reagan.

**Conservatives Ascendant**

Ronald Reagan's 1980 election exemplifies another realignment and ushered in his transformative presidency (Sloan 2008). Reagan's personal political transformation mirrored the larger shift in public opinion during the 1960s and 1970s.

He began his Hollywood film career as a political liberal. By the 1960s, while serving as president of the Screen Actors Guild, he had become a staunch conservative, driven largely by the issue of communism in the film industry. He served as a television host and gradually emerged as a leading spokesman for the conservative cause. He was twice elected governor of California, in the process emerging as the successor to Goldwater and standard bearer of the conservatives in the Republican Party.

Several scholars argue that Reagan's landslide presidential election victories in 1980 and 1984 mark a realignment in American politics (Bowen 2011; Clubb et al. 1990; Gould 2003; Kleppner et al. 1983; Manza and Brooks 1999; Milkis 1993; Paulson 2007; Rosenof 2003; Rutland 1996; Sloan 2008). There is certainly an argument to be made in this regard. In 1980, he won over who came to be known as the "Reagan Democrats," who were drawn by his social conservatism on issues like abortion and on his anti-communist foreign policy. Blue-collar, formerly Democratic, voters remained Republican voters in the presidential elections into the years of the two Bush presidencies. The Reagan coalition was largely middle class and white and was built on changing class and cultural dynamics. Reagan's views on civil rights were similar to Goldwater's: he personally opposed racism and segregation but opposed affirmative action and federal government intrusion into domestic police powers. Unsurprisingly, African Americans continued to increase their support for Democrats during the Reagan years (Carmines and Stimson 1989: 54; Grantham 1988).

In domestic politics, President Reagan dealt skillfully with a divided Congress and worked in a bipartisan fashion with the speaker of the House, Tip O'Neill (D-MA). Reagan achieved passage of legislation that continued the reduction of regulations begun under the Carter administration, famously cut marginal income tax rates, and trimmed domestic government spending. The Federal Reserve took severe measures to control the money supply, thereby quashing the stagflation that

had plagued the nation's economy throughout the Carter years, though that policy contributed to a severe recession in 1982.

In foreign affairs, Reagan brought renewed emphasis on the Cold War, including providing aid, sometimes with questionable legal authority, to anti-communist forces in Central America and elsewhere. He pushed for a large expansion of military spending, including development of strategic defensive weapons. When the Soviet Union collapsed in 1991, Republicans claimed victory for Reagan's foreign policy, a claim grudgingly acceded to by many if not most Democrats (Bowen 2011; Gould 2003; Johnson 2003).

Reagan's success marked the peak of Republican dominance of the presidency during the years 1980 to date. The party won 6 of 10 presidential elections from 1980 to 2016. Reagan's victories can be viewed as the apex of the conservative reaction to the Democrats' movement to the left in the late 1960s. By positioning themselves out of the mainstream, catering to marginal groups at the expense of the great middle, Democrats found themselves with a losing electoral strategy. Bill Clinton, who won twice, was a southerner who initially ran from the moderate wing of the party, positioned precisely to counter the growing strength of the Republicans.

Democrats lacked enough marginal groups to make up a coalition that could outnumber the Republicans. Asians began the era more often voting Republican but shifted to the Democrats after 2000. Hispanics leaned consistently toward the Democratic Party throughout the period but even more so in the mid-1990s, increasing their turnout as the decade wore on. But the total numbers of these minority voters were not enough to counter the white, middle class, and Reagan Democrat coalition of Republican voters.

By Reagan's first term, unauthorized immigration had become a significant political issue. In 1982, the Immigration and Naturalization Service apprehended more than 1.2 million illegal aliens, registering what was then an astonishing increase: 34 percent over two years. Broad support for immigration

reform developed as a result when it became increasingly clear that the United States had difficulty patrolling its more than 5,000 miles of border to the south. Combined legal and illegal immigration exceeded the peak years of the early 1900s, representing an estimated 40 to 50 percent of the annual population increase (LeMay 2009: 356).

Most undocumented immigration was from Latin America. Latino immigrants and their descendants voted Democratic. But the total Hispanic voting population was negligible, so the debate over immigration was not especially partisan. The most notable response to the increase in unauthorized immigration in the 1980s was bipartisan: the enactment of the Immigration Reform and Control Act of 1986 (IRCA, 100 Stat. 3360; see LeMay 1994). The IRCA established a new balance in opposing principles: on the one hand, it attempted to control illegal immigration by strengthening the border patrol and placing stiff penalties on employers who knowingly hired unauthorized immigrants; on the other hand, it granted amnesty and legal residency to more than three million illegal aliens. (For a summary of the IRCA provisions, see LeMay 2007: 199–205.)

The Republican Party's electoral rise in the 1980s rang the death knell for what remained of the New Deal coalition. Reagan Democrats provided Reagan and George H. W. Bush with their large victories in the 1980s. White ethnic voters, who had voted 63 percent for JFK in 1960, went for Reagan by 66 percent in 1984. They saw the Democratic Party less as champions of their middle-class aspirations and more as a party working for racial minorities, the very poor, and leftist activists (Greenberg 1996). The failure of the Democratic Party to hold the Reagan Democrats, and the loss of the white South, led to the final demise of the Democrats as the majority party. President Reagan carried 49 states in 1984, losing only home state Minnesota to Vice President Walter Mondale (Gillon 1992).

The presidential elections of the 1980s did not represent a broad movement toward a permanent Republican majority. Republicans lost the Senate in 1986 and never won the House of

Representatives during the period. The Reagan years witnessed the emergence of a system of close two-party competition throughout the nation. The major parties were beginning to take shape as the representatives of two distinct governing sentiments: a belief that disadvantaged groups should be extended certain protections and a belief that the security and heritage of the country as a whole should be sustained. As Byron Shafer and his colleagues have noted in a series of trenchant analyses, this amounted to two different political majorities in the country: a liberal majority embodied by the Democrats and a conservative majority embodied by the Republicans (Shafer 2003; Shafer and Claggett 1995; Shafer and Spady 2014).

After 1984, a group of Democrats created the Democratic Leadership Council. This centrist organ of the party advocated movement to the ideological center. They hoped to recapture the White House and the corporate and small-business donors who had left the party during the Reagan ascendancy while retaining the left-of-center supporters of the party, attracting moderates and even some social conservatives (Galston and Kamarek 1989). This movement within the Democratic Party would eventually prove to be significant, as the Democrats under Clinton adjusted to the reality of a now-competitive conservative opponent in the Republican Party.

In 1988, the liberal wing of the Democratic Party prevailed in securing the party's nomination for Massachusetts governor Michael Dukakis, who lost to Vice President George H. W. Bush. The Republicans won the Electoral College, 426 to 111 and won 53.4 percent of the popular vote to the Democrat's 45.6 percent (Gillon 1992). Bush's election is often viewed as Reagan's third presidential victory.

## Parity and Polarization

In 1992, Bill Clinton won the White House, aided by the campaign of Independent H. Ross Perot and the lingering effects of a recession. The Clinton-Gore ticket won 370 electoral votes and 43 percent of the popular vote to 168 electoral votes

and 37.4 percent of the popular vote to Bush-Quayle. (Perot won 18.9 percent of the popular vote but no electoral votes.) Clinton's initiative to reform the national health care system, spearheaded by his wife, First Lady Hillary Clinton, became a debacle. The proposal failed even to be brought to vote in Congress.

In the 1994 midterm elections, Newt Gingrich, minority whip of the House of Representatives, led the Republicans to majorities in both houses of Congress in what came to be called the "Republican Revolution." The party held 52 seats in the Senate and 230 seats in the House, the first time since 1952 when the Republicans won control of both houses of Congress (Bear 2000; Remini 2006; Rutland 1996). The Republican Revolution stressed major reforms of government, a balanced budget amendment, and welfare reform, amounting to what Gingrich and other leaders called the "Contract with America."

Clinton went on to reelection in 1996, improving his popular vote from 43 percent in the 1992 election to 49.9 percent in 1996; his Electoral College vote increased from 370 to 379. Clinton was the first Democrat since FDR to win reelection, aided by an economic expansion that had continued since 1991. He enjoyed the lowest combination of unemployment and inflation in more than two decades. Clinton deftly handled himself as a defender of Medicare against the Gingrich-led Republican Congress.

In 1998, the Republican-led House (223–211) showed less political savvy when it impeached Clinton, who was subsequently acquitted in the Senate. Their attempt to remove Clinton backfired. In the 1998 midterm elections, they lost four seats in the House (Remini 2006).

In 2000, George W. Bush defeated Vice President Gore for the presidency in a disputed election resolved by a controversial decision by the U.S. Supreme Court (*Bush v. Gore*, December 12, 1999). The Bush-Cheney ticket actually lost the popular vote to the Gore-Lieberman ticket, 47.9 to 48.4 percent. With Bush in the White House and his party in control

of both houses of Congress (50–50 in the Senate, 221–212 in the House), Republicans completely controlled the elective branches of the national government for the first time since 1953 (Gould 2003; Remini 2006). Bush was reelected in 2004 with a comfortable margin. But it was becoming clear that the rising number of Latino voters could pose a long-term dilemma for the GOP.

Republicans' gains were more transitory than it appeared at the time. The reality is that the two parties were at roughly even strength, as evidenced in the "perfect tie" of the 2000 election (Ceaser and Busch 2001). But for Ralph Nader's third-party campaign for the presidency, Al Gore very likely would have won Florida and the overall election. The September 11, 2001, terrorist attacks spiked Bush's approval ratings to all-time highs. He quickly announced a "War on Terrorism," invading first Afghanistan in late 2001 and then Iraq in 2003.

After 9/11, Congress nearly unanimously enacted two laws with nearly unprecedented bipartisan support. The first was the USA Patriot Act of 2001 (PL 107–56, summarized in LeMay, 2007: 219–221). In 2002, Congress enacted the Homeland Security Act of 2002 (HR 5005, summarized in LeMay 2007: 221–223), which also passed with large majorities (LeMay 2006: 208). The law merged 22 federal agencies into a new Department of Homeland Security, the most extensive reorganization of the federal bureaucracy since the creation of the Department of Defense after World War II.

There has been no lasting change in the sentiments of the people. Like Gingrich and Congress tried to impeach President Clinton in 1994, President Bush overreached following his comfortable reelection win. He pushed widely unpopular moves to privatize Social Security and major revisions to the tax code. His poll numbers dropped. When public support for the Iraq War plunged, he had difficulty enacting his agenda.

By 2006, public opinion of the Bush presidency changed considerably, with fatigue over the war in Iraq replacing fears of Islamist terror. The Democrats recaptured the House of

Representatives and selected California representative Nancy Pelosi as speaker, the first woman ever to hold that post. Democrats recaptured a majority of state governorships. Any notion of an enduring Republican majority vanished in just two years. These shifting fortunes set up the 2008 election of Senator Barack Obama (D-IL).

In 2008, Obama won 95 percent of black men and 96 percent of black women, who comprised 13 percent of the electorate; he won 69 percent of first-time voters (called millennials), who made up 11 percent of the electorate. He lost white voters overall, but carried 54 percent of white voters aged 18–29. Obama won only 43 percent of white voters, who made up 74 percent of the electorate. He carried 56 percent of the women vote, who were 53 percent of the electorate. He won 67 percent of the Hispanic vote (9 percent of the electorate) and 62 percent of the Asian vote (2 percent of the electorate). Likewise, he won 79 percent of the Jewish vote (2 percent of the electorate). Another group in the Obama coalition was the LBGT community. In 2012, the numbers were comparable (NYT Exit Polls 2008, 2012). At the end of his second term, he enjoyed a 56 percent approval rating. Had Hillary Clinton won similar numbers in 2016, she would have won.

The tide was shifting to Republicans, however, when Republicans won in the 2010 and 2014 midterm elections. In 2016, moreover, Republican Donald Trump won 306 Electoral College votes, while Democrat Hillary Clinton won 232, although he lost the popular vote, wherein Clinton won 48.3 percent, 65,788,583, to Trump's 46.2 percent, 62,955,363 popular votes. Trump won marginally in enough swing states to carry the election: 51.3 percent in Georgia, 51.8 percent in Iowa, 47.6 percent in Michigan, 50.5 percent in North Carolina, 52.1 percent in Ohio, 48.8 percent in Pennsylvania, and 47.8 percent in Wisconsin. Trump won the male vote 52 percent to Clinton's 41 percent. He won among 45–64-year-olds by 52 percent to Clinton's 44 percent; and among 65-and-older voters, Trump won by 52 percent to Clinton's 45 percent.

Republicans carried the Senate, 52 to 48, and the House, 241 to 194. They won the governorships in Vermont, New Hampshire, North Dakota, Indiana, Utah, and Wyoming (www .cnn.com/election/results)

## Conclusion

As of the 2016 election, then, the electorate proved to be divided to a great degree on racial and ethnic lines. That has been the general story of the parties in the last generation: parity and usually divided government. This would seem to reflect the sorting out of the parties along liberal (Democratic) and conservative (Republican) lines. This ideological sorting of the parties, and to a lesser extent the voters, resulted in equilibrium between the parties rather than a choice for one over the other (Lawrence 2001; Stonecash 2002).

Independents play an important role in elections. They alternate their choice of party from one election to the next, depending upon the performance of the party in power. By definition, such vote switchers are not very loyal to any party (Stonecash 2002). The result is not a traditional realignment, that is, a sustained period of one-party dominance across the branches of the national government. What emerged was a balance of power between Democratic and Republican identifiers, with a sizable independent vote and a degree of ticket splitters in all three groups, resulting in a frequent sharing of power by parties evenly matched in most elections, rather than a particular party dominating everywhere (Erikson et al. 2002).

In effect, voters' choice to support both parties amounted to a kind of electoral fine-tuning of public policy and administration. Some scholars have emphasized that the American people have not become as ideologically polarized as have their partisan representatives (Fiorina et al. 2010). As Michael Barone (2014) notes, "We now have two ideologically distinct political parties. The liberal party seems to have an edge, though not an overwhelming one, in presidential elections. But the

conservative party, to the dismay of many political scientists, has an edge, though again not overwhelmingly, in elections to the House of Representatives."

Even though the Republicans under George W. Bush were able to achieve, for the first time since Dwight Eisenhower, unified control of the federal government, there were signs the future might belong to the Democratic Party (Judis and Teixeira 2006). Many party analysts speculated that President Obama's election, and the changes in policy he and his party have brought about, may signal another transformative election. The surprising election of Republican Donald Trump in 2016, however, suggests that the Obama legacy may be limited and that Trump's virtual "hostile takeover" of the Republican Party and the party's sweeping electoral victories to control all three branches of the federal government and a majority of state houses and state legislatures may signal the arrival of a period of Republican Party dominance, with a marked policy shift to populist nationalism.

## References

Aldrich, John. 1995. *Why Parties? The Origin and Transformation of Party Politics in America*. Chicago: University of Chicago Press.

Aldrich, John. 2012. *Why Parties?: A Second Look*. Chicago: University of Chicago Press.

Allen, Oliver E. 1993. *The Tiger: The Rise and Fall of Tammany Hall*. Cambridge, MA: Da Capo Press.

Anbinder, Tyler. 1992. *Nativism and Slavery*. New York: Oxford University Press.

Ashworth, John. 1983. *American and Aristocrat: Political Party Ideology in the United States, 1837–1846*. Cambridge, UK: Cambridge University Press.

Barone, Michael. 1990. *Our Country: The Shaping of America from Roosevelt to Reagan*. New York: The Free Press.

Barone, Michael. 2014. *Shaping Our Nation: How Surges in Migration Transformed America and Its Politics.* New York: Random.

Bayor, Ronald, and Timothy Meagher, eds. 1995. *The New York Irish.* Baltimore, MD: Johns Hopkins University Press.

Bear, Kenneth S. 2000. *Reinventing Democrats: The Politics of Liberalism from Reagan to Clinton.* Lawrence: University Press of Kansas.

Bennett, Marion. 1963. *American Immigration Politics: A History.* Washington, DC: Public Affairs Press.

Blum, John Morton. 1980. *The Progressive Presidents: Roosevelt, Wilson, Roosevelt, Johnson.* New York: W. W. Norton.

Bowen, Michael. 2011. *The Roots of Modern Conservatism.* Chapel Hill: University of North Carolina Press.

Brinkley, Alan. 1995. *The End of Reform.* New York: Knopf.

Busch, Andrew E. 2001. "The Development and Democratization of the Electoral College," in Gary L. Gregg, ed., *Securing Democracy: Why We Have an Electoral College.* Wilmington, DE: ISI Books.

Carmines, Edward, and James Stimson. 1989. *Issue Evolution: Race and the Transformation of American Politics.* Princeton, NJ: Princeton University Press.

Ceaser, James. 1979. *Presidential Selection: Theory and Development.* Princeton, NJ: University of Princeton Press.

Ceaser, James W., and Andrew E. Busch. 2001. *The Perfect Tie: The True Story of the 2000 Presidential Election.* Lanham, MD: Rowman and Littlefield.

Chambers, William N., and Walter D. Burnham. 1967. *The American Party System: Stages of Political Development.* New York: Oxford University Press.

Clanton, Gene. 1991. *Populism: The Humane Preference in America, 1890–1900.* Boston: Twayne.

Clubb, Jerome M., William Flanigan, and Nancy Zingale. 1990. *Partisan Realignments: Voters, Parties, and Government in American History.* Berkeley Hills, CA: Sage.

Cooper, John Milton. 1983. *The Warrior and the Priest: Woodrow Wilson and Theodore Roosevelt.* Cambridge, MA: Belknap Press of Harvard University Press.

Cooper, John Milton. 2001. *Breaking the Heart of the World: Woodrow Wilson and the Fight for the League of Nations.* Cambridge, UK: Cambridge University Press.

Cooper, John Milton. 2009. *Woodrow Wilson: A Biography.* New York: Vintage.

Daniels, Josephus. 1946. *The Wilson Era.* 2 vols. Chapel Hill: University of North Carolina Press.

Dinken, Robert J. 1987. *Campaigning in America: A History of Election Practices.* Westport, CT: Greenwood Press.

Draper, Theodore. 1957. *The Roots of American Communism.* New York: Viking.

Epstein, David. 2012. *Left, Right, Out: A History of Third Parties in America.* London: Arts and Imperium Press.

Erikson, Robert S., Michael B. MacKuen, and James A. Stimson. 2002. *The Macro Polity.* New York: Cambridge University Press.

Finan, Christopher. 2003. *Alfred Smith: The Happy Warrior.* New York: Hill and Wang.

Fiorina, Morris P., Samuel J. Abrams, and Jeremy C. Pope. 2010. *Culture War: The Myth of a Polarized America.* 3rd ed. New York: Longman.

Foner, Eric. 1995. *Free Soil, Free Labor, Free Men: The Ideology of the Republican Party before the Civil War.* New York: Oxford University Press.

Foner, Philip S. 1977. *The Formation of the Workingmen's Party of the United States.* New York: AIMS.

Fraser, Steve, and Gary Gerstle, eds. 1990. *The Rise and Fall of the New Deal Order, 1930–1980.* Princeton, NJ: Princeton University Press.

Freidel, Frank. 1990. *Franklin Roosevelt: A Rendezvous with Destiny.* Boston: Little, Brown.

Galston, William, and Elaine Kamarek. 1989. *The Politics of Evasion.* Washington, DC: Progressive Policy Institute.

Garraty, John A. 1949. *Silas Wright.* New York: Columbia University Press.

Gerring, John. 1998. *Party Ideologies in America, 1828–1996.* Cambridge, UK: Cambridge University Press.

Gerring, John. 2001. *Party Ideologies in America, 1828–1996.* Cambridge, UK: Cambridge University Press.

Gillespie, J. David. 1993. *Politics on the Periphery: Third Parties in a Two-Party America.* Columbia: University of South Carolina Press.

Gillon, Steven M. 1992. *The Democrat's Dilemma: Walter Mondale and the Liberal Legacy.* New York: Columbia University Press.

Gould, Lewis. 2003. *Grand Old Party: A History of the Republicans.* New York: Random House.

Gould, Lewis. 2008. *Four Hats in the Ring: The 1912 Election and the Birth of Modern American Politics.* Lawrence: University Press of Kansas.

Grantham, Dewey. 1988. *The Life and Death of the Solid South: A Political History.* Lexington: University of Kentucky Press.

Greenberg, Stanley. 1996. *Middle Class Dreams: Politics and the Power of the New American Majority.* New Haven, CT: Yale University Press.

Greenstein, Frederick. 1970. *The American Party System and the American People.* Englewood Cliffs, NJ: Prentice-Hall.

Haas, Garland. 1994. *The Politics of Disintegration: Political Party Decay in the United States, 1856–1900.* Jefferson, NC: McFarland and Company.

Hamby, Alonzo. 1992. *Liberalism and Its Challenger: From F.D.R. to Bush.* New York: Oxford University Press.

Hamilton, Alexander. 1985. *Selected Writings and Speeches of Alexander Hamilton.* Newton Frish, ed. Washington, DC: Enterprise Institute.

Hamilton, Alexander. 2003. *The Papers of Alexander Hamilton.* 27 vols. Harold C. Syrett, et al., eds. New York: Signet Classics.

Harbaugh, William H. 1963. *The Life and Times of Theodore Roosevelt.* New York: Collier.

Higham, John. 1981. "Integrating America: The Problem of Assimilation in the Nineteenth Century." *Journal of American Ethnic History* 1: 7–25.

Hoerder, Dirk. 1982. *American Labor and Immigration History, 1872–1920.* Urbana: University of Illinois Press.

Hofstadter, Richard. 1969, *The Idea of a Party System: The Rise of Legitimate Opposition in the United States, 1780–1840.* Berkeley: University of California.

Holt, Daniel W. 1984. *The Political Culture of the American Whigs.* Chicago: University of Chicago.

Holt, Michael F. 1999. *The Rise and Fall of the American Whig Party: Jacksonian Politics and the Onset of the Civil War.* New York: Oxford University.

Hoogenboom, Ari. 1961. *A History of the Civil Service Reform Movement, 1865–1883.* Urbana: University of Illinois.

Howe, Daniel Walker. 1984. *The Political Culture of the American Whigs.* Chicago: University of Chicago Press.

Hyneman, Charles S., and Donald S. Lutz. 1983. *American Political Writing during the Founding Era: 1760–1805.* 2 vols. Indianapolis, IN: Liberty Fund.

James, Scott. 2000. *Presidents, Parties, and the State: A Party System Perspective on Democratic Regulatory Choice, 1884–1936.* Cambridge, UK: Cambridge University Press.

Jefferson, Thomas. 1944. *The Life and Selected Writings of Thomas Jefferson*. Adrienne Koch and William Peden, eds. New York: Modern Library.

Jenson, Richard. 1971. *The Winning of the Midwest: Social and Political Conflict*, 1888–1896. Chicago: University of Illinois Press.

Jenson, Richard. 1983. "The Last Party System: Decay of Consensus, 1932–1980," in Paul Kleppner, et al., eds. *The Evolution of American Electoral Systems*. Westport, CT: Greenwood Press, pp. 219–225.

Johnson, Haynes. 2003. *Sleepwalking through History: America in the Reagan Years*. New York: W.W. Norton.

Judis, John B., and Ruy Teixeira. 2004. *The Emerging Democratic Majority*. New York: Lisa Drew/Scribner-Simon & Schuster.

Kazin, Michael. 1995. *The Populist Persuasion: An American History*. New York: Basic Books.

Kehl, James A. 1981. *Boss Rule in the Gilded Age: Matt Quay of Pennsylvania*. Pittsburgh: University of Pittsburgh.

Kleppner, Paul. 1979. *The Third Electoral System, 1853–1892: Parties, Voters, and Political Cultures*. Chapel Hill: University of North Carolina Press.

Kleppner, Paul, et al. 1983. *The Evolution of American Electoral Systems*. Westport, CT: Greenwood Press.

Kleppner, Paul. 1987. *Continuity and Change in Electoral Politics, 1893–1928*. Westport, CT: Greenwood Press.

Ladd, Everett Carl, Jr., and Charles Hadley. 1978. *Transformations of the American Party System: Political Coalitions from the New Deal to the 1970s*. 2nd ed. New York: W.W. Norton.

Lawrence, David G. 1997. *The Collapse of the Democratic Presidential Majority*. Boulder, CO: Westview Press.

Lawrence, David G. 2001. "On the Resurgence of Party Identification in the 1990s," in Jeffrey E. Cohen, Richard Fleisher, and Paul Kantor, eds. *American Political Parties: Decline or Resurgence?* Washington, DC: Congressional Quarterly Press.

LeMay, Michael. 1985. *The Struggle for Influence.* Lanham, MD: University Press of America.

LeMay, Michael. 1987. *From Open Door to Dutch Door.* New York: Praeger.

LeMay, Michael. 1994. *Anatomy of a Public Policy.* Westport, CT: Praeger.

LeMay, Michael. 2006. *Guarding the Gates.* Westport, CT: Praeger Security International.

LeMay, Michael. 2007. *Illegal Immigration: A Reference Handbook.* 1st ed. Santa Barbara, CA: ABC-CLIO.

LeMay, Michael. 2009. *The Perennial Struggle.* 3rd ed. Upper Saddle River, NJ: Prentice-Hall.

LeMay, Michael, ed. 2013. *Transforming America: Perspectives on U.S. Immigration*, Vols. 1–3. Santa Barbara, CA: ABC-CLIO/Praeger.

LeMay, Michael, and Elliott Barkan, eds. 1999. *U.S. Immigration and Naturalization Laws and Issues: A Documentary History.* Westport, CT: Greenwood Press.

Lester, Connie. 2007. *Up from the Middle of Hell: The Farmer's Alliance, Populism, and Progressive Agriculture in Tennessee, 1870–1915.* Westport, CT: Praeger.

Link, Arthur. 1972. *Woodrow Wilson and the Progressive Era, 1910–1917.* New York: Torch Books.

Lipset, Seymour, and Stein Rokkan, eds. 1967. *Party Systems and Voter Alignments: Cross-National Perspectives.* New York: The Free Press.

Litt, Edgar. 1970. *Ethnic Politics in America.* Glenview, IL: Scott, Foresman.

Madison, James. 1981. *The Mind of the Founder.* Marvin Meyers, ed. Hanover, NH: University Press of New England.

Manza, Jeff, and Clem Brooks. 1999. *Social Cleavages and Political Change: Voter Alignments and U.S. Party Coalitions.* New York: Oxford University Press.

Marcus, Robert. 1971. *Grand Old Party: Political Structure in the Gilded Age, 1880–1896.* New York: Oxford University.

McMath, Robert C. 1993. *American Populism: A Social History, 1877–1898.* New York: Hill and Wang.

McSweeney, Dean, and John Zvesper. 1991. *American Political Parties.* London: Routledge.

Milkis, Sidney. 1993. *The President and the Parties: The Transformation of the American Party System since the New Deal.* New York: Oxford University.

Morris, Edmund. 2001. *The Rise of Theodore Roosevelt.* New York: Random.

Morris, Edmund. 2002. *Theodore Rex, 1901–1909.* New York: Random.

Myers, Gustavus. 1971. *The History of Tammany Hall.* New York: Dover.

Neal, Don. 1983. *The World beyond the Hudson: Alfred E. Smith and National Politics.* New York: Garland Press.

Nichols, Roy F. 1967. *The Invention of the American Political Parties.* New York: Macmillan.

NYT Exit Polls. http://elections.nytimes.com/2008/results/ presidential/national-exit-polls. http://elections.nytimtes .com/2012/%20results/presidential/national-exit-polls.

Paulson, Arthur. 2007, *Electoral Realignments and the Outlook for American Democracy.* Boston: Northeastern University Press.

Pickus, Noah. 2005. *True Faith and Allegiance: Immigration and American Civic Nationalism.* Princeton, NJ: Princeton University Press.

Raybeck, Robert J. 1959. *Millard Fillmore: Biography of a President.* Buffalo, NY: Buffalo Historical Society.

Reichley, A. James. 1981. *Conservatism in an Age of Change.* Washington, DC: Brookings Institution Press.

Reichley, A. James. 2000. *The Life of the Parties: A History of American Political Parties.* Lanham, MD: Rowman and Littlefield.

Remini, Robert, ed. 1972. *The Age of Jackson.* Columbia: University of South Carolina Press.

Remini, Robert. 2006. *The House: The History of the House of Representatives.* New York: HarperCollins.

Rippley, Lavern. 1973. *The German Americans.* Chicago: Claretian.

Rosenof, Theodore. 2003. *Realignment: The Theory That Changed the Way We Think about American Politics.* Lanham, MD: Rowman and Littlefield.

Rutland, Robert Allen. 1996. *The Republicans: From Lincoln to Bush.* Columbia: University of Missouri Press.

Safire, William. 1978. *Safire's Political Dictionary.* New York: Random House.

Sanders, Elizabeth. 1999. *Roots of Reform: Farmers, Workers, and the American State, 1877–1917.* Chicago: University of Chicago Press.

Sarasohn, David. 1989. *The Party of Reform: Democrats in the Progressive Era.* Jackson: University Press of Mississippi.

Schattschneider, E. E. 1960. *The Semisovereign People: A Realist's View of Democracy in America.* New York: Holt, Rinehart and Winston.

Schlesinger, Arthur M., Jr., ed. 1973. *A History of U.S. Political Parties.* New York: Chelsea House.

Shafer, Byron E. 2003. *The Two Majorities and the Puzzle of Modern American Politics.* Lawrence: University Press of Kansas.

Shafer, Byron, and Anthony J. Badger. 2001. *The Constitution in American Political Development.* New York: Cambridge University Press.

Shafer, Byron E., and William J. M. Claggett. 1995. *The Two Majorities: The Issue Context of Modern American Politics.* Baltimore, MD: Johns Hopkins University Press.

Shafer, Byron E., and Richard H. Spady. 2014. *The American Political Landscape.* Cambridge, MA: Harvard University Press.

Sibley, Joel. 1991. *The American Political Nation, 1838–1893.* Stanford, CA: Stanford University Press.

Skowronek, Stephen. 1997. *The Politics Presidents Make: Leadership from John Adams to Bill Clinton.* 2nd ed. Cambridge, MA: Belknap Press of Harvard University Press.

Slayton, Robert A. 2001. *Empire Statesman: The Rise and Redemption of Al Smith.* New York: The Free Press.

Sloan, John. 2008. *FDR and Reagan: Transformative Presidents with Clashing Visions.* Lawrence: University Press of Kansas.

Spencer, Ivor. 1959. *The Victor and the Spoils: A Life of William L. Marcy.* Providence, RI: Brown University Press.

Stonecash, Jeffrey M. 2002. "Interpreting the Rise and Decline of Split-Ticket Voting." Presented at the American Political Science Association, Annual Meeting, Boston, MA.

Sundquist, James L. 1983. *Dynamics of the Party System: Alignment and Realignment of Political Parties in the United States.* 2nd ed. Washington, D.C.: Brookings.

Ueda, Reed. 1980. "Naturalization and Citizenship," in Stephen Thernstrom, ed. *Harvard Encyclopedia of American Ethnic Groups.* Cambridge, MA: Harvard University Press.

Van Buren, Martin. 1867. *Inquiry into the Origin and Course of Political Parties in America.* New York: Hurd and Houghton.

Vaughn, William P. 1983. *The Antimasonic Party of the United States, 1826–1843.* Lexington: University of Kentucky Press.

Widmer, Edward. 1999. *Young America: The Flowering of Democracy in New York City.* New York: Oxford University Press.

Wilentz, Sean. 2004. *Chants Democratic: New York City and the Rise of the American Working Class.* New York: Oxford University Press.

Wilentz, Sean. 2005. *The Rise of American Democracy: Jefferson to Lincoln.* New York: W. W. Norton.

Wilentz, Sean. 2007. *Andrew Jackson: The American Presidents Series: The 7th President, 1829–1837.* New York: Macmillan.

Williams, R. Hal. 1978. *Years of Decision: American Politics in the 1880s.* New York: John Wiley and Sons.

Williams, R. Hal. 2010. *Realigning America: McKinley, Bryan, and the Remarkable Election of 1896.* Lawrence: University Press of Kansas.

Witcover, Jules. 2003. *Party of the People: A History of the Democrats.* New York: Random House.

Zentner, Scot. 2005. "Regimes and Revolutions: Madison and Wilson on Parties in America," in John Marini and Ken Masugi, eds. *The Progressive Revolution in Politics and Political Science.* Lanham, MD: Rowman and Littlefield.

Zolberg, Aristide R. 2006. *A Nation by Design: Immigration Policy in the Fashioning of America.* Cambridge, MA: Harvard University Press.

Zvesper, John. 1984. "The Madisonian Systems." *Western Political Quarterly* 37: 236–256.

## Introduction

This chapter discusses some major problems associated with political party competition in the United States today, focusing on national elections for members of Congress and the presidency. A cautionary note is warranted for the proposed solutions that have been offered in the discourse on the American political party system. The reader must be sensitive to the fact that proposed solutions, when actually implemented, often have unanticipated consequences that may cause future problems. No proposed solution is without a partisan bias— different solutions will impact the two major political parties differently, as well as affect third parties vying for major-party status. Proposed solutions may impact who becomes a candidate for a national-level office and the relative chances of an outsider candidate (often called a dark horse) from emerging as a serious contender. They may enhance the already considerable advantage of incumbency.

An early voting location at the Davenport, Iowa, Public Library on October 24, 2012. The Democrats have traditionally stressed early voting; the Republicans focused on Election Day turnout. The Iowa race has become an important race in the primaries and in the general election for president. (AP Photo/Charlie Neibergall)

## The Voters

### Who Should Be Allowed to Vote?

The United States has had a long and complex history of times when certain categories of persons were welcomed and could easily naturalize and soon vote and other times when certain persons were suspected of not being able to assimilate or considered simply unworthy of naturalization and citizenship (LeMay and Barkan 1999; LeMay 1987, 2006, 2009; Barone 2014; Zolberg 2006). The groups most notoriously denied naturalization for a long period were Asian immigrants—Chinese, Japanese, and Koreans in particular. From 1882 until 1952, Asians faced severe restrictions—being totally banned from naturalization. Women were denied the right to vote until 1920. Blacks were legally held as slaves and not allowed to vote until the Fourteenth Amendment and even longer by the Jim Crow laws adopted in many states after Reconstruction. Eastern Europeans faced similar bias, and immigrants from those countries took, on average, many more years than did immigrants from northwestern Europe to naturalize and vote. Immigrants from Great Britain, Germany, and Scandinavia were usually naturalized in five years, and a number of states allowed them to participate and vote in local elections even while being noncitizens (LeMay 2013, Vol. 1; Ueda 1980).

Several east coast states adopted a literacy test to ban the political participation of immigrants from eastern European countries, and, in the post-Reconstruction period, Southern states followed suite to deny blacks the vote.

Today, Hispanics (especially those from Mexico and such Central American countries as El Salvador, Guatemala, Honduras, and Nicaragua) face much longer times before they are naturalized and can legally vote, and gerrymandering is more often used against them to dilute the effectiveness of their vote when they finally can do so. Racial and religious minorities frequently are considered to be unworthy or unable to assimilate, and such prejudice is used to justify discrimination against

them, particularly when it involves voting rights and access to vote and to run for political office.

Current politics exhibit a pronounced degree of xenophobia aimed at Mexicans, Muslims, and immigrants from the Middle East (often erroneously all labeled as "Arabs") within a significant portion of the Republican Party base, its rank-and-file voters, and some independents who are among the most vocal Donald Trump supporters.

Yet, the Republican Party advocated for resettlement assistance for Cuban refugees in the 1960s, helping them to naturalize as soon as they were legally able to (after five years' residency) and encouraging their vote. Republicans ran Cuban American politicians on their slates, winning long-term Republican Party support of Cuban American voters (LeMay 2013, Vol. 3: 161).

Some third-party movements were xenophobic and strenuously advocated long periods for naturalization. The Know Nothing Party, for example, wanted immigrants to wait 21 years before they could naturalize and vote (LeMay 1987, 2013, Vol. 1). Groups like the 100 Percenters, the American Party (there were three times a third party used the American Party label; each time they were anti-immigrant), America First, the Workers Party, the Workingmen's Party, and other nationalist parties all advocated denying immigrants the right to vote for long periods of time. Until late in the 20th century, organized labor typically opposed open immigration and frequently led campaigns against immigrants and their ability to assimilate, naturalize, and vote. Social movements like the Chinese Exclusion League, the Asian Exclusion League, the Secret Order of the Star Spangled Banner, the Ku Klux Klan, and America First joined political parties advocating against immigrants from countries whom their members felt should not be allowed to assimilate, fearing especially the Yellow Peril and what they deemed the mongrelization of America (LeMay 1987: 53–102; LeMay 2009). On occasion, the Supreme Court upheld the constitutionality of laws denying Asians the right to vote or

executive orders incarcerating Japanese immigrants and even native-born citizens of Japanese ancestry in internment camps during World War II (LeMay 2009: 82–86).

It took the civil rights movement of the 1960s and the Voting Rights Act of 1965 to finally break down the Jim Crow barriers to Black Americans being able to vote (LeMay 2009: 371–373).

Ironically, Native Americans were denied participation for a long time. They were forced onto reservations and restricted from voting in state and local elections off reservation (LeMay 2009: 183–193). It was not until 1924 that the Indian Citizen Act officially recognized the citizenship of off-reservation Native Americans, finally allowing them the vote (LeMay 2009: 369; LeMay and Barkan 1999: 151).

For several hundreds of years of American history, nonwhites were routinely considered unworthy of assimilation, and many were legally denied basic civil rights and civil liberties, including the right to vote.

## The Declining Importance of Party Identification

*Party identification* is the term used by political scientists (and journalists, pollsters, and others) to designate the political party to which an individual self-identifies; the term connotes loyalty to a political party. It is usually determined by the party with which a voter is registered or which the individual most commonly supports by voting, by donations, or by other means (working in a campaign, talking to friends and neighbors to support, and so on) (Aldrich 2012; Bartle and Bellucci 2009; Bond and Fleisher 2000; Campbell 1980; Cohen et al. 2001; Green et al. 2004; Groenendyk 2013; Hershey 2007; Holbrook 2016; Judis and Teixeira 2004; Paulson 2007; Shafer 2003).

Party identification is measured on a 7-point Likert scale, such as Strong Democrat on one extreme and Strong Republican on the other, with Independent being the midpoint on the scale (Bartle and Bellucci 2009). Party identification is

sometimes assessed as one form of social identity—as a person might identify with a religious or ethnic group, social class, race or gender group, sexual orientation group, and so on (Hershey 2007) (http://www.people-press.org/2013/04/07/a-deep-dive-into-party-identification).

Political scientists first categorized party identification as a stable phenomenon developed as a result of family, personal, social, and environmental factors that lasted a lifetime, only shifting markedly in realigning elections (Campbell 1980). More recently, however, party identification is considered less stable, more flexible, and more a matter of personal choice. This school of thought stresses the breakdown of the two-party system and a growing dealignment as evidence for the shift in the stability of political party self-identification (Keller 2007; Mayhew 2005; Groenendyk 2013; Skowronek 1997, 2011; Wilentz 2016).

Individuals who self-identify with a political party, especially those who strongly identify, tend to vote in high percentages for that party's candidates for various offices and across various levels of government. They are the most likely among voters to cast a straight party ticket and tend to be the most faithful in turnout for elections—both primary and general elections. The level of party identification was highest in the 1970s but has declined since the 1990s. Currently, independents have grown in number, now being larger than Democrats or Republicans, with 40 percent choosing that label (www.pewresearch.org/data-trend/politicalattitudes /party-identification/, accessed June 20, 2016). Analysts have noted sharp differences in party identification by race, gender, generation, and degree of formal education (www.people-press .org/2015/04/07/a-deep-dive-into-party-identification).

Democrats, for example, hold advantages in party identification among blacks, Asians, Hispanics, well-educated adults, and so-called millennials. Republicans have stronger support among whites (particularly white men), those with less formal education, and evangelical Protestants (www.pewresearch.org/ data-trend/politicalattitudes/party-identification). According

to 2014 Pew Research Center data, 40 percent of the American public self-identify as independents (the highest rate in 75 years of polling), 32 percent self-identify as Democrats, and 23 percent self-identify as Republicans. When one takes into account the "partisan leanings" of independents, 48 percent self-identify as Democrat or leaning Democrat and 39 percent self-identify as Republican or leaning Republican, a gap that has remained fairly steady since 2009. Jacqueline Salit argues that the rise of independents is a positive development, that such independent voters are by choice nonideological radicals, but radicals nonetheless, pushing for structural reforms and a post-partisan system future (Salit 2012).

Some scholars stress that political parties combat several fundamental problems of democracy: how to regulate the number of candidates seeking public office, how to mobilize voters, and how to achieve and maintain the majorities needed to obtain public policy goals once elected to office (Aldrich 2012; Bond and Fleisher 2000; Cohen et al. 2001; Holbrook 2016). Weak parties (as organizations) mean the parties can no longer regulate the number of candidates, nor maintain stable majorities, nor effectively marshal sufficient majorities in government so as to avoid deadlock and to actually govern. Other scholars note that the weakening of party identification may portend an electoral realignment, in this case with an emerging Democratic majority that may signal the beginning of a new political party system (Judis and Teixeira 2004; Paulson 2007; Shafer 2003). Still other scholars assess that the weakening of the two major parties may enable the emergence of a third or minor party to majority-party status and that the weakening of stable major political party ties is a necessary precursor to realignment (Lowi and Romance 1998; Neto and Cox 1997; Rosenstone et al. 1996; Winger 1997).

### Coalitions of Voting Blocs and Shifts in Voter Allegiance

Many Americans decry that there are "hyphenated-Americans" who participate in elections as voting blocs—casting large

percentages of their votes to a particular political party and its candidates on the basis of their "ethnicity" or "other-group" identification and loyalty. Such critics of American politics state that we are all simply Americans and should assimilate and not retain other ethnic loyalties (national origin, racial, religious).

But as far back as the founding era, politicians realized that citizens could be appealed to on the basis of such loyalties and could be moved to support those politicians and their political party. Although each such group was in the numerical minority, if the majority white male citizen vote was split fairly closely among the two major political parties, then such ethnic voting blocs could provide the margin of victory in elections, and as political machines developed they ran slates of candidates for local, state, and ultimately even national offices that were comprised of ethnically diverse politicians who could appeal to such groups (LeMay 2009: 122–168).

Over time, as their members assimilated, the different voting blocs voted less consistently for particular parties. When such linkages between ethnic group and party began to weaken, the parties tried to build new coalitions. Sometimes, a particular candidate won over large numbers of such voters, and their loyalty to his or her party persisted for decades. At other times, the party took stands on legislative proposals or enacted laws that appealed to large numbers of particular groups, again cementing linkages or ties between those group loyalties and that political party that lasted a generation or more. The building of such voting bloc coalitions has been labeled "alignment." Numerous political science scholars have described such significant shifts in alignments in given elections as dealignment and realignment (Aldrich 1995; Barone 2014; Bartle and Bellucci 2009; Campbell 1980; Cox 1997; Gerring 2001; Green et al. 2004; Groenendyk 2013; Haas 1994; Kleppner 1987; Kleppner et al. 1983; Lawrence 1997; Manza and Brooks 1999; Neto and Cox 1997; Reichley 2000; Rosenof 2003; Williams 2010).

Other scholars debunk the realignment theory, arguing that many forces are at play in any given election and that a

consistent coalition of voting blocs does not align or dealign on anything like a generational cycle (Mayhew 2004, 2005; Schlesinger 2011; Shafer and Badger 2001).

Preelection (tracking) polls and postelection (exit) polls demonstrate that demographic groups of voters in the electorate do move in large numbers in support of or opposition to given candidates, especially presidential candidates. Political parties develop strategies in an attempt to attract the support of such demographic groups that the politicians, at least, view as potential voting blocs. They target their political advertisements to appeal to groups. They take positions on issues to appeal to groups of voters as blocs. Conventional political wisdom, for example, argues that a Republican candidate for president cannot win the office if he loses more than 40 percent of the Hispanic vote (a fact disproved by Trump in the 2016 election). Likewise, it argues that Republicans cannot win unless they garner at least upwards of 55 percent of the white male vote, or blue-collar white workers labeled Reagan Democrats. Republicans appeal to and expect to garner the heavy majority of the "Evangelical Christian vote." Until 2016, Republican candidates expected to win a majority of white women voters and a large majority of white males. In 2016, Donald Trump won the election in the Electoral College even while losing the popular vote by more than 2.8 million votes by adhering to that political strategy and "turning out" an unusually high percentage of such voters.

In the past (particularly in JFK's election), Democrats counted on winning a majority of the Catholic vote—although in recent years that voting bloc has shifted to Republican Party allegiance. Democrats clearly target blacks, Hispanics, LGBT, Asians, the unionized worker, upper-educated (college or postgraduate) white voters, and women, especially women of color and college-educated women.

To illustrate, a mid-June 2016 national NBC-*Wall Street Journal* poll (which had a margin of error of 3.1 percent) found that Secretary Hillary Clinton was favored by 87 percent of

African American voters to Trump's 5 percent, 69 percent of Latino voters to Trump's 22 percent, 53 percent of millennials (ages 18–34) to Trump's 30 percent, and 52 percent of women voters to Trump's 35 percent. Conversely, the poll found that Trump was supported by 49 percent of white voters to Clinton's 37 percent, 48 percent of men compared to Clinton's 38 percent, and 40 percent of self-described "independents" to Clinton's 30 percent (http://www.NBC-WSJ, May 19 to June 23, 2016).

## Ideological Purity of the Two Major Parties— The Dichotomy of Conservative Republicans versus Liberal Democrats

Citizens differ considerably as to the extent to which a political ideology motivates their participation, voting, and political party affiliation or allegiance. Some citizens want their party to be ideologically consistent, or "pure." Others vote for politicians who advocate policies they support, and the party affiliation, the conservative versus liberal (or progressiveness) ideology of the politician, does not matter for those voters. Such voters are often described as "voting their pocket-books." There has been a trend since the 1980s for the two parties to become more ideologically consistent. Most Republican voters, and most Republican candidates and officeholders, are conservative. Likewise, most Democratic voters, and most Democratic candidates and officeholders, are progressives (the now more fashionable term for liberals).

There are some scholars who applaud that trend, arguing that it makes for "more responsible political parties." Others decry the trend, arguing it results in a dysfunctional Congress, in policy deadlock, and in a "do-nothing" government. People who prefer that the national government be a limited government are happy with that result. People who expect and want government to address, and mitigate if not resolve, the problems facing the country are unhappy with

that result (see, for example, Cox 1997; Galderisi et al. 1996; Gerring 2001; Greenberg 1996; Lowi and Romance 1998; Reichley 2000).

The *responsible-party model* was developed in countries with a parliamentary system. Some scholars of American politics have advocated that the American two-party system should move or already is moving in that direction (Greenberg 1996; Schlesinger 2001, 2011; Shafer and Badger 2001). Having political parties that are ideologically consistent is a value stressed by the responsible-party model. Voters can rely on the party label of the candidate to know where that politician will stand on issues and what policies that politician will advocate or oppose once in government. That knowledge simplifies and "rationalizes" voter choice in the election. Arguably, it results in political party members in government actually doing what they said they will do in the election (Bartle and Bellucci 2009; Groenendyk 2013; Klingemann et al. 1994).

Other scholars argue that the firm political ideology of the parties, when they are so evenly divided as they increasingly seem to be in American politics, simply results in deadlock and the inability to effectively govern (Galderisi et al. 1996; Hershey 2007).

## Ideology versus Pragmatism in Primary and General Elections

The extent to which voters do and should vote for candidates for office based on the candidate's ideology, and conformity, if you will, to what the party establishment considers correct or "pure," versus based on which candidate is more likely "win" the election varies. In primary elections, there tends to be more emphasis on ideological consistency. In the general election, party operatives in particular want their candidate to win. The party pols and strong party identifiers (the party-in-the-electorate) may back candidates even in the primary whom they assess (or the polls indicate) are more likely to win the general

election. The idea of the party-as-organization stresses the pragmatic value of winning office. Pols will advocate that after winning the nomination, candidates should "pivot" for winning the general election (Hershey 2007).

For the party, winning the election means their candidates become "the-party-in-government" and can influence the policy agenda of government and appointments to executive branch positions and judicial offices. It also determines which party will be in the majority and which in the minority, which party impacts committee assignments and committee chairmanships, who becomes speaker of the House or Senate majority leader, even who occupies the best office suites in the House and Senate office buildings. Winning influences future campaign donation prospects and from whom campaign contributions will come.

In order to get things done, to actually govern and to successfully enact legislation, the division between the branches of government and the constraints of achieving a majority vote (increasingly a super-majority of at least 60 votes in the Senate) often requires at least some measure of bipartisanship and reaching across the aisle to work with members of the other party to craft bills that have a greater chance of being adopted. Good governance argues for pragmatism in the general election. But legislative districts are now so often drawn to achieve "safe" districts and to secure reelection that the incentives in primary elections is to be ideologically more "pure." The political pressure of the primary election is to be ideologically consistent with the party's base, whose members generally are more ideologically consistent than are general election voters.

The needs of the primary election versus the general election pull candidates in two directions. This is especially true for statewide offices, as opposed to local or legislative district offices. The smaller and more demographically homogenous the electoral district is, the more incentive the candidate has to be ideologically consistent with the party and, presumably, with its rank-and-file voters. The larger and more demographically

heterogeneous the electoral district, the greater is the incentive for the candidate to be pragmatic.

There is a tendency for larger electoral districts or more densely populated districts to develop a political culture that favors the pragmatic approach. Large cities with highly diverse populations develop a political culture wherein the citizens want and expect their elected officials to solve problems and get things done, to do the day-to-day work of governing. The political culture favors pragmatism, for to win the election, the politician must be pragmatic rather than strictly ideological.

Similarly, career politicians are typically more pragmatic than newcomers to politics. An ideological bent often motivates an "outsider" candidate to challenge an incumbent in the primary election. In most cases, the incumbent has a considerable advantage in the general election. While challengers are more likely to defeat an incumbent in the primary election, they are less likely (since they would be of the other party) to do so in a general election. Career politicians, by the very length of the electoral experience they have, can build a grassroots organization and strong electoral support enhancing the safe nature of their elections and allowing them to be more pragmatic in the general election. Occupying an office for a number of years better enables them to "bring home the bacon," so to speak, to provide material incentives to the voters of their districts, their constituents, which again favors pragmatism.

## The Need to Play to a Party's Base versus Outreach and Diversity of Coalitions

The party that is safely in the majority in a particular district is induced to cater to the party's base voters in an election, especially in a primary election. This results in moving the two major parties to their ideological extremes. Democratic Party candidates become more liberal; Republican Party candidates become more conservative. Extreme partisanship can often result in policy-making deadlock in both the Congress and in state legislatures. There is less electoral incentive to compromise. Incumbents fear that they will be challenged in primary elections

by opponents who are to the right of Republican officeholders and to the left of Democratic officeholders.

Even when national electoral results (as in Barack Obama's 2008 election and his 2012 reelection) moved many Republican Party officials to assess the election results as indicating that the party needed to reach out more to minority voters and to broaden "their tent" to develop and include a more diverse coalition of voting bloc support, the effect of gerrymandered congressional districts worked more powerfully in the opposite direction. Representatives from safe congressional districts, and the increasingly conservative base of the Republican Party, kept the party's candidates for office from changing their electoral strategy to reach out to build a more diverse coalition of voters (often meaning appealing to ethnic minority groups). The more ideologically pure party loyalists who disproportionately turn out for and determine the results in primary elections keep officeholders and party candidates from "compromising." To stay in office, or to win primary elections, candidates feel compelled to appeal to and appease their base. "Compromise" becomes a political dirty word. Effective public policy making is weakened, and policy deadlock results. The extreme partisanship evident in Congress results in an increasingly dysfunctional Congress, especially in the U.S. House of Representatives, whose approval ratings have sunk to an all-time historical low. Moderates in both major political parties are voted out of office or choose to retire out of frustration with the inability of Congress to get anything done. The institutional or cultural climate of Congress, which is increasingly partisan and because of gerrymandered districts and the Senate's use of the filibuster, makes it less and less likely for representatives to reach across the aisle and try to formulate and enact bipartisan legislation.

## The Candidates

### The Candidate Selection Process

Many critics of the complex presidential selection process point out that it is becoming increasingly hard for anyone but

a millionaire to consider running, at least for the major party's nomination. Even if one's personal wealth is not in the millions, the potential candidate needs a supporter with deep pockets or the backing of a political action committee (PAC) or super-PAC. Persons with name recognition also have an advantage, as the Trump nomination illustrates. In the past, the major political parties could select a relatively unknown candidate—a dark horse—and quickly develop that candidate's name recognition. Today, the national party organization's relative weakness makes that process more difficult.

Candidates who are "media savvy" likewise have a distinct advantage in obtaining the nomination of a major party for any national-level office. The ability to access and use the social media for fund-raising and for support in the early primaries gives an edge to such candidates, as so aptly demonstrated by Donald Trump's campaign.

Campaign finance favors some candidates and hampers others. Candidates with huge "war chests" discourage potential rivals. Some candidates have dropped out early in the primary phase when their campaigns failed to raise sufficient funds to continue in the race. Another distinct advantage of some candidates is already holding a highly visible office viewed as a stepping stone to a higher office. Governorship of a large state, or being a U.S. senator, for example, gives the potential presidential candidate a sense of "gravitas" marking him or her as "presidential timber." It is almost always an advantage to being an incumbent running for reelection. On occasion, however, the mood of the voting public shifts and favors the outsider over the "establishment," as was the case in 2016 with the Republican Party field of 17 candidates who initially sought their party's presidential nomination. The outsider and non-politician, Donald Trump, became the nominee of the Republican Party precisely because he was the outsider, in a year in which the Republican primary rank-and-file voters clearly preferred someone whom they viewed as being better able to "clean up the mess in Washington" and who could better "shake up the

party establishment." For many such primary election voters, supporting Trump was meant to "send a message to the Republican Party establishment."

And to the contrary, the national Presidential Debate Commission sets the rules as to who will or will not be allowed on the stage for the nationally televised presidential debates. Several otherwise qualified candidates were forced out of the race in part because they were not allowed on the "main stage" of the presidential debates.

The 2016 presidential race also broke several unwritten but normally important traditions as to who was perceived to be of presidential timber. Secretary Hillary Clinton was the first woman ever to be the presidential nominee of a major political party, shattering that glass ceiling. Donald Trump became the oldest major-party nominee and the first with no prior electoral office experience who was not a former famous general since 1940, when Wendell Willkie, a 48-year-old chief executive of a large electric utilities holding corporation, won the Republican Party nomination for president and went on to win in the Electoral College vote (although he lost the popular vote by nearly two million votes).

## The Establishment versus Outsider Candidates

In 2016, both major parties struggled in their respective presidential nomination processes over the issue of whether or not the conditions of the times favored an outsider to Washington politics who was therefore more open to and able to "reform" national politics versus the argument that world and even domestic economic and national defense issues favored an establishment candidate who had the experience on day one to be commander-in-chief and the know-how to get things done. An outsider candidate, by definition, begins the process as a dark horse. The Republican Party primary voters opted for the outsider in selecting Donald Trump. The Democratic Party primary voters chose the quintessential establishment candidate

and perceived front-runner from the very start in Secretary Hillary Clinton, who had been on the national political scene for several decades, was a former First Lady, former U.S. senator from New York, former candidate (in 2008) for the office, and former secretary of state in the first Obama administration. She clearly described herself and her campaign as continuing the Obama legacy. By contrast, Senator Bernie Sanders (I, Vermont), despite his decades of experience in Washington, D.C., was considered the outsider and a dark horse who began the process with a miniscule 3 percent in the polls but who ended up with more than 40 percent of the votes. As a U.S. senator, he had caucused with the Democrats but was officially registered independent (and self-described Democratic Socialist); he did not register as a Democrat until his race for the nomination of the party. The outsider status of Trump and Sanders was also indicated by the support (or lack thereof) of the unbound or super-delegates of their respective parties.

The fact that Donald Trump won his party's nomination against more than a dozen insider candidates clearly demonstrated that a plurality (but not a majority) of the Republican Party's rank-and-file voters (the party-in-the-electorate) was in an "anti-establishment" mood. Four of the seventeen declared candidates (Carson, Cruz, Fiorina, and Trump) were, at least for a time, considered to be among the front-runners for the nomination, and they proudly billed themselves as outsiders and "anti-establishment." The two finalists (Trump and Cruz) won significantly more votes and more delegates than any of the 13 establishment candidates. Republican Party voters were in a mood for an outsider candidate and were sending a message to the party establishment that they wanted a change agent who would shake up Washington as well as the party and would move the party and the country, if elected, in a new direction.

The Trump candidacy illustrates that simply raising and spending the most money doesn't always win the race. Former governor of Florida Jeb Bush raised $100 million before

entering the primary race, outspent all his rivals, and spent tens of millions of dollars for anti-Trump ad buys; yet, he was a lackluster campaigner, and Trump's free media, generated by his radical rhetoric, appealed to the anti-establishment mood of the rank-and-file Republican primary voters. Trump won the nomination handily after Bush, despite his huge war chest, was forced to suspend his campaign.

In the Democratic Party, Secretary Clinton ultimately won the nomination but only after a surprisingly strong run by Senator Sanders. Clinton had the support of a vast number of super-delegates (more than 500) but also won the most primary votes and the most pledged delegates, carried the most states, and won more of the primary-election states. Senator Sanders won more of the caucus states and raised far more "small dona-tion" contributions than Secretary Clinton, more than any pre-vious Democratic Party candidate, including President Barack Obama in his 2008 and 2012 elections. Senator Sanders was the only candidate, from either party, who refused to estab-lish a PAC or super-PAC. Despite his dark horse and outsider status, he also showed that many voters were in the mood for an outsider by drawing huge crowds to his rallies, by winning many more states than expected, and by raising tens of millions of dollars by small donations from millions of rank-and-file contributors. (He boasted at his rallies that his average contri-bution was $27.)

## The Campaigns

### The Length of Presidential Campaigns

Presidential campaigns now cost upwards of a billion dollars per major-party candidate. Some candidates for a presidential run begin their preliminary organization two to even three years before the election, and formal campaigns of the primary season now start a year and a half before the November gen-eral election. By the time of the general election, most voters are sick of the endless campaigning, the omnipresent television

ads, the telephone calls for support or letters appealing for donations, and the seemingly endless political hype of the campaigns. The ads themselves have become increasingly negative, many downright nasty. While negative ads have proven to be effective, they turn off some citizens from participating in elections and political campaigns. Candidates for all national offices spend more time raising money for their campaigns than they do actually campaigning and holding rallies to reach out to the voters and discussing issues or their plans for public policy or governing if and when they are elected.

During the course of long campaigns, the relations between the candidates and the media become strained and increasingly adversarial, which results in less information for the citizen/voter. The media emphasizes the horse race nature of the election. In trying to secure the nomination against their party rivals who hold similar positions on the issues, candidates try to distinguish themselves and gain ground on their rivals not only by going negative but often personal.

It is exceedingly difficult to win the presidency and almost as difficult to win a second term. It is not unusual, therefore, for candidates to run several times, stretching their presidential runs to many years. Most European democracies, especially those with a parliamentary system, strictly limit the campaign season, typically to a few months' duration. In the 2016 presidential election, for example, Ted Cruz, the first candidate to enter the Republican primary race, did so 596 days before the election. Vice President Joe Biden decided not to enter 384 days before the election, citing in part as the reason he did so was that it was "too late" for him to be competitive. The first caucus in the U.S. 2016 race was 281 days prior to the election. Contrast that long period to the official campaigns of a few other major democracies: Mexico's are 147 days, the United Kingdom limits its campaigns to 139 days, Canada to 78 days, France to 2 weeks, and Japan to 12 days! (http://www.npr.org/sectons/itsallpolitics/2015/10/21/450238156, accessed June 17, 2016). The U.S. system requires that a candidate raise millions

of dollars to finance campaign expenses—for candidate and top-level campaign staff travel, advance staff, campaign office expenses, campaign fund-raiser expenses, and most particularly, for advertisements—which must last for such an extended period.

The length of U.S. campaigns has been increasing over time, moreover, in what has been called "primary creep." Prior to 1976, presidential campaigns began within the year of the election. But as states jostled to be the first to hold their caucus or primary, the dates kept pushing back (Sabato 2006). One impact of the *Citizens United v. Federal Election Commission* decision was to make it financially possible for candidates to run year-and-a-half-long campaigns.

No sooner had the 2016 election finished than speculation of who would be the leading contender for the 2020 Democratic presidential nomination began in the press and in "postelection" analysis as to why the Democrats lost so badly.

### The Complexity of National, State, and Local Elections

America spends tens of billions of dollars on elections when one combines the amount spent in an election cycle (e.g., 2016) on races for the presidency, Congress (House and Senate), statewide offices (such as governor and state legislatures), and local offices (www.opensecrets.org/overview/index.php, accessed June 17, 2016), including expenditures by candidates, parties, PACs and super-PACs, and 501(c)(4) organizations. The system is mind-bogglingly complex, as campaign finance laws vary for each of the categories of races mentioned in the preceding passage of text and for each level of government (national, state, and local). All 50 states have different election laws that control who may run, how one establishes a campaign committee, what reporting documents are required to be filed and by what dates, whether a caucus or a primary election will be held and when it will be held, whether or not the primaries are open or closed, when voters have to register to vote and

what kinds of documents they must show to do so, who may legally register voters, who is legally barred from voting, where the voter has to go to cast a ballot, whether a voter may vote by mail-in-ballot, the length of the voting period, and the format of the ballot the voter receives. The position of the candidates' names on the ballot is determined by such state laws, as is the use (or not) of "write-in" candidates and party label designations. And all these rules affect differentially the candidates' and the party's electoral chances.

The sheer complexity of elections in the American federal system bewilders many voters and probably discourages many from participating. It is not easy to be a well informed and active voter. Caucuses demand much more time and effort by the voter to participate than do primaries. It is easier to get information about candidates and their positions for national-level offices than for state level and for state than for local (city/county/legislative districts). Many states allow voters to cast one vote for all the offices for all the candidates affiliated with one party (called a straight-party ticket); others require the voters to cast their vote for each office and referendum issue on the ballot. Such rules and regulations impact electoral turnout, favoring major-party candidates over third-party candidates and candidates with well-established name recognition over the lesser-known or dark horse candidates.

Complexity increases the length of time and the costs of elections, which in turn affects candidates' decision whether or not to enter the race and their electoral chances if and when they do decide to enter the competition.

### The Cost of Campaigns

Campaign finance is the financing of electoral campaigns at the federal, state, and local levels. At the federal level, campaign finance law is passed by the Congress and implemented (enforced) by the Federal Election Commission (FEC), an independent federal agency. Virtually all campaign spending is

financed privately. Public presidential financing is available for qualifying candidates for president (nominees of the two major parties), but the subsidy is subject to spending limits.

Federal law limits how much individuals and organizations may contribute to political campaigns, political parties, and other FEC-regulated organizations. Corporations and unions are barred from donating directly to candidates or to national party organizations. Races for nonfederal offices are regulated by state and local laws, which vary considerably from state to state.

Critics of American politics call for campaign finance reform (Green 2002; Post 2014). Such criticism increased markedly as a result of the Supreme Court's decision in *Citizens United*. The Court struck down a federal prohibition on independent corporate campaign expenditures, one of the Court's most controversial rulings in decades (Post 2014). Critics maintain that selling access to politicians to the highest bidder (referred to as "pay to play"), and pricing practically everyone—except millionaires—out of the ability to participate effectively in our democracy, shades and corrupts the political system. Opponents of campaign finance reform argue there is little empirical evidence to show that campaign contributions really influence members of Congress. They further argue that negative campaign ads improve the democratic process by increasing voter turnout and voter knowledge (Samples 2006; Smith 2001; Smith 2006; Gill and Lipsmeyer 2005).

Whether or not the current system of campaign finance corrupts the processes of American democracy, the sheer cost of national-level elections is viewed by many as problematic. In the 2016 Democratic primary contest, Senator Bernie Sanders stressed to a near single-message extent the dangers to our democracy of a "corrupt and broken campaign finance system." In 2008, candidates for office, the major political parties, and independent groups spent more than $5 billion, and more than $2.4 billion of that was for the presidential campaigns alone. President Obama's campaign spent $730 million, and

John McCain spent $333 million—the most expensive presidential race to that point in time (Dziedzic 2012).

The 2016 Republican presidential nomination field began with 17 declared candidates and the Democratic field with 4; all totaled, the 2016 presidential races cost several billions of dollars. Senate election campaigns in geographically large states with expensive media markets (like California, Florida, Illinois, Michigan, New York, New Jersey, Pennsylvania, and Texas) run into the tens of millions of dollars. Apart from whether or not campaign contributions influence or corrupt the politicians, the sheer amount of time politicians must spend raising huge amounts of campaign funds (their war chest, as it is so often called) means that they have less time to devote to governing, to studying legislative proposals thoroughly to discern the likely anticipated and unanticipated consequences, and to communicate with their rank-and-file voters rather than almost solely with those from whom they are soliciting contributions.

A consequence of limits on individual contributions is the use by campaigns of so-called bundlers—persons who have contacts with wealthy donors and who can therefore gather contributions from many individuals in an organization or community and then donate large sums to the campaigns. Such bundlers are often recognized with honorary titles or access to exclusive events featuring the candidates. Such practices are viewed by many as currying favor or access that has, at the least, the appearance of inside connection and/or corruption. The use of bundlers has increased markedly since 2000. In the 2008 campaign, bundlers for the major primary candidates for both parties numbered in the thousands (Johnson and Blatz 2010; Kirkpatrick 2007). Lobbyists assist campaigns by arranging fund-raisers, assembling PACs, and seeking donations from other clients. A number of lobbyists become campaign treasurers and fund-raisers for national-level politicians.

The sheer cost of national campaigns has led to the development and increasing influence of supposedly independent PACs and super-PACs. Federal law recognizes four types of

political action committees: connected PACs, non-connected PACs, leadership PACs, and super-PACs—the latter rising since the 2010 elections, officially known as "independent-expenditure-only committees." Finally, there are 501(c)(4) organizations, so-called social welfare organizations, which are allowed to participate in political campaigns so long as their primary purpose is the promotion of social welfare and not political advocacy. Examples are NAACP, Planned Parenthood, the Sierra Club, the National Rifle Association, Crossroads GPS, and Americans for Prosperity. Since they do not have to disclose who their donors are, their use in campaigns has climbed sharply since 2010, and their total expenditures for presidential campaigns in 2012 exceeded those of all the super-PACs combined.

### *Citizens United* and Campaign Finance Reform

Critics of the current campaign finance system, and advocates of campaign finance reform, argue that the current system is corrupt. They especially disagree with the Supreme Court's decision in the *Citizens United v. Federal Election Commission* (08–205, 558 U.S. 310, 2010) decision. Campaign finance controversies hinge on how one measures or assesses whether or not large donations from wealthy donors or lobbying groups or other vested interests (donors to the PACs, super-PACs, and 501(c)(4) organizations) are given with the intent to sway or influence the politician in his or her public policy stands. Such donations would be illegal, and therefore corrupt, if given "quid pro quo," that is, for an express vote in return for the donation. Such blatant corruption is exceedingly hard to prove. In the recent Supreme Court decision regarding the lower federal court's corruption conviction of former Virginia governor Robert McDonnell, the justices remanded the case back to the lower court, overturning the conviction. They ruled: "Our concern is not with tawdry tales of Ferraris, Rolexes, and ball gowns. It is instead with the broader legal implications of the

government's boundless interpretation of the federal bribery statute. A more limited interpretation of the term 'official act' leaves ample room for prosecuting corruption with the text of the statute and the precedent of this court" (http://www.usa today.com/story/news/politics/2016/06/27/supreme-court-robett-mcdonnell-virginia-governor-curruption/83547198/, accessed February 18, 2017).

Political donors tend to give to "friendly politicians," whose policy stances are already compatible to the interests of the donor and thus do not have to be "bought." Others donate to PACs and super-PACs for the express purpose of supporting negative ads against politicians they oppose, trying to help defeat them in an election. In the 2010 *Citizens United* decision, the Supreme Court, in a 5–4 ruling along strictly partisan lines, upheld the constitutionality of unlimited donations by corporations, groups, and individuals to "independent-expenditure-only committees" as being protected exercise of free speech. Since corporations are "legal persons," the justices ruled in *Citizens United v Federal Election Commission*, their freedom of speech cannot be curtailed or limited by campaign finance regulations of the Federal Elections Commission.

Critics decry the *Citizens United* decision for its promotion of "dark money" and the rise in such spending to the point that it exceeds all other campaign spending combined (http://propublica.org/article/two-dark-money-groups-outspending-all-super-pacs-combined, accessed June 30, 2016). If a wealthy businessman can lavish $175,000 in gifts to a politician, as was the case with Governor McDonnell, then critics ask, why else other than trying to buy favorable treatment would such lavish gifts be given?

The need to prove, basically in writing, that there was a specific government policy act that was the pro quo makes prosecuting such bribery cases exceedingly difficult. Corporations clearly view their political contributions as "investments" to insure access to politicians. At the very least, the ability of corporations and wealthy businessmen to accrue huge sums

of money to donate to political campaigns results in a very uneven playing field. As already mentioned, critics assert that the tradition of selling access to politicians through donations (which they describe as "to the highest bidder" and as "pay to play") essentially prices nearly everyone but millionaires out of the ability to run for higher offices (Green 2002).

Yet, defenders of the First Amendment greeted the 5–4 *Citizens United* decision with enthusiasm (Post 2014). Smith (2001) argues that all restriction on campaign giving should be eliminated since they violate the right to free speech and ultimately diminish citizens' power. Another sharp critic of campaign finance reform laws and proposals argues that the laws have exactly the opposite of their intended effect: that they increase the likelihood that incumbents will be reelected and diminish the prospects of candidates who are not wealthy being elected (Smith 2006).

## Overturning *Citizens United*

The Supreme Court, by its 5–4 ruling, decided on political party or ideological lines and reached its controversial conclusion in *Citizens United v. the Federal Election Commission*. In doing so, it interpreted the Constitution. Although conservative Republicans usually rail against an "activist" court, the *Citizens United* decision was an instance of judicial activism and hardly "strict-constructionism." If the court so ruled in one case, it could overturn its decision and rule differently. This is illustrated by the decision in *Brown v. Board of Education of Topeka, Kansas* (1954), in which it ruled that segregated schools were inherently unconstitutional, overturning its earlier ruling in *Plessy v. Ferguson* (1896), which had established the "separate-but-equal" doctrine that essentially gave a constitutional blessing to de jure segregation and the South's Jim Crow laws (LeMay 2009: 284–285, 331–332).

It is legally possible that the Court could overturn *Citizens United*, but it is politically highly unlikely. The current 4–4

split among the justices, and the vacancy of a ninth justice position, means the Court could not and will not reverse itself in the foreseeable future. This is all the more the case with the election of President Trump, who pledged during his campaign to appoint an arch-conservative justice who would be ideologically alike to the late justice Antonin Scalia. Yet another way would be for the U.S. Congress to pass legislation that defines corporations, at least for the purposes of campaign financing, as not being a "person" with the same free speech rights as a real person/citizen. Again, this solution is possible but even more improbable than the Court reversing itself. The Democrats would have needed a sufficiently large "wave" election (a tsunami, as it is labeled), in which they won control of both houses of Congress as well as retaining the White House. In fact, they are in the minority in both house of the Congress.

Another complication to such a solution is that money, even vast amounts of dark money, does not always win elections. If that were the case, Jeb Bush would have been the 2016 Republican nominee. PACs and super-PACs, and their wealthy contributors, might come to the conclusion on their own that spending vast sums on political campaigns does not work well enough to be judged a good return on their investment.

Finally, *Citizens United* might effectively be overturned by a political revolution along the lines suggested and proposed by Senator Bernie Sanders. While he failed in his effort to lead such a revolution in the short term, he may have set in motion a political movement that in the somewhat distant future might do so. At the very least, his surprisingly strong showing in the presidential primary has influenced the Democratic Party platform, and the platform calls for the sorts of campaign finance reform that essentially mitigates if not outright overturns the effects of the *Citizens United* decision.

By contrast, the unexpected victory of Republican nominee Donald Trump in the 2016 general election resulted in

the appointment of Neil Gorsuch, a conservative in the Scalia tradition, who will be opposed to overturning *Citizens United*.

## National Laws That May Affect the Length and Cost of Elections

The seemingly endless length of the presidential election season has induced some proposals to use national legislation to shorten the season. The long season makes the process more costly, and the public financing of elections has been proposed as the solution. If there were a federal law establishing federal funding of elections, at least of national elections, that alone would give leverage for a top-down mandating of a shorter season: "he who pays the piper, calls the tune." Many European Union countries have laws limiting donations as well as the length of campaigns. They all have a far shorter national election season than does the United States and spend far less on elections than does the United States (Casas Zamora 2005; Herbert and Shiratori 1994; Katz and Crotty 2006; Nassmacher 2009) (http://www.idea.int/politicalfinance; http://www.idea.int/parties/european-elections-and-campaigns).

But public financing of elections, especially of the presidential election, has been tried and subsequently rejected. Presidential candidates waived public financing because it had limits on the amount the candidate could spend, and candidates found they could raise and spend far more without federal funding. If one of the two major-party candidates waived the federal funds, then the other felt compelled to do so (as did President Obama in 2008 and 2012, for example) in order to stay competitive.

Another critique of proposed campaign finance reforms is that they simply do not work. Candidates find ways (loop holes) to get around limits. Several critics suggest that the best way to deal with campaign finance reform is to have no limits but strict transparency—that all donations have to be promptly reported to the FEC and the public be made aware of the source and amount of the donation (Post 2014; Samples 2006;

Smith 2001) (http://www.oyez.org/cases/2000-2009/2008_
08_205, accessed July 5, 2016).

Critics further point out that strict limits on funds (and by
extension the public financing of elections) and on the time
of a campaign season favors the well-known candidate versus
the dark horse, the incumbent versus the challenger (Samples
2006; Smith 2001; Smith 2006). Although campaign finance
limits and mandatory public financing of presidential elec-
tions would level the playing field between Democrats and
Republicans, it would disadvantage minor-party candidates
who would need to spend more time and money to make up
for their minor-party status and less name recognition of their
candidates and of the party itself. Many if not most American
citizens know and recognize Hillary Clinton (D) and Donald
Trump (R).

But relatively few know Gary Johnson (Libertarian) or Jill
Stein (Green).

## The States

### The 50 State Party Systems

One major controversy in the American political party system
arises from the fact that the Constitution of the United States
establishes a *federal* system in which the states, as constituent
units with their own powers, share political power with the na-
tional government. The Constitution, moreover, is silent on the
issue of political parties. This means that the "reserved powers"
clause in the Constitution delegates the authority to regulate
elections and political parties to the respective state govern-
ments. In the United States, in a very real sense, we do not have
a one party system; we have 50 party systems dominated by
two major parties. Each state has the power and legal authority
to regulate the parties and, broadly, to determine the nature of
elections within the state. States choose whether primary elec-
tions or caucuses are used, whether an open or closed primary
system is used, what laws govern campaign contributions, and

what laws regulate issues of political corruption (e.g., what constitutes "bribery"). Each of the 50 states determines whether or not citizens may or must register a party affiliation and when they must do so in relation to primary or general elections. Each state determines what type of ballot is used, whether such ballots must be cast on Election Day, whether many days may be used, whether the ballot must be cast in person at a polling place, or whether mail-in-ballots may be used. Each state stipulates how "absentee" ballots will be handled and counted. Each state determines the number and location of polling places. State laws specify what documents may or must be used to establish identity and residency for voting or other electoral purposes (such as how a candidate establishes residency to qualify to run for an office).

The bewilderingly complex array of such electoral laws, rules, and procedures results in many citizens not being able to participate or effectively "disenfranchises" some citizens from political participation. Some states strip convicted felons from ever being able to vote again, even after they have served their prison terms, while other states allow felons, after serving their sentences, to once again vote. Certainly, not all states are equally "democratic" in their electoral practices. In the 19th century, 18 states even allowed noncitizens to vote in local elections (Ueda 1980: 737–740). Some critics argue that the very complexity of America's electoral politics discourages political participation. And indeed, participation in American politics trails that of almost all other developed democracies (Campbell 1980; Erikson and Tedin 2014; Hershey 2007; McSweeney and Zvesper 1991; Neto and Cox 1997; Reichley 2000).

Many state legislatures clearly enact electoral policies and procedures to favor one party. Broadly speaking, greater political turnout and participation benefits the Democratic Party; and conversely, smaller turnout favors the Republican Party. In turn, easier access to voting increases voter turnout, and more barriers or stringent requirements to vote results in smaller turnout.

While the Constitution allows for such extensive diversity, there is nothing to prevent the states from voluntarily coordinating to establish more uniformity in election laws and procedures. The use of the primary, for example, could become standardized. Regional primaries would reduce the current bewildering array. More standardized ballot forms could be adopted, much like states often adopt "best practices" in other areas of public policy. In recent years, Republican-dominated states have adopted similar "voter id" laws that clearly have been enacted to discourage voting, to make the ballot less accessible, and to reduce turnout. Just as they have voluntarily copied one another's laws on the matter, they could just as easily pass laws that ease the burden and increase voter turnout if they chose to do so.

Yet another argument for keeping the diversity, and resulting complexity, is the "states as laboratories" perspective. The states are diverse in their population size and diversity and in the nature of their economies, industrialization versus agriculture, and urbanization versus rural residency. Such diversity is better served, some say, by the diversity of election practices among the 50 states. State government, being "closer to the people," can experiment with policy and test whether or not certain policy approaches work well and are cost effective and so on. Then those practices can be copied by similar states. Any number of laws now in the national codes were first tried by the states and then passed on up to the national level. The states differ considerably in their respective political cultures, and, one could argue, the election practices should reflect that differing political culture. The United States has so diverse a population that great diversity in its politics, including electoral political practices, is appropriate.

## States' Rules on Ballot Access

States have the legal authority to set the rules, regulations, and procedures that govern ballot access. But change is not a simple

solution. Each of the 50 states (and the U.S. territories) set their own rules on ballot access. Some states have very low filing fees to run for an office. Others have stringent regulations regarding when one has to file to get on the ballot. Some states require a certain level of past electoral results (say, 10 or 15 percent of the previous election votes for that office) for a party to get on the ballot. This makes it very difficult for minor parties to get their nominees on the ballots of all 50 states. Relative newcomers to politics, outsider candidates, often lack campaign staff personnel who know the complex rules determining access in caucus versus closed or semi-closed, or semi-open and open primaries system states. Such candidates lack the on-the-ground organizational field operations.

Tradition and past practice are powerful influences on the state's ballot access rules. States like Iowa and New Hampshire jealously guard their "first in the nation" status of caucus and primary elections and set the dates for their elections to maintain that status. Having ground operations in the early states requires knowledge of their complex rules and the finances to develop and mount those ground operations. It is especially hard to mount a presidential campaign, let alone win one.

Having "name recognition" helps the outsider to challenge the establishment candidate. Being independently wealthy means such candidates can more readily hire political campaign professionals to advise them on doing what is needed to build a ground operation or gain ballot access by acquiring the requisite number of signatures or garnering a sufficient percentage in polls. Lacking enough money or name recognition means that dark horse candidates must begin running far in advance to raise the campaign funds or increase their name recognition. Even a self-declared billionaire, like Donald Trump, cannot actually "self-fund" a viable and credible presidential campaign.

Timing is another factor influencing this issue. In a year in which the outsider runs against an incumbent running for re-election, the challenger normally has a more difficult task. It is

always easier to challenge for an "open seat." An incumbent is automatically on the ballot. The challenger has to "earn" access to the ballot. As Senator Bernie Sanders found out, it is easier to call for a political revolution than it is to actually pull off leading one. As is true for most institutional barriers, they are institutionalized or entrenched for a reason. Getting states to change their institutionalized rules is always difficult and normally requires years to accomplish.

Elections are influenced by macro-level trends. The candidate cannot control outside influences, such as foreign affair "events," the political culture influencing the outsider versus the establishment, or what issues predominate the electorate's motivations, such as the state of the economy dictating domestic issues as being more compelling than foreign policy issues. Since one cannot know those factors well in advance of the campaign, it is more difficult to change institutional barriers like ballot access to respond to those other "extraneous" variables. Cultural or social variables are sometimes more compelling than are structural barriers like ballot access (Aldrich 1995; Brinkley 1995; Campbell 1980; Cox 1997; Gerstle 2001; Groenendyk 2013; Haas 1994; Kleppner 1987; Lawrence 1997; LeMay 2009; Manza and Brooks 1999; Reichley 2000; Rosenof 2003; Shafer and Badger 2001).

## Caucuses and Conventions

The different degree of success that Senator Bernie Sanders enjoyed in caucuses to select delegates to the Democratic National Convention during the 2016 Democratic presidential nomination battle and that self-described outsider candidate Senator Ted Cruz enjoyed in caucus states in the Republican nomination battle raised anew the controversy over the use of caucuses and conventions to select delegates to the national convention to nominate the major-party candidate for the presidency as opposed to selecting such delegates by a primary election. By nature, caucuses and conventions are less democratic than are

primary elections. They were the principal targets for reform pushed by the progressive movement in the early twentieth century (Fink 1999; Gerring 2001; Groenendyk 2013; Hershey 2007; Kleppner 1987; Milkis and Mileur 1999; Sarasohn 1989; Shafer and Badger 2001).

In the caucus and convention system, only members registered with the political party can participate; the voting is conducted by local (precinct) party meetings and is done by raising hands or breaking into groups and the votes being counted manually by the number of supporters for each candidate. Simply put, the vote is public, not secret, and frequently, speakers for each candidate proclaim why they back a given candidate and try to persuade any undecided voters. This takes the commitment of several hours, instead of just a few minutes in the privacy of the voting booth. The caucuses select delegates to attend conventions (typically held at county or congressional district level and from there to state conventions) who pledge that support of a given candidate. Caucuses require that a candidate have a well-organized ground game to get out his or her supporters to attend the caucuses and conventions. They were the original way in which political parties chose candidates until the secret ballot, until the more democratic system of the primary election gradually gained favor during the beginning of the 20th century with the progressive reform movement (http://www.diffen.com/difference/Caucus_vs_primary).

For the 2016 presidential elections, 11 states and 2 U.S. territories used the caucus system: Iowa (traditionally the first in the nation), Nevada, Minnesota, Colorado, Hawaii, Maine, Kansas, Wyoming, Alaska, Washington, and North Dakota and the two U.S. territories American Samoa and the U.S. Virgin Islands. In the past, some of those states (such as Colorado) used the primary system but because of the economic recession of 2008 switched to the caucus system to save money. After the 2016 election, however, Colorado's economy was much improved, and a proposal to switch back to the primary system was passed in the 2016 general election, as was a

proposition that made the primary an open primary, allowing unaffiliated (a.k.a. "independent") registered voters to vote in the primary.

Another concern with the caucus system is that it has sometimes been the case that a candidate "won" at the caucus selection race but failed to get enough of his or her delegates to be elected to and show up to vote at the state convention and thereby to actually win a majority of delegates to the national convention.

State legislatures pass the laws and rules governing elections and specifically whether to use the caucus and convention versus the primary election process. Primaries cost more to operate, and often the state party organizations want or need to save money and therefore opt for the caucus system. Some states (such as Iowa) use a nonbinding "straw" poll at the caucus to measure which candidates have a plurality of support, but the statewide convention actually selects the delegates to the national convention. It is sometimes the case that one candidate "wins" the caucus straw poll but loses a majority of the delegates to another candidate at the state convention—as was the case in 2012, when, in Iowa, Governor Romney was first declared the winner and then a few days later Rick Santorum was declared the winner; but, at the state convention, Ron Paul actually won a majority of the delegates to the national convention.

Because caucuses are closed to all but registered party members, they are considered less democratic than are open primaries, which allow independents to vote. They are also considered less democratic because the ballot is not secret (i.e., cast in the privacy of the voting booth). Turnout in caucuses is substantially less than in primary elections. It is common for as few as 10 percent of the eligible voters to participate in the caucus. Thus, the most ideologically committed voters or the most committed of supporters of a specific candidate dominate the process. Usually, the state decides whether to hold a caucus or a primary, and this decision applies to both parties.

In Wyoming, however, there are variances between the process used by Republican and Democratic parties. Another difference is that there are some delegates—called unpledged delegates in the Republican party system and super-delegates in the Democratic party system—who are not bound by the results of either the caucus or the primary in their state. Such delegates to the national convention are free to vote for the candidate of their choosing on the first ballot. They are commonly party or elected officeholders and are quintessentially establishment delegates, sometimes referred to as "politicos."

## The Primary Election System: Open or Closed? Binding or Preferential?

At the heart of the presidential electoral process is the elaborate system used to select delegates who represent the state at the national convention of the two major political parties (and used by several of the minor parties as well). The national convention officially nominates the party's presidential nominee. Such delegates are "awarded" to one of the presidential candidates, and the candidate with the majority of delegates on his or her side wins the nomination. States vary in how they award delegates. Some states use a "winner-take-all" approach and award all the delegates to the winner of the state's caucus or primary. Other states award delegates in proportion to the percentage of votes received by the candidates. Each state decides whether to use a primary, and if so, what type of primary, or to use a caucus. In some cases, such as the state of Washington, a different process is used by the Republican and the Democratic parties.

The states that do use the primary system (39 of them in 2016) vary as to the type of primary election they use: closed primary, semi-closed primary, open primary, semi-open primary, run-off, or a mixed system. In a closed primary, citizens may vote only if they are registered members of that party. Independents cannot participate in either party's primary. In a

semi-closed primary, registered party members can vote only in their own party's primary, but unaffiliated voters are allowed to participate, depending on the state, by registering for that party on-site on primary election day or once inside the voting booth. In an open primary, voters may vote in any party regardless of their own party affiliation. In semi-open primaries, voters need not declare a party affiliation before entering the voting booth, but when voters identify themselves to election officials, they must request a party's specific ballot. A run-off primary is one in which the ballot is not restricted to one party, and the top two candidates advance to the general election regardless of party affiliation—but a second round is needed if no candidate attains a majority in the first round. A mixed system was used in West Virginia. The parties were allowed to determine whether or not the primaries would be open to independents. Republican primaries were open, while the Democratic Party was closed. In 2007, however, the Democratic Party voted to open its primary to unaffiliated voters.

States that use a closed primary are Arizona, Connecticut, Delaware, Florida, Kentucky, Maryland, New Mexico (Democratic Party), New York, Oklahoma, Oregon, Pennsylvania, South Dakota, and West Virginia. The semi-closed primary is used in Massachusetts. States that use the open primary are Arkansas, California, Georgia, Hawaii, Idaho, Indiana, Michigan, Mississippi, Missouri, Montana, New Jersey, South Carolina, Tennessee, Vermont, Virginia, and Washington. The semi-open primary is used in Illinois, New Hampshire, and North Carolina (http://www.diffen.com/differences/Caucuses_vs_Primary).

The argument for using some form of a closed primary system is that the political parties are private organizations that are choosing not only their candidates for national office but also their party's leader and should therefore be closed to registered party members only. The argument for some form of the open primary system is that these elections are elections run by and paid for by the state and are therefore public elections that

should be open to all voters—including independent or unaffiliated voters.

Similarly, there is controversy as to whether or not the primary should be binding or simply a preferential poll. Those who view the parties as private organizations prefer that the primary results be binding on the delegates (i.e., they are bound to vote for the candidate who won their state on the first ballot of the national convention). Those who view the primary election as a public election favor the preferential option—a popular or "straw" vote that indicates the voters' preference to guide the delegates but does not bind them to vote for the candidate who won the state on the first ballot. In 2016, in the Republican race, some delegates have argued that no delegate is or can be legally "bound" to a given candidate and that by the very "republican" nature of the party systems, delegates are free to vote their conscience.

### Replacing Winner-Take-All Primaries or the Electoral College

Various state governments use winner-take-all rules for their state-run primaries. The U.S. Constitutional provision establishing the Electoral College awards the number of delegates to the College complying with those winner-take-all provisions. By their very design, those rules, and indeed the Electoral College itself, are less democratic devices. They are powerful institutional barriers to third or minor parties and their candidates. If all states used proportional representation instead of winner-take-all, the delegates awarded to the Electoral College would essentially reflect the popular vote (Gregg 2001). And even some supporters of the two major political parties are troubled by the fact that a major-party candidate can win the popular vote but lose the election in the Electoral College. Indeed, this has happened twice in recent history, in 2000 and 2016; in both cases, a third-party candidate failed to win any Electoral College votes but drew enough popular

votes in some narrowly contested swing states to result in the winner of the popular vote losing in the Electoral College. In 2000, the Republican Bush-Cheney ticket won 271 electoral votes and 47.9 percent of the popular vote, while the Democrat Gore-Lieberman ticket won only 266 electoral votes but won 48.4 percent of the popular vote. Likewise, in 2016, the results were even more dramatic. The Democratic ticket of Clinton-Kaine won nearly three million more popular votes than did the Republican Trump-Pence ticket, yet lost the election. In 2016, the Republican Trump-Pence ticket won 304 electoral votes but only 46.2 percent of the popular vote, whereas the Democratic ticket of Clinton-Kaine won only 227 electoral votes but won 48.2 percent of the popular vote (www.presidency.ucsb.edu). The key swing states that tipped the Electoral College vote to Trump-Pence—Florida, Ohio, Pennsylvania, Michigan, and Wisconsin—all had the third-party tickets of the Libertarians and the Green Party polling more than enough votes in each state to account for the winning margin for Trump.

A seemingly simple solution would be to do away with the Electoral College and elect the president directly by popular vote. Proposals to do precisely that arose after the 2000 and 2016 presidential elections. But the simple solution is politically difficult. To formally amend the Constitution to eliminate the Electoral College and to elect the president by direct popular vote requires two-thirds of both Houses of Congress to pass the proposed amendment or requires two-thirds of the states to call for a convention to amend the Constitution, followed by ratification of the amendment by three-fourths of the states (Article V of the U.S. Constitution). Politically, that is an exceedingly difficult task, which is why in more than 225 years, the U.S. Constitution has only been amended only 27 times. Since 1970, the League of Women Voters has supported amending the Constitution to eliminate the Electoral College and points out that 70 percent of the American public support the idea of the direct election of the president (Special Edition,

National Popular Vote Study, *The Norman Voter*, 2009, http://www.norman.ok.lwvnet.org).

Some proponents suggest another way to change the selection of the president without formally amending the Constitution: a proposal called the national popular vote interstate compact (NPVC). This interstate compact would guarantee the presidency to whichever candidate who received the most popular votes in the entire United States by using the mechanism of the Electoral College itself to ensure that the candidate who receives the most popular votes is elected president. The NPVC would take effect when enacted in identical form by states possessing a majority of the electoral votes, that is, enough electoral votes to elect a president (270 of 538). Currently, 11 states with 165 elected delegates support the National Popular Vote bill, which would need to be enacted by states with 105 more. A bill has been passed by 34 state legislative chambers in 23 states, most recently by a bipartisan 40–16 vote in the Republican-controlled Arizona House, 28–18 in the Republican-controlled Oklahoma Senate, 57–4 vote in the Republican-controlled New York Senate, and 37–21 in the Democratic-controlled Oregon House (http://www.national popularvote.com/).

Political support for this solution hinges on the disproportionate effect of the so-called swing states, wherein 11 states determined the 2016 presidential election outcome (http://www.politico.com/story/2016/06/donald-trump-hillary-clinton-battleground-states-224025. Accessed July 5, 2016). Proponents of the Electoral College dispute and challenge what they label as several "myths" about its effects: myths about big cities and big counties, electoral fraud, small states, postelection changes of rules, the interstate compact and congressional consent, the so-called faithless electors, 15 percent presidents, regional and extremist candidates, the two-party system, and recounts and missing vote counts (Gregg 2001).

Proponents of the NPVC maintain that the states can use their exclusive and plenary power to decide the manner in

which their electoral votes are awarded and that the compact (Article 1, Section 10, Clause 3) permits states to enter into legally enforceable contractual obligations to undertake agreed joint action with other states.

## Options for Reform

State governments have the legal authority to regulate elections held within their jurisdictions. Primary elections are more democratic than are caucuses and conventions. States could, therefore, adopt primaries, as have 35 of the 50 states. To be the most democratic, they could adopt the open primary form (now used in 16 states)—thus allowing independent and unaffiliated voters to participate in primary elections (http://www .diffen.com/difference/Caucus_vs_Primary.)

The U.S. Congress can establish rules about national-level elections (for House or Senate seats, and for the presidency). It has set, for example, minimal age limits for candidates to be eligible to run (i.e., at least 35 years old to run for president). It has banned states from imposing a poll tax or a literacy test on voters to participate in national-level elections. Arguably, using an expansive interpretation of the equal protection clause of the Constitution, Congress could legally specify that primary elections be used for national-level offices. Such a law would extend the rationale of the *Reynolds v. Sims* (1964) decision to primary elections. But being legally possible is a far cry from being politically acceptable, let alone, likely. Even if Congress enacted such legislation only for states that operate the election of candidates for office, as opposed to those states that empower the political parties, as private organizations, to run those elections, that alone would establish a trend that would eventually result in almost all states adopting the national standard. Given today's deeply polarized Congress, however, such legislation would be virtually impossible to pass.

The National Council of State Legislatures (NCSL) occasionally promotes "best practices" laws, for example, standardized

approaches to certain regulatory laws. The NCSL could recommend that states use the open primary form. Such a recommendation, while not binding, would increase political pressure on the states to move in that direction. But again, making such a recommendation is politically unlikely. The open primary system is not without political consequences, of which the NCSL is well aware. The open primary system, relative to the closed primary or to the caucus system, would weaken political parties-as-organizations (Hershey 2007; Schlesinger 2011). As we have seen earlier, the primary system of elections (whether open or closed) is more costly than is the caucus system. State governments want flexibility in their power to control elections so as to react to economic conditions that impact their state budgets—for example, depressions or recessions. The open primary encourages a higher percentage of eligible voters actually turning out to vote. But that tends to have a partisan bias—favoring Democrats over Republicans and incumbents over lesser known challengers. The open primary system is biased in favor of the incumbent running for reelection over the challenger, more typically a lesser-known and thus dark horse candidate.

In 2016, California adopted a system, also used in Louisiana and Washington, that has been dubbed the "top two" open primary selection process. Any candidate could choose to run in the primary—regardless of party affiliation—and the top two candidates receiving the most votes then run against one another in the subsequent general election. The reform was advocated by two former moderate Republicans—former governor Arnold Schwarzenegger and Lieutenant Governor Abel Maldonado. They predicted the system would have several benefits: it would produce a higher turnout for no-party preference voters (NPPs); it would result in the election of more moderate candidates (like themselves) who would no longer have to rely on their party's most partisan and ideological members to win; it would produce a higher turnout overall.

In fact, however, voter turnout (of NPPs and overall) was not higher in 2016 than in previous primaries. Turnout for

elections is impacted by many factors. The 2016 primary had no initiative measures on the ballot (they would only be on the general election ballot). There were no "exciting" races at the top of the ticket, and apparent shoo-in incumbents were running for reelection. This top-two primary had intra-party and inter-party impacts. It resulted in some "upstarts" in the Democratic Party beating more establishment candidates and in several statewide office and congressional district races in which only two Democrats were on the ballot (http://www .pbs.org/newshour/rundown/jungle-primary-affected-califor nia-primary, accessed July 4, 2016). Also called the "jungle" primary, it had an impact as well on third-party candidates like the Green, Peace and Freedom, and American Independent parties, none of whose candidates survived to be on the ballot in the general election.

It is little wonder that states which use the closed primary or the caucus system are states that are one-party or one-party-leaning states. Strong parties like to control their environment; they prefer predicable results. As a result, they favor the caucus system or the closed primary systems, since those systems maximize the party's ability to control the nomination process, a central reason for being a party. Among the top (11) swing states in 2016, only Michigan, Virginia, and Wisconsin have open primaries.

Colorado, Iowa, and Nevada are caucus states. Florida, New Hampshire, North Carolina, Ohio, and Pennsylvania use the closed primary or semi-open primary (www.politico.org/blogs/ swing-states-2016-election, accessed July 4, 2016).

### Regional Primaries

One proposed solution to the problem of election complexity is to hold regional primaries. The 2016 presidential nomination elections involved two primary election events dubbed "Super Tuesday" and "Super Tuesday II." The first ever Super Tuesday was held in 1980 and involved only three states. By

1988, it had grown to nine states. In 2016, Super Tuesday (also known as "Southern Super Tuesday" and the "SEC Primary" [since many of the involved states are members of the SEC athletic conference]) was held on March 1 and involved 12 states: Alabama, Arkansas, Georgia, Massachusetts, Minnesota, Oklahoma, Tennessee, Texas, Vermont, and Virginia. In addition, the Republicans held a Republican-only primary in Alaska and the Democrats a Democratic-only primary in American Samoa. Super Tuesday II saw primaries and caucuses in Hawaii, Idaho, Michigan, and Mississippi and was held a week later, on March 8, 2016.

These elections inspired calls for a series of primaries that would each be regional: East, South, Midwest, and West. The idea is that holding regionally concentrated races would reduce the total length of time of the primary election season and save candidates of both major parties time and money by the elections being held in a geographic region. Some suggest it might help the visibility and viability of third-party candidates as well. A related proposal is to rotate when the various regions would hold their respective races—breaking the current emphasis afforded to the Iowa caucus and the New Hampshire primary and the current Southern-dominated Super Tuesday. There is considerable opposition to the idea in states that now have an advantage of being early or of being considered more important as a "bell-weather" primary. Some argue that regional primaries would help the lesser-known or non-front-runner candidates in their respective parties. But other critics of this suggested solution argue that the regional concentration of multiple states would tip the scale or front-load the campaign to whichever candidates had the edge in that particular region. There would simply be less time for a dark horse candidate to build momentum.

There are demographic and political culture arguments for a regional approach. States in a given region often share similar characteristics in the make-up of their populations. But that is not always the case—it would certainly depend on how the

region is defined and drawn up. And the concentration in regions is also more likely to make the states that have the bigger media markets become more dominant in such a regional primary. Massachusetts, New York, and New Jersey would dominate the Northeast. Florida and Georgia would dominate the South. Illinois and Michigan would dominate the Midwest. California would dominate the West Coast. And what about states that are located far from any mainland region (Hawaii and Alaska)? That also begs the question about the territories of Puerto Rico, American Samoa, and the U.S. Virgin Islands. Would the bundling of states into regional primaries make these other states or territories nearly irrelevant? Their more distant locations already render them marginal in the selection process. This solution might make them mere footnotes in the presidential nomination race.

Regional primaries, as in the very use of the primary system itself, cannot be dictated from the national level down. The states jealously guard their status of controlling elections. For this solution to be implemented, the majority of states would have to agree on the plan. And the cliché that the "devil is in the details" would certainly apply. Which states would fall into which regions? Border states could easily go one way or another. Missouri could be grouped with the South or with the Midwest. Maryland could be East Coast or Southern. One proposal deals with such issues by simply defining the region by the four standard time zones. That would mean each region would have political, cultural, economic, and demographic diversity. Each region would have rural and urban states, agricultural and industrial states, northern and southern states, and some combination of both Democratic-dominated or -leaning and Republican-dominated or -leaning states. While that simplifies the defining of a region, it also means grouping states together that do not see themselves as "like" the other states in the region. It is politically unlikely that a majority of states would agree to such a plan, would agree to opt for a primary as opposed to a caucus, or would

agree to the planned rotation of timing of primary elections among the four regions.

## The Geographical Split of the Two Major Parties and Competitive Swing States

The population of the United States is fairly evenly divided in party affiliation between the two major parties. Each of the parties has various safe states that they routinely carry and several other states that lean toward one or the other party. There are several other states that are considered "toss-up" states, where either of the major-party's candidate has a good chance of winning a statewide or national office. Finally, there are a half-dozen to a dozen true swing states that are always highly competitive between the two parties and that ultimately determine the national election results, especially for the presidency and the U.S. Senate.

The traditionally Democratic states are California, Connecticut, District of Columbia, Delaware, Hawaii, Illinois, Maine, Maryland, Massachusetts, Minnesota, New Mexico, New York, Oregon, Rhode Island, Vermont, and Washington (for a total of 186 Electoral College votes). The "leaning Democratic" states are Michigan, Nevada, New Jersey, Pennsylvania, and Wisconsin (for a total of 67 Electoral College votes).

The traditional toss-up states are Colorado, Florida, Indiana, Nebraska (1 Electoral College vote), New Hampshire, North Carolina, Ohio, and Virginia (for a total of 95 Electoral College votes).

The traditionally Republican states are Alabama, Alaska, Arkansas, Idaho, Kansas, Kentucky, Louisiana, Nebraska (4 Electoral College votes), North Dakota, Oklahoma, South Carolina, South Dakota, Tennessee, Texas, Utah, West Virginia, and Wyoming (for a total of 144 Electoral College votes). The "leaning GOP" states are Arizona, Georgia, Mississippi, Missouri, and Montana (for a total of 46 Electoral College votes).

Thus, at the start of any general election, the Democratic Party can normally count on about 250 Electoral College votes

of the 270 needed to win the White House. Republicans can count on 190 Electoral College votes. Thus, to win the presidency, the Democrats have to garner only about 20 votes from among the toss-up states, whereas the Republicans have to garner about 80 of them. In essence, the Republican Party has to "sweep the swing states."

An effect of this "electoral map" strategy is that candidates from both the major parties concentrate their campaigning in the 8 to 11 swing states. Democrats tend to campaign more in the leaning GOP states, hoping to "pick-off" one or another of the five (in 2016, Arizona seemed to be the most vulnerable). To the contrary, Republicans campaign heavily in the toss-up or swing states and have to compete as well in all six of the leaning Democratic states, hoping to win at least a few of them to insure against any losses in the truly swing states. Ohio is traditionally considered a *must-win* state for both the major parties. As a result, both parties campaign most heavily there (http://www.aol.com/article/2016/07/01/NBC-battleground-map). Trump won in 2016 by pulling off "surprise" wins in Ohio, Florida, Pennsylvania, Michigan, and Wisconsin—although by narrow margins in all of them—such that Secretary Hillary Clinton lost the Electoral College vote despite compiling in excess of 2.8 million more popular votes than did Donald Trump.

Both parties campaign only lightly in their respective safe states in order to conserve campaign resources (time, money, media ads, travel time and costs, etc.). Both parties tend essentially to ignore the states that are safe for the other party, again to conserve resources. It is typically considered a "waste" of resources to campaign very heavily in the other party's safe states.

Essentially, the electoral importance of the swing states is greatly enhanced and those states get the vast share of both party's campaigning and candidate visits, while the truly safe or largely uncontested states receive comparatively little attention in actual campaigning. A flip side of this electoral map effect

is that both parties tend to "fund-raise" most heavily in their respective safe states, except for a few states, like New York and California, which are typically prime targets for fund-raising efforts by both parties. Winning super-majorities in these safe states accounts for how a candidate wins the popular vote but may still lose the Electoral College, as happened in 2000 and in 2016.

Besides tipping the scale to the swing states in spending of campaign resources by both national major parties, their campaign messages are designed to appeal to voters in swing states, particularly toward the perceived interest or leanings of the independent voters.

### Effects of Gerrymandered Districts

State legislatures draw lines to form electoral districts; they typically do so to favor a particular major party to the detriment of the other major party and all minor-party candidates. This process serves to enhance the power and electoral advantage of incumbents. The process is named after Elbridge Gerry, governor of Massachusetts in 1810, who drew a district the shape of which reminded Boston journalists of a salamander. They put his name and the word *salamander* together and dubbed the district a "gerrymander." The name stuck and now applies to any such oddly shaped district drawn to give an ethnic, racial, religious, partisan, or similar demographic advantage to one party or candidate. It is still used in many states, particularly against (by diluting their vote) black and Hispanic voters, but the practice goes back to the founding period, as Founding Father Patrick Henry designed Virginia's electoral districts in an unsuccessful attempt to foil the election of James Madison. Today, gerrymandered congressional districts drawn after the 2010 election, which was a "wave" election bringing the Republican Party to power in a host of state legislatures, insures that Republicans will remain in power in the Congress, likely until at least 2020, unless the courts act to invalidate

district lines or a revolution by voters occurs (http://www
.coopercenter.org/publications/gerrymanderings-long-history-
virginia-will-decide-mark-end; http://bdistricting.com/about
.html, accessed June 30, 2016). In a controversial 2006 Texas
redistricting case before the Supreme Court, the justices ruled
that the redistricting was legal. The decision largely preserved
a belief in and continued practice of gerrymandering (http://
jurist.law.ptt.edu/paperchase/2006/06/supreme-court-leaves-
texas.php).

Scholars and the courts have disputed how badly demo-
graphically skewed a district must be to be considered a ger-
rymandered district. Political parties, however, believe in the
effects of gerrymandering and try to devise district lines that
will use that effect while still passing muster with the Supreme
Court or challenges in federal district courts (http://www.poli
ticsandpolicy.org/article/gerrymandering-proving-all-politics-
is-local, accessed June 30, 2016).

The opportunity to gerrymander arises out of the once-a-
decade reapportionment (to roughly achieve a "one-man,
one-vote" balance among districts) required by two Supreme
Court decisions. In *Baker v. Carr* (369 U.S. 186, 82 S. Ct.
691, 1962), the Court ruled that Tennessee's congressional
districts were unconstitutionally apportioned because the state
had failed to reapportion after the census (actually after several
censuses). The ruling requires state legislatures to redraw dis-
tricts every ten years. Then, in 1964, the Supreme Court, in
*Reynolds v. Sims* (377 U.S. 533), ruled that districts must be
close enough in population size as to ensure one man one vote.
In such redrawing, however, officeholders can dilute the oppo-
sition party's votes by cracking its voters into several districts,
thereby making it more difficult to obtain a majority in any
district, and can waste the opposition party's vote by packing
its voters into unnecessarily safe districts, thereby reducing its
ability to compete in the remaining districts.

The Voting Rights Act of 1965 added racial considerations
to political party registration into the mix. Rather than creating

districts solely on the basis of party registration, states began to manipulate the concentration of certain minorities (blacks, Hispanics, Asians), thereby changing the political landscape. The U.S. Supreme Court has ruled unconstitutional such racially biased redistricting. Gerrymandering, however, remains constitutional, and the practice continues across the nation.

In Texas, a controversy erupted in 2003 when the Republican-controlled legislature redistricted in the middle of the decade rather than in 2001. The legislators maximized the number of Republican House representatives in the state, and the districts they drew disproportionately diluted Hispanic and black votes. The Supreme Court, in 2006, ruled that the dilution of the votes of minorities to be in violation of the 1965 Voting Rights Act in only one district.

Maryland and North Carolina are tied for the honor (or perhaps the dishonor?) of being the most gerrymandered states, with an 88 out of a possible 100 average gerrymandering score. Republicans drew congressional district boundaries in 6 of the 10 most gerrymandered states, but that in part reflects the fact that after the sweeping wave election of 2010, Republicans won control of the most states. Gerrymandered districts are easier to get away with in more densely populated areas (i.e., around big cities and metro areas). According to a 2012 *Washington Post* study, the 10 most egregiously gerrymandered congressional districts were the following: North Carolina's 12th, Maryland's 3rd, Florida's 5th, Pennsylvania's 7th, North Carolina's 1st, Texas's 33rd, North Carolina's 4th, Illinois's 4th, Texas's 35th, and Louisiana's 2nd (http://washingtonpost.com/blogs/wonkblog/wp/2014/05/15/america's-most-gerrymandered-congressional-districts).

Legislators controlling a strong majority of legislative seats often draw the districts to give their opponents the smallest number of safe seats while drawing their party an overwhelmingly large number of safe districts. That 2012 analysis found that the Democrats were underrepresented by 18 seats in the

House, relative to their vote shares in the 2012 congressional elections (see web link in the preceding paragraph).

Some states have attempted to deal with gerrymandering by establishing nonpartisan special commissions to redraw district lines after every census year. Other states have given their courts the power to reapportion districts. But the practice is still used in many states and is done to give incumbents safe seats, to advantage one party versus another, or to dilute the votes of third- or minor-party candidates.

## The Parties

### The Parties versus PACs and Super-PACs

Numerous political party scholars have noted and somewhat bemoaned the apparent decline of the national-level political parties vis-à-vis the increasing number and financial and political clout of non-party organizations, such as the various PACs, super-PACs, and 501(c)(4) organizations (Bond and Fleisher 2000; Burnham et al. 2009; Cohen et al. 2001; Holbrook 2016; Mann and Ornstein 2016; Sabato and Larson 2001; Shafer 2003). Presidential candidates are far less beholden to, dependent upon, or controlled by the national committees of the respective political party organizations. The candidates and their supportive PACs and super-PACs raise more money for the presidential campaigns than do the party committees. Increasingly, the candidates themselves put together and hire professional campaign staff—pollsters, press spokesmen, media consultants, campaign finance directors and assorted "bundlers," campaign advance-staff, and so on—independent of the major-party organizations.

In the 19th century, during the eras of the second- and third-party systems, national parties-as-organizations, and the "mass party" itself, developed in no small measure to control the candidates (Gould 2008; Haas 1994, McSweeney and Zvesper 1991; Reichley 2000; Remini 1972; Wilentz 2007). Until more recent times, the party-as-organization performed

those campaign organizational tasks or supplied the candidates with party consultants to help them do so, and, for the most part the grassroots, rank-and-file faithful of the party accomplished much of the campaign legwork. Today, if a candidate has or can raise sufficient campaign funds, he or she can make all those organizational and personnel selections without needing the party's help to do so, thereby greatly reducing the power of the party. Some bemoan the resulting decline of the party, while other scholars and analysts argue that the party's relative weakness is good for democracy (Aldrich 2012; Cohen et al. 2001; Gill and Lipsmeyer 2005; Green 2002; Kirkpatrick 2007; Mann and Ornstein 2016; Sabato and Larson 2001; Smith 2006).

Super-PACs and candidate-supportive but not-directly-affiliated PACs have grown in number and influence especially since the *Citizens United* decision, because they can provide anonymity to their donors that the Republican National Committee, Democratic National Committee, or other official party organizations cannot. They have less to no limits on the amount a contributor may donate as compared to the official party organizations.

## Strengthening the Democratic National Committee and the Republican National Committee

If the problem is that the parties are too weak, an obvious and simple solution is to strengthen their respective national committees. That, however, is much easier said than done. As we have seen, campaign finance laws and court decisions like *Citizens United* have resulted in PACs, super-PACs, and the various 501(c)(4) organizations being able to raise far more money for campaigns than can the Democratic National Committee and the Republican National Committee. If candidates are less dependent on the national committees of their respective parties for major funding, they are less responsive to those national committees.

As the two major parties shift increasingly toward their base, and as an ideological perspective motivates the party's rank-and-file voters at the grassroots level, that level of the party becomes more important than the party's national committees. The 2016 Republican Party presidential nomination race demonstrated that 2016 was a year of the outsider. National committees are the very embodiment of the establishment. In 2016, the party-in-the-electorate had more influence than the party-as-organization.

Yet another factor in the weakness of the national committee is that the position of chair of the national committee is selected by the presidential nominee. The party that subsequently loses the presidential general election race, then, tends to have a weaker chairperson. That party is then "led" by various politicians—for example, the speaker of the House, the Senate majority leader, or prominent governors vying for the next presidential race. The party chairperson cannot simply "speak" for the party.

And for the party that wins the White House, the sitting president is the titular head of the party, and again, the chairperson is no longer a leading spokesperson of the party.

There are, in short, many compelling factors that make the national committees weaker institutional elements of the political party. Institutional factors, finances, political culture, more independent presidential campaign organizations, the increasing influence of the social media, the growing number of political consultants, and a "professional" class of campaign operatives available for hire by a campaign separate from the national committees are among the variables that weaken the national committees and make any effort to "strengthen" the committees less likely and more complex and complicated. There simply is no "easy fix."

## Structural Barriers to Minority (Third) Parties

Political scientists stress that structural barriers in the American political party system work to hinder the rise and long-term

prospects of third parties (Cox 1997; Gillespie 1993; Gold 1995; Lowi and Romance 1998; Neto and Cox 1997; Rosenstone et al. 1996; Winger 1997). One such barrier is the single-member district system of legislative body elections used throughout most local, state, and national elections: "The single-member district plurality system not only explains two-party dominance, it also ensures short lives for third parties that do appear . . . because to survive, political parties must offer tangible benefit to their supporters" (Rosenstone et al. 1996: 15). Other scholars have studied many democracies and found that institutional barriers explain 61 percent of the variation in the effective number of parties among democracies (Neto and Cox 1997: 164).

The winner-take-all representation, used in most American elections, as opposed to proportional representation, severely undercuts the long-term electoral prospects of third parties (Gillespie 1993; Lowi and Romance 1998; Winger 1997). Minor-party candidates cannot win often enough to sustain their careers and show their supporters that voting for them makes sense, that it is not a wasted vote, and that it will result in tangible benefits (Cox 1997).

State governments, which control election laws, rules, and procedures, typically set thresholds to ballot access and to debate-stage access in presidential elections. They set thresholds high enough (e.g., 15 percent support in major polls) to limit the number of candidates on the stage by sorting out those with "too little support" or the "frivolous" candidates. Such procedural rules effectively limit whether third-party candidates for the presidency can realistically compete. Rarely have third-party candidates for president been able to be on the ballot in all 50 states; this structural barrier has often limited such candidates to less than 10 percent of the popular vote (Gold 1995: 753).

Because structural barriers result in low electoral results and few wins, they influence the ability of third-party candidates to raise campaign funds. Except for ideologically committed

supporters of ideologically based third parties, donors able to and prepared to make substantial donations want to back "winners" and tend not to contribute to third-party candidates. Without substantial funds being available, candidates for state-wide or national offices simply lack sufficient money to mount credible races. The third-party candidate for president who was able to garner the most popular votes in recent years, Ross Perot, was a multimillionaire who largely self-funded his campaign (Gold 1995; Gillespie 1993).

Gillespie (1993) studied third parties from 1820 to 1990 and shows how structural constraints and the resulting lack of electoral success of third parties contribute significantly to cultural constraints. The American political culture itself sustains and even enhances the long-term advantages of the major parties in the two-party system (Gillespie 1993; Lowi and Romance 1998; Winger 1997). The bandwagon effect of the American political culture enhances the impact of the "everyone wants to back a winner" aspect of American elections and the horse race nature of media coverage of campaigns, which further depresses support for third-party candidates. Founding Father James Madison argued that all societies tend to divide into two groups (Madison 1981: 189; see also Reichley 1981 and Hofstadter 1969).

## Changing the American Political Culture

The two-party system is favored by the current political culture. A multiparty system is considered "European" and linked to a parliamentary system rather than to our presidential/Congressional system. In one sense, changing the political culture would require no legislative action by the Congress, or indeed, by the two major parties' national committees (Fiorina et al. 2010). It probably would require many state legislatures enacting laws that shifted from a winner-take-all system to a proportional representation system. That would be politically difficult, but is legally possible for them to do.

Political culture changes slowly and is influenced by many factors, so one would assess this "solution" as unlikely and

politically improbable; civic nationalism can be shaped but that the process is long, slow, and very complex (Aldrich 1995; Barone 2014; Campbell 1980; Cox 1997; Galderisi et al. 1996; Gerring 2001; Glynn et al. 2004; Green et al. 2004; Haas 1994; Holt 1984; Lowi and Romance 1998; Manza and Brooks 1999; McSweeney and Zvesper 1991; Pickus 2005; Shafer and Badger 2001; Zolberg 2006).

## The Media

### The Media Focus on the Horse Race versus the Issues and Aspects of Electoral Campaigns

The media, whether print or electronic, are businesses. They emphasize what "sells" their product, which is information. Therefore, they stress the "horse race" aspect of elections— who's ahead, who's behind, and how it changes week to week— particularly in presidential elections. They use a so-called tracking poll, one that is repeated periodically with the same group of people to check and measures changes of opinion or knowledge overt time. In presidential races, major polling organizations take tracking polls weekly or biweekly, and the media reports the results emphasizing who is ahead, who is behind, or who's poll numbers are rising or falling (Bardes and Oldendick 2016; Berensky 2015; Burnham et al. 2009; Burstein 2014; Clawson and Zoe 2016; Erikson and Tedin 2014; Manza and Cook 2002).

A related type is the benchmark poll. It is used by candidates, often as the first poll taken in a campaign, before candidates formally announce that they are running for office. It is usually a short and simple survey—showing the candidates what type of voters are likely to support them, who they are likely to lose to, and everyone in between. This lets the campaign know which voters are persuadable and on whom they should spend limited resources to be most effective. It gives candidates an idea of what messages, ideas, or slogans might be the strongest motivator with the electorate. Those points become part of their stump speech. All polls are subject to sampling error, often expressed

as a margin of error. Polls have built-in biases: for example, response, question wording, coverage, and timing biases.

A result of the media's emphasis on the horse race nature of campaigns is that it affects the electorate (potential voters surging to the candidate who is "winning"). Issues are under-covered. How well a candidate is doing in tracking polls influences who is willing to donate to the campaign. The amount of money a candidate raises early in the race can be viewed as sort of a "financial primary." It may discourage other potential candidates from even entering the race. Sometimes, the polls dominate the candidate's message: Donald Trump's 2016 primary campaign had a stump speech that consisted almost entirely on how well he was doing in the polls. Polls may induce a candidate to stay in the race long after it is mathematically unlikely to win a majority of pledged delegates. In the 2016 Democratic primary race, Senator Bernie Sanders argued that his stronger showing in polls measuring his relative strength in a hypothetical general election match up with Donald Trump compared to Secretary Hillary Clinton's was a reason for the party to select him rather than her. He argued that "super-delegates" should "flip" and change their declared support from Clinton to him. It became his self-declared "viable path" to the nomination.

Even intra-party presidential debates can become dominated by the horse race nature of the campaign. Critical issues and the candidates' stands on those issues are ignored or downplayed as limited time is eaten up with how well or not candidates are doing in the polls. Rules for access by candidates to the presidential debate stage, evident in the 2016 Republican primary, are sometimes determined by how the various candidates are doing in a series of major tracking polls.

## Congressional Law to Regulate Media and Poll Use in Elections

Congressional legislation regulating campaign air time illustrates how difficult and complex any solution can be when

national laws attempt to regulate the media and poll use in elections. Such laws run afoul of the First Amendment's freedom of speech doctrine. The closest thing to such an approach, the media's "golden rule" so to speak, was a provision of the 1934 Communications Act (47 U.S.C. 151), section 357 of which "requires radio and television stations and cable systems which originate their own program to treat legally qualified political candidates equally when it comes to selling or giving away air time." This provision is known as the "equal opportunity" or "fairness doctrine" (http://uspolitics .about.com/od/electionissues/a/fcc_equal_time.htm; see also Paglin 1989).

The Federal Communications Commission (FCC) was established by this law, and it issued rules regulating licensed radio, television, and cable broadcasting stations. It defined *legally qualified* to mean a person who is a *declared* candidate running for office. In December 1967, President Lyndon Johnson (D-TX) conducted an hour-long interview with all three major networks. Democrat Eugene McCarthy demanded equal time, but the networks rejected his appeal because President Johnson had not yet declared he would run for reelection (and, indeed, he subsequently declared he would *not* run for reelection). In 2016, Jeb Bush delayed his formal announcement that he was a candidate for the Republican Party presidential nomination in order to avoid similar FEC fund-raising regulations.

In 1959, Congress amended the 1934 Act after the FCC ruled that Chicago broadcasters had to give "equal time" to a mayoral candidate named Lar Daley, who was then running against the incumbent mayor, Richard Daley. Congress established four exemptions to the equal time rule: (1) regularly scheduled newscasts, (2) news interview shows, (3) documentaries (except if the documentary is about the candidate), and (4) on-the-spot news events (http://uspolitics.about.com/ od/CampaignsElections/tp/, accessed July 5, 2016). In 1960, when the first-ever presidential debates were broadcast, the

FCC ruled such debates as on-the-spot news and thus did not have to include all other candidates (minor- or third-party candidates, for example). The League of Women Voters, which at that time was a sponsor of presidential debates, criticized the rule. The Congress subsequently established a bipartisan Presidential Debate Commission and the League of Women Voters was no longer sponsoring presidential debates.

Another complication concerns a definition: what is a news interview program or a regularly scheduled newscast? The FCC's 2000 election guide, and subsequent guides, expanded the category of exempt programs to include reruns of shows they hosted, like *The Phil Donahue Show*, *Good Morning America*, *Howard Stern Show*, *Jerry Springer Show*, and *Politically Incorrect*. Broadcasters faced a quirk when Ronald Reagan ran for president. Did it mean if they were showing an old movie in which Ronald Reagan starred that they had to give equal air time to his Democratic opponent? The FCC ruled they need not. Had Fred Thompson achieved his party's nomination, that same exemption would have applied to reruns of the popular TV show *Law and Order*. When Howard Stern interviewed Arnold Schwarzenegger, then running for governor of California, he did not have to interview the other *134 candidates* for governor!

A television or radio station cannot censor a campaign ad, but the broadcaster is not required to give free air time to a candidate unless free air time is given to a different candidate. Since 1971, broadcast stations have been required to make "reasonable" time available to candidates for federal office and must run those ads at the same rate offered a "most favored" advertiser. But what constitutes "reasonable" time? And when (in what time slot) must such "free air time" ads be run?

The complexity of such regulations of the air waves illustrates how difficult enactment of such a federal law can be. And as electronic "casting" evolves, from broadcasting to narrowcasting (e.g., social media blogs, tweets, Facebook), such

regulation and the equal time or fairness doctrine become ever more complex and difficult to regulate.

### Changing How the Media Covers Elections

The media chooses to cover elections as if they were horse races because like a horse race, that is exciting and it draws more readers or gains a television network more viewers, which in turn means newspapers can charge more from their advertisers and television networks can charge higher rates for their air time. It is also easier for the journalists to write the story—polling data gives them the gist of their article or televised segment. It takes more work to cover the stand on the issues taken by politicians, and complex issues are more difficult to make understandable to the readers or viewers and, frankly, are often considered "boring" to the general public.

But the media (newspapers, magazines, radio, and television) are, in part, licensed for performing a public service—of informing the public so we have an informed electorate. The media could choose to cover issues more carefully and thoroughly. They can "fact check" the claims made in political ads. They could do analyses of various proposed "plans" put forth by politicians as to their likely impact, how realistically one could expect such plans to be adopted and passed into law. How realistic is it, for example, that if President Donald Trump could really have an "awesome wall" built? Could he realistically get Mexico to pay for it? Would a proposed policy such as a Muslim ban pass constitutional muster?

Print and electronic media are privileged to "embed" their reporters with presidential campaigns. They have access to the campaign developments that the average citizen does not. They could stress issues but tend to focus on the titillating details or the "gotcha" gaffs the candidate makes in response to questions. The electronic media focuses on a few "sound bites" from campaign events and stump speeches by the major-party

candidates and then play those sound bites repeatedly on all the media outlets.

That same development is evident in the manner in which the media covers the social media—tweets and re-tweets, for example, by major candidates. Instead of covering the content of speeches, the media over-focuses on miscues, minor mistakes in a name, or some politically incorrect statement. They seldom label an outright lie as such.

The media is not solely to blame for this trend. As consumers, citizens influence what and how the media covers politics. If readers demanded more substantive coverage of issues, the media would respond to that market demand. The media has government regulation that is supposed to insure equal time to candidates, at least in their "free" air time coverage. But in an effort to appear "equal" in their treatment, the media often fails to make the public aware that one or the other party may be the source of much more than 50 percent of some distortions.

While the public complains about the negativity of political ads, their voting behavior and political contribution behavior show that negative ads work. And so politicians, political parties, PACs, and super-PACs run more and more negative ads, and the media financially benefits from all that paid advertisement. They are businesses, after all, and taking care of their bottom line is to be expected.

The media helps form or influence political culture, but being human social organizations they are in turn influenced by the prevailing political culture. As long as citizens are obviously paying more attention to the horse race nature of electoral campaigns, the media will continue to overemphasize that aspect. Reporters are in competition with one another, as are networks and talk radio stations and blogs and other social media outlets. Reporters want the "scoop," and the gotcha question can provide one. The more sensational the item, the greater the coverage, and the more it is covered by more and more of the media. Sometimes, the very nature of "what people are talking about" comes to be considered newsworthy. Political

propaganda, rumors, and outright false "plants" are picked up, carried, and even sensationalized by the media, at the very least distorting the coverage of campaigns and electoral behavior.

The media may have the ability to change the way they cover politics, but such change is difficult and unlikely to occur given the business nature and constraints of the media and the impact on the media of the American political culture. While the media and politicians often play adversarial roles, at times they also "scratch one another's back." Politicians give media special access, but in turn use the media to plant or otherwise "spin" coverage of their campaigns.

## References

Aldrich, John. 1995. *Why Parties: The Origin and Transformation of Party Politics in America*. Chicago: University of Chicago Press.

Aldrich, John. 2012. *Why Parties? A Second Look*. Chicago: University of Chicago Press.

Alexander, Herbert E., and Rei Shiratori, eds. 1994. *Comparative Political Finance among the Democracies*. Boulder, CO: Westview Press.

Bardes, Barbara, and Robert W. Oldendick. 2016. *Public Opinion: Measuring the American Mind*. Lanham, MD: Rowman and Littlefield.

Barone, Michael. 2014. *Shaping Our Nation: How Surges in Migration Transformed America and Its Politics*. New York: Random House.

Bartle, John, and Paolo Bellucci. 2009. *Political Parties and Partisanship: Social Identity and Individual Attitudes*. New York: Routledge.

Berensky, Adam, ed. 2015. *New Directions in Public Opinion*. 2nd ed. New York: Routledge.

Bond, Jon R., and Richard Fleisher, eds. 2000. *Polarized Politics: Congress and the President in a Partisan Era*. Washington, DC: Congressional Quarterly Press.

Brinkley, Alan. 1995. *The End of Reform.* New York: Knopf.

Burnham, Walter D., et al. 2009. *Voting in American Elections.* Palo Alto, CA: Academia Press.

Burstein, Paul. 2014. *American Public Opinion, Advocacy and Policy in Congress: What the Public Wants and Gets.* Cambridge, UK: Cambridge University Press.

Campbell, Angus. 1980. *The American Voter.* Chicago: University of Chicago.

Casas Zamora, Kevin. 2005. *Paying for Democracy: Political Finance and State Funding for Parties.* Colchester, UK: ECPR Press.

Clawson, Rosalie, and Zoe M. Oxley. 2016. *Public Opinion, Democratic Ideals, Democratic Practices*, 3rd ed. Washington, DC: Congressional Quarterly Press.

Cohen, Jeffrey E., Richard Fleisher, and Paul Kanter, eds. 2001. *American Political Parties: Decline or Resurgence?* Washington, DC: Congressional Quarterly Press.

Cox, Gary W., 1997. *Making Votes Count: Political Economy of Institutions and Decisions.* Cambridge, UK: Cambridge University Press.

Dziedzic, Nancy. 2012. *Election Spending.* Detroit: Greenhaven Press.

Erikson, Robert S., and Kent L. Tedin. 2014. *American Public Opinion: Its Origins, Content, and Impact.* 9th ed. London: Pearson Press.

Fink, Leon. 1999. *Progressive Intellectuals and the Dilemmas of Democratic Commitment.* Cambridge, MA: Harvard University Press.

Fiorina, Morris P., Samuel J. Abrams, and Jeremy C. Pope. 2010. *Culture Wars: The Myth of a Polarized America.* 3rd ed. New York: Longman.

Galderisi, Peter F., Robert Hertzberg, and Peter McNamara, eds. 1996. *Divided Government: Change, Uncertainty, and*

*the Constitutional Order.* Lanham, MD: Rowman and Littlefield.

Gerring, John. 1998. *Party Ideologies in America, 1828–1996.* Cambridge, UK: Cambridge University Press.

Gerring, John. 2001. *Party Ideologies in America, 1828–1996.* Cambridge, UK: Cambridge University Press.

Gerstle, Gary. 2001. *American Crucible: Race and Nation in the Twentieth Century.* Princeton, NJ: Princeton University Press.

Gill, David, and Christine Lipsmeyer. 2005. "Soft Money and Hard Choices: Why Political Parties Might Legislate against Soft Money Donations." *Public Choice* 123 (3–4): 411–438.

Gillespie, J. David. 1993. *Politics at the Periphery: Third Parties in Two-Party America.* Columbia: University of South Carolina Press.

Glynn, Carroll, and Susan Herbst. 2004. *Public Opinion.* Boulder, CO: Westview Press.

Gold, Howard. 1995. "Third Party Voting in Presidential Elections: A Study of Perot, Anderson, and Wallace." *Political Research Quarterly* 48 (3): 753.

Gould, Lewis. 2008. *Four Hats in the Ring: The 1912 Election and the Birth of Modern American Politics.* Lawrence: University Press of Kansas.

Green, Donald, Bradley Palmquist, and Eric Schickler. 2004. *Partisan Hearts and Minds: Political Parties and Social Identities.* New Haven, CT: Yale University Press.

Green, Mark. 2002. *Selling Out: How Big Corporate Money Buys Elections, Rams through Legislation, and Betrays Our Democracy.* Washington, DC: Regan Books (HarperCollins).

Greenberg, Stanley. 1996. *Middle Class Dreams: Politics and the Power of the New American Majority.* New Haven, CT: Yale University Press.

Gregg, Gary L., ed. 2001. *Securing Democracy: Why We Have an Electoral College.* Wilmington, DE: ISI Books.

Groenendyk, Eric. 2013. *Competing Motives in the Partisan Mind.* New York: Oxford University Press.

Haas, Garland. 1994. *The Politics of Disintegration: Political Party Decay in the United States, 1856–1900.* Jefferson, NC: McFarland and Company.

Hershey, Marjorie R. 2007. *Party Politics in America.* 12th ed. London: Pearson/Longman.

Hofstadter, Richard. 1969. *The Idea of a Party System.* Berkeley: University of California.

Holbrook, Thomas. 2016. *Altered States: Changing Populations, Changing Parties and the Transformation of the American Political Landscape.* New York: Oxford University Press.

Holt, Daniel. 1984. *The Political Culture of the American Whig Party.* Chicago: University of Chicago Press.

Johnson, Haynes, and Dan Blatz. 2010. *The Battle for America 2008: The Story of an Extraordinary Election.* New York: Penguin Books.

Judis, John B., and Ruy Teixeira. 2004. *The Emerging Democratic Majority.* New York: Scribner-Simon and Schuster.

Katz, Richard S., and William Crotty, eds. 2006. *Handbook of Party Politics.* London, UK: Sage.

Keller, Morton. 2007. *America's Three Regimes: A New Political History.* Oxford: Oxford University Press.

Kirkpatrick, David. 2007. "The Use of Bundlers Raises New Risks for Campaigns." *The New York Times*, August 31, A-16.

Kleppner, Paul. 1987. *Continuity and Change in Electoral Politics, 1893–1928.* Westport, CT: Greenwood Press.

Kleppner, Paul, et al. 1983. *The Evolution of American Electoral Systems.* Westport, CT: Greenwood Press.

Klingemann, Hans-Dietz, Richard Hofferbert, and Ian Budge. 1994. *Parties, Politics, and Democracy.* Boulder, CO: Westview Press.

Lawrence, David. 1997. *The Collapse of the Democratic Presidential Majority.* Boulder, CO: Westview Press.

LeMay, Michael. 1987. *From Open Door to Dutch Door.* New York: Praeger Press.

LeMay, Michael. 2006. *Guarding the Gates.* Westport, CT: Greenwood Press.

LeMay, Michael. 2009. *The Perennial Struggle.* 3rd ed. Upper Saddle River, NJ: Prentice-Hall.

LeMay, Michael, ed. 2013. *Transforming America: Perspectives on U.S. Immigration*, Vols. 1–3. Santa Barbara, CA: ABC-CLIO.

LeMay, Michael, and Elliott Barkan, eds. 1999. *U.S. Immigration and Naturalization Laws and Issues.* Westport, CT: Greenwood Press.

Lowi, Theodore, and Joseph Romance, eds. 1998. *A Republic of Parties? Debating the Two Party System.* Lanham, MD: Rowman and Littlefield.

Madison, James. 1981. *The Mind of the Founder.* Marvin Meyers, ed. Hanover, NH: University Press of New England.

Mann, Thomas E., and Norm Ornstein. 2016. *It's Even Worse Than It ~~Looks~~ Was.* New York: Basic Books.

Manza, Jeff, and Clem Brooks. 1999. *Social Cleavages and Political Change: Voter Alignments and U.S. Party Coalitions.* New York: Oxford University Press.

Manza, Jeff, and Fey Lomax Cook. 2002. *Navigating Public Opinion: Polls, Policy, and the Future of American Democracy.* Oxford: Oxford University Press.

Mayhew, David. 2004. *Electoral Realignments: A Critique of an American Genre.* New Haven, CT: Yale University Press.

Mayhew, David. 2005. *Divided We Govern: Party Control, Law-Making, and Investigations, 1946–2002.* New Haven, CT: Yale University Press.

McSweeney, Dean, and John Zvesper. 1991. *American Political Parties.* London: Routledge.

Milkis, Sidney, and Jerome Mileur, eds. 1999. *Progressives and the New Democracy.* Amherst: University of Massachusetts Press.

Nassmacher, Karl-Heinz. 2009. *The Funding of Party Competition.* Baden-Baden: Nomos Verlag.

Neto, Octaviott, and Gary W. Cox. 1997. "Electoral Institutions, Cleavage Structures, and the Number of Parties." *American Journal of Political Science* 41 (1): 155.

Paglin, Max. 1989. *A Legislative History of the Communications Act of 1934.* New York: Oxford University Press.

Paulson, Arthur. 2007. *Electoral Realignments and the Outlook for American Democracy.* Boston: Northeastern University Press.

Pickus, Noah. 2005. *True Faith and Allegiance: Immigration and Civic Nationalism.* Princeton, NJ: Princeton University Press.

Post, Robert C. 2014. *Citizens Divided: Campaign Finance Reform and the Constitution.* Cambridge, MA: Belknap Press of Harvard University.

Reichley, A. James. 1981. *Conservatism in an Age of Change.* Washington, DC: Brookings Institution Press.

Reichley, A. James. 2000. *The Life of the Parties: A History of the American Political Parties.* Lanham, MD: Rowman and Littlefield.

Remini, Robert, ed. 1972. *The Age of Jackson.* Columbia: University of South Carolina Press.

Rosenstone, Steven J., Roy L. Behr, and Edward H. Lazarus. 1996. *Third Parties in America.* 2nd ed. Princeton, NJ: Princeton University Press.

Rosenof, Theodore. 2003. *Realignment: The Theory That Changed the Way We Think about American Politics.* Lanham, MD: Rowman and Littlefield.

Sabato, Larry. 2006. *Divided States of America: The Slash and Burn Politics of the 2004 Presidential Election.* London: Pearson/Longman.

Sabato, Larry, and Bruce Larson. 2001. *The Party's Just Begun: Shaping Political Parties for America's Future.* London: Pearson/Longman.

Salit, Jacqueline. 2012. *Independents Rising: Outsider Movements, Third Parties, and the Struggle for a Post-Partisan America.* New York: St. Martin's Press.

Samples, John. 2006. *The Fallacy of Campaign Finance Reform.* Chicago: University of Chicago Press.

Sarasohn, David. 1989. *The Party of Reform: Democrats in the Progressive Era.* Jackson: University of Mississippi Press.

Schlesinger, Arthur M., Jr. 2001. *The Party's Just Begun: Shaping Political Parties for America's Future.* London: Pearson/Longman.

Schlesinger, Arthur M., Jr., ed. 2011. *History of American Presidential Elections, 1789–2000.* New York: Chelsea House.

Shafer, Byron. 2003. *The Two Majorities and the Puzzle of Modern American Politics.* Lawrence: University Press of Kansas.

Shafer, Byron and Anthony Badger. 2001. *Contrasting Democracy: Substance and Structure in American Political History, 1775–2000.* New York: Columbia University Press.

Shafer, Byron, and Anthony J. Badger. 2001. *The Constitution in American Political Development.* New York: Cambridge University Press.

Skowronek, Stephen. 1997. *The Politics Presidents Make: Leadership from John Adams to Bill Clinton.* 2nd ed. Cambridge, MA: Belknap Press of Harvard University.

Skowronek, Stephen. 2011. *Presidential Leadership in Political Time.* 2nd ed. Lawrence: University Press of Kansas.

Smith, Bradley. 2001. *Unfree Speech: The Folly of Campaign Finance Reform.* Princeton, NJ: Princeton University Press.

Smith, Rodney. 2006. *Money, Power, and Elections: How Campaign Finance Reform Subverts American Democracy.* Baton Rouge: Louisiana State University Press.

Ueda, Reed. 1980. "Naturalization and Citizenship," in Stephen Thernstrom, ed. *Harvard Encyclopedia of American Ethnic Groups.* Cambridge, MA: Harvard University Press.

Wilentz, Sean. 2007. *Andrew Jackson: The American President's Series: The 7th President, 1829–1837.* New York: Macmillan.

Wilentz, Sean. 2016. *The Politicians and the Egalitarians: The Hidden History of American Politics.* New York: W. W. Norton.

Williams, R. Hal. 2010. *Years of Decision: American Politics in the 1880s.* New York: John Wiley and Sons.

Winger, Richard. 1997. "Institutional Obstacles to a Multiparty System," in Paul S. Herrnson and John Green, eds. *Multiparty Politics in America.* Lanham, MD: Rowman and Littlefield.

Zolberg, Aristide. 2006. *A Nation by Design: Immigration Policy and the Fashioning of America.* Cambridge, MA: Harvard University Press.

## Introduction

*This chapter presents 10 original essays on the topic of American political parties. It includes essays by established scholars of the topic, by scholars just beginning their professional careers, and by activists involved in political party activity—some "boots on the ground" activists who make up the rank-and-file party members at the grassroots, for the two major parties, a third party, or a non-partisan political group. The essays collectively provide insights and a perspective beyond and different from the expertise of the author.*

## Why I Am a Democratic Activist
### *Ryan Macoubrie*

In the first TV interview I ever gave, I was identified—in the chyron across the bottom of the screen—as "Ryan Macoubrie, Democratic activist." I'd never been called an activist before, and it was somewhat of a shock to see myself called one then, because in my mind I was a *volunteer*, not an *activist*. But I embrace the title now. I am a Democratic activist.

---

Thousands of protestors march in the "Free the People Immigration March" to protest President Trump and his administration's immigration policy to enforce illegal immigration expedited removals, in Los Angeles, California, on February 18, 2017. Protestors called for an end to ICE raids and deportations and supporting sanctuary for undocumented immigrants. (AP Photo/Ringo H.W. Chiu)

And let's examine those two points apart: Democratic and activist. First, Why am I a Democrat? Second, Why am I an activist?

I am a Democrat because I share and support the values of the Democratic Party—our time-honored basic American values, which are, in short and in no particular order, as follows:

We value reason and creativity—encouraging everyone to think for themselves.

We value equality and fairness—treating others as we would want to be treated.

We value diversity and inclusion—welcoming everyone into our community.

We value cooperation and compromise—working together to get good things done.

We value innovation and courage—daring to do new things.

We value compassion and generosity—helping people.

We value safety and security—protecting public interests.

We value responsibility and accountability—holding ourselves and each other to high moral standards.

We value knowledge and utility, freedom and opportunity, equity and empowerment, honesty and integrity, excellence and efficiency, transparency and open communication.

We value civility and kindness, humility and service, honor and respect, justice and peace.

And these values—Democratic values, basic American values—define our vision of a positive politics in a strong democracy: where everyone is informed, everyone participates, and everyone benefits.

This vision and these values support and inform the politics and policies we pursue—from investing in education to protecting and expanding voting rights, from growing broad

economic prosperity to supporting marriage equality, from updating immigration laws to protesting injustice, trusting science, and embracing change.

I am an activist, working daily to promote these Democratic values and politics, because it is incredible fun.

"Improving the world should be fun," wrote Ted Sorensen, in his memoir *Counselor*; and it is fun. Since I first started volunteering at my local Democratic Party office, just a few years ago, I've met hundreds if not thousands of impressive and interesting people; I've been interviewed on TV and invited to travel around the country; I've shaken hands with senators and celebrities, in ball rooms and living rooms; and I've even gone undercover to spy on Republican candidates running for president, for vice president, for Senate, and for other offices, to record them and report back. Politicking is very, very fun.

And besides being fun, being an activist in local politics has also been quite enlightening.

"You learn by living," wrote Eleanor Roosevelt, in her book of that title; and, by living it, I've learned more about party politics (the significant differences between Democrats and Republicans, and Independents, and Libertarians, et al.), more about our American political process (caucuses and primaries, delegates and conventions, nominations and withdrawals, election laws and campaign finance requirements, ad infinitum), and more about the nuts and bolts of democracy in our republic (how governments work and laws are made, etc.) than I could ever learn in school or from books alone.

And everything I've learned teaches me how vitally important it is for people to actively participate at all levels of politics—especially local politics.

As Richard Nixon wrote, in his book *The Challenges We Face*,

The word politics causes some people lots of trouble. Let us be very clear—politics is not a dirty word. It should, in fact, be the part-time job of every American. Without citizen participation in politics, self-government inevitably

degenerates into anarchy or dictatorship. Actually, bad politics and bad government are caused by good citizens who do not bother to take an active interest by voting and working in the political party of their choice.

The businessman, the student, the American in every walk of life should choose the party that comes closest to his political beliefs and ideas, roll up his sleeves, and get to work. He should make his voice heard in that party.

Political parties, like all democracies, require informed and engaged members. Everyone can participate, and everyone should. So register to vote, affiliate with a party, attend the meetings, express your opinions, contribute your talents, and vote. It's easy.

From my perspective and experience, political activism is important, is educational and enlightening, and—if you stick with it—is very fun. And you do have to stick with it, keep showing up, because when you first start volunteering in local politics it's often very boring.

Most volunteers who show up in party offices to be helpful are put to menial tasks—answering the office phone, making phone calls for candidates, stuffing letters into envelopes, licking stamps, etc. Most people get frustrated with such work, because it's not what they thought they were signing up for. So they leave, and they never come back. Everyone suffers from the loss—for the party has lost a helper, and the volunteer is disillusioned.

But if you stick with it, good things happen.

Consider my story: I volunteered in our office, as a writer, and I was asked to write a fund-raising letter for the party. I did and helped print the letter, fold it, stuff it into envelopes, write on the addresses, lick the stamps, and mail them all. And while waiting for responses and funds to come in, I kept showing up at the office and at public events, answering phone calls

and doing grunt work. When the letter finally raised several thousand dollars for the Democrats, I was then given better work to do.

And I kept doing that work, too; and, in the process, I became a Democratic activist—committed to the cause. Now I write speeches for candidates running for public office, plus I meet famous people and get interviewed on TV.

And you can, too. And you should.

## Bibliography

Nixon, Richard. 1960. *The Challenges We Face*. New York: McGraw-Hill.

Roosevelt, Eleanor. 1960. *You Learn by Living: Eleven Keys for a More Fulfilling Life*. New York: Harper.

Sorensen, Ted. 2008. *Counselor: A Life at the Edge of History*. New York: Harper.

*Ryan Macoubrie is 1st Vice Chair, El Paso County Democratic Party.*

## Why I Became a Republican Party Activist
*Charles "Chuck" Larson*

I was born in 1949 into a farm family and community in Benson, Minnesota, which had a long history of voting Democratic, especially in presidential elections. During my pre-teens, I often heard stories about how Franklin D. Roosevelt had saved the country after Republican Party policies had nearly ruined it.

At age 14, my parents moved our family to Colorado Springs. This move generated considerable culture shock because we were now living in a middle-class suburban community with a strong military presence, with several military installations in the area: the army's Fort Carson and the Peterson and Shriever air force

bases. After graduating high school and attending a year of college, I joined the U.S. Navy. In the summer of 1971, while home on leave and preparing to deploy to Vietnam, I was asked by a friend of my father if I would register to vote and support him in his bid to win election as a county commissioner. To do so, I would have to register as a Republican in order to vote in the closed primary election. I did so the next day and signed up for an absentee ballot as the election would occur while I was deployed. My father was none too happy about my decision to register as a Republican but agreed as long as I changed my party affiliation to Democrat after the general election.

At age 24, another off-year election was scheduled in 1974, when I was being discharged from the Navy. At that time, I was somewhat unsure as to which political party I felt more comfortable about affiliating with, so I began some research, including talking to several local elected officials. I found out that most people willing to run or already elected to public office had the best interests of their constituents in mind. I found that they differed primarily in how they would go about addressing problems or ideas and that those ideas varied by their party affiliation.

The difference is not as great today as it was in the early 1970s, but it remains as an important ideological or philosophical difference today. A major difference, for example, is on the respective party's stances on states' rights. Most Republicans believe that we should be governed in public policy primarily set by the closest government entity or level: school district, city, county, and state government and then by the federal level of government. Democrats are much more apt to govern by laws from a central government, using rules and regulations to attempt to promote equality for everyone. Living in a sparsely populated state far from the east coast and Washington, D.C., it was quite apparent to me that we had different needs than many other people residing in the United States. I felt we needed stronger city, county, and state officials who would have a better understanding of our local needs and rights. I have

remained a registered and active Republican ever since I first registered to vote at the age of 22.

### How I Became a Party Activist

When I was in my early 30s, I had bought out the family business and was the father of two sons while working my way into community leadership with the local Republican Party organization and with a local Lions Club. Our local school board had hired a new superintendent. This person was from New York State and immediately began trying to change schools and the school system's policies to approach things more like the way they did in New York State. This new approach caused considerable problems, and the issue came to a head when the board, at the direction of the superintendent, decided to fire an elementary school principal. This principal had been in the area ever since the district had been founded more than 30 years before. The firing prompted a public meeting with thousands of local residents attending in support of the principal. After the meeting, it was obvious that the school board was backing the superintendent. I was asked to attend a citizens' meeting on what we should do next and two days later found myself as the cochairman of a recall committee. The experience became a very eye-opening one into the complexities of local politics. I started to realize that if you were willing to put yourself out into the public arena, and if you were willing to work hard on an issue, you could have great impact on what was happening in your local community.

It amazed me to find how little the average person knew about or was willing to learn about local political issues. Such people were willing to talk to me for a minute or two and to sign the petition to recall their school board members. I was not feeling good about the apparent results, but we were getting the necessary number of signatures ahead of the required time for the recall petition. It was flattering to have the local television stations interviewing me for the nightly news segment. When a member of the superintendent's office, a person

whom I respected, took me to lunch, he asked me to hold the petitions for as long as I could; I agreed to do so. Within a couple of weeks, the school board announced that it had fired the superintendent it had hired from New York and replaced him with a local-born assistant superintendent. We never submitted our petitions and left the school board intact. But the lessons I learned about local politics during that short time period have affected me and my political thinking even to this very day.

I have served as a precinct leader and a campaign manager and have put in many miles walking door to door canvassing for candidates and putting up yard signs. I have organized various fund-raisers, given nominating speeches, and traveled many miles for candidates. I have been active for 36 years but until the last 8 to 10 years would not have considered myself an activist as I still do not attend rallies or stand on street corners screaming. I think of my role as more to educate and help others who are now struggling with the question I had many years ago: which party or candidate best represents the way I feel about my community and country.

*Chuck Larson is a retired financial advisor residing in Colorado Springs.*

## Donald Trump's Proposed Immigration Policies
*John Vile*

Issues of immigration have surfaced throughout U.S. history. During the undeclared war with France in the 1790s, Federalists adopted the Alien Acts, which allowed the president to deport "dangerous" aliens and lengthened the time required for immigrants (who typically sided with rival Democratic-Republicans) to become citizens. They also adopted the Sedition Act, which made it a crime to criticize the president.

During the 1850s, as the Whig Party disintegrated and the Democrat Party split, the American Party, or Know Nothing Party, which opposed Roman Catholic immigrants, advocated

restrictive immigration laws. In a letter to Joshua F. Speed, dated August 24, 1855, Abraham Lincoln unequivocally repudiated the party. Lincoln asked, "How can anyone who abhors the oppression of negroes, be in favor of degrading classes of white people?" He opined that if Know Nothings had their way, the Declaration of Independence would read "All men are created equal, except negroes, and foreigners, and Catholics."

Although limiting citizenship to free whites, for the most part, both major parties supported relatively liberal immigration policies until the end of Reconstruction, the disappearance of the American frontier (which immigrants had done so much to settle), and the transition to an industrial economy. Increasing fears that Chinese immigrants who worked long hours and could seemingly subsist on much less than white citizens might eventually outnumber them, depress their wages, and take away their jobs led to Chinese exclusion laws. In time, fears of assassination, anarchism, and communism, which were tied to foreign influences, led to further restrictions on immigration as well as Sedition Acts that resembled those of the Federalist era. In addition to seeking to exclude the mentally ill and the physically infirm, immigration laws sought to restrict individuals with anarchist or communist ideologies committed to the destruction of governments.

Although the United States has had moderate governments to its north and south, economic problems, the presence of gangs, and drug violence in Mexico and other Latin American countries have led to a fairly steady stream of immigrants into the United States, especially in southwestern states that were once part of Mexico. Often encouraged by those who seek to employ them, especially in seasonal agricultural jobs, many immigrants bypass the paperwork necessary to secure the relatively limited number of visas available to individuals from this region. Many bring families and bear children in the United States who, under the provision of Section One of the Fourteenth Amendment, become U.S. citizens upon their births. As middle- and lower-class wages in the United States

have stagnated, the presence of such undocumented, or illegal, aliens generated increased resentment. Court decisions require that immigrant children, who may not be fluent in English, be educated and have ruled that parents may not only compete for jobs with U.S. citizens but qualify for other publicly provided social services. Stories of immigrants involved in car accidents and criminal activities stir especially violent emotions.

Rising politicians, like leaders of third parties, seek to identify issues that more experienced candidates and established parties have missed or underestimated. On June 16, 2015, in announcing his quest for the Republican presidential nomination from his New York Trump Tower, Donald J. Trump portrayed the United States as "a dumping ground for everybody else's problems" and the Mexican government as an accomplice to U.S. immigration woes. Threatening to deport all illegal aliens and to build a big wall at Mexico's expense, Trump charged that Mexicans were bringing drugs and crime into the country. After observing that "they're rapists," he added, "and some, I assume, are good people." Although his characterization hardly endeared him to most Americans of Hispanic descent, Trump's campaign gained traction, especially among white male blue-collar voters who more traditionally had voted with the Democrat Party, whose leader was seeking to lift the threat of deportation over law-abiding individuals who had been brought to the United States as children and were seeking higher education.

As concern about international terrorism rose, fueled by violence and civil war in Iraq, Afghanistan, and Syria and attacks by radicalized Muslims in Belgium, Paris, and San Bernardino, California, Trump further criticized President Barack Obama for failing to identify "radical Islam" as the existential threat. On December 7, 2015, Trump announced that "Donald J. Trump is calling for a total and complete shutdown of Muslims entering the United States until our country's representatives can figure out what [the hell] is going on." Faced with rising journalistic criticism that such a ban would violate the First

Amendment's protection for the free exercise of religion and concepts of equal protection and due process, Trump moderated his position in June 2016, indicating that he instead advocated banning immigrants from all terrorist countries, many of which are predominately Muslim.

The Constitution vests the power of naturalization and of control over foreign commerce in Congress, which has adopted legislation throughout U.S. history regulating immigration. Early legislation limited citizenship to free whites. At the end of the 19th and the beginning of the 20th centuries, courts accepted congressional bans preventing immigration and naturalization and upholding other restrictions on entire races (although recognizing the rights of natural-born U.S. citizens of such races). Not only has Congress revised such laws, but it also would likely fall afoul of Supreme Court decisions that emphasize equal protection and due process and subject all fundamental rights like religion and suspect categories like racial classifications to heightened judicial scrutiny.

Given the high deference that American courts usually accord both to Congress and to the president when it comes to matters involving immigration, naturalization, and national security, the United States has the power to exclude immigrants known to espouse or embrace violent anti-governmental ideologies. The mere fact that a potential immigrant knowingly associated or still associates with radical groups like ISIL, the Taliban, or Boko Haram provides more than adequate grounds for excluding them from the country.

However, U.S. courts often invalidate laws that they consider to be over- or under-inclusive. If faced with a genuine case or controversy, they might use the over-inclusive standard to decide that denying refuge to an otherwise qualified mother and child seeking asylum from bloody conflicts in countries (Muslim or otherwise) known to be terrorist havens would fall afoul of this standard. Courts might further sympathize with the pleas of a native who served as a translator for U.S. forces in Afghanistan or Iraq who was subsequently facing persecution

or death from terrorist or anti-American governments there. Historically, the United States has welcomed refugees fleeing persecution in communist countries like the Soviet bloc states, Castro's Cuba, and South Vietnam.

From the viewpoint of the standard of under-inclusiveness, foreign-born citizens have committed a number of terrorist acts in the United States, which self-radicalized immigrants who arrived from other Western democracies that do not sponsor terrorism could also commit. In addition to violating fundamental principles embodied in the First and Fourteenth Amendments, basing exclusions solely or chiefly on nationality or religion is more likely to provide a façade of security than more individualized investigations.

Trump's rhetoric, however, tapped into deep, almost primal, fears of outsiders and foreigners. There are certainly circumstances where courts would accept congressional judgments that the flow of migrants from a particular nation posed such a threat as to allow for a truly temporary ban that would enable U.S. agents to secure better information or develop more pointed questions to separate immigrants who are dangerous from those who are not. Courts are far less likely to accept long-term laws and policies that use race or religion as substitutes for such investigations.

In the period leading up to World War II, the United States imposed strict immigration quotas that seriously limited the number of individuals, including Jews, who could come to the United States. Many perished in concentration camps as a consequence of their inability to find asylum. After the Japanese attack on Pearl Harbor that led to American entry into the war, the government restricted the movement of U.S. citizens of Japanese descent and isolated them in camps, even as their compatriots distinguished themselves in fighting against the Nazis. Although contemporary court decisions upheld these restrictive orders, today they are widely regarded as unconstitutional, and in 1988, Congress apologized and provided reparations to living members of this group.

The Statue of Liberty remains an enduring symbol of America's historic willingness to welcome immigrants to its shores. John Kennedy referred to the United States as a nation of immigrants. Others have called it a melting pot. The United States can rarely control the timing of refugee movements, and U.S. humanitarian responses will typically fall short of opening its borders to a massive influx of new immigrants. While U.S. leaders can provide for the nation's security knowing that it does not have room for everyone, if they remain true to its own constitutional principles, they should not categorically ban freedom-seeking peoples on the basis of race or religion.

*John R. Vile is professor of political science and dean of the University Honors College at Middle Tennessee State University.*

## Structural Barriers or Impediments to Third-Party Candidates
### *Christina Villegas*

The American political system is commonly referred to as a two-party system. This does not mean that only two parties exist and operate within the sphere of U.S. politics. Like other political systems throughout much of the West, the United States features a wide variety of national and regional third parties in addition to the two dominant parties. Unlike multiparty systems, such as those in countries like Canada, France, and Germany, however, third parties in the United States rarely have a realistic chance of victory. Consequently, for over 150 years, the Democrats and Republicans have dominated electoral politics at the state and national levels.

In spite of its prominent role in American politics, the two-party system is not mandated by the U.S. Constitution. In fact, many of the nation's leading Founders had serious misgivings about the nature of party politics. Eventually, several initial critics, such as James Madison, embraced the idea of party

politics—but none envisioned the development of a permanent two-party system.

The modern two-party system also holds a tenuous position in the current affections of the general public. A recent Gallup poll showed strong support for the emergence of a third party, with 60 percent of the American public saying a third party is needed for adequate representation (McCarthy 2015).

Based on these factors, why then has the American two-party system endured?

Political scientists John F. Bibby and L. Sandy Maisel (2003) observe that, in spite of widespread voter dissatisfaction, the inability of even the most popular third-party candidates (such as Perot, Buchanan, or Nader) "to dent the Republican-Democrat electoral juggernaut demonstrates a fundamental truth about the American party system: It is a system in which two-party dominance has been institutionalized" (22). In other words, over time, a combination of electoral procedures, laws, and practices have developed that frustrate the ambitions of third parties and reinforce the continued existence of the two-party system.

### Single-Member Districts

The first major barrier to third-party success is the single-member district system for electing legislators. This system, which is mandated by federal law and the laws of most states, differs from a proportional, multi-member district system in which multiple representatives are chosen from individual districts, or at large, based on their party's share of the overall vote. Under proportional systems, representatives of various parties are able to win legislative seats even when they do not receive a plurality of the vote. Under a single-member district system, in comparison, only the candidate who receives the most votes wins the seat from a given district. Thus, even a significant percentage of the vote is not translated into electoral victory for candidates who fail to win a plurality. This makes it difficult for non-major-party candidates to compete. As Rosentone et al. (1996) explain, "unlike a proportional representation system

where 20 percent of the votes usually yields some seats in the legislature, in a single-member-district plurality system a party can receive 20 percent of the votes in every state and yet not win a single seat" (16).

## The Electoral College

The single-member district barrier to third-party success is compounded by a second major barrier—the Electoral College method of selecting the nation's president. Under this process, electoral votes are allotted to the individual states and Washington, D.C., based on representation in Congress. The states then hold individual contests to determine how those votes will be distributed. To be elected president, a candidate must receive a majority of the total 538 electoral votes cast.

Over time, 48 states and Washington, D.C., have adopted the practice of awarding the entire slate of electoral votes to the candidate who receives the most votes. This practice, known as winner-take-all, means that candidates will receive electoral votes in a given contest only if they come in first. Thus, third-party candidates are unlikely to win any electoral votes even if they have substantial popular backing. A well-known example is that of Ross Perot, who won nearly 19 percent of the popular vote nationwide but did not take home a single electoral vote because he failed to win a plurality in any single contest.

## Ballot Access

State-imposed ballot access restrictions pose an additional electoral impediment for third parties. The U.S. Constitution gives the power to regulate the time, place, and manner of elections to the state governments. Therefore, each state has its own requirements for a candidate's name to appear on the ballot. Parties whose candidates have earned a certain percentage of the vote in previous elections are not required to comply with these restrictions. Thus, whereas Republican and Democratic candidates automatically appear on state ballots, minor-party

candidates and independents must first comply with often cumbersome ballot access laws—these frequently include filing fees and stringent mandates for signatures collected from registered voters within a specific time period. Several states not only impose onerous ballot access requirements that make it difficult for a minor-party's candidate to appear on the ballot, they also further hamper such candidates by not allowing or restricting write-in-votes (Gillespie 2012).

**Additional Barriers**

Even when third-party candidates are able to gain access to state ballots, several additional handicaps, such as the rules governing campaign finance and a lack of access to media coverage, prevent candidates from acquiring the financial resources and public exposure necessary to wage effective campaigns. Consequently, third parties often have a difficult time recruiting qualified candidates to run for office or donors willing to support them. This is compounded by the fact that voters, fearful of wasting their vote on a minor-party candidate who has little chance of electoral success, are often reluctant to abandon the two major parties.

**Conclusion**

Given the multiple institutional barriers to third-party success, it is unlikely that the two-party system, dominated by the Republicans and Democrats, will disintegrate anytime soon. Furthermore, several arguments are made in the defense of the status quo. One of the most prominent is that the two-party system helps aggregate interests and moderate the electorate, making the diverse political system in the United States more governable and stable (Bibby and Maisel 2003). Nevertheless, by drawing attention to policies and issues that the major parties might otherwise ignore and providing a forum for dissatisfied voters, third party candidates still fulfill an influential role in the nation's political discourse (Dwyre and Kolodny 1997).

## References

Bibby, John F., and L. Sandy Maisel. 2003. *Two Parties—or More? The American Party system*. 2nd ed. Cambridge, MA: Westview Press.

Dwyre, Diana, and Robin Kolodny. 1997. "Barriers to Minor Party Success and Prospects for Change," in Paul S. Herrnson and John C. Green, eds. *Multiparty Politics in America*. Lanham, MD: Rowman and Littlefield.

Gillespie, J. David. 2012. *Challengers to Duopoly: Why Third Parties Matter in American Two Party Politics*. Columbia: The University of South Carolina Press.

McCarthy, Justin. 2015. "Majority in U.S. Maintain Need for Third Major Party." Gallup, September 25. http://www .gallup.com/poll/185891/majority-maintain-need-third-major-party.aspx

Rosentone, Steven J., Roy L. Behr, and Edward H. Lazarus. 1996. *Third Parties in America*. 2nd ed. Princeton, NJ: Princeton University Press.

*Christina Villegas is an assistant professor of political science at California State University, San Bernardino.*

## Libertarians: Philosophical Activism
*Lance Haverkamp*

Most people, for a while at least, vote like their parents did, but at some point they begin to come to different decisions about a topic or two. Then you start looking around for a party that agrees with you on topic X, Y, or Z. In America, that usually means one of the two major parties, simply because they are the most familiar. As long as you never get past thinking about topics—be they abortion, guns, the environment, poverty, or whatever—you rarely progress beyond the two big parties. Most parties are comprised of people who have specific interests. Their members are either for or against certain behaviors,

and they want to use the government as a club to force the rest of the population to toe the line.

Political parties are made of smaller groups of people, with similar beliefs. Democrats are comprised of an environmental group, a legal abortion group, a welfare state group, an antigun group, a socialized health care group, and so forth.

Likewise, Republicans are comprised of a gun rights group, an anti–alternative lifestyle group, a business economics group, an abortion-is-murder group, an anti-recreational drugs group, and so forth.

### Libertarians Are Wildly Different, in Every Regard!

Overarching, guiding principles are what unite Libertarians; the individual issues are minutia. Those involved in promoting a Libertarian approach to government are not out to tell others how to behave or what to fund. Our positions on specific issues are the result of applying guiding principles to each specific topic. An oversimplification of Libertarian principles is often stated as "don't hurt people, or take their stuff." Sure, it's an oversimplification, but it's also pretty accurate. So, Libertarianism is the idea that you can do whatever you want, as long as you don't hurt people, or take their stuff.

- Want to dye your hair purple? Go ahead, just don't force me to do the same.

- Want to donate $1,000 toward termite research? Go ahead, just don't force me to do the same.

- Want to live in a commune with your three wives and two husbands? Go ahead, just don't force me to do the same.

You see, none of your decisions hurts me. None of them deprives me of my life, liberty, health, or happiness. And while some may consider your choices to be weird, wasteful, or against their personal beliefs, none of those choices actually causes anyone any harm (assuming your three wives and two husbands are all consenting adults). The "don't hurt people" principle is

called the non-aggression principle, and is about not *initiating* aggression; it has nothing to do with pacifism. It means "don't throw the first punch, but defend yourself if needed."

Now, if you pass a law requiring that "everyone dye their hair purple," you're forcing me to do something against my will, which violates the "don't hurt people" principle. Or, if you pass a law requiring "free purple hair dye for everyone," you're taking everyone's money, through forced taxation, to purchase purple hair dye, which violates the "don't take their stuff" principle. See, we answered the questions of purple hair dye by applying the principles to the issue. The exact same process works for more important questions too: crime, poverty, welfare, the police state, and so forth. Just apply the principles to the issue.

About the only area where Libertarians agree that some common funding needs to happen is "common defense." There are internal disagreements among Libertarians about which, if any, areas regarding common defense are important enough to violate the "don't take their stuff" through the taxation principle. Hardly anyone would donate money to purchase an aircraft carrier until the enemy is marching through downtown, but by then, it's too late. Tariffs on imports and outsourcing may be perfectly reasonable approaches to fund national-level common defense, without the government stealing part of your paycheck.

What about taxes to fund fire suppression? That's a common defense issue too. Ancient Rome had private fire departments. If you paid fire premiums, like insurance, they came out and helped you extinguish the fire. If you didn't have their insurance, they would offer to help—if you gave them your house. At least you could buy back anything that they were able to save from the fire. I think we all know what happened to ancient Rome: the city burned to the ground because not enough people had funded the private fire departments, and there was no backup from a larger territory. So what's the solution? Do we send in the jackbooted thugs (tax collectors) to extort fire department funding under threat of violence? No, that would

violate the "don't hurt people" principle. Oh, then we evict the people and hold a tax sale at the Sheriff's office to collect the tax money? No, that violates the "don't take their stuff" principle, but placing a tax lien on the property, to be collected with interest from the proceeds of any future sale, would not be unreasonable.

Criminal courts and prisons also fall under common defense. So does treatment for the criminally insane. But we're talking about real crime, with real victims, not victimless crimes like jaywalking, prostitution between consenting adults, or running a lemonade stand without a permit.

Some people get hung up on ideas like "Libertarians want to legalize prostitution." No, we simply recognize that no one's getting hurt, so no real crime has taken place. Again, we're talking about consenting adults—no one is being forced against his or her will. We also hear similar complaints about Libertarians "being pro-choice." The fact is most Libertarians are against abortion. That being said, there is no point in criminalizing abortion, because *no* genie can *ever* be put back in the bottle. Criminalizing abortions won't stop them; it will only create more suffering, by driving them back underground. A case can easily be argued that an abortion is the ultimate violation of the non-aggression principle, and many Libertarians would agree.

Most issues that are not common defense in nature would rely on charity for funding. Medical research, arts programs, indigent care, community food banks, and so forth would all fall into this category. But, some of those programs are necessary, you argue? Yes, they are! But does *necessary* mean *government*? Of course not; government is not charity; government is force. And forcing people to pay for things they don't support isn't charity; it's extortion.

People can choose what charities or types of organizations they support, without the backroom deal making, lobbying, and corruption that comes with government funding. We wouldn't have arguments about taxpayer funds going to Planned Parenthood or to faith-based programs, because there

would be no government funding of charities. There are already non-profit agencies who review and rate charities by their efficiency. There are already umbrella or funnel agencies who monitor and distribute funds to deserving charitable organizations. Just pick a few of these umbrella groups and set up a monthly bank draft.

We may wind up in a society where not enough money is voluntarily given to charity, but does that make it morally OK to take money from workers under threat of government force? Libertarians say "no"; extortion is still extortion, even if the voters approve it. There are middle-ground approaches for charitable funding. While it wouldn't be Libertarian, voters could pass a law to require a percentage of personal income to be given directly to tax-exempt organizations of the *donor's* choice. While it's not completely force free, it would at least keep charity private and plentiful.

Libertarian activists are philosophers; we are always looking for ways to ensure individual human rights and free individual choice, while never hurting people, nor taking their stuff. Like any group, there are differing opinions about the best policies and procedures to achieve success. What's important to remember is how differently Libertarians define that success—the freedom to do whatever you want: as long as you don't hurt people, or take their stuff.

*Lance Haverkamp is former El Paso County Chair of the Libertarian Party. He resides in El Paso County, Colorado.*

## Political Activism: The Nonpartisan Way
*Julie Ott*

What if you could influence the political process without having to affiliate with a party? What if democratic principles were more important than partisanship? Civic education and civic engagement are necessary to a working democracy, as is vigilance, but they do not have to align with a party.

As a nonpartisan political activist, I believe in good government and accountability no matter which party is in charge. Government should be inclusive and serve the common good; the ideals of representative and responsible government should be universal. Neither majority party has a lock on efficient government. There are examples of good government as well as mismanagement and hypocrisy in both of the major parties and probably in the minority parties as well. Partisanship and personal allegiances can lead to extremist views that discourage thoughtfulness, cooperation, and moderate policy. While I believe that most people going into public service have the best of intentions, I have a deep frustration with politicians who refuse to compromise with members of other parties. How can anyone expect to govern with that stance?

I have found that my interests in political activism align with the political education and action stance of the League of Women Voters (LWV). The League of Women Voters is a nonpartisan political organization encouraging informed and active participation in government. The League influences public policy through education and advocacy. The organization also serves as a political training ground.

Why a League of Women Voters?

The League of Women Voters traces its origins to the women's suffrage movement. The movement began in 1848 when Elizabeth Cady Stanton and Lucretia Mott organized the first Woman's Rights Convention in Seneca Falls, New York. Among their demands was women's suffrage. The idea was radical at the time. Over the next 72 years, women strategized, organized, marched and protested, and were beaten and went to jail as part of the struggle for their right to vote. The history of suffrage is an illuminating read. It is worth noting that both major parties, Republicans and Democrats, were resistant to women's suffrage.

In March 1919, Carrie Chapman Catt, president of the National American Woman Suffrage Association, anticipated the end of the suffrage struggle and recognized that women

were not experienced in citizenship. Catt suggested founding a nonpartisan League of Women Voters to foster education in citizenship, government, and politics and to support legislation that would improve the lives of women. Founded February 14, 1920, the national League of Women Voters predates final certification of the Nineteenth Amendment granting women the right to vote on August 26, 1920. Within a year of its founding, LWV was organized in each of the 48 states.

The League's mission was to educate women for their new roles as voters. Citizenship schools, forums, and discussion of ideas and legislation offered women a place to exchange ideas and work for things of common interest.

The new LWV trained its members to be citizen advocates, adopting an advocacy platform in its first year. Members lobbied both political parties with the platform in the presidential election year of 1920. These original positions promoted literacy and citizenship instruction, public health, child welfare, and an end to child labor in the United States. They also demanded more equal rights for women: from independent citizenship for married women to equal pay and freedom from discrimination in the workplace.

Since its founding, the League has changed its name to League of Women Voters of the United States and changed its model to be a more decentralized organization and allowed men to join. It is still nonpartisan, and the overall mission has remained the same: to educate voters and to encourage their active participation in government. The LWV continues to have advocacy positions in the realms of social policy, environment, and government. They adapted models used for suffrage to lobby on matters important to them. Today, League members are still at it, locally, in state houses, and nationally.

Before taking an advocacy position, members study an issue, educating themselves to better understand the issue and discussing the best position a League might take to affect good government. Members reach a decision by consensus. From

the resulting position, a League can advocate and take action. League positions can be adopted and advocated locally or on the state or national level. This study process can be slow, but the thoughtful, deliberate approach allows members to contemplate the possibilities of policy and its effects. The attitude of keeping an open mind while considering one's values instead of blind allegiance to a party can only benefit the common good.

Aside from lobbying for its causes, local Leagues often have Observer Corps. Attending government meetings is a useful way of understanding how government works and ensuring that government operates in an open and transparent manner. What is expedient for politicians is not always best for the common good.

Can League members be active in a political party? Absolutely! Carrie Chapman Catt recognized that political parties held the power to get things done. She urged League members to "be a partisan, but be an honest and an independent one. Important and compelling as is the power of the party, the power of principle is even greater" (Stuhler 2003). Maud Wood Park, first president of the LWV, addressing early misperceptions about the League, noted that LWV members were urged to enroll in the political party of their choice and help secure support for League measures within the party. She also noted that women could take time to learn all sides of public questions as a basis for choosing party affiliation. This has not changed. Members can come together on issues of mutual concern and work within their political party to affect change.

From its beginnings, the LWV has shared "disinterested unpartisan information on parties, candidates and measures" (Stuhler 2003). The tradition continues. Educating oneself on candidates and issues beyond the hyped-up partisanship that exists in our modern political world is a must if we want to cast an informed vote. In politics, money can influence opinion, no candidate or issue is exempt from "spin," and fake news

sources and stories abound. Responsible voters must seek out facts and find trusted news sources. The LWV continues to serve as a dependable resource for political information. Many local Leagues publish ballot issue information that includes the pros and cons of proposed measures. Some Leagues offer ballot issue and candidate forums or sponsor visits to legislators. In recent years, the national LWV, along with state and local Leagues, have collaborated on the publication of VOTE411 .org, an online voters' guide providing candidate surveys as well as the pros and cons of ballot measures.

The League of Women Voters is also known for its voter registration efforts and voter protection. Voter registration was once seen as a responsibility of the parties, but LWV has been instrumental in encouraging registration regardless of affiliation.

My first experience working with the League of Women Voters was proofreading the answers to a candidate survey— and leaving in the errors made by the candidates. Candidates are responsible for their own answers; it was not up to us to correct them. Years later, I am now the chairperson of my local League's Voter Service Team. The team organizes an online version of these candidate surveys, and candidates' answers are still given verbatim. Our team is a community resource; we register voters, educate voters on ballot questions, and monitor and advocate legal and practical access to the ballot.

I have chosen to remain unaffiliated, except for the occasional primary election, from the political parties because I believe that remaining nonpartisan allows me to pursue both parties' candidates without favoritism while at the same time advocating for inclusive and representative government. I want the facts, the truth, and understanding of all sides of a public issue before making a decision. Finally, I want to encourage my fellow Americans to educate themselves about the political process and actively engage in their government regardless of which party they choose for themselves.

## References

Jeydel, Alana. 2004. *Political Women: The Women's Movement, Political Institutions, the Battle for Women's Suffrage and the ERA*. Lanham, MD: Routledge.

Stuhler, Barbara. 2003. *For the Public Record: A Documentary History of the League of Women Voters*. St. Paul, MN: Pogo Press.

Young, Louise M. 1989. *In the Public Interest: The League of Women Voters 1920–1970*. Westport, CT: Praeger Press.

*Julie Ott is an activist and admin team member with League of Women Voters of the Pikes Peak Region. She has served as newsletter editor for her local League and for the League of Women Voters of Colorado. She is the current chair of the Voter Service Team.*

## Party Identification and Core Political Principles
### Paul Goren

In the minds of American voters, party identification and core political principles function as central predispositions that guide public opinion. Party identification can be defined as a psychological attachment to the Democratic Party or the Republican Party. Partisan attachments develop during adolescence, grow stronger as a person ages, and influence political judgments and voting choices (Campbell et al. 1960). Core political principles are strong beliefs about society and public affairs, the role of government, and the major issues of the day. Core principles also shape a wide range of political judgments and electoral choices.

Does party identification shape core principles, or do these principles shape party identification? If party identification shapes core beliefs, this would suggest that what people believe about key issues is driven by conformity pressures to toe the party line. This is an unflattering portrait of the American voter. Conversely, if core beliefs drive party loyalties, this would

imply that people choose parties for issue-based and principle-based reasons. This represents a more flattering portrait of the voter.

Research supports both hypotheses. Classic and contemporary works on party identification maintain that partisans adopt the party positions on political matters with little or no thought. As Campbell et al. (1960) put it in their seminal book *The American Voter*, party identification "raises a perceptual screen through which the individual tends to see what is favorable to his partisan orientation" (133). This is called partisan bias. To take an example, even though inflation declined between 1981 and 1988 when Republican Ronald Reagan served as president, a majority of strong Democrats believed that inflation had gotten worse (Bartels 2002). There is considerable evidence that partisanship shapes individuals' core beliefs about government and society as well as their positions on significant issues (Lavine et al. 2012).

This classic model of party identification has been challenged in a number of works. Revisionist theories of party identification maintain that people review their partisan commitments from time to time and, when warranted by their core beliefs or evidence of partisan mismanagement of the economy or foreign affairs, update their partisan loyalties (Fiorina 1981). To take an example, Republicans who backed George W. Bush in the 2004 election may have moved into the independent category by 2008 because they were dismayed by the economic downturn and the war in Iraq.

Although Fiorina's research presents partisans in a more flattering light, it is important to recognize that much of the work suggests that party revision occurs only under limited conditions. Supporters of abortion rights are much more likely to align with the Democratic Party over the GOP but only if they care deeply about choice and know where the parties stand on abortion. Because the number of people who satisfy both conditions constitutes a minority of electorate, the level of issue-based party choice is also limited (Carsey and Layman 2006).

Therefore, while core beliefs motivate party updating for some people in some situations, the party-to-core-belief link remains the dominant causal pathway.

Recent research suggests a pair of critical exceptions to the conditional model of party updating. First, beliefs about the principle of government activism in the economic and social welfare policy domains—what scholars call "operational ideology"—shape party identification to a much greater extent than party identification shapes these beliefs (Chen and Goren 2016; Ellis and Stimson 2012). In this perspective, people who favor robust government activism to regulate the market and help those in need are more likely to identify with the Democratic Party compared to people who oppose strong government. There is also evidence that partisans toe the party line on the role of government, but the effect is smaller. And there is little evidence that the effects of operational ideology on party identification are limited to certain groups or hold under limited conditions.

Relatedly, research has showed that people's beliefs about moral issues such as abortion and gay rights shape their party ties. People who take socially liberal positions on these issues tend to identify with the Democratic Party more strongly over time compared to people who are pro-life and anti-gay rights (Goren and Chapp 2017). And similar to operational ideology, the propensity to ground partisan identities in moral issues does not seem to be limited to subsets of the public or to hold under specific conditions. In conjunction, this line of research suggests that a powerful pair of core beliefs shapes party identification in the American public.

The 2016 presidential election pitted Republican Donald Trump against Democrat Hillary Clinton. Both candidates were viewed very unfavorably by the vast bulk of the general public. Nevertheless, most partisans voted loyalty for the party nominee. Part of this no doubt reflects blind loyalty, a willingness to cheer for the party team even if it is being led by an unpopular candidate. But additionally, party voting is also driven by the fact that people choose a party and back its candidates because that party supports the core principles favored by these

individuals. In short, party loyalty is partly blind and partly reflects the core beliefs that people hold about society, government, and the key issues that have defined American politics for many years.

## References

Bartels, Larry M. 2002. "Beyond the Running Tally: Partisan Bias in Political Perceptions." *Political Behavior* 24(2): 117–150.

Campbell, Angus, Phillip E. Converse, Warren E. Miller, and Donald E. Stokes. 1960. *The American Voter.* New York: Wiley.

Carsey, Thomas M., and Geoffrey C. Layman. 2006. "Changing Sides or Changing Minds? Party Identification and Policy Preferences." *American Journal of Political Science* 50(2): 464–477.

Chen, Philip, and Paul Goren. 2016. "Operational Ideology and Party Identification." *Political Research Quarterly* 69: 703–715.

Ellis, Christopher, and James A. Stimson. 2012. *Ideology in America.* New York: Cambridge University Press.

Fiorina, Morris P. 1981. *Retrospective Voting in American National Elections.* New Haven, CT: Yale University Press.

Goren, Paul, and Christopher Chapp. 2017. "Moral Power: How Public Opinion on Culture War Issues Shapes Partisan Predispositions and Religious Orientations." *American Political Science Review* 111 (1): 110–128.

Lavine, Howard G., Christopher D. Johnston, and Marco R. Steenbergen. 2012. *The Ambivalent Partisan: How Critical Loyalty Promotes Democracy.* New York: Oxford University Press.

*Paul Goren is professor of political science at the University of Minnesota.*

## Perspectives on Homeland Security
*Adilene Sandoval*

The Department of Homeland Security was created in re-
sponse to the 9/11 attacks on the United States, with the goal
to protect the nation against various threats (LeMay 2006: 29,
207–210). Since the creation of the Department of Home-
land Security, a variety of different topics have been placed
under its command. Immigration is one such topic and has
been at the forefront of American debate and policy since the
nation's founding. Another topic that poses a threat to the
United States' homeland security is diseases and pandemics.
Diseases and pandemics have resulted in many casualties all
around the country and should be addressed properly. Addi-
tionally, a more recent topic that concerns homeland security
is cyber-security. Cyber-security refers to the idea of securing
cyberspace from possible threats to hardware and software
that support critical infrastructure systems or the informa-
tion contained within the hardware or the software. Focusing
on these topics, the Republican and Democratic platforms of
2016 discussed the critical issues facing homeland security
and provided their assessments and perspectives toward these
matters.

In the 2016 Republican platform, the party declared its
stance on immigration. The Republican Party explained that
"our immigration system must protect American working
families and their wages, for citizens and legal immigrants
alike" (https://gop.com/platform: 25). Additionally, the party
also expressed its sentiments toward illegal immigration. The
Republican platform claimed that "illegal immigration en-
dangers everyone, exploits the taxpayers, and insults all who
aspire to enter America legally" (25). Contrasting the Repub-
lican platform, the Democratic platform expressed that the
United States is a country founded on immigration. The 2016
Democratic platform viewed immigration as a "defining as-
pect of the American character" (16). The Democratic Party

explained that immigration has played an important role in United States' history and asserted that the party supports legal immigration within "reasonable limits." Democrats postulate that current immigration policy breaks illegal families apart, leading to unnecessary hardship and worsening social conditions. This is a prime reason for the Democrats to fight for immigration reform, which would favor law-abiding immigrants. The Republican platform is limited in scope, and it does not account for the role that desirability plays in the partition of jobs for American citizens. American employers have often complained that they cannot get native workers to take jobs like picking crops, plucking chickens, and so on. As such, immigrants are not in reality competing with or negatively impacting American lives. Immigration is a homeland security issue because immigrants whether legal or illegal continue to come to the United States.

Another homeland security topic is diseases and pandemics. The Democratic platform explained that it is vital to continue investing in global health, arguing that it will better prevent potential pandemics that could spread to the United States. Democrats explained that they will work with "health officials to reduce the risks associated with unintentional or deliberate outbreaks of infectious diseases" (48). Individual measures and investments should be taken to prevent such diseases, as they pose a threat to homeland security. While the 2016 Democratic platform addressed the issue of global health as being vital to our homeland security, the Republican platform did not address the issue. Such platforms are drafted every four years in the time of elections so each party has a written document expressing the problems each party identifies and the resolutions to such problems. Thus, it is likely that the Republican Party does not find pandemics and diseases to be a threat to the U.S. homeland. However, as shown throughout history, pandemics and diseases can greatly impact U.S. homeland security through the loss of thousands of American lives, as illustrated by the Spanish Influenza, the great influenza pandemic of

over Hillary Clinton could be interpreted as a repudiation of Obama's policies, the coda to the large Republican victories in the mid-term elections of 2010 and 2014.

However, the electoral landscape is more complicated than the foregoing indicates. Clinton won the popular vote nationally, primarily because of the great number of Democrats now in California, the result of high levels of Latin American immigration to that state. Trump won the Electoral College with close victories in Florida and the upper Midwest states. Both candidates exhibited character flaws, with personal attacks and a frenzied media marking most of the campaign. Trump had never held elective office and seemed clownish to many; Clinton was dogged by a criminal investigation and suspicions of corruption. All of this makes it somewhat difficult to determine whether the final vote reflects a lasting electoral arrangement.

There is reason to believe, however, that Trump's victory signals a presidential electoral advantage for the Republicans coincident with the party's emergent strength elsewhere. Trump was an unconventional candidate, to be sure, and not just because he was a celebrity businessman. His was a populist campaign, focusing on immigration restriction, trade protectionism, and a less interventionist foreign policy. It is likely that these views helped Trump to his victories in the heretofore rust belt Democratic strongholds of Wisconsin, Michigan, and Pennsylvania. Despite the controversy surrounding him, his core policies were aimed, as he said, at making the Republicans the party of the American "worker."

Modern conservatism, which has been so influential within the Republican Party since the 1960s, largely opposes the populist elements of Trump's agenda. Conservatives emphasize more so than Trump unrestricted free market economics and personal morality rooted in religion. But Trump's views are nevertheless largely consistent with the Republican Party's traditional nationalism. This aspect of the party can be traced to its roots in the early Federalist and Whig parties, both of which tended to be more restrictive on immigration and favored tariffs

to support domestic industry. This nationalist appeal incorporates a concern for free market principles and religious liberty, but within a broad notion of the common good.

The populist conservatism of the new Republicans contrasts with the contemporary Democrats' emphasis upon multiculturalism, which tends to pit different parts of the electorate against one another. This was reflected in Clinton's claim that half of Trump's supporters were racists and sexists and therefore were "deplorables" and "irredeemable." Such sentiments apparently did not sit well with white blue-collar workers, a number of whom twice voted for Obama but who eventually backed Trump. Indeed, with his brazen unwillingness to be defensive about himself or his policies, Trump tapped into the public's apparent belief that "political correctness" had become tiresome and divisive.

Trump's economic message seemed to resonate with voters in key states. It has been widely noted that throughout the Western world there has been growing anxiety about globalization and the stagnation of working class wages. Vermont senator Bernie Sanders's strong challenge to Clinton for the Democratic nomination focused on that anxiety. But while Sanders argued for better trade deals and railed against Wall Street, he did not focus as clearly on an unapologetically "America First" program as did Trump. Moreover, both Clinton and Sanders continued, like President Obama, to present climate change as the chief long-run threat to the nation. Clinton went so far as to allow herself to be videotaped asserting that she was going to put coal miners out of work. Such rhetoric has contributed to the impression that the Democrats have lost touch with working-class voters. Those voters would form the core of Trump's support.

In the weeks after the election, many Democratic leaders seemed to think that the best strategy for their party going forward was to continue to emphasize multiculturalism. There is some cold logic to this insofar as Clinton's defeat can be traced to decreased black voter turnout in Milwaukee, Detroit, and

Philadelphia. The low turnout in Detroit most certainly hurt her in Michigan. On the other hand, Clinton in 2016 did as well in and around Philadelphia as Obama did in 2012. Trump won Pennsylvania by drawing more than 200,000 more voters from the rest of the state. White working-class turnout appears to have increased, and this most certainly was for economic reasons.

But it appears that Trump, despite his rhetoric, also did slightly better among Hispanic and black voters than did Mitt Romney in 2012. The thought among many commentators has been that demographic changes in the country, especially the rising Latino vote, would eventually give the Democrats an insurmountable advantage over the Republicans. But this advantage might be offset by the growing strength of this new, more populist Republican Party. If the dire warnings about Trump's personality prove to be unwarranted, he and his party are likely to gain support from many of those who otherwise were put off by his unusual campaign, particularly suburban women and minorities.

It is difficult for one party to hold the presidency for three consecutive terms, so perhaps any Republican likely would have won in 2016. And perhaps Hillary Clinton simply was not a very good candidate. But the fact remains that the Democratic Party has lost ground badly during Barack Obama's presidency. The evolution of the Republican Party under Trump may portend the ascendancy of the Republicans. The vote he received in the election may represent more of a floor than a ceiling for the party in coming presidential elections. But much depends on specific events, which cannot be foreseen, and specific choices made by leaders of both parties. Some of us saw the real possibility of a Trump victory. But if 2016 has confirmed anything, it is the age-old truth that politics is little more predictable than the weather.

*Scot Zentner is professor of political science at California State University-San Bernardino.*

## The Trump Factor in American Politics: Teaching Trump through the Lens of Practical Politics
*Robert W. Smith*

### Trump: The Course

This essay had its inception in a political science course offered by the author in the summer of 2016 entitled The Trump Factor in American Politics. The course was taught during the height of the tumultuous 2016 presidential primary campaign and focused on the rise of Donald Trump as a candidate for the Republican nomination. To that point in time, Trump, who had been an outsider and a long shot to capture the nomination, began a fast and furious rise to the top of the Republican field. The seeming fascination of Donald Trump by the media also precipitated his meteoric rise in the polls. This seemed like an appropriate time to offer a course focused on someone who was emerging as a unique candidate in presidential politics. He was the businessman-turned-celebrity-turned-politician, and the American people could not escape his endless presence across all forms of media. Love him or hate him, Donald Trump was someone to be reckoned with in political circles. However, what could political science tell us about the man and the candidate? This essay offers one particular approach, grounded in that summer's course, to offer some insights into and observations on Donald Trump the candidate and now president.

### Trump from Out of the Blue

It was clear at the outset of the 2016 primary season there was a major battle shaping up between the ends of the political continuum within both political parties in the United States. On the Republican side, there were 17 candidates vying for the position of standard bearer for the party, and indeed the continuum of candidates ranged from moderates to ultra-conservatives. Many of these candidates had indeed been

running for a long time. But curiously, Donald Trump the billionaire celebrity businessman was also throwing his hat into the arena. No one was giving him much of a chance, given how the political process thrives on cultivating long-standing ties and an established campaign organization. Trump had neither, but he had a message to "make America great again," notwithstanding the fact that the slogan has very different meanings to many different groups.

This became a rallying cry for Trump supporters that seemed to grow day to day during the primary campaign season. In primary debate after debate, Donald Trump offered sound bites and tweets and was gruff and at times controversial. His remarks not only emboldened his supporters but attracted more and more followers to his campaign. Most of his opponents and mainstream Republicans still dismissed his campaign and looked askance at his controversial remarks and style. But what soon became clear after he and his forces mounted victory after victory in the primary campaign was that his remaining opponents soon saw the writing on the wall and dropped out one after the other. Trump was delivering a powerful message attractive to rank-and-file voters of the Republican Party and perhaps to the general electorate as well. Following primary victories in Florida, New York, and California, Trump had amassed the 1,237 votes needed to clinch the nomination—he secured 1,447 (Lee 2016). Donald Trump had successfully secured the Republican nomination for president. He was nominated at the Republican Convention on July 19, 2016 (Rafferty 2016).

### Why Study Trump?

Studying what was happening in the Trump for president campaign and his seeming attractiveness to Republican voters was fueled by a twofold interest. First, political science is empirical; it takes a positivist stance and uses rigorous methodology to look back at history. Yet, something was unfolding that

warranted more immediate treatment at some level of scrutiny beyond empirical analysis. Yet, perhaps, the lens of political science could still be applied to the Trump phenomenon. The thinking was that this was a perfect time to hold a class on Trump (and related developments in the 2016 campaign primaries). There were lessons to be learned, as something different seemed to be happening in the field.

This premise speaks to the primary argument that political science simply doesn't sufficiently apply what is known in the field that is of practical significance for better understanding politics—namely, the application of practical politics. Too many scholars teach political science as a pure academic discipline. And they should. Applying knowledge like any hard science is something to strive for. And clearly, many political scientists do embrace practical politics and examine the role of media, teach polling techniques, have students placed in top internships in political campaigns, and do their best to bridge theory and practice. But many of my colleagues do not take this applied approach as seriously. The Trump candidacy presented the opportunity to be proactive in the study of a different type of emerging candidate and to use practical politics to determine if Donald Trump was in fact that different kind of candidate (Diersing 2016).

The second thread that jumped off the pages of the unfolding campaign was the media coverage being generated by Donald Trump. It was Donald Trump against the bevy of Republican primary candidates, Trump against Republican Party elites, Trump against the media, and Trump against the Democrats. Indeed—as advanced by his campaign—who wasn't against him (Cillizza 2016)? Just like any good course, trying to work in elements of recent or controversial news stories to demonstrate key points in theory and substance, the Trump campaign was a readymade course to discuss a variety of political science topics such as the role of the media, polling, the mechanics of the primary process, dynamic political primaries and the process of voting, and even democratic representation itself. It also

presented an opportunity to discuss whether Donald Trump's candidacy was fitting into some key political science theories or norms.

To summarize, there were several distinctive features that needed to be explored sooner rather than later, especially with the general election fast approaching. The fact that Donald Trump represented a unique political candidate who fractured or disrupted traditional political mechanisms and processes needed examination, and the fact that the Trump candidacy itself became a media phenomenon held implications for political communications, the role of the media, and an assessment of popular culture affecting how political dynamics function as we know it. And these were just a few threads to be examined. As such, there was not so much a need to revisit Trump's background and motivations, because he had always been running for something (Blair 2005). But the fact that political science was behind the curve on seeing the impact of Donald Trump pointed to the need for an immediate treatment of Trump's impact on American politics. A course was an ideal way to do this.

## Practical Politics and the Trump Campaign

The best way to understand the candidacy and success to date of Donald Trump is to embrace practical politics as both a means and an end. The fact that Donald Trump has defied various elements of political theory and thinking points to the need to take a different vantage point to assess his impact on American politics. One way to do that is to examine concrete actions taken in the Trump candidacy as opposed to reliance on long-held political norms. This is not a repudiation of a rigorous approach with a positivist and empirical mindset, but it is to suggest that a balance of perspectives offers the best insight into evaluating the Trump candidacy in 2016. Ever since Theodore Roosevelt (1888) offered his essay on practical politics, it is clear that politics (or the practice of politics) is at heart an action-oriented, behaviorist, and socially constructed paradigm best understood from observing human behavior in a political

context. Even Harold Laswell (1936) identified a simple yet telling proposition about politics as who gets what, why, when, and how. Political science has long traditions which can guide us to profound insights, but equally important insights arise from the real-time action of politics in operation.

At this point, a rather simple and precise definition of what is meant by practical politics is appropriate. For this essay, practical politics means what actually takes place or is possible in political life. This broad and straightforward definition is necessarily inclusive and considers the nuts and bolts of campaigning, political machinations in the field and in board rooms, and applied strategies in campaigning and communications and equally involves the backroom negotiating, deal making, and the art of compromise consistent with political decisions and considerations. The dimension most useful for this essay is the unfolding developments during a campaign that define and frame the campaign for public office as it evolves in real time. The Trump candidacy offers just such an opportunity. Recently, Donovan and Larkin (2006) examined the seeming misfit between traditional political science and practical politics and argued for a more "fruitful" relationship between academia and practical politics. Major theoretical quandaries have arisen between practical politics and philosophical inquiry (Graham 1978). The heart of the matter is that the Trump phenomenon offers a laboratory or applied teaching moment to bridge current political events and developments juxtaposed against theory and literature from political science. This essay examines those lessons from the Trump candidacy in 2016.

## Exploring the Trump Factor through Political Science

In examining the Trump factor, the starting point necessitates a review of Donald Trump, his background, and his political experiences and orientations. The primary season and its machinations offer an ideal opportunity to highlight primary dynamics and processes. Concepts of political communication and the role the media plays in presidential politics are equally

illuminated. The implications for the Republican Party with Trump as the outsider-turned-standard-bearer equally force consideration of the role of political parties and the reality of a realignment occurring within the Republican Party itself. It is important to examine the dynamics in the Democratic primary as well. And this approach reveals insights into typologies of candidates and theories of populism that seemed to be drivers in both Republican and Democratic politics in 2016. In closing, practical politics can inform citizens and scholars about the lasting impact of the Trump factor in American politics. Although there are several theories and constructs that can be examined, the course focused on personality-driven politics, the primary process, the role of political parties, populism and authoritarianism, media influences, Trump and popular culture, and Trump versus the Democrats.

## Is Trump Unique?

It is clear that through the lens of traditional political science (and how Trump has countered that perspective), Trump is unique. From a more practical-politics viewpoint, Trump is still unique, which is not surprising, hence the relevance of a lens of practical politics. Trump conveys a profound social radiance, love him or hate him, and that is always a unique attribute among politicians. He has crafted an antiestablishment image and persona as someone not among the beltway politicians. His sometimes vulgar remarks and rude frankness are not seen as criticism in Trump's world (Ponnuru and Lowry 2016). He was in the right place at the right time to take advantage of an antiestablishment frame of reference. And it is unique for a Donald Trump (the outsider) specifically to be in the right place at the right time. He has advocated extreme positions balanced with a flavor of pragmatism, which is precisely why many voters believe Washington is not working today. And he has articulated a perspective that political parlor games cannot be tolerated anymore by rank-and-file voters. Moreover, he is

able to connect with citizens' anger over the establishment that it has failed at "ground level." He argues that politics is too professionalized and the gotcha culture of today needs someone who can operate above that level.

Equally, campaign management matters, and the campaign was all Trump and his small group (including family members) who micro-managed the campaign. This is similar to how his businesses are run (*The Economist* 2016). It is probably fair to conclude Donald Trump has exploited citizens' fears on all counts and has delivered crass and some non-factual answers for problems—but it doesn't seem to matter. Nonetheless, he has tapped into an era of hyper-terrorism, globalization and migration, economic malaise, and a variety of social problems that are looking for a solution (Green 2016). Donald Trump has cast himself in that role as *the solution*.

On the other side, Hillary Clinton seems to represent a great deal of what is wrong with politics today (Binelli 2016). Her recurrent problems with her use of an unofficial email server, the Benghazi incident, and the questioned activities by the Clinton Foundation leave both candidates with record-high unfavorable polls. Yet, she equally represents a more predicable place to land than Donald Trump. Her election would harken a call to centrism and a slow-and-steady approach to resolving the problems facing this country. In many respects, it seems that depending on the final outcome, we may see calls for candidates even more extreme than Donald Trump but better than Hillary Clinton as a choice (Smith 2016). Hence, these future developments will be precisely a product of practical politics as demanded by the electorate and warrant a clear place in better understanding presidential elections than may be possible with more traditional political science approaches.

As Donald Trump basks in his election victory, perhaps there are some positives we could see: a new more balanced America-centric foreign policy, a better-managed government, value appropriateness by government, internationalism as opposed to globalization, a negotiate-compromise-and-win

policy, retaining of valued social programs, and improvement in the economy. Therefore, expect to see pragmatism from a Trump administration that may be a refreshing change from the typical gridlock associated with Washington, D.C., these days. Some might call this an application of "practical politics."

## Overall Implications

It seems appropriate to offer five significant implications that rise from a consideration of a Trump presidency through a lens of practical politics:

- The anger quotient is real, as are the antiestablishment, anti-elitism, and antipolitics sentiments that have been brewing for 30 years.
- There is a real shift in orientation of rank-and-file Republican Party members against their party elites and against set norms and the leadership of the Republican Party.
- Presidential campaigns may need to be retooled, given the propensity of the Trump campaign to bypass traditional vetting through party processes.
- There must be renewed emphasis placed upon a balanced role for the media in setting the agenda for public policy and political life.
- No matter how we analyze the Trump candidacy and the primaries and election of 2016, this campaign season has highlighted the imperative of our participation as voters in a democratic society.

## Practical Politics as the Bridge to Political Science

A second definition of practical politics describes the baser elements as an embodiment of political intrigue, scheming, and dishonest dealings. The primaries and election of 2016, in terms of outrageous pronouncements or leaked email documents, reveal there are plenty of bare knuckles and Tammany

Hall style politics that have occurred in the 2016 electoral season. Yet, there is only one lens that can adequately capture these elements and offer a keener insight or valid explanation. That is the lens of practical politics, which offers a firsthand perspective to demonstrate and reveal concepts, processes, and dynamics that are central to an understanding of our system of government. Equally, the direct and focused examination of the Trump primary and general campaigns offers an immediate opportunity to translate theory, principle, or tenets to action and explain what we are seeing in real time and on the ground. This, of course, allows a lens to connect textbook to practice and to see if long-held tenets in the field still apply. Above all, the lens of practicality adds relevance with grounding in the basic elements of political science.

Positives that emerged from the course included the following: (a) movement away from party elites; (b) empowerment of rank-and-file voters; (c) synergy returns to politics; (d) increased scrutiny of candidates; (e) that active political change is possible; (f) that pragmatism may prevail, and (g) that the electorate matters. The negatives emerging from the Trump campaign include the following: (a) basic divisions exacerbated by politics; (b) loss of rational debate; (c) superficial media coverage; (d) loss of party control; (e) personality-driven politics; (f) suppressed voting; (g) disruptive elections, and (h) the science of politics disrupted.

These outcomes are not offered as conclusions, except that they offer important points to focus on when evaluating the efficacy of American politics. Whether one assesses the Trump candidacy as a positive or negative takeaway concerning the resilience or fragility of the election process, or whether one thinks it is a repudiation or empowerment of the rank and file against political elites, whether one assesses how the media shapes or assists our political process, or that the campaign focuses on the rise of personality politics versus the loss of political party stability, the import of the Trump candidacy lies in the real-time impact that can and must be applied to have

an effectively running and current discourse on the state of American politics in the 21st century. Political science is an applied field, and the discipline must utilize opportunities like the Trump campaign to embrace that role.

## References

Binelli, M. 2016, March 24. "The Good Fight." *Rolling Stone*, 40–45.

Blair, G. 2005. *Donald Trump: The Candidate*. Simon & Schuster, p. 8.

Cillizza, Chris. 2016. "I Still Can't 'Wrap My Mind' Around a Trump Presidency." *RealClear Politics*. http://www .realclearpolitics.com/video/2016/11/16/chris_cillizza_i_ still_can't_wrap_my_mind_around_a_trump_presidency

Diersing, C. 2016. "Teaching Trump: Huge Challenge." *USA Today*. http:eds.a.ebscohost.com/eds/delivery?sid=0clbedfb-acfo-4c7b-a723-e57838c8d492%40.

Donovan, C., and Larkin, P. 2006. "The Problem of Political Science and Practical Politics." *Politics* 26(1): 11–17.

*The Economist*. 2016. "Family Values." Schumpeter. http:// www.economist.com/news/business/21705294-donald-trump-running-his-campaign-family-business-family-values

Graham, G. 1978. "Practical Politics and Philosophical Inquiry." *The Philosophical Quarterly (1950–)* 28(112): 234–241.

Green, J. 2016. "The Great GOP Realignment." *Bloomberg*. https://www.bloomberg.com/politics/articles/2016–02–04/ the-great-gop-realignment

Laswell, H. 1936. *Who Gets What, When and How*. New York: Whittlesey House.

Lee, M.J. 2016, May 26. "Donald Trump Has Delegates and Clinches GOP Nomination." www.cnn.com/2016/05/ 26/politics/donald-trump-has-delegates-to-clinch-GOP-nomination./

Ponnuru, R., and R. Lowry. 2016. "Toward a Conservative Populism." *National Review*. https://www.nationalreview .com/nrd/articles/430401/toward-conservative-populism

Rafferty, A. 2016, July 19. "It's Official: Trump Wins GOP Presidential Nomination." NBC News. www.nbcnews.com/ storyline/2016-convention/trump-wins-GOP-presidential-nomination-n612616

Roosevelt, T. 1888. *Essays on Practical Politics*. New York: G.P. Putnam's Sons.

Smith, E. 2016. "The Age of Rage." *New Statesman*. http://www.newstatesman.com/world/2016/04/ donald-trump-and-age-rage

*Dr. Robert W. Smith is a full professor of political science and public affairs at Savannah State University. His research and publications are in the areas of public budgeting/finance, ethics in government, and civic engagement/participation.*

## Introduction

*This chapter profiles the organizations and people involved in the American political party system and American politics at the national level. It begins with a description of the organizations that are active in the political party arena of American politics.*

*After describing and discussing key organizational actors in the American political process at the national level, the chapter lists and profiles individual actors involved. These include elected politicians, political party activists, and the leaders of political action committees and formal party organizations at the national level.*

## Organizations

### AFL-CIO Workers' Voices PAC

The American Federation of Labor and Congress of Industrial Organizations (AFL-CIO) Workers' Voices PAC is a new initiative to build an independent voice for the working and middle class. It builds upon an AFL-CIO network of 14,000 union worksites around the nation and reaches out to

---

Senator Hillary Clinton addresses the Emily's List 2008 Convention Gala at the Democratic National Convention held in Denver, Colorado, on August 26, 2008. Emily's List is a PAC that strongly supported the presidential candidacy of Secretary Clinton in 2008 and again in 2016. (AP Photo/ Matt Rourke)

nonunion members and their families and into communities. It counters—although hardly matches—the millions of dollars that the conservative PACs and super-PACs raise and spend. Besides building a network of union and nonunion workers, it focuses on voter registration and voter protection, especially in communities of color and among seniors and students, groups hit by the wave of voter suppression laws recently passed in many states and pushed by corporate backers across the nation. Its website is a vehicle to activate workers, to join via e-mail and social networks like Facebook and Twitter. It employs "click to call" technology to customize direct mail postcards to legislators and uses relational voter data tools to merge online networks into phone banks and canvass persuasion efforts at the local level. A key leader of the new initiative is AFL-CIO political director Mike Podhorzer.

### America Leads PAC

This super-PAC was an independent-expenditure-only PAC to promote the presidential bid of New Jersey governor Chris Christie. It was established by Phil Cox, the former executive director of the Republican Governors Association (RGA), and Paige Hahn, the former finance director of the RGA. It spent several millions of dollars in the 2016 election cycle, some to fund TV ads for Governor Christie, and even as much to attack Donald Trump during the early period of the Republican presidential nomination primary season.

### American Bridge 21st Century

This is a liberal super-PAC that does opposition research to aid Democratic candidates and organizations. It was founded in 2010 by David Brock, a conservative-turned-liberal activist. In 2004, Brock started Media Matters, a liberal website that monitors the media for conservative "misinformation." As a super-PAC, it can accept unlimited donations, including large ones, from major Democratic donors and

labor unions. Among its most prominent contributors is billionaire hedge fund manager George Soros, the group's largest donor in the 2012 cycle, who contributed $1 million. The American Federation of State, County, and Municipal Employees donated $575,000. In 2012, American Bridge 21st Century spent $338,000 on independent electioneering communications—mostly attacking Republicans. It shares its research with major Democratic super-PACs such as Priorities USA Action, Senate Majority PAC, and House Majority PAC. Its success led to the creation of similar right-wing opposition research groups, such as America Rising. Its 2016 spending target was $17 million.

## American Crossroads PAC

This independent-expenditure-only super-PAC was founded by such giants of the conservative movement in American politics as Karl Rove, Ed Gillespie, and Mike Duncan. The super-PAC's president is Steven Law. It is a super-PAC primarily spending on anti–Hillary Clinton TV ads but stressing such views as the need to change course in American politics; that the American voters deserve better than this (i.e., the Obama/Clinton agenda); and that we (the rank-and-file voters) have to bring about the needed change.

## Americans for Prosperity

This organization is a 501(c)(4) PAC founded in 2004 as one of the first, and leading, 501(c)(4)-type political organizations. It is a very conservative political advocacy group, founded by David Koch and Karl Rove. It primarily raises "dark money" to fund negative TV ads against liberal opponents. It promotes lower taxes, less government regulation, and economic prosperity. It set the model for a host of similar right-wing oriented 501(c)(4) organizations which, in the 2012 election cycle, raised and outspent all other PAC types combined.

### The Center for Public Integrity

The Center exemplifies the *think tank organization*. It was founded in 1989 by Charles Lewis. It is one of the oldest and largest nonpartisan, nonprofit organizations of investigative news and was the winner of the 2014 Pulitzer Prize for investigative journalism. It does no advocacy work. Its editorial staff consists of professional journalists, Freedom of Information Act experts, copy editors, and data experts. It is one of the best known and regarded "truth fact-checkers." The Center distributes its investigations through its award-winning website and to all forms of the media around the globe.

### Center for Responsive Politics

The Center is another Washington, D.C.,-based nonprofit, nonpartisan research group (think tank). It was founded in 1983 by Hugh Scott. Its central focus and contribution to the American political scene is that it tracks money in politics, showing spending data for federal elections. Its tracking over time and comparative raising and expenditure data for politicians and groups is widely considered the most nonpartisan and accurate of federal election spending data.

### Club for Growth

The Club for Growth is a political advocacy group operating through two political arms: Club for Growth Action and Club for Growth PAC, a 501(c)(4) super-PAC. It claims a national network of 100,000 pro-growth, limited government Americans and is a leading pro-growth advocacy group lobbying for free market and limited government policies. Its founders are Stephen Moore, Richard Gilder, Harlan Crow, and Thomas Rhodes, and its president is David McIntosh. In the mid-period of the Republican presidential nomination primary season, it ran an anti-Trump campaign. It issues what it terms KEY VOTE alerts and congressional scorecards (ranking House and Senate members on the purity of their conservative

votes on legislation). It runs independent issue ads on television (particularly Fox News) and on conservative talk radio. It supported Senator Ted Cruz for the Republican presidential nomination in 2016.

### Commission on Presidential Debates

The commission began in 1987, sponsored by the Democratic and Republican Parties, and designed and ran the presidential debates in all presidential election cycles from 1988 forward and one vice presidential debate in the general election cycle. In part, it was established to counter debates which had previously been sponsored by and organized by independent groups like the League of Women Voters or by specific media groups. It is a 501(c)(4) nonprofit organization. The presidential and vice presidential debates are sponsored by private contributions from foundations and corporations. The Commission members are three Democrats and three Republicans appointed by the parties. They do not open the primary debates to third-party candidates and for general election debates set the standard to be on stage at 15 percent support in the national polls, effectively closing off access to the nationally televised presidential debates to third-party candidates.

### Conservative Solutions PAC

This super-PAC was formed to support the presidential nomination bid of Florida senator Marco Rubio in 2016. The super-PAC raised more than $60 million and spent $58 million. Supported heavily by conservative Republicans in Florida, it spent the money on anti-Trump television ads before the Florida primary, which Donald Trump won handily; the loss of that primary knocked Senator Rubio out of the presidential race.

### Crossroads GPS

This is a 501(c)(4) PAC headquartered in York, Nebraska. It is one of a couple of Crossroads organizations founded by

Republican operative Karl Rove. It plans grassroots policy strategies, runs negative television ads, and organizes constituent letters to urge action on what it calls common sense items for positive change. It supports conservative policy proposals and is noted for its anti-Obamacare campaign ads. Its CEO is Steven Law.

### Democratic Congressional Campaign Committee (DCCC)

The DCCC is the official campaign arm of the Democrats in the U.S. House of Representatives. It recruits and supports the election of candidates for Congress. It raises campaign funds, plans national strategies for their expenditure (deciding which key district races have the best prospects for victory), advises on campaign strategies and positions on issues, and supports television and other media ads. The DCCC chairman since 2009 is Representative Ben Ray Lujan (D-NM).

### Democratic Governors Association

The Association was founded in 1983. It bills itself as an independent voluntary political organization supporting Democratic governors for election and aims to develop candidates to compete for the office. As of 2016, it supported 18 state governors and 2 U.S. territorial governors. It raises funds to contribute to their political campaigns and provides media advice and political strategy. Its chairman is Governor Jon Bel Edwards (D-LA) and its executive director is Elisabeth Pearson.

### Democratic National Committee (DNC)

Founded in 1848, the DNC is the official national organization of the Democratic Party, headed by a chairperson selected by the National Convention in presidential campaign years. It supports policy positions (called "planks" in the party platform) adopted at the National Convention. In 2016, the platform was notably pro-choice, pro–gay marriage, pro–development

of alternative energy, health care reform (health care for all with a public option or adoption of a single-payer system), education reform, and comprehensive immigration reform. The DNC's current chairman is Tom Perez.

## Democratic Senatorial Campaign Committee (DSCC)

The DSCC seeks to recruit and support Democratic candidates for the U.S. Senate. It raises campaign funds, works to elect candidates to the Senate, offers advice on campaign strategy, and promotes common campaign themes and media ads. Its 2016 chairman was Senator Jon Tester of Montana. Its current chairman is Chris Van Hollen. Its executive director is Tom Lopach. It targeted Illinois, Pennsylvania, Wisconsin, and Iowa as key races for the Senate in 2016. Because Republicans had been so successful in the off-presidential year of 2010, in 2016 the Republicans had to defend 24 seats to the Democrats' 10 seats. Given the higher voter turnout expected in presidential election year, the Democratic Party hoped to "flip the Senate" by winning a majority in the Senate—a bid that failed.

## Democratic Underground (DU)

DU is an online organization backing the Democratic Party and its candidates for state and national level offices. Begun in 1991, it is noted for its satirical commentary. It organizes grassroots-level activists committed to electing Democratic candidates. It is run by David Allen.

## Democrats Moving America Forward

An information website for the DNC, it promotes voter registration drives, early voting, absentee voting, and military and overseas voting. It builds grassroots and outreach efforts. On issues, it emphasizes alternative energy, health care reform, education reform, and comprehensive immigration reform.

## Democrats.org

Democrats.org is the website of the Democratic Party. It posts relevant news stories on politics: positive ones about Democrats

and negative stories on Republicans. It also posts the most recent party platform.

### Emily's List

Emily's List is a PAC to elect pro-choice Democratic women to office at all levels—local, state, national elected office and both legislative and executive offices. It was founded by Ellen Malcolm in 1985. Its current president is Stephanie Schriock. It claims three million members; as of 2015, it has 800 electoral victories, an 80 percent win record. It backed Secretary Hillary Clinton for president, having bundled more than $800,000 for her campaign.

### Endorse Liberty

Endorse Liberty is a Ron Paul Libertarian super-PAC headquartered in Salt Lake City. It is an independent-expenditure-only super-PAC that in 2016 supported the failed presidential nomination bid of Senator Rand Paul (R-KY). It promotes libertarian issues and positions, raises funds to expend on behalf of Senator Paul, and runs ads aimed at building the Libertarian movement within the Republican Party.

### Federal Election Commission (FEC)

The FEC is an independent regulatory agency established in 1975 by amendment to the Federal Elections Commission Act (FECA) of 1974. Congress established the FEC to administer the FECA, the law that governs the financing of federal elections. Its duties are to disclose campaign finance information, enforce the provisions of the FECA, and oversee the public funding of presidential elections. The commission is comprised of six members, three Democrats and three Republicans, appointed by the U.S. president with the consent of the Senate. Its members serve a six-year term, with two members appointed every two years. By law, no more than three members can be of the same political party. At least four votes are required for

any official FEC action. The chair rotates among the members each year, with no commission member serving more than once during his or her term.

## Fox News Network

Fox News is a basic cable and satellite network owned by the Fox Entertainment Group, 21st Century Fox. It is headquartered in New York City. In 1996, it was created by Australian American media mogul Rupert Murdoch. Until late July 2016, it was built and run by Roger Ailes. It claims to reach nearly 95 million U.S. households and 81.4 percent of the cable network news. It is the dominant cable network in the United States and widely considered to be the "Republican Party network."

## Freedom Works for America

Freedom Works is a libertarian advocacy group based in Washington, D.C. It trains volunteers, activists, and campaigns associated with the Tea Party movement. It was founded in 2004 by Matt Kibbe and Ryan Hecker. Kibbe is the president and CEO of Freedom Works, Inc. Freedom Works for America is its super-PAC founded in September 2011. Ryan Hecker is its COO and notable for laying out the platform of the nascent tea party movement on his online Contract for America. It claims six million grassroots members in its volunteer data base. It is a super-PAC backing conservative candidates. It extensively employs the social media, like Twitter, Facebook, and YouTube. Its ex-chairman is Dick Armey, a leading voice in the tea party movement and former Republic House majority leader who left Freedom Works in the fall of 2012. Freedom Works, Inc. is a 501(c)(4) nonprofit that in 2004 merged Empower America and Citizens for a Sound Economy, an industry-funded think tank promoting deregulation and largely funded by Charles and David Koch. It was a prominent supporter of Senator Ted Cruz (R-TX). It spent a half-million dollars supporting Cruz in his Texas Senate bid.

### Gallup Poll

Arguably the best-known polling organization in America, the Gallup Poll was founded in 1935 by George Gallup. Its current CEO is Jim Clifton. It is a Washington, D.C.,-based national polling organization. With its long history in polling, it is known to produce reliable poll results on a host of politically related issues and on candidates, especially those running for national office. It provides data-driven news based on U.S. and world polls and public opinion research. It is noted for its daily tracking polls and benchmark polls.

### Green Party of the United States (GPUS)

The GPUS describes itself as a federation of state parties (in 30 states and the District of Columbia) comprised of grassroots activists, environmentalists, social justice advocates, nonviolent resisters, and regular citizens who oppose corporate-dominated politics. They hold that government must be part of the solution, but when it is dominated by the top 1 percent, it is part of the problem. Today, the party has 100 local-elected officials around the country. The Green Party movement worldwide began in 1972. In the United States, the party was founded in 1984 in St. Paul, Minnesota. It has fielded a presidential candidate in every election since. It selected its name, GPUS, in 1999. The party is based on four pillars: peace, ecology, social justice, and democracy. In 2000, GPUS nominated Ralph Nader for president, who received about 3 percent of the popular vote, but no Electoral College votes, and likely cost Vice President Al Gore the election. Its nominee in 2012 (and again in 2016) was Massachusetts physician Jill Stein. Jill Stein was also a two-time nominee of the party for governor of Massachusetts. In the 2012 election, the vice presidential nominee was Cheri Honkala, an antiparty activist. The ticket received 470,000 votes.

### Harris Poll/Harris Interactive, Inc.

Harris Interactive is a market research firm based in Rochester, New York, working in a wide range of industries, countries,

and territories in North America, Europe, and Asia. The Harris Poll was founded in 1956 by Louis Harris, a political science opinion research specialist. In 1975, Gordon Black founded Harris Interactive, which in 1996 merged with Louis Harris Associates and in 2014 was acquired by Nielsen. Over the past 50 years, it has become a media staple around the world for poll data on sports, health, politics, and the economy. Its chairman emeritus is Humphrey Taylor, one of the giants of the polling industry, and its president and CEO is Kimberly Till.

### Heritage Foundation

Founded in 1973 by Joseph Coors, Paul Weyrich, and Edwin Feulner, the Heritage Foundation is a conservative think tank and lobbying organization based in Washington, D.C. Its CEO is Jim DeMint. It bills itself as the leader of the conservative movement and rose to prominence during the Reagan administration. In 1980, it issued its "mandate for leadership," which became the blueprint for the Reagan conservative policy agenda. It has assets of more than $174 million, claims more than 500,000 members, and has been a leading critic of the Obama administration's liberal policies.

### House Majority PAC

This is a super-PAC focused on holding Republicans accountable and helping to elect Democratic Party candidates to the House of Representatives. It was founded in 2011 as an answer to the various Republican party outside-spending groups started by Karl Rove, the Koch brothers, and Sheldon Adelson. The House Majority PAC spent $36 million in the 2012 election cycle. It won 8 of 10 seats it spent its most money on and 63 percent of the races it spent significant money on. Its founder, executive director, and chief political strategist is Alixandria Lapp.

### Keep the Promise

Keep the Promise is a network of five independent super-PACs that supported Senator Ted Cruz in his 2016 bid for

the Republican Party presidential nomination. Three of the five PACs are funded by multimillion dollar donations from an individual or family.

## League of Women Voters

The League was founded in 1920 by Carrie Chapman Catt and Susan B. Anthony at the final meeting of the National American Women Suffrage Association. It is headquartered in Washington, D.C. It is a nonpartisan political organization that registers, educates, and engages voters, seeks to reform money in politics, and defends the environment. It is organized at the local, state, and national levels in more than 1,000 state and local chapters. It reports revenue of more than $4.6 million. Its president is Elisabeth MacNamara.

## The Libertarian Party

The Libertarian Party is one of the largest of the "minor" parties of the American two-party system. Founded in 1971 by David Nolan, it is headquartered in Washington, D.C. In 2012, the Libertarian Party was on the ballot in 36 states and on all 50 states in 2016. It adopted its party platform at its national convention in May 2016, held in Orlando, Florida, where Gary Johnson, a former two-term Republican governor of New Mexico (1995–2003), was nominated as the party's presidential nominee, and William Weld, former two-term Republican governor of Massachusetts (1991–1997), as its vice presidential nominee.

## Make America Great Again PAC

This super-PAC was established to support the presidential bid of Donald Trump. Its treasurer is Leslie Caldwell. It raised more than $1 million to support him, despite his frequent primary campaign claim that he was "self-funded." It raised more for the general election and has funded anti-Hillary ads.

## MapLight

MapLight is a nonprofit, nonpartisan research organization that tracks the influence of money in politics. It publishes a database on campaign contributions to politicians and how they vote on bills and national legislation. Its database focuses on campaign finance and its linkage to voting behavior. It was founded in 2005 and is headquartered in Berkeley, California. Its cochairs are Doug Edwards and Melanie Sloan.

## MoveOn.org

This 501(c)(4) is a joint website organization of civic action and political action committees. Founded in 1998 by George Soros, Joan Blake, Eli Parsier, and Wes Boyd, its electoral field director is Matt Blizek. It has raised tens of millions of dollars to support liberal policy. Over the past 18 years, it has been part of legislative victories to end the war in Iraq, promote health care reform, and encourage economic fairness. It pioneered online organizing, innovating an array of tactics that are now commonplace in social policy advocacy and in elections, such as the Internet virtual phone bank and crowd-sourced television ads.

## MSNBC

MSNBC is an American cable and satellite television network providing news coverage and political commentary from NBC News on current events and carries various nightly "opinion" program blocs with a liberal slant. It is the progressive answer to Fox News. Its slogan is "the place for politics." It is owned by the NBCUniversal News Groups, a unit owned by Comcast. It was founded in 1996 in New Jersey by John Nicol and Tom Rogers, in a separate partnership with Microsoft and General Electric's NBC unit. Its president and CEO is Phil Griffin, and Brian Williams is the channel's chief anchor and managing editor of breaking news coverage. Headquartered in New York City, MSNBC Live is the network's flagship

daytime news platform. It is viewed in 94.5 million households and is a sister channel to CNBC, CNBC World, NBC, the Weather Channel, NBCSN, E!, Esquire Network, and the Golf Channel.

## NAACP

The NAACP, founded in 1909, is the oldest continuously active civil rights organization, with its national headquarters in New York City. It published *The Crisis* magazine, edited by one of its cofounders, W. E. B. Du Bois. Other notable African American cofounders are Ida Wells-Barnett and Mary Church Terrell. Founded to secure the rights of all people, its most notable campaign in its early years was anti-lynching. NAACP is a 501(c)(4) organization independent-expenditure-only political activist organization. Its current president and CEO is Cornell W. Brooks.

## National Institute on Money in State Politics

A national, free, nonpartisan verifiable archive of contributors to political campaigns in all 50 states, the National Institute on Money in State Politics began in 1999. Its headquarters is located in Helena, Montana. Its president is Bert Brandenburg, president of Appleseed, and its executive director is Edwin Bender. It is one of the most reliable and nonpartisan sources of campaign fund raising and expenditure data.

## National Opinion Research Center

Located and operating out of the University of Chicago, the National Opinion Research Center is one of the largest independent social research organizations. It was founded in 1941 and is noted for its academic excellence and scientific rigor. It collects, analyzes, and publishes opinion survey and other data, and its collection is known for its large, national survey data.

### National Republican Congressional Campaign Committee (RCCC)

The RCCC is the Republicans' national committee that works for the election of Republican candidates to the House of Representatives—the party's answer to the DCCC. It was formed in 1866. It raises funds for Republican congressional races and advises candidates on electoral strategy and campaign-themed media ads. Its 2016 chairman was Representative Greg Waldon (R-OR-2). Its executive director is Liesl Hickey.

### National Republican Senatorial Campaign Committee (NRSCC)

Like its Democratic counterpart, the NRSCC is the national committee helping to elect Republicans to the Senate. It supports and assists current and prospective Senate candidates. Its current chairman is Senator Roger F. Wicker (R-MS). Its executive director is Rob Collins.

### National Rifle Association (NRA)

Founded in 1871, the NRA is one of the most powerful lobbies in the nation and an exemplary 501(c)(4) organization in electoral politics. It was founded by George Wood Wingate and William Conant Church. It used to be largely nonpartisan or bipartisan and emphasized gun safety training. Since 1975, it advocates strenuously for gun rights and has directly lobbied for pro-gun legislation at the state and national levels. Headquartered in Fairfax, Virginia, its membership, as of 2013, was more than five million. Its CEO is Wayne LaPierre.

### Organizing for Action

Started by President Barack Obama's campaigns of 2008 and 2012, Organizing for Action now has 250 local chapters and organizes grassroots volunteers. Its chairman is Jim Messina and its executive director is Katie Hogan. It promotes campaign

support and legislative advocacy to insure and continue the Obama legacy.

### Our Principles PAC

This super-PAC was formed to educate and engage American voters about the men and women who seek national office and about the challenges and issues they should confront should they be elected to office. It was formed in 2016 to thwart Donald Trump's presidential campaign. It founder is Katie Parker, the former deputy campaign manager of former governor and presidential candidate Mitt Romney. Tim Miller, former Jeb Bush manager, is its communications director. In the later part of the Republican presidential primary season, it raised and spent 4.4 million dollars on anti-Trump television ads.

### PEW Research Center

PEW is a nonpartisan think tank based in Washington, D.C. It began in 2004 and has assets of $37 million. It works to inform the public about issues, attitudes, and trends that shape America and the world. Its research areas include U.S. politics and policy, journalism and the media, Internet, science and technology, religion and public life, Hispanic trends, global attitudes and trends, and social and demographic trends. Its published opinion and trend data are highly respected and nonpartisan.

### Planned Parenthood

Planned Parenthood is a 501(c)(4) organization that provides clinics around the United States offering low cost women's reproductive health services. Its president is Cecile Richards, and its chair is Jill Lafer. Its areas of operation include abortion, birth control, body image, general health care, men's sexual health, the morning-after pill contraception, pregnancy, relationships, sex and sexuality, sexual orientation and gender, sexually transmitted diseases, and women's health.

### Priorities USA

Priorities USA is an independent-expenditure PAC, a 501(c)(4) super-PAC that supports the election of Democratic candidates. It began as an Obama super-PAC. In 2016, it supported Secretary Hillary Clinton's bid for the Democratic Party's presidential nomination. It was founded in 2011 by Bill Burton and Sean Sweeny, formed to reelect President Obama in 2012. Its executive director is Anna Capara, and its senior political advisor is Paul Begala.

### Public Policy Polling

Public Policy Polling is a U.S. polling firm based in Raleigh, North Carolina, and founded in 2001 by Dean Debnam, its first president and current CEO. It is known for highly accurate polling for key races. It tends to lean Democratic and focuses on the so-called house-effect analysis.

### Rasmussen Reports

Founded in 2003, the company collects, publishes, and distributes public polling information. It notably does tracking polls at national and state levels on elections, politics, current events, and the president's job approval ratings. It was founded by Scott Rasmussen and is headquartered in Asbury Park, New Jersey.

### Ready for Hillary

This independent super-PAC was formed to support and agitate for Secretary Hillary Clinton to run for president in 2016. In ended on April 2, 2016, when Secretary Clinton announced and launched her official campaign. It had collected a list of four million e-mail addresses of supporters, and upon its closure donated much of its supplies and its campaign bus to Emily's List.

### Real Clear Politics

Real Clear Politics, a Chicago-based news and polling data aggregator, was formed in 2000 by John McIntyre and Tom

Bevan. It is very conservative oriented and publishes opinions, news, and political analysis.

### Republican Governors Association

Founded in 1963, the RGA works to elect Republican governors. It is headquartered in Washington, D.C. Its 2016 chair is Susana Martinez (R-NM).

### Republican National Committee

The Republican National Committee provides leadership for the Republican Party. It is responsible for organizing the National Convention, drafting the party platform, fund raising, and finalizing election strategy. It was founded in 1856. It is headquartered in Washington, D.C., and was chaired by Reince Priebus, who, after the election of Donald Trump, was selected to be his chief of staff.

### Research 2000

This is a public opinion and marketing research firm based in Olney, Maryland. It has been conducting research on elections since 1999. Its president is Del Ali. It is notable for asking unusual polling questions, such as comparing Donald Trump to Joseph Stalin and identifying the significance of the "gender gap" it calls "Generation Jones," and analyzing the key to the 2006 midterm elections.

### Restore Our Future, Inc.

Restore Our Future, Inc. is a noted Republican/Conservative super-PAC supporting Mitt Romney. It was founded in 2012 by Carl Forth, Charles Spies, and Larry McCarthy. McCarthy is a long-time Republican political operative famous for developing the "Willie Horton" ad. In 2012, it raised $150 million. It uses social media platforms such as YouTube and Facebook to raise its war chest.

### Right to Rise USA

This independent-expenditure super-PAC, raised more than $86 million to support Jeb Bush for the Republican presidential nomination in 2016. Its treasurer was Charles Spies. It was headquartered in Los Angeles and exemplifies the Republican/Conservative/Establishment super-PACs that arose after the *Citizens United* decision.

### Senate Majority PAC

This super-PAC was formed to help take back the Senate majority status for the Democratic Party. It raised more than $67 million for the 2014 election cycle. For 2016, it has raised nearly $19 million, according to OpenSecrets.org.

### The Sierra Club

The Sierra Club was founded by the legendary conservationist John Muir in 1892. It is a good example of an interest group that develops a political advocacy PAC, a 501(c)(4) super-PAC. It is the largest and most influential grassroots environmental organization, with 2.4 million members and supporters. It helped pass the Clean Air Act, the Clean Water Act, and the Endangered Species Act. It pushes to move the U.S. economy away from fossil fuel dependency toward clean energy and renewable energy sources. It has 64 chapters nationwide. Its national headquarters is in Oakland, California, and its legislative lobbying office is in Washington, D.C. Its executive director is Michael Brune.

### Stand for Truth PAC

In November 2015, this super-PAC was formed to support Senator Ted Cruz in his bid for the Republican Party nomination for president. It spent more than $4 million on TV ads promoting Ted Cruz for president. It raised $2.4 million in 2015 and in 2016 spent $5.2 million for TV ads and $1 million on anti-Trump attack ads. It was led by Josh Robinson and Hal Lambert.

### Susan B. Anthony List

This is a pro-life PAC, formed as the counterpart to Emily's List. It is a 501(c)(4) nonprofit which aims to reduce abortions. It raises and expends money to support women candidates for office through its SBA List Candidate Fund. It was founded in 1993 by Marjorie Dannenfelser and Rachel MacNair.

### The Tea Party Movement

The Tea Party is a grassroots movement promoting conservative positions on national security and sovereignty and domestic tranquility. It was established in September 2004. Considering the Constitution inherently conservative, it advocates 15 nonnegotiable core beliefs: illegal aliens are here illegally, pro-domestic employment is indispensable, a strong military is essential, special interests must be eliminated, gun ownership is sacred, government must be downsized, the national budget must be balanced, deficit spending must be ended, bailout and stimulus plans are illegal, reducing personal income taxes is a must, reducing business income taxes is mandatory, political offices must be available to average citizens, intrusive government must be stopped, English as our core language is required, traditional family values are to be encouraged. It claims tens of millions of members. Its president is attorney Steve Eichler. In 2016, the Tea Party supported Dr. Ben Carson, Senator Ted Cruz, and Senator Rand Paul.

### VOX

VOX is a general interest news site formed to explain news, politics, public policy, world affairs, popular culture, and science issues and events. Begun in 2005, its president is Mena Trott. Its site was launched in October 2006. Its editor-in-chief is Ezra Klein.

### You Gov

This is an international website firm based on market research and formed in the United Kingdom, with operations in Europe,

North America, Middle East, and Asia Pacific. It was founded in May 2000 by Stephan Shakespeare, Nadhim Zahawi, and Peter Kellner. It is a global market research data company.

### Zogby International

Zogby International is a research company serving a variety of industries, governments, colleges, universities, and nonprofit organizations. It has polled for four presidential election cycles and many off-year state and local elections. It does a variety of opinion polling and data analyses. Its president and CEO is John Zogby.

## People

*The following section presents short biographical sketches of individuals active in political parties and U.S. elections. Some are elected politicians, some political party organizational leaders, and some are political activists and leaders of various political action committees or similar organizations.*

### Sheldon Adelson (1933–)

According to Forbes, Sheldon Adelson is the 14th richest person in the world, with an estimated net worth of $27.2 billion. He is the chairman and CEO of Las Vegas Sands, America's biggest casino company. Adelson began life in poverty in Boston's tenement neighborhood but proved his entrepreneurial skills when, at age 12, he borrowed $200 to buy a corner newspaper stand location. Over several decades, he built his fortune, in vending machines, selling newspaper ads, helping small businesses go public, developing condos, and hosting trade shows. In 1995, he built the Venetian Hotel and Casino for $1.5 billion. In 2015, his family secretly bought the *Las Vegas Review Journal* newspaper for $140 million.

Adelson is willing to use hundreds of millions of dollars to buy influence in the Republican Party, exemplified by what became known as the "Adelson primary" in 2016, in which

candidates such as Jeb Bush, John Kasich, and Chris Christie went to Las Vegas to meet him, pitch their campaign vision, and solicit his money.

### Roger Ailes (1940–2017)

Roger Ailes was an American television executive and the founder and former chairman and CEO of Fox News and the Fox Television Stations Group, owned by media mogul Rupert Murdoch. Ailes was forced to resign in late July 2016 (after the Republican Party National Convention) over allegations of sexual harassment by a half-dozen former Fox News employees. Ailes rose to prominence in Republican Party circles as the media consultant to Presidents Richard Nixon and George H. W. Bush and for Rudy Giuliani's first mayor's race. Ailes was born in Ohio and educated at Ohio University. Prior to his death on May 18, 2017, he had an estimated worth of $25 million. In 1988, he coauthored *You Are the Message: Secrets of Master Communicators.* He founded Fox News in 1996, gradually guiding it to become the largest cable news network and the unofficial voice of the Republican Party and media leader of the conservative political movement.

### Richard "Dick" Keith Armey (1940–)

Dick Armey is a noted American politician and lobbyist and from 1985 to 2003 was a member of the House of Representatives from Texas (R-TX-26). He was the Republican whip and then majority leader from 1995 to 2003. He left the House, succeeded as majority leader by John Boehner in 2003, when he went to serve as executive of Freedom Works, where he continued until 2012. He was notable, with Newt Gingrich, as one of the leaders of the 1990s "Republican revolution" and its "contract with America." Armey is a former economics professor and since leaving Freedom Works is a political consultant, advisor, and lobbyist.

## David Axelrod (1955–)

David Axelrod is a noted journalist, political commentator, and political consultant, best known for being the senior advisor to President Obama's presidential campaigns and in the White House. He graduated from the University of Chicago with a BA degree in political science. At age 27, he began as a reporter, then the youngest ever, for the *Chicago Tribune* newspaper. He founded two organizations: Citizens United for Research in Epilepsy and Axelrod and Associates, later known as AKPD Message and Media. In 1984, he began his political consultant career when he joined the management team for then representative Paul Simon (D-IL) in his run for the U.S. Senate. In 1987, he worked for the successful reelection campaign of Harold Washington, the first black mayor of Chicago. Axelrod has been a high-level political consultant to Bill Clinton, John Edwards, and Hillary Clinton. He worked for Barack Obama's 2005 campaign for the U.S. Senate. In 2006, he was political advisor and then chief advisor to Representative Rahm Emanuel (D-IL). In 2008, he was senior advisor to Barack Obama's successful campaign for the U.S. presidency. He then served in the White House as senior advisor, 2009–2011. He is author of a bestselling book *Believer: My Forty Years in Politics*. In 2013, he left the White House and joined the faculty of the University of Chicago as director of the Institute of Politics. He is also a senior political analyst for NBC News and for MSNBC. In 2014, he served as the strategic advisor to the Labour Party, UK. In 2015, he began the podcast The Axe File.

## Paul Begala (1961–)

Paul Begala is an American political consultant and CNN political commentator. He was a noted advisor to the pro-Hillary super-PAC, having previously served as counselor to President Bill Clinton. He and his then–business partner James Carville were the chief strategists of the 1992 Clinton/Gore campaign.

Begala was educated at the University of Texas-at-Austin. He is the author of books *Is Our Children Learning? The Case Against George W. Bush* (2000) and *It's Still the Economy, Stupid* (2002). According to the Center for Responsive Politics, he earned $600,000 as the political consultant to Priorities USA and Priorities USA Action, the pro–Hillary Clinton super-PACs.

## George H. W. Bush (1924–)

George Herbert Walker Bush served as the 41st president of the United States (1989–1993). George H. W. Bush was born in Massachusetts. He attended the Phillips Academy in Andover, Massachusetts. In 1943, he enlisted in the U.S. Navy and became its youngest naval pilot. He flew 58 combat missions during World War II and, as a torpedo bomber pilot, was shot down by Japanese anti-aircraft fire and rescued by a U.S. submarine. He was awarded the Distinguished Flying Cross for bravery in action. After the war, he completed his education, married Barbara Pierce, and raised his family of six children. He graduated from Yale University, captain of the Yale baseball team and member of the prestigious honor society Phi Beta Kappa. After Yale, he began a career in the oil industry in West Texas. Like his father, Prescott Bush, who was a U.S. senator (R-CT), he began his career in politics, serving two terms in the Congress (R-TX) and twice ran unsuccessfully for the Senate. He was appointed to several high-level positions: ambassador to the United Nations, chairman of the Republican National Committee, chief of the U.S. Liaison Office to the People's Republic of China, and director of the Central Intelligence Agency. He campaigned for the Republican nomination for president in 1980, losing to Ronald Reagan, who then selected him as his vice presidential running mate. He served as vice president, 1980–1988. In 1988, he won the nomination of the Republican Party for president and picked Dan Quayle (R-ID) as his running mate. They went on to defeat

Massachusetts governor Michael Dukakis in the general election. Bush served as president 1989–1993, during which time he sent U.S. troops into Panama to overthrow General Manuel Noriega. When Iraq invaded Kuwait, President Bush formed a coalition of United Nations allied nations that sent 118,000 troops into battle—Operation Desert Storm—and routed Iraq's million-man army.

After being hit by a recession in the U.S. economy, Bush lost his bid for reelection to Democrat Bill Clinton in 1992.

## George W. Bush (1946–)

George W. Bush served as the 43rd president (2001–2009), a wartime president after the airborne terrorist attacks on September 11, 2001. George Bush was born in New Haven, Connecticut. The family moved to Midland, Texas. Bush graduated from Yale and took a business degree from Harvard, and then returned to Midland and also entered the oil business. He married Laura Welch and they had twin daughters. His first foray into politics was an unsuccessful run for the House of Representatives. He later co-owned the Texas Rangers baseball team. He ran for governor of Texas, serving as its 46th governor from 1995 to 2000. He was elected U.S. president in 2000, after a closely contested race against Al Gore, who won more popular votes but lost the White House when the U.S. Supreme Court, in *Bush v. Gore* (2000), awarded the Electoral College votes of Florida to Bush (Bush-Cheney won 271 to 266). In winning the presidency, Bush became only the second president to be son of a former president (the other father-son presidents were John Adams and John Quincy Adams). After the attacks of September 11, 2001, President Bush formed a new cabinet-level Department of Homeland Security. Other of his notable first-term actions were sending U.S. armed forces into Afghanistan and reorganizing the nation's intelligence services, passing major tax cuts and a major domestic education policy—No Child Left Behind—which became the signature

policy accomplishment of his first term. In 2004, Bush-Cheney ran for reelection against Kerry-Edwards and won 51 percent to 48 percent. Bush ordered the invasion of Iraq in 2005. His tax cuts and deficit spending contributed to an economic recession after a housing market and financial market collapse in 2008.

### John Ellis "Jeb" Bush (1953–)

Jeb Bush was born in Midland, Texas. In 1974 he married Columba Gallo. He cofounded the first charter school in Florida, the Liberty City Charter School. In 1986, he was elected Florida's secretary of commerce. In 1987–1988, he worked for his father's presidential campaign. In 1994, he ran for but lost the election for governor of Florida. In 1998, he was elected lieutenant governor of Florida. In the same year, he ran for governor of Florida, which he won, and served two terms as the state's 43rd governor (1999–2007). In 1999, he formed Choose Life, a pro-life advocacy group. In 2016, Jeb Bush ran as a candidate for the Republican Party nomination for president. Despite amassing a campaign war chest in excess of $100 million and having a super-PAC that raised nearly as much, he was seen by many Republican primary voters as too progressive on immigration reform and too much of an establishment candidate in a year when the outsider and anti-establishment candidates were favored. He lost to Donald Trump.

### Jimmy Carter (1924–)

President Jimmy Carter, the 39th president of the United States, 1977–1981, was born in Plains, Georgia. He married Rosalyn Smith in 1946. He earned a BS degree from the U.S. Naval Academy in 1946 and became a U.S. Navy submariner, involved in its nuclear submarine program. He did graduate work at Union College in reactor technology. In 1953, upon the death of his father, he resigned from the Navy to run the family farm in Georgia. In 1962, he was elected to the Georgia State Senate. In 1966, he lost his first bid for the office of

governor. He ran again and won that office in 1971. In 1974, he served as Democratic National Committee chair and in December of that year announced his presidential bid. Despite starting as the decidedly dark horse candidate in the primaries, he won the nomination and the presidency in 1976. His notable achievements as president included founding the U.S. Department of Education and the U.S. Department of Energy; signing of the 1977 Panama Canal Treaty, the Camp David Accords, and the Salt II Treaty with the Soviet Union; and establishment of full diplomatic relations with the People's Republic of China. The Iran hostage crisis after the Iranian Revolution contributed to a marked drop in his job approval ratings, and when he ran for reelection in 1980 he lost badly to Republican Ronald Reagan. After leaving the White House, he went on to a post-presidency career many rate as more successful than his presidency. In 1982, he became a university distinguished professor at Emory University. He founded the Carter Center (focused on human rights). He was awarded the Nobel Peace Prize in 2002, one of only four presidents in U.S. history to have been so awarded. As former president, he went on several foreign diplomacy missions and domestically was notably involved with Habitat for Humanity. He is the author of 29 books, including *Why Not the Best?* (1975), *A Government as Good as Its People* (1977), *Keeping Faith: Memoirs of a President* (1982, 1995), *Beyond the White House: Waging Peace, Fighting Disease, Building Hope* (2007), *A Call to Action: Women, Religion, Violence, and Power* (2014), and *A Full Life: Reflections at Ninety* (2015).

### James Carville, Jr. (1944–)

Chester James Carville, Jr., is a noted American political commentator and media consultant and prominent Democratic Party strategist. He gained national attention leading the successful presidential campaign of Bill Clinton in 1992. Carville was born in Louisiana. He graduated from Louisiana State

University, Baton Rouge, and took his JD degree from LSU. He served in the U.S. Marine Corps for two years. From 1973 to 1979, he worked as a litigator and taught high school. Carville was first involved in consulting work with Gus Weill, who ran an advertising firm specializing in political campaigns in Baton Rouge. Prior to the Clinton campaign, Carville joined his consulting partner Paul Begala to run several successful gubernatorial campaigns: Robert Casey in Pennsylvania in 1986, Zell Miller in Georgia in 1990, and Brereton Jones in Kentucky in 1991. Carville and Begala rose to prominence, leading the campaign of Senator Harris Wofford of Pennsylvania from a 40-point deficit to victory over White House–backed Dick Thornburgh. During that campaign, Carville coined the slogan "it's the economy, stupid," which he later used in Bill Clinton's 1992 campaign. After Clinton defeated George H. W. Bush in 1992, Carville received the Campaign District Manager of the Year award from the American Association of Political Consultants. His role in the Clinton campaign was featured in the documentary-feature-length and Academy Award–nominated film *The War Room*. He married Mary Matalin, a Republican and now Libertarian political consultant/analyst, in 1993. He has worked on several foreign campaigns, including for Tony Blair, former prime minister of the UK, and Ehud Barak of Israel's Labor Party. He worked briefly in a last-minute consulting role on Senator John Kerry's 2004 presidential campaign. He taught at Northern Virginia Community College and in 2006 began working in the film and media industry. He is now a regular contributor and political consultant to CNN, where he cohosted *Crossfire* from 2004 to 2005. In 2009, he began teaching political science at Tulane University and in 2014 joined Fox News Channel as a contributor.

## Hillary Rodham Clinton (1947–)

The 2016 Democratic presidential nominee, Secretary Hillary Clinton, was born in Chicago, Illinois, on October 26, 1947.

She graduated from Wellesley College in 1969 and Yale University Law School in 1973. She is the first woman selected as a major party's presidential nominee. She was a registered Republican until 1968. After serving as a congressional legal counsel, she moved to Arkansas and married Bill Clinton in 1975. In 1978, she was appointed the first legal chair of the Legal Services Corporation and in 1979 the first woman partner of the Rose law firm. She served as Arkansas First Lady, 1983 to 1992, and as First Lady of the United States, 1993–2001, during which time she led an unsuccessful effort to pass a single-payer, national health care plan and helped create programs for children's health care, adoption, and foster care. Her marriage endured the Whitewater controversy in 1996 and the Lewinsky scandal in 1998. After her husband left office, Hillary ran for and was elected senator from New York, taking office in 2001 and serving until 2009. Following the September 11 attacks, she voted for the war in Afghanistan and voted for the Iraq Resolution. She sought to hasten the withdrawal of troops from Iraq and opposed the Iraq war troop surge in 2007. She voted against Senate approval of Supreme Court nominees John Roberts and Samuel Alito. Clinton was reelected to the Senate in 2006. She ran for president in 2008, losing to then senator Barack Obama but winning more delegates than any previous female candidate. President Obama appointed her as secretary of state in January 2009; she served in that office until 2014. Notable events during her term as secretary of state, in which she traveled more miles than any previous secretary, were the Arab Spring movement, which prompted her to advocate the U.S. military intervention in Libya, and the 2012 Benghazi attack. While secretary of state, she wrote her fifth book and undertook extensive speaking engagements before announcing her bid for the presidency. Her six books are *Hard Choices* (2015), *Living History* (2004), *It Takes a Village* (1996, 2006), *An Invitation to the White House* (2000), *Dear Socks, Dear Buddy* (1998), and *The Unique Voice of Hillary Rodham Clinton* (1997). She won the Democratic

primaries and was nominated by the Democratic Party on July 28, 2016. Clinton and her vice presidential pick, Senator Tim Kaine (D-VA), were defeated by Republican nominee Donald Trump and vice presidential nominee Mike Pence (R-IN) in the general election.

### William Jefferson Clinton (1946–)

William J. Clinton was the 42nd president of the United States, serving 1993–2001. He was the first president of the baby boomer generation, born in Hope, Arkansas. As a youth in Boys Nation, he met President John F. Kennedy at an event in the Rose Garden. He is a graduate of Georgetown University, taking a degree in foreign service in 1968. He was class president in 1964 and 1965 and in 1964–1967 a congressional intern with Senator William Fulbright. He was a Rhodes scholar at University College, UK, where he studied philosophy, politics, and economics.

He earned his JD degree from Yale Law School in 1973, where he met his future wife, Hillary Rodham. After Yale, he moved to Arkansas. He married Hillary in 1980, the year he ran for a seat in Congress but lost. He served as attorney general of Arkansas, 1977–1979. He ran and served a term as the 40th governor of Arkansas, 1979–1981. He ran again and was the 42nd governor of Arkansas, serving 1983–1992. While governor, he helped establish a "centrist Democrat" organization, the Democratic Leadership Council, 1990–1991. Clinton ran for the Democratic nomination for the presidency in 1992—surviving in a tough-fought primary battle, securing the nomination, and winning the White House with Senator Al Gore as his running mate, defeating the incumbent Republican president, George H. W. Bush, whose reelection bid was marred by an economic recession. As titular head of the Democratic Party, Bill Clinton moved the party to the center. He sent peace-keeping forces to Bosnia, was a strong proponent of expanding the North Atlantic Treaty Organization, and

negotiated the world trade agreement, the North American Free Trade Agreement. He launched a worldwide campaign against drug trafficking but failed in an effort to enact a single-payer system of national health care. His centrist budget policy helped spur an economic recovery that saw the U.S. economy in best health in decades, which lasted until he left office, with a budget surplus. He won reelection to a second term but was embroiled in the Lewinsky sex scandal and was impeached by the House of Representatives but not convicted in the Senate. Since leaving the White House, he founded the Clinton Foundation, raising hundreds of millions of dollars and funding various charity efforts around the world. He is now an "elder statesman" of the Democratic Party and has worked with the Obama administration despite their original animosity during 2008. William Clinton is author of five books: *My Life* (2004), *Giving* (2007), *Back to Work* (2011), *Between Hope and History* (1996), and *Clinton Foreign Policy Reader* (2000).

### Ted Cruz (1970–)

Senator Ted Cruz (R-TX) was born in Calgary, Canada. In 1992, he graduated from Princeton University and from Harvard Law School in 1995. He married Heidi Nelson in 2001. From 1999 to 2003, he served as director of the Office of Policy Planning, Federal Trade Commission, and was deputy attorney general in the U.S. Department of Justice. In 2000, he was the domestic policy advisor to George W. Bush's presidential campaign. He served as solicitor general of Texas, 2003–2008, and as an adjunct professor, University of Texas School of Law at Austin, 2004–2009. In 2013, Cruz was the first Hispanic American (of Cuban descent) to be elected to the U.S. Senate from Texas. He chairs the Senate Judiciary's Subcommittee on Oversight, Federal Rights and Agency and the Commerce Committee's Subcommittee on Space, Science, and Competitiveness. Cruz announced his campaign for the Republican Party nomination for president in March 2015 and

appealed strongest to the libertarian/conservative wing in the Republican Party. He won the Iowa caucus and was the last remaining candidate in the field of 17 to continue to challenge Donald Trump. He suspended his campaign on May 3, 2016, after losing the Indiana primary. He spoke at the Republican National Convention in Cleveland in July, notably refusing to endorse Donald Trump.

### Jim DeMint (1951–)

Jim DeMint is an American politician, who is a leading figure in the Tea Party movement and member of the Republican Party. He was educated at the University of Tennessee, Knoxville, and Clemson University. He ran an advertisement firm in Greenville from 1981 to 1983, when he created the DeMint Group. He served as representative from South Carolina's 4th Congressional District from 1999 to 2005. He served as senator from South Carolina (R-SC) from 2005 to 2013, winning reelection in 2012. He resigned from the Senate in 2013 to become president of the Heritage Foundation, a conservative think tank based in Washington, D.C.

### Maureen Dowd (1952–)

Maureen Dowd is an American columnist for the *New York Times* as well as a best-selling author. She earned her BA degree from Catholic University in 1973. She has been a reporter or columnist for *The Washington Star, Time,* and *New York Times.* She won a Pulitzer Prize for her series of columns on the Monica Lewinsky scandal in 1999. She began serving as the *New York Times* Washington bureau correspondent in 1986. In 1991, she received a Breakthrough Award from Columbia University and in 1994 won the Matrix Award from New York Women in Communications. She became a columnist for the *New York Times* op-ed page in 1995. In 2010, she was ranked 43 on the 100 most influential liberals in America and in 2007 was 37th on the same list. Her columns have been notably critical of

President Bill Clinton, Vice President Dick Cheney, and President Barack Obama. She has authored two books: *Bushworld: Enter at Your Own Risk* (2004) and *Are Men Necessary: When Sexes Collide* (2005).

## Matt Drudge (1966–)

Matt Drudge is an American political commentator and self-described news aggregator, famous for his online Drudge Report, a conservative news and commentary website. He is arguably one of the most influential Republican media personalities. Drudge was born in Takoma Park, Maryland. In 1989, he moved to Los Angeles, where he worked in the gift shop of CBS Television. In 1994, he began publishing an e-mail newsletter and in 1995 launched the Drudge Report. In 1996, he quit his day job and began covering politics. In the 1996 campaign, he was the first to report Bob Dole's vice presidential choice and ran articles on Bill Clinton's sexual harassment accusations. By 1998, he was a household word and was the first to publish a story on the Clinton-Lewinsky affair. His use of the Internet has changed the way news is disseminated. He began a weekly program on Fox News as well as his own radio show for ABC. In 2001, he published his coauthored book (with John Phillips) *The Drudge Manifesto*, which became a best seller. In 2001, his *The Matt Drudge Show* debuted on talk radio, which ran until 2005.

## Jennifer Granholm (1969–)

Jennifer Granholm was born in Vancouver, Canada. She is an attorney, educator, published author, politician, and now a CNN political commentator. She graduated from the University of California–Berkeley and earned her law degree from Harvard Law School. While at Harvard Law, she was editor-in-chief of the *Harvard Civil Rights-Civil Liberties Law Review*. Granholm served as the attorney general of Michigan, 1999–2003, and as governor of Michigan for two terms, 2003–2011. She

served on President Obama's transition team in 2009. She was active in Obama's 2012 campaign and served as a surrogate for the Hillary Clinton 2016 campaign. She coauthored, with her husband, *A Governor's Story: The Fight for Jobs and America's Future* (2011). She was host, on Current TV, of *The War Room with Jennifer Granholm*.

### Phil Griffin (1956–)

Phil Griffin is president of MSNBC, the cable news channel. He manages its day-to-day operations, which included development of its political opinion/commentary shows and its slogan "The Place for Politics" for its slate of programs. After Griffin graduated from Vasser College, he joined CNN in 1980. He produced shows like *Hardball with Chris Matthews* and *The Big Show with Keith Olbermann*, 1997–1998. From 1988–1991, he was writer/producer of *Today* on CNN. He has been with MSNBC since it was launched in 1996. He crafted its branding campaign Lean Forward. He became its senior vice president in 2005 and has had executive oversight of the network since 2006. Griffin launched such successful MSNBC shows as *Morning Joe*, *The Rachel Maddow Show*, *The Ed Show*, and *The Last Word with Lawrence O'Donnell*. He was named president of MSNBC in 2008. He has guided the network as the liberal/Democratic-leaning rival to the Fox News Network.

### Louis Harris (1921–2016)

Louis Harris was a prominent public opinion analyst. He was born in New Haven, Connecticut. Harris graduated from the University of North Carolina with a degree in economics in 1942. He served in the U.S. Naval Reserve from 1942 to 1946. Upon leaving the Naval Reserve, Harris joined the Elmo Roper firm conducting its political research. He authored several books: *There Is a Republican Majority* (1954), *The Negro Revolution in America* (1964), *Black-Jewish Relations in New York City: The Anguish of Change* (1973), and *Inside America* (1987). Harris

wrote for the *Washington Post* and for *Newsweek*, 1963–1968 and for the Chicago News-New York Daily News Syndicate, 1969–1988. He left Roper in 1960 to work for the Kennedy campaign, becoming the first presidential pollster. In 1962, he was chief polling analyst for CBS News, developing the computer analysis of voting results from a few key precincts that were used to project a winner. In 1969, he moved to ABC News as a polling analyst. In 1992, he retired, and then began LH Research. In 1996, LH was bought by Gordon Black and became known as Harris Interactive.

### Ryan Hecker

Ryan Hecker is a Houston attorney and the chief operating officer and treasurer of the super-PAC Freedom Works for America. He was a leading activist for the Tea Party movement both locally and nationally. He is a board member of the Houston Tea Party and was the chief organizer of Contract from America, a grassroots fiscal reform plan now signed by 80 congressional members and 300 candidates for the Senate and the House. Freedom Works claims 300,000 members.

### Harold Ickes (1939–)

Born in Baltimore, Maryland, Harold M. Ickes was White House deputy chief of staff under Leon Panetta, for President Bill Clinton (1993–1997). He is the son of Harold L. Ickes, who served as the secretary of the interior under President Franklin D. Roosevelt. He graduated from Stanford University in economics in 1964 and from Columbia Law School. He was a civil rights activist in the 1960s and took part in the Freedom Summer. He has practiced law for many years in New York City. He has been active in Democratic Party politics for more than 40 years, working for the campaigns of Eugene McCarthy, Birch Bayh, Morris Udall, Ted Kennedy, and Jesse Jackson; he was senior advisor to David Dinkins' mayoral campaign in 1989. Since 2005, he has been associated with

Catalist, a progressive data collection and voter file organization. In 2009, he joined New York governor David Paterson's election campaign as senior advisor. He chaired Bill Clinton's presidential campaign in New York in 1992. He was senior advisor to Hillary Clinton's Senate campaign and was dubbed "Hillary's Hammer." Ickes now heads Media Fund, a 527 committee. He worked as a political strategist for Hillary Clinton's presidential primary campaign in 2008. Currently, he is on the DNC's Rules Committee.

## Tom Jensen

Tom Jensen is the director of Public Policy Polling (PPP), overseeing its day-to-day operations. As such, he is a leading pollster most often used by Democratic party candidates and is known for accuracy in polling for key races. He was born in Ann Arbor, Michigan. He is an honors graduate from the University of North Carolina–Chapel Hill. At PPP, Jensen writes their blog and Twitter accounts and crafts most of their political surveys. He is frequently a guest commentator on television and radio shows and has been an expert political analyst for a number of publications, such as the *New York Times*, *Wall Street Journal*, *Christian Science Monitor*, and *US News and World Report*.

## Gary Johnson (1953–)

Gary Johnson is an American businessman, politician, and Libertarian Party nominee for president (2012, 2016). He was born in North Dakota. He endorsed Ron Paul in the 2008 election. From 2011 to 2016, he served on the Board of Directors of Students for Liberty, a nonprofit libertarian organization. Prior to his change to the Libertarian Party, in 2011, Johnson was a registered Republican. He attended the University of New Mexico, 1971–1975, earning a degree in political science. He started a business, Big J Enterprises, in 1976, which soon earned $38 million, employing 1,000. He sold the

business in 1999. Johnson ran for governor of New Mexico in 1994, won and served until 1998, and then was reelected to a second term. He was a fiscal conservative as the 29th governor, introducing cost-benefit analysis to the state during his first term and a school voucher program in his second term (1995–2003). In 2011, he ran for the Republican Party nomination for president but withdrew and declared for the Libertarian Party, running on a ticket with James Gray of California as his vice presidential nominee. The ticket received 0.99 percent of the popular vote, or 1.27 million votes. He announced for the presidential nomination again in 2016 and selected former two-term Republican governor of Massachusetts William Weld as his vice presidential candidate. He helped found Our American Initiative PAC, an independent-expenditure PAC that helps fund Libertarian campaigns. In 2013, Johnson authored a book *Seven Principles of Good Government.* Some analysts maintain that the Johnson-Weld ticket contributed to the Clinton-Kaine loss in such states as Florida, Pennsylvania, Ohio, Michigan, and Wisconsin, likening their effect to the Ralph Nader impact on the 2000 presidential race.

### Tim Kaine (1958–)

U.S. senator Tim Kaine (D-VA) was the 2016 Democratic Party candidate for vice president. He was a missionary, a civil rights lawyer, a teacher, and politician. He was educated at the University of Missouri in Columbia and earned his law degree from Harvard Law School. He worked in his father's iron-working shop in Kansas City. He served as a missionary at the Jesuit technical school in Honduras. He practiced law in Richmond for 17 years, in civil rights law regarding housing discrimination due to race and disability. In 1994, he was elected to the City Council as member in Richmond. In 1998, he won as mayor of Richmond, serving until he went on to become lieutenant governor of Virginia in 2002. He was elected as the 70th governor of Virginia in 2006. He also served as the

chair of the Democratic National Committee from 2006 to 2010. He was elected to the U.S. Senate in 2012. He serves on the Armed Services Committee, the Budget Committee, the Foreign Relations Committee, and the Special Committee on Aging. He is founder and cochair of the bipartisan Career and Technical Education caucus in the Senate. In 2014, Kaine cohosted a bipartisan conference on climate change and its effects on Virginia. He coauthored, in 2015, the Elementary and Secondary Education Act.

### Gene Karpinski (1952–)

Gene Karpinski is president of the League of Conservation Voters. He is a graduate of Brown University and earned his JD in 1977 from Georgetown University Law Center when he joined Congress Watch as its field director. In 1981, he became the executive director of Colorado Public Interest Research Group and has served for 21 years as director of the U.S. Public Research Group, a national lobbying office for state public interest research groups across the country, leading many environmental issue campaigns. Karpinski serves on the national boards of a number of national organizations: America Votes, Earth Share, Partnership Project, Beldon Fund, and the National Association of Public Interest Law. After serving for 12 years as a League of Conservation Voters (LCV) member and on its board of directors and its PAC, he became LCV president in 2006.

### John Kerry (1943–)

Former U.S. secretary of state John Kerry assumed that office in 2013, as the 68th secretary of state and the first sitting Senate Foreign Relations Committee chair to do so. He was born in Colorado, son of a foreign service officer. He graduated from Yale University, serving in the U.S. Navy for two tours of duty. He was a combat swift boat skipper patrolling the rivers of the Mekong Delta. He was awarded a Silver Star,

a Bronze Star with Combat V, and three Purple Hearts. He returned to the United States and was vocal against the Vietnam War, testifying before the Senate Foreign Relations Committee. In 1976, he earned his law degree from Boston College School of Law and worked as a prosecutor in Massachusetts against organized crime, fought for victims' rights, and created programs for rape counseling. He became lieutenant governor of Massachusetts in 1982 and in 1984 was elected to the U.S. Senate, where he served for 28 years. Kerry became chairman of the Senate Foreign Relations Committee in 2009 and chairman of the Senate Select Committee on POW/MIA Affairs. As chair of the Foreign Relations Committee, he was instrumental in the ratification of the New START Treaty, a nuclear arms reduction agreement with Russia. He was the Democratic Party's nominee for president in 2004, losing to the Bush-Cheney ticket. He is author of the best-selling books *A Call to Service: My Vision for a Better America* and *This Moment on Earth*, an environmental book he coauthored with his wife, Teresa Heinz Kerry.

## Matt Kibbe

Matt Kibbe served as president of Freedom Works from 2004 to 2015. He is founding president and chief community organizer of Free the People, a nonprofit libertarian organization. Matt Kibbe earned his BA in economics from Grove City College and did graduate work in economics at George Mason University. He is CEO of Freedom Works. He is a frequent guest commentator on such television shows and channels as HBO, *Real Time with Bill Maher*, CNN, MSNBC, PBS, The Blaze TV, and CSPAN. Kibbe was the budget director of the U.S. Chamber of Commerce and served as the senior economist for the Republican National Committee under RNC Chair Lee Atwater. He is the author of *Don't Hurt People and Don't Take Their Stuff: A Libertarian Manifesto* (2014) and coauthor of *Give Us Liberty: A Tea Party Manifesto* (2010).

## Charles Koch (1935–)

Charles Koch was born in Wichita, Kansas. He is president of Koch Industries. His estimated worth is $44.2 billion. Charles graduated from the Massachusetts Institute of Technology in 1959. He joined the family business and became its CEO and chairman in 1967. Like his father, Fred C. Koch, the founder of the family oil business, he supports conservative politics. Fred Koch was the founder of the ultra-conservative John Birch Society. Charles donates millions of dollars annually to various conservative think tank organizations. He founded the Cato Institute in 1977 and Americans for Prosperity in 1984. The Koch brothers favor laissez-faire economics and low taxes, are notably anti-union, are for the privatization of most public services and welfare programs, are vigorously anti–global climate change, and have financially aided the growth of the Tea Party movement. Charles Koch is the author of *The Science of Success: How Market-Based Management Built the World's Largest Private Company.*

## David Koch (1940–)

David Koch is the executive vice president of Koch Industries. He was born in Wichita, Kansas. He earned his BS degree from the Massachusetts Institute of Technology. He joined the family oil business in 1970, which he and his brother then built into Koch Industries, a diversified corporation of oil pipelines, refineries, building materials, paper towels, and Dixie Cups, valued at $115 billion. David Koch's 2015 estimated worth is $44.2 billion. He resides in New York City. In 1984, David founded Americans for Prosperity and Citizens for a Sound Economy. In 1980, Koch ran for vice president on the Libertarian ticket with Ed Clark for president. He is a philanthropist: in 2006, he gave $20 million to the Johns Hopkins University School of Medicine for cancer research; in 2008, he pledged $100 million over 10 years to renovate New York State Theatre in the Lincoln Center for the Performing Arts and $10 million

to renovate the fountains outside the Metropolitan Museum of Art. David and his brother Charles pledged to spend $900 million on political activity, education, and criminal justice reform in 2016. They normally are big donors to the Republican Party and its presidential candidate but with Donald Trump as nominee they spent their money on down-ticket races. According to *Forbes Magazine*, David ranks ninth among billionaires, number 7 in the United States, and was ranked sixth in 2005.

### Alixandria Lapp (1975–)

Alixandria Lapp is the executive director of House Majority PAC, founded in April 2011. She serves as its chief political strategist. She led the campaign to seize majority control of the House of Representatives in 2006. She was the Democratic Congressional campaign director and then became director of the independent-expenditure PAC, raising $55 million. The Democrats gained 30 seats in 2006. In 2008, Lapp served as consultant to set up the DCCC's independent-expenditure program.

### Steven Law (1961–)

Steven Law is the president and CEO of American Crossroads, founded in 2010. He earned his law degree from Columbia Law School and served as the chief of staff to Senator Mitch McConnell (R-KY, 1991–1997). From 1998 to 2000, he was the executive director of the National Republican Senatorial Campaign Committee. Previously, he served as chief legal officer and general counsel of the U.S. Chamber of Commerce. Law was appointed deputy secretary of labor by George W. Bush. He promoted the Bush administration's e-government initiative to promote union financial integrity reform.

### Corey Ryan Lewandowski (1973–)

Corey Lewandowski is an American political operative and now CNN political commentator, best known as former campaign

manager of Donald Trump's campaign for president (January 2015 to June 2016). He was born in Lowell, Massachusetts. Lewandowski was educated at the University of Massachusetts, Lowell, and at American University. He worked as a lobbyist associated with Americans for Prosperity. He also worked for a national voter registration group. His father was a local politician. He worked on congressional and senate campaigns and worked for the Republican National Committee in 2001. As Trump's campaign manager, he worked through the primary season to the point where Donald Trump emerged as the presumptive nominee. Controversy over his handling of a newspaper reporter led to his forced resignation on June 20, 2016. He was replaced by Paul Manafort. Lewandowski went on to work as a political commentator for CNN.

### Charles Lewis (1953–)

Charles Lewis is a former *60 Minutes* producer who founded the Center for Public Integrity. He became a journalist in 1977, at ABC News, and then at CBS News's *60 Minutes*. In 1989, he left *60 Minutes* to begin the Center for Public Integrity out of his home. It has grown to a staff of 40 people doing investigative reporting. He is currently the executive editor of the Investigative Reporting Workshop and is a MacArthur fellow. He has spent his career investigating the use and abuse of power. In 1994, he oversaw and edited the report *Well Healed: Inside Lobbying for Health Care Reform*. He edited *Buying the President*, 1996, 2000, 2004. In 1998, the Center wrote *The Buying of Congress*, in 2003, *Windfalls of War*, and in 2004, *Outsourcing the Pentagon*. In 2005, he was made Ferris professor at Princeton and Shorenstein fellow at Harvard University. He is a tenured professor of journalism at American University. In 2009, he cofounded Investigative News Network, a nonprofit consortium of more than 90 nonprofit, nonpartisan newsrooms across the country. He started the International Consortium of Investigative Journalism, which according to

the *Encyclopedia of Journalism* is the first global website devoted to international exposés.

### Rush Limbaugh (1951–)

Rush Limbaugh is an American entertainer, radio talk show host, writer, and conservative political commentator. He was born in Cape Girardeau, Missouri. He attended but did not graduate from Southeast Missouri State University. He worked for a number of years in various radio capacities, as a disc jockey and sports news, until he began a radio talk show in California in 1984. In 1988, he was broadcasting his own radio show from WABC, in New York City. He is oft married, four times with three divorces, which is ironic given the party's emphasis on family values. His current spouse is Kathryn Rogers, whom he married in 2010. He has received numerous awards: the Marconi Award for Syndicated Radio Personality of the Year Award in 1992, 1995, 2000, and 2004 and the William F. Buckley Jr. Award for Media Excellence in 2007. From 1992 to 1996, he broadcast a one-half-hour syndicated television show produced by Roger Ailes. He launched a line of neckties designed by his then wife Marta. Ronald Reagan called him the number one voice for conservatism in America. His talk shows are enormously successful: his weekly cumulative audience is estimated at 13.25 million listeners, the most listened to talk show program in America. His Rush Limbaugh television show airs for three hours each weekday. In 2008, he signed a $400 million contract, to run until 2016. In 2015, *Forbes Magazine* listed his earnings at $79 million for the previous year. The magazine ranked him as the 11th highest-earning celebrity in the world. In 2003, his career survived a prescription drug addiction scandal. He has authored several books, including *The Way Things Ought to Be* (1993) and *See: I Told You So* (1993), both *New York Times* best sellers. His other books are a series: *Rush Revere and the Brave Pilgrims* (2013), *Rush Revere and the First Patriots* (2014), *Rush Revere and the American Revolution* (2014), and

*Rush Revere and the Star-Spangled Banner* (2015). He is widely considered the voice of the conservative movement, a powerful force in the Tea Party movement, and the most influential commentator in Republican politics.

### Tom Lopach (1973–)

Tom Lopach is the executive director of the DSCC. Lopach was born in Helena, Montana. He received a BA degree from Gonzaga University in 1992. He was the field representative for Democrat Pat Williams from 1992 to 1996. He was Senator Ted Kennedy's (D-MA) office manager in 1999 and was the finance director to the late senator's 2006 reelection campaign. He then worked for Senator Jon Tester (D-MT), serving as his chief of staff from 2010 to 2014. When Senator Tester became chair of the DSCC, he picked Lopach, his long-time aide, to be its executive director (2014 to date).

### Ben Ray Lujan (1972–)

Ben Ray Lujan (D-NM) is a representative in Congress serving as chair of the DCCC. Born and raised in New Mexico, he earned a BA degree in business administration from New Mexico Highlands University. He served as New Mexico Cultural Affairs Department's director of administrative services and chief financial officer. Lujan then served as chairman of the New Mexico Public Regulation Commission and worked to increase renewable energy portfolios to include solar energy, and New Mexico, California, Oregon, and Washington formed the Joint Action Framework on Climate Change to craft regional solutions to climate change. He worked to overhaul the New Mexico Fire Fund to improve fire services in New Mexico and to improve health care by investigating denial practices of the health insurance industry. He participates in a variety of caucuses, reflecting the diversity of his district: Congressional Hispanic Caucus, Native-American Caucus, and the Natural Gas Caucus. Lujan and Representative Frank Wolf (R-VA) founded

the bipartisan Technology Transfer Caucus to help move technology innovations. He was assigned to the House Democratic leadership as chief deputy whip.

### Elisabeth MacNamara

Elisabeth MacNamara is the 18th president of the League of Women Voters (LWV) of the United States. She graduated from Emory University with a BA in 1976 and a JD in 1979 and is a member of Phi Beta Kappa, Omicron Delta Kappa, and Pi Delta Epsilon. She has lived, since 1974, in DeKalb County, Georgia. She joined the LWV in 1983 and has served in leadership at all levels. She was on the board of directors of the State League in 1983, serving until 1991. In 1984, she joined the board of directors of the DeKalb League. In 1997, she was president of the DeKalb League and in 1999 on the regional board of directors of the League of Women Voters of Georgia and served as its president in 2001. She is an attorney, retiring as deputy chief assistant district attorney in the juvenile court division of DeKalb County. She served as a state attorney for the National Center for State Courts and as law clerk for the Superior Court of DeKalb County. She is a volunteer in several other organizations. In leading the LWV, she spearheads its voter registration drives, its political education forums, and its public policy analyses. She was instrumental in the LWV position to advocate for reform of the Electoral College and to support the popular vote for electing the president.

### Rachel Maddow (1973–)

Rachel Maddow is the host and anchor on MSNBC's *The Rachel Maddow Show* (TRMS). She was born in Castro Valley, California. She was educated at Lincoln College and Stanford University, where she received her BA degree in political science. She attended Oxford University in Oxford, UK, as a Rhodes scholar, from where she earned her Ph.D. in political science. Rachel Maddow began working at MSNBC as a

political analyst, and in 2008 the cable news network launched its political news and commentary nightly broadcast show *The Rachel Maddow Show*, with Rachel as anchor. She is the recipient of an Emmy Award for her work on the show. The *Washington Post* named TRMS as one of the top shows of the decade and Rachel as the Break Out Star of 2008. The *Los Angeles Times* put TRMS at number 1 in Best of Television 2008. Politico.com rated her one of the Top Ten Political Newcomers of 2008. Maddow is the author of *Drift: The Unmooring of American Military*, which on its release in 2012 was ranked number 1 on the *New York Times* best-seller list. Rachel lives in New York City and Massachusetts with her partner, artist Susan Mikula.

### Dan Malloy (1955–)

Dan Malloy is the Democratic governor of Connecticut and current chair of the Democratic Governor's Association. Governor Malloy was born in Stamford, Connecticut. He credits his mother, a nurse, for his values. Overcoming learning disabilities, he went on to graduate Magna Cum Laude from Boston College and earned his JD from Boston Law College in 1982. He served as an assistant prosecutor in New York City for four years, winning 22 convictions of 23 felony cases he tried. He was elected mayor of Stamford and served from 1995 to 2009. He was elected governor of Connecticut in 2010 and reelected in 2014. He led the state in a dramatic economic recovery, adding more than 70,000 jobs for the best period of private job sector growth since the 1990s. He led expansion of the state's uninsured population through the state's care exchange, with 280,000 residents enrolling in the first open-enrollment period. He inherited a $3.67 billion deficit and turned that deficit into a balanced budget with an expanded rainy day fund. He was recipient of the John F. Kennedy Profile in Courage Award in 2016 for his decision to resettle Syrian refugees and in 2013 for signing the most comprehensive gun

violence prevention legislation in the country. Connecticut experienced one of the largest decreases in violent crime and property crime in any state in the nation and more than halved the national average. He was selected chairman of the DGA Association in 2016. He received honorary degrees from the University of New Haven, the University of Saint Joseph, the University of Bridgeport, and Nichols College.

### Susan Martinez (1959–)

Susan Martinez is governor of the state of New Mexico and serves as chair of the RGA. In 2010, she became the state's first female governor and the first Hispanic female elected governor in the history of the United States. Her parents ran a small security guard business, and she worked as a security guard while attending college. Born and raised in the Rio Grande Valley, she lives is Las Cruces. She earned her BA from the University of Texas at El Paso and her law degree from the University of Oklahoma School of Law. She served as the elected district attorney for the Third Judicial District in Southern New Mexico from 1996 to 2010. She was named by *Time* magazine as one of its 100 Most Influential People in 2013 and the *Hispanic Business Magazine* named her its Woman of the Year. As governor, she signed a tax reform law and worked to amend the state's tax code. She has emphasized education and job creation in the energy sectors.

### John McCain (1936–)

Senator John McCain (R-AZ) was born at the Coco Solo Naval Station, Panama Canal, the son of Admiral John S. McCain, Jr. Both his father and grandfather were four -star admirals. McCain graduated from the Naval Academy in 1958 and its Naval Flight School in 1960. He volunteered for Vietnam and in 1967 was shot down on his 23rd mission. He was moved to the "Hanoi Hilton" in 1969 and spent 5.5 years in prison there. A true war hero, he was awarded the Silver Star, the Bronze

Star, a Purple Heart, the Legion of Merit, a Distinguished Flying Cross, and a Naval Commendation Medal.

In 1981, he retired as a captain and moved to Arizona. He was elected to the U.S. House of Representatives (R-AZ) in 1982 and reelected in 1984. Embroiled in a campaign finance scandal, he survived the controversy and went on to enact campaign finance reform, the McCain-Feingold Act of 2002. In 1987, he ran for the U.S. Senate, eventually serving four terms. In the U.S. Senate, he chairs the Armed Services Committee (2015); he currently serves on the Committee on Homeland Security and is a member of the Committee on Indian Affairs and an ex-officio member of the Committee on Intelligence. He also cochairs the Senate National Security Caucus. McCain ran unsuccessfully for the Republican presidential nomination in 2000 (losing to George W. Bush) and ran and won the nomination in 2008 but lost to then senator Barack Obama.

### Jim Messina (1969–)

Jim Messina is a political operative and high-ranking political advisor, managing President Obama's reelection campaign in 2012. He was born in Denver, Colorado, and graduated from the University of Montana. He managed the successful reelection campaign of Democratic Mayor Dan Kemmis of Missoula, Montana. He started his political career working for U.S. senator Max Baucus of Montana in 1995 and served as chief of staff to U.S. representative Carolyn McCarthy (D-NY) in 1999. From 2002 to 2004, he served as chief of staff of U.S. senator Byron Dorgan (D-ND) and in 2005 as chief of staff to Senator Baucus (D-MT). He served as White House deputy chief of staff for President Obama from 2009 to 2011. In 2012, he managed President Obama's reelection campaign. After President Obama's win, Messina moved to head Organizing for Action in 2013, while also cochairing Priorities USA, the super-PAC backing Hillary Clinton. That year, Messina launched The Messina Group, providing political consultancy

to political campaigns, advocacy organizations, and businesses, serving as campaign strategy advisor for the British Conservative Party, operating from the United States during the general election campaign in 2015. The American Association of Political Consultants named him Campaign Strategist of the Year in 2012. He serves on the board of directors of several organizations and business: Hyperloop Technologies, Lanza Tech, Vectra Networks, Privacy.com, the U.S. Soccer Foundation, and Montana Land Reliance.

### Rodell Mollineau (1977–)

Rodell Mollineau is a registered lobbyist, political consultant, former president of American Bridge 21st Century, and co-founder of Rokk Solutions, LLC (May, 2015).

He was the former staff spokesman for Senate Majority Leader Harry Reid (D-NV). He helped start American Bridge 21st Century in April 2011, building it to a staff of 25 researchers and 19 trackers for the 2012 presidential election cycle. By 2014, it had a budget of more than $17 million and a staff of 120, and it stocked a number of its operatives to work for Secretary Hillary Clinton's campaign. Mollineau stepped down as president of American Bridge 21st Century in 2014 to establish his own private independent consultancy firm, Rokk Solutions.

### Rupert Murdoch (1931–)

Rupert Murdoch is the Australian-born, American media mogul and multibillionaire (2016 net worth estimated at $11.7 billion). He was born in Melbourne, Australia, the son of the owner of several local and regional newspapers. In 1952, his father died, and Rupert took over the Adelaide newspapers *News* and *Sunday Mail*. By 1956, he expanded to Perth and then to Sydney in 1960. In 1965, he founded the country's first daily paper. He moved to London in 1968, buying *The News of the World*, a Sunday tabloid. He expanded to

the United States, in 1973, buying the *San Antonio News*, and founded *Star*, in 1974. In 1976, he bought *New York Post* and in 1979 founded and headed News Corp, a global conglomerate. In the 1980s and 1990s, he expanded his media empire, buying *Chicago Sun-Times*, *Village Voice*, *New York Magazine*, and the *Times* and *Sunday Times* in London. In 1985, he acquired 20th Century Fox and Fox Film, which he consolidated into FOX, Inc. In 1990, he set up STAR TV in Hong Kong. He is also part owner of the Los Angeles Kings, NHL franchise, the Los Angeles Lakers, Staples Center, Fox Sports Radio, and Fox Sports.com. In 2007, he purchased Dow Jones and *The Wall Street Journal*. Always involved in conservative politics, in 2010, he donated $1 million each to the RGA, the U.S. Chamber of Commerce, and various Republican candidates. In 2015, he handed over leadership of 21st Century Fox to his son James.

### Barack Obama (1961–)

Barack Obama was the 44th president of the United States (2009–2017). He was born in Hawaii and raised with his grandparents. After working his way through college on scholarships, he moved to Chicago, where he worked with a group of churches as a community organizer to help rebuild communities devastated by high unemployment because of the closure of local steel plants. He went on to Harvard Law School, becoming the first African American president of the *Harvard Law Review*.

He returned to Chicago to lead voter registration drives, taught constitutional law at the University of Chicago, and eventually ran for the state legislature. In the Illinois State Senate, he passed the first major ethics reform law in 25 years, cut taxes for working-class families, and expanded health care. As United States senator from Illinois (D-IL), he worked on bipartisan lobbying reform and transparency in government by putting federal spending online. He burst on the national

political scene by giving the Democratic National Convention Keynote Address in 2004. He ran for president in 2008, and after a tough primary battle with then senator Hillary Clinton (D-NY), he was elected president and sworn in on January 20, 2009. He was reelected in 2012. He and his wife, Michelle, are the parents of two daughters Malia and Sasha. Obama is the recipient of the Nobel Peace Prize, one of only four U.S. presidents to have been so honored. Obama is author of three books: *Dreams of My Father* (2004), *The Audacity of Hope* (2007), and *Of Thee I Sing* (2010).

### Bill O'Reilly (1949–)

Bill O'Reilly was an American television host on Fox until 2017, author, historian, syndicated columnist, and political commentator. He was born in New York City. He attended Marist College, Boston University, and Harvard University, receiving his BA in history in 1971. He taught history at the high school level and earned an MA in broadcast journalism from Boston University. In 1995, having established himself as a media personality, he was accepted into Harvard University's John F. Kennedy School of Government, earning his MA degree in 1996. He is officially registered with the Independence Party of New York but widely viewed as a Republican Party and conservative commentator. His most prominent media role was as host of *The O'Reilly Factor* on Fox News, as anchor of the news magazine show *Inside Edition*, and as host of *The Radio Factor* until 2009. After Harvard, in 1996, he was hired by Roger Ailes, chairman and CEO of the then startup Fox News Channel to anchor *The O'Reilly Report*. He was a noted radio talk show host until 2009. His career as a television commentator has been marked by considerable controversy but by huge financial and ratings success. He was awarded an Emmy in 2008.

He worked for several radio stations, anchoring news feature programs, and in 1982 joined CBS as a news correspondent. In 1986, he joined ABC News as a correspondent and then as a

general assignment reporter for ABC News programs like *Good Morning America*, *Nightline*, and *World News Tonight*.

### Rand Paul (1963–)

Senator Rand Paul (R-KY) is a leading advocate of libertarian values within the Republican Party. Rand Paul is a physician. He practiced ophthalmology in Bowling Green, Kentucky, for 18 years. He has been married for 25 years to Kelley Ashby Paul and they have three sons. He is the son of Ron Paul, also a physician and U.S. representative and presidential nomination candidate. Rand Paul attended Baylor University and graduated from Duke Medical School, in 1988. He completed general surgery internship at Georgia Baptist Medical Center in Atlanta, Georgia.

In 1993, he moved back to Bowling Green. In 1995, he founded the Southern Kentucky Lions Eye Clinic. He is a former president and 17-year member of Lions Club International and has received many of its highest commendations. In 2002, the Twilight Wish Foundation recognized him with the Outstanding Service and Commitment to Seniors award. He recently traveled to Guatemala and Haiti on a medical mission trip with the University of Utah's Mormon Eye Center, treating more than 200 patients, restoring vision to many via cataract surgery. He was elected to the U.S. Senate in 2010 and serves on the Foreign Relations Committee; the Health, Education, Labor and Pensions; Homeland Security and Government Affairs; and Small Business and Entrepreneurship. He ran for the Republican Party nomination for president in 2016 and after losing to Donald Trump sought to be and was successfully reelected to the U.S. Senate.

### Ron Paul (1935–)

Ron Paul is a leading voice for libertarianism. He served in the House of Representatives and was a three-time candidate for the Republican presidential nomination. He was born in

Pittsburgh, Pennsylvania. He graduated from Gettysburg College and the Duke University School of Medicine, and during the 1960s served as a flight surgeon in the U.S. Air Force. He and his wife Carol and family moved to Texas in 1968, where he practiced medicine, specializing in obstetrics/gynecology. He and his wife are the parents of 5 children and have 17 grandchildren. He served in Congress in the late 1970s and early 1980s, advocating limited government. In 1976, he endorsed Ronald Reagan for president. He served on the House Banking Committee and has been a strong advocate of monetary policy and sharp critic of the Federal Reserve. He consistently voted to lower taxes, abolish federal taxes, and limit government spending. He left Congress in 1984, going back to his medical practice. He was reelected to Congress in 1997, from the 14th District of Texas. He served on the House Committee on Financial Services and the House Committee on Foreign Affairs and was chair of the Subcommittee on Domestic Monetary Policy and Technology. He retired from Congress in 2013.

## Mike Pence (1959–)

Mike Pence is a former governor of Indiana and current vice president of the United States, elected in 2016. He was born and raised in Columbus, Indiana. He married Karen Batten in 1985. He was educated at Hanover College, graduating in 1981. In 1986, he earned his law degree from Indiana University Robert McKinney School of Law. In 1991, he became president of the Indiana Policy Review, a free market think tank. In 1994, he hosted a statewide radio talk show *The Mike Pence Show*, which was syndicated to 18 stations until 1999. From 1995 to 1999, he also hosted a Sunday morning television show in Indianapolis. In 2000, he was elected to the U.S. House of Representatives from the 2nd District of Indiana and reelected to his sixth term in 2010. In 2010, he won the Indiana straw poll for president. He won the governorship

in 2012, taking office in January 2013 as its 50th governor. In March 2015, he signed the highly controversial religious objections bill. That law, combined with a troubled economy, severely hurt his poll ratings. He was tapped by Donald Trump to be his vice presidential candidate and nominated by the Republican National Convention in July 2016. He was elected vice president and headed the Trump presidential transition team.

### David Plouffe (1967–)

David Plouffe is an American political strategist, campaign manager, and senior advisor to Barack Obama. He was educated at the University of Delaware, Newark, and earned his degree in 2010. In 1990, Plouffe worked on Senator Tom Harkin's reelection campaign. In 1997–1998, he was Representative Dick Gephardt's chief of staff. In 2000, he joined AKPD Message and Media, working with and under David Axelrod. In 2008, he was the campaign manager for Senator Obama's presidential campaign. He was the outside political advisor to Obama in 2009. He served as senior advisor to President Obama, 2011–2013. He authored a book in 2009, *The Audacity to Win*. Since 2013, he has served as a political contributor for Bloomberg TV and ABC News.

### John Podesta (1949–)

John Podesta is a political operative and chairman of the Center for American Progress and a visiting professor of law at the Georgetown University Law Center. Podesta was born in Chicago, Illinois. He founded the Center for American Progress and the Podesta Group. He is a 1971 graduate of Knox College and worked for the Eugene McCarthy presidential campaign. He attended Georgetown University and took his JD from Georgetown University Law Center in 1976. In 1988, he founded Podesta Associates. He cochaired President Obama's transition team in 2008. That same year he published the book

*The Power of Progress: How American Progressives Can (Once Again) Save Our Economy, Our Climate, and Our Country.* In 2009, he accompanied former president Bill Clinton to North Korea to negotiate the release of two American journalists. Podesta served as chief of staff to President Bill Clinton from 1988 to 2001, was responsible for all policy development and coordinated work with the Congress, cabinet agencies, and staff activities of the White House. He was a principal on the National Security Council. In 1997–1998, he was the assistant to the president, deputy chief of staff, and senior policy advisor. He previously held several positions on Capitol Hill: counselor to Democratic Leader Tom Daschle; chief counsel for the Senate Agricultural Committee; chief minority counsel to the Senate Judiciary Committee on Patents, Copyrights, and Trademarks, Security and Terrorism, and Regulatory Reform; and counsel on the Majority Staff of the Senate Judiciary Committee. He was the campaign manager of Secretary Hillary Clinton's 2016 presidential campaign.

## Reince Priebus (1972–)

Reinhold "Reince" Priebus is the chairman of the Republican National Committee. He was born in Dover, New Jersey. He was raised in Kenosha, Wisconsin. He was educated at the University of Wisconsin–Whitewater and received his JD from the University of Miami School of Law. Priebus has a long history with grassroots work with the Wisconsin Republican Party, serving as the state party treasurer and as its first vice chair. In 2006, he worked in corporate law for a Wisconsin law firm. He was chairperson of the Wisconsin Republican Party, 2007–2011, during which time the party won the U.S. senate seat and picked up two House of Representative seats and won majorities in both the Wisconsin State Assembly and its Senate. In 2009, he served as general counsel to the Republican National Committee. He was elected chairman of the RNC in 2011, and again in 2013, and was its longest serving chairman

in modern history. With the successful election of President Donald Trump, he was selected Trump's White House chief of staff.

### Harry Reid (1939–)

Senator Harry Reid was the senior U.S. senator from Nevada and served as the Senate majority leader. He was born in a little mining town, Searchlight, Nevada. He married Landra Gould in 1959. Reid graduated from Utah State University in 1961 and George Washington University, from which he earned his law degree. In 1968, he was elected to the Nevada State Assembly. In 1970, he was elected as the state's lieutenant governor, serving 1971–1975. In 1977, he was appointed chairman of the Nevada Gaming Commission, where he was noted for reforms to clean up the gaming industry. He ran for the United States Congress in 1982 and was the representative from Nevada's 1st Congressional District, 1983–1987. He ran for and won his U.S. Senate seat in 1986. After winning his third term, in 1998, he served as the Democratic Party assistant Democratic leader—its whip. In 2010, he was elected to a fifth term and was Nevada's senior senator. He sponsored the bill creating Nevada's first national park, the Great Basin National Park. He retired from the Senate in 2016.

### Cecile Richards (1957–)

As president of Planned Parenthood Federation of America and Planned Parenthood Action Fund, Cecile Richards leads the grassroots and national movement that for nearly a century has worked to build a network of approximately 700 clinics, centers, and health care providers serving 2.7 million patients. It provides sex education to more than one million people, men and women. Its websites receive an estimated 60 million visits annually from persons seeking health care service and education in English and Spanish. Before joining Planned Parenthood, Richards served as deputy chief of staff for

House Democratic leader Nancy Pelosi. In 2004, she founded and served as president of America Votes, a coalition of 42 national grassroots organizations working to maximize registration, voter education, and voter participation. She began her career organizing low-wage workers in the hotel, health care, and janitorial industries in California, Louisiana, and Texas. Since joining Planned Parenthood, she has expanded its advocacy for access to health care coverage and services under the Affordable Care Act. In 2011, Richards led a national campaign to preserve Planned Parenthood services through federal programs. Supporters have doubled, reaching seven million. She is a frequent speaker and commentator on women's rights, reproductive rights, and sex education and is a regular contributor to the *Huffington Post*. She serves on the board of directors of the Ford Foundation. She lives in New York City with her husband and three children.

## Mitt Romney (1947–)

Mitt Romney is the former governor of Massachusetts and was the Republican candidate for president in 2012. He was born in Detroit, Michigan, the son of former governor of Michigan George Romney. He was raised in Michigan. He was educated at Brigham Young University, Harvard Law School, and the Harvard Business School. In 1969, he married Ann Davies, and they have five children. In 1977, he was hired by Bain and Company, a Boston management consulting firm. In 1994, he ran for the Massachusetts Senate but lost that election. In 2002, he took over the Salt Lake City Organizing Committee for the 2002 Olympic Games, managing them to great success. In 2003, he began his single term as governor of Massachusetts, notably pushing its Universal Health Care law. In 2008, he first ran for president, losing the nomination to Senator John McCain (R-AZ), but in the race he raised and spent $110 million, $45 million of which was his own money. He ran for president again in 2012; this time, he won the Republican Party

nomination, selected Wisconsin representative Paul Ryan as his running mate, but lost to President Barack Obama and Vice President Joe Biden. His net worth is estimated at $250 million. He has authored two books: *Turnaround: Crisis, Leadership and the Olympic Games* (2004) and *No Apology: The Case for American Greatness* (2010), a *New York Times* best seller. In the 2016 presidential election, he was a leading voice against the party's nomination of Donald Trump.

### Karl Rove (1950–)

Karl Rove is a noted Republican political operative and founder of American Crossroads and Americans for Prosperity. He was born in Denver, Colorado. He has been married three times, in 1976, in 1986, and in 2012 to his current wife, Karen. He dropped out of the University of Utah in 1971 to assume a paid position of executive director of the College Republican National Committee. He later attended the University of Maryland, George Mason University, and the University of Texas–Austin. In 1981, he founded a direct mail consulting firm, Karl Rove and Company, in Austin, Texas.

He managed George W. Bush's presidential campaigns in 2000 and 2004, earning the moniker "The Architect" of the Bush campaigns. He was senior advisor and deputy chief of staff to President Bush in 2005–2007 and a senior advisor to the president, 2001–2007. In 2010, he was advisor to American Crossroads, the Republican 527 organization. In 2012, Rove was into the American Association of Political Consultant's Hall of Fame. He is a Fox News contributor and writes a weekly op-ed column for the *Wall Street Journal.* He is author of two books: *The Triumph of William McKinley* and his 2010 memoirs *Courage and Consequence.*

### Marco Rubio (1971–)

Marco Rubio is an American attorney, politician, and reelected U.S. senator from Florida. He was born in Miami, the son

of Cuban immigrants. He attended Takio College and Sante Fe College in Gainsville, Florida. He took his BA degree in political science from the University of Florida in 1993 and his JD from the University of Miami School of Law in 1996. That year, he worked for the Bob Dole presidential campaign in Florida. In 1998, he was elected city commissioner for West Miami. In 2000, he was elected to the Florida House of Representatives and was reelected in 2004 and 2006. He served as the majority whip there and then majority leader. At age 34, in 2005, he was elected speaker of the Florida House of Representatives. In 2008, he set up a law firm and served as adjunct professor at Florida International University, until 2011. In 2010, he ran for and won as U.S. junior senator from Florida. In 2014, he became part of the majority party in the Senate. He ran for the Republican Party's nomination for president in 2016, suspending his campaign on March 15 after losing the Florida primary to Donald Trump. He took some time before announcing his endorsement of Donald Trump. He later announced his run for reelection to the U.S. Senate in 2016, after previously saying he would not run. He spoke at the 2016 Republican National Convention, endorsing Trump.

### Paul Ryan (1970–)

Representative Paul Ryan (R-WI) is the speaker of the House since October 2015. He was born in Janesville, Wisconsin. In 2000, he married Janna Little. He was educated at Miami University of Ohio, earning his degree in economics and political science, and at American University. In his early career, he worked for a media consulting firm and was legislative aide to Senator Bob Kasten, Senator Sam Brownback, and Representative Jack Kemp. In 1998, at age 28, he was elected to the House of Representatives from Wisconsin's 1st District. He served on and chaired the House Budget Committee, 2011–2015, where he notably issued the Republican budget plan The Path to Prosperity. He chaired the House Ways and Means Committee

in 2015. He was the Republican Party's nominee for vice president in 2012, with Mitt Romney for president. In 2013, he sponsored, with Democratic senator Patty Murphy, the Bipartisan Budget Act of 2013. Upon Representative John Boehner's sudden resignation from the House of Representatives and as speaker of the House, Paul Ryan was elected to that position—the third in line for the presidency and arguably the second most powerful office in the nation—in October 2015 and was reelected speaker in 2016.

### Bernie Sanders (1941–)

Bernie Sanders is in his second term in the U.S. Senate, winning reelection in 2012. Born in Brooklyn, Sanders attended Brooklyn College and the University of Chicago. After graduating in 1964, he moved to Vermont. In 1981, he was elected mayor of Burlington, serving for four terms. He was married to Deborah Shiling in 1964–1966 and in 1988 married Jane O'Meara. He lectured at the John F. Kennedy School of Government at Harvard and at Hamilton College in upstate New York. He served for 16 years in the House of Representatives, the longest-serving independent member of Congress in American history and caucuses with the Democrats. He has focused on the shrinking middle class throughout his career. As chair of the Senate Committee on Veterans Affairs, he helped pass legislation reforming the VA health care system. He remains on the Budget Committee, the Environment and Public Works Committee, and the Energy and Natural Resources Committee. He ran for the Democratic Party nomination for president in 2016, losing to Secretary Hillary Clinton only after a long-fought battle and winning 45 percent of the primary votes.

### Stephanie Schriock (1973–)

Stephanie Schriock is president of Emily's List. She graduated from Mankato State University in Minnesota and took her MA

from the Graduate School of Management at George Washington University. She was the national finance director for Howard Dean's 2004 presidential campaign, developing new fund-raising Internet strategies. The success led to her being selected campaign manager by Jon Tester, who won a difficult U.S. Senate race, and Stephanie became his chief of staff. She managed Al Franken's Senate campaign in Minnesota. His hard-fought win solidified her reputation as a major force in Democratic politics. She joined Emily's List in 2010, successfully raising more than $52 million and helping elect a record number of women to the House and the Senate and guiding the organization to unprecedented growth, with more than three million women and men among its community.

### Chuck Schumer (1950–)

Charles "Chuck" Ellis Schumer is the senior U.S. senator of New York. He was born in Brooklyn. Chuck resides in Brooklyn with his wife, Iris Weinshall, and two daughters. In 1980, he ran for and won a seat in the 9th Congressional District and served the district for 18 years. In 1998, he was elected to the U.S. Senate and became senior senator when Daniel Patrick Moynihan retired in 2000. Reelected in 2004, he served on the Senate Finance Committee and as chair of the DSCC for two cycles, stepping down in 2008. In 2006, he was selected to serve as the vice chair of the Democratic Conference and in 2010 as chair of the Democratic Policy and Communications Center. He is the ranking member on the Senate Rules Committee, which oversees federal elections, voting rights, campaign finance, and the operation of the Senate complex. He sits on the Banking, Housing, and Urban Affairs Committee; is the ranking member of the Judiciary Committee and its Subcommittee on Immigration, Refugees, and Border Security; and on the Joint Committee on the Library. In 2017, he replaced Senator Harry Reid as his party's leader in the Senate.

### George Soros (1930–)

George Soros is founder and chair of the Soros Fund Management and the Open Society Foundation. He was born in Budapest, survived the Nazi occupation, and fled communist Hungary for England in 1947, where he graduated from the London School of Economics. He moved to the United States, becoming a billionaire through the international investment fund he founded and managed. He is a renowned philanthropist, whose Open Society supports efforts in more than 100 countries, and in 2011 spent $835 million to promote human rights and transparency. He has authored more than a dozen books, including *The Tragedy of the European Union* (2014). He is a leading financial supporter of the liberal Democratic party's electoral efforts and Democratic-related super-PACs. He is the Democratic Party's equivalent to the Republicans' Koch brothers.

### Jill Stein (1950–)

Dr. Jill Stein was the Green Party's 2012 candidate for U.S. president. She was born in Chicago and graduated magna cum laude from Harvard in 1973 and from Harvard Medical School in 1979. She is a physician, organizer, and pioneering environmental-health advocate and was the nominee of the Green Party again in 2016. She was the principal organizer for the Global Climate Convergence for People, Planet, and Peace-over-Profit. She began her political activism as a physician in the 1990s, exposing the link between toxic exposures and illness. She worked as a grassroots activist to help pass the Clean Election Law by voter reformation in Massachusetts, later overturned in the state legislature. In 2002, she was recruited by the Green-Rainbow Party to run for Massachusetts governor against Mitt Romney, her first foray into electoral politics. She was twice elected to town meetings in Lexington, Massachusetts. She cofounded the Coalition for Healthy Communities, a nonprofit, in 2003. She was a Green-Rainbow Party

candidate in two additional races, one for state representative in 2004 and one for secretary of state in 2006. She received more than 350,000 votes in the 2006 campaign, the greatest total vote ever for a Green-Rainbow Party candidate. She has received several awards for health and environmental protection. She has coauthored two reports: *In Harm's Way: Toxic Threats to Child Development* (2002) and *Environmental Threats to Healthy Aging* (2009). After the 2016 election, she briefly led a recount effort in two states. Some critics have maintained that her third party run was, in part, the reason Secretary Clinton lost the Electoral College vote in several states, enough College votes to cost Clinton the presidency.

## Jon Tester (1956–)

Jon Tester is the U.S. senator from Montana and chair of the DSCC. Born in Montana, he married Sharla Bitz in 1978. He was educated at the University of Great Falls, earning a degree in music in 1978. He taught music and was elected to the Big Sandy School District. He was elected to the Montana State Senate in 2008 and reelected in 2012. He chaired the Senate Committee on Indian Affairs, 2014–2015, and has been an outspoken advocate for rural America and small businesses and a champion of responsible energy development, sportsmen's issues, clean air and water, Indian nations, and women's and veteran's access to quality health care. He serves on the Veteran's Affairs, Homeland Security, Indian Affairs, and Banking and Appropriations Committee. In 2016, he was selected as chair of the DSCC.

## Richard Trumka (1949–)

Richard Trumka is president of the AFL-CIO, which, at 12.5 million members, is the largest labor union organization in the United States. He was elected president of the federation in 2009. He served as its secretary-treasurer, 1995–2009. He spearheaded union organizing and collective bargaining, affiliating with other labor and workers alliances. In 2014, the

union fulfilled a $10 billion pledge to the Clinton Global Initiative to invest in the nation's crumbling infrastructure while boosting the sagging job market. He led the AFL-CIO in revamping its political campaign, expanded its political outreach beyond union members and their families, and created a capacity for year-round mobilization. He was instrumental in President Obama's 2008 election and 2012 reelection, as well as the election of progressives like Senators Elizabeth Warren (D-MA), and Sherrod Brown (D-PA).

### Donald Trump (1946–)

Donald J. Trump is a billionaire real estate mogul, reality television star, and the 45th president of the United States. Trump was born in Queens, New York. He was married several times to former models: Ivanka Winklmayr, from 1977 to 1992; Marla Maples, 1983 to 1999, and Melania Knauss, 2005 to present. He attended Fordham University in 1964 and received his degree in economics from the Wharton School of Finance, University of Pennsylvania, in 1968. He took over his father's real estate business in 1971. In 1980, he opened the Grand Hyatt and a casino in Atlantic City. In 1989, he purchased Eastern Airlines Shuttle, renaming it Trump Shuttle. He is the founder of a number of businesses: the Trump Organization, the Trump Entrepreneur Institute, Trump Entertainment Resort, Trump Shuttle, and Trump Mortgage. His estimated net worth is $4.5 billion. In 2004, he appeared as host of *The Apprentice*, a reality television show. In 2012, he briefly contemplated running for the presidency and was embroiled and largely led the anti-Obama "birther" movement. On June 16, 2015, he announced his candidacy for the Republican Party nomination for president, running in a field of 17. In May 2016, he won the Indiana primary, knocking out of the race his last standing opponent, Senator Ted Cruz (R-TX), becoming the presumptive nominee. He clinched the nomination on May 26. On July 15, 2016, he announced his choice for vice

president, Governor Mike Pence of Indiana. He accepted the GOP nomination on July 21, 2016, won the Electoral College vote, and was inaugurated president on January 20, 2017. Trump is the author of nine books: *Trump: The Art of the Deal* (1987), *The America We Deserve* (2000), *Trump: How to Get Rich* (2004), *Why We Want You to Be Rich* (2006), *Think Big and Kick Ass in Business* (2007), *Trump 101: The Way to Success* (2007), *Trump: Never Give Up* (2008), *Think Like a Champion* (2009), and *Time to Get Tough* (2011).

### Katrina vanden Heuvel (1959–)

Katrina vanden Heuvel is the editor/publisher of *The Nation* magazine and a frequent commentator for ABC, MSNBC, CNN, and PBS. She is a graduate summa cum laude of Princeton University. She is author of articles in *The Washington Post*, *The Los Angeles Times*, the *New York Times*, *Foreign Policy* magazine, and *The Boston Globe*. A progressive activist and commentator, she serves on the board of numerous organizations: The Institute for Policy Studies, The Campaign for America's Future, The Correctional Association of New York, the Franklin and Eleanor Roosevelt Institute, Research to Prevent Blindness, the Jules Stein Eye Institute, the Nation Institute, and the Sidney Hellman Media Foundation. Katrina vanden Heuvel is author of *The Change I Believe In: Fighting for Progress in the Age of Obama* and *Meltdown: How Greed and Corruption Shattered Our Financial System and How We Can Recover*. She is coeditor of *Taking Back America—and Talking Down the Radical Right* and *Voices of Glasnost: Interviews with Gorbachev's Reformers* and editor of *The Nation: 1865–1990* and *A Just Response: The Nation on Terrorism, Democracy and September 11, 2001*.

### Scott Walker (1967–)

Scott Walker is the 45th governor of Wisconsin and ran in the presidential primaries of the Republican Party in 2016. Walker was born in Colorado Springs, Colorado. His family

moved to Iowa and then to Wisconsin. He graduated in 1986, during which time he achieved the rank of eagle scout, which he credits for solidifying his interest in public service. He worked for the Tommy Thompson gubernatorial campaign in 1986 and then enrolled in Marquette University. He became a student senator. He ran for student government president in 1988 but lost. He left Marquette without a degree when he went to work full-time for the American Red Cross and part-time for IBM. In 1990, he ran for the Wisconsin State Assembly, winning the nomination but losing the general election. He eventually won a seat in the Assembly, serving from 1993 to 2002. He served as the Milwaukee County executive from 2002 to 2010, at which time he ran for and won the office of governor. He introduced a budget plan that limited collective bargaining of most Wisconsin public employees. He faced and survived a recall election in 2012 and was reelected governor in 2014, notably with the extensive financial funding by the Koch brothers, who also contributed heavily to his presidential bid in 2016.

### Jeff Weaver (1956–)

Jeff Weaver is a Democratic political advisor and was the campaign manager for the Bernie Sanders campaign for the presidential nomination of the Democratic Party in 2016. He is the owner of Victory Comics, a comic bookstore in Falls Church, Virginia. Prior to the Sanders campaign run, he was Sanders's chief of staff and congressional campaign manager. Weaver graduated from the University of Vermont and served as a legislative assistant to Sanders in the House of Representatives and was campaign manager for Sanders's successful U.S. Senate bid. Weaver then served as his chief of staff. He rejoined Senator Sanders to manage his 2016 presidential bid.

### Roger Wicker (1958–)

Roger Wicker is the U.S. senator from Mississippi (R-MS) and chair of the National Republican Senate Campaign

Committee. He was born in Pontotoc, Mississippi, the son of former circuit court judge Fred Wicker. He married Gayle Long, and they have three children. He earned his business and law degrees from the University of Mississippi. He served in the Air Force and the Air Force Reserve. He served 11 terms in the U.S. House of Representatives, 1995–2007, from the 1st Congressional District of Mississippi. He was elected to the U.S. Senate in 2007 and serves on the Armed Services Committee (chairing its Subcommittee on Seapower) and the Commerce, Science, and Transportation Committee and is on the Congressional Board of Visitors, U.S. Merchant Marine Academy.

## Introduction

*This chapter presents primary source data and documents related to American political parties. Its first section presents data—tables and bar and line graphs—that help depict trends and essential data to better understand American political parties. Its second section presents excerpts from and synopses of primary documents impacting parties and elections. Those documents include sections of the Constitution of the United States, relevant laws enacted by the Congress, presidential veto messages, and excerpts of related Supreme Court decisions.*

## Data

Table 5.1 lists the "toss-up," or traditionally swing states, and how the states selected their delegates to the national conventions to nominate a presidential candidate.

Table 5.2 shows the top 10 most expensive elections for the Senate and House, 2016 election cycle.

---

Dr. Jill Stein, the Green Party presidential candidate, who garnered about 1 percent of the popular vote, appears at a news conference in front of Trump Tower in New York City on December 5, 2016. She spearheaded unsuccessful recount efforts in Pennsylvania, Michigan, and Wisconsin. She received enough votes in each of those states to effectively cost the loss of the electoral college votes of those states for Hillary Clinton, thereby assuring Clinton's loss and Trump's win in the 2016 presidential election. (AP Photo/Mark Lennihan)

**Table 5.1    Top Swing States, 2016 Cycle, and Their Delegate Selection Method**

| State | Method Used |
|---|---|
| Colorado | Caucus |
| Florida | Closed Primary |
| Iowa | Caucus |
| Michigan | Open Primary |
| Nevada | Caucus |
| New Hampshire | Semi-open Primary |
| North Carolina | Semi-open Primary |
| Ohio | Semi-open Primary |
| Pennsylvania | Closed Primary |
| Virginia | Open Primary |
| Wisconsin | Open Primary |

*Source*: Data from www.politico.com/blogs/swing-states-2016-election, accessed July 7, 2016.

**Table 5.2    The Top 10 Most Expensive Congressional Races, 2016**

| Senate | | House | |
|---|---|---|---|
| State | Amount Raised ($) | District | Amount Raised ($) |
| 1. Pennsylvania | 29,743,488 | 1. Maryland, 08 | 16,257,233 |
| 2. Ohio | 25,183,797 | 2. Wisconsin, 01 | 9,204,314 |
| 3. Wisconsin | 22,569,824 | 3. Florida, 18 | 7,439,728 |
| 4. New York | 22,294,935 | 4. Illinois, 10 | 6,730,503 |
| 5. Illinois | 20,962,686 | 5. California, 23 | 6,454,654 |
| 6. Florida | 18,410,869 | 6. New York, 01 | 5,455,428 |
| 7. California | 15,911,686 | 7. Arizona, 02 | 5,439,126 |
| 8. Colorado | 15,710,667 | 8. California, 24 | 4,755,286 |
| 9. Missouri | 14,813,314 | 9. Minnesota, 02 | 4,617,648 |
| 10. Arizona | 14,547,566 | 10. California, 17 | 4,599,623 |

**Election Cycle 2016, by Political Party**

| By Party | Total Raised ($) | Total Spent ($) |
|---|---|---|
| Democratic Party | 384,393,201 | 313,550,004 |
| Republican Party | 397,453,660 | 311,555,568 |
| Democratic National Committee | 101,923,063 | 100,757,940 |
| Republican National Committee | 150,401,391 | 137,867,474 |
| DCCC | 101,725,643 | 55,748,172 |
| RCCC | 101,388,856 | 49,830,406 |
| DSCC | 88,721,349 | 68,704,957 |
| RSCC | 59,906,846 | 41,030,041 |

DCCC, Democratic Congressional Campaign Committee; DSCC, Democratic Senate Campaign Committee; RCCC, Republican Congressional Campaign Committee; RSCC, Republican Senate Campaign Committee.

*Source*: Data from http://www.opensecrets.org/overview/topraces.php and http://www.opensecrets.org/parties/. Data from FEC, released June 1, 2016, accessed July 7, 2016. Center for Responsive Politics.

**Table 5.3    Presidential Election Results, 1980–2016**

| Year | Presidential Ticket | Electoral College Vote | Percentage Popular Vote |
|---|---|---|---|
| 1980 | Reagan/Bush | 489 | 50.7 |
| 1984 | Reagan/Bush | 525 | 58.8 |
| 1988 | Bush/Quayle | 426 | 53.7 |
| 1992 | Clinton/Gore | 370 | 43.0 |
| 1996 | Clinton/Gore | 379 | 49.2 |
| 2000 | Bush/Cheney | 271 | 47.9 |
| 2004 | Bush/Cheney | 286 | 50.7 |
| 2008 | Obama/Biden | 365 | 52.9 |
| 2012 | Obama/Biden | 332 | 51.1 |
| 2016 | Trump/Pence | 304 | 46.2 |

*Source*: Data from http://www.presidency.ucsb.edu, accessed January 6, 2016.

Table 5.3 presents the election results of presidential elections from 1980 to 2016, listing the winning ticket, its Electoral College vote, and percentage of the popular votes cast.

Table 5.4 shows the major parties identified as being on a majority of states' ballots for the 2016 presidential election cycle, the number of states on which they are on the ballot, and the year in which that party was founded. Note the long history of the two major parties in contrast to that the Libertarian, Green, and Constitutional parties.

Table 5.5 lists and describes the roles that a modern president is called upon to play. The first four roles have a constitutional basis, and the last four are roles without a constitutional basis that have developed by tradition or common practice since FDR's presidency.

Table 5.6 lists each of the presidents of the United States, their years in office, and the political party of which they were the titular head.

**Table 5.4  Major Parties on Majority of States' Ballots, 2016**

| Political Party | Number of States | Year Founded |
| --- | --- | --- |
| Democratic Party | 50 + D.C. | 1828 |
| Republican Party | 50 + D.C. | 1854 |
| Libertarian Party | 48 + DC | 1971 |
| Green Party | 36 + DC | 1991 |
| Constitutional Party | 26 | 1991 |

*Source*: Data from http://www.us-political-parties.insidegov.com, accessed July 14, 2016.

**Table 5.5  The Many Roles Played by the U.S. President**

| | |
| --- | --- |
| 1 | **Chief of State**—living symbol of the nation: awards medals, congratulates heroes, greets foreign dignitaries, makes patriotic speech on July 4 |
| 2 | **Chief Executive**—appoints thousands and oversees millions of federal workers in the executive branch, enforces laws, executes policy, holds cabinet meetings, reads and responds to official reports of the federal bureaucracy |

3    **Chief Diplomat**—negotiates treaties, accepts diplomats and
     ambassadors, makes foreign policy, writes letters to or calls heads of
     state, attends foreign funerals

4    **Commander-in-Chief**—in charge of all U.S. armed forces—Army, Navy,
     Air Force, Coast Guard, Marine Corps; can activate State Militia to National
     Guard, prosecute wars; appoints heads of the military branches

5    **Legislative Leader**—influences legislation in Congress, addresses
     Congress in annual State of the Union speeches urging laws and policies,
     signs bills into law, makes speeches in Congress, vetoes legislation

6    **Chief of Party**—titular head of the party, helps party members to get
     elected or reelected; appoints chair of the National Committee, helps raise
     money, selects from party appointments to the cabinet

7    **Chief of the Economy**—appoints council of economic advisors; suggests
     policy or laws for unemployment, inflation, taxes, business profits, and
     general prosperity of the economy; meets with business and labor leaders
     to discuss needs/problems

8    **Comforter-in-Chief**—travels to meet with families/people after national
     disasters, mass killings, and so on; addresses the nation about such events.

*Source*: Description from http://www.scholastic.com/teachers/article/seven-roles-one-president and Scholastic Inc., *The Presidency, Congress, and the Supreme Court*, 1989.

**Table 5.6   The Presidents of the United States and Years in Office**

| President | Years in Office | Party Affiliation |
|---|---|---|
| George Washington | 1789–1797 | None |
| John Adams | 1797–1801 | Federalist |
| Thomas Jefferson | 1801–1809 | Democratic-Republican |
| James Madison | 1809–1917 | Democratic-Republican |
| James Monroe | 1917–1825 | Democratic-Republican |
| John Quincy Adams | 1825–1829 | Democratic-Republican |
| Andrew Jackson | 1829–1837 | Democrat |
| Martin Van Buren | 1837–1841 | Democrat |
| William Henry Harrison | 1841 | Whig |
| John Tyler | 1841–1845 | Whig |
| James K. Polk | 1845–1849 | Democrat |
| Zachary Taylor | 1849–1850 | Whig |
| Millard Fillmore | 1850–1853 | Whig |

*(continued)*

**Table 5.6**    (*continued*)

| President | Years in Office | Party Affiliation |
| --- | --- | --- |
| Franklin Pierce | 1853–1857 | Democrat |
| James Buchanan | 1857–1861 | Democrat |
| Abraham Lincoln | 1861–1865 | Republican |
| Andrew Johnson | 1865–1869 | Democrat |
| Ulysses S. Grant | 1869–1877 | Republican |
| Rutherford B. Hayes | 1877–1881 | Republican |
| James A. Garfield | 1881 | Republican |
| Chester A. Arthur | 1881–1885 | Republican |
| Grover Cleveland | 1885–1889 | Democrat |
| Benjamin Harrison | 1889–1893 | Republican |
| Grover Cleveland | 1893–1897 | Democrat |
| William McKinley | 1897–1901 | Republican |
| Theodore Roosevelt | 1901–1909 | Republican |
| William H. Taft | 1909–1913 | Republican |
| Woodrow Wilson | 1913–1921 | Democrat |
| Warren G. Harding | 1921–1923 | Republican |
| Calvin Coolidge | 1923–1929 | Republican |
| Herbert Hoover | 1929–1933 | Republican |
| Franklin D. Roosevelt | 1933–1945 | Democrat |
| Harry Truman | 1945–1953 | Democrat |
| Dwight D. Eisenhower | 1953–1961 | Republican |
| John F. Kennedy | 1961–1963 | Democrat |
| Lyndon B. Johnson | 1963–1969 | Democrat |
| Richard M. Nixon | 1969–1974 | Republican |
| Gerald Ford | 1974–1977 | Republican |
| Jimmy Carter | 1977–1981 | Democrat |
| Ronald Reagan | 1981–1989 | Republican |
| George H. W. Bush | 1989–1993 | Republican |
| Bill Clinton | 1993–2001 | Democrat |
| George W. Bush | 2001–2009 | Republican |
| Barack Obama | 2009–2017 | Democrat |

*Source*: Data from Schlesinger, Arthur, Jr. Ed. 2011. *History of American Presidential Elections, 1789–2000*, 4th ed., 3 vols. New York: Chelsea House.

Table 5.7 lists the states and the method used, as of the 2016 election cycle, to select delegates to the national convention and for the nominations of candidates for office.

**Table 5.7 The 50 States and Their Use of Caucus versus Primary Type**

| State | Type of Election—Caucus, Primary, Open, or Closed |
|---|---|
| Alabama | Open Primary |
| Arizona | Closed Primary |
| California | Primary—Top Two |
| Colorado | Caucuses |
| Connecticut | Closed Primary |
| Delaware | Closed Primary |
| District of Columbia | Primary |
| Florida | Closed Primary |
| Georgia | Open Primary |
| Hawaii | Open Primary |
| Idaho | Open Primary |
| Illinois | Semi-Open Primary |
| Indiana | Open Primary |
| Iowa | Caucuses |
| Kansas | Caucuses |
| Kentucky | Closed Primary |
| Louisiana | Caucuses |
| Maine | Caucuses |
| Maryland | Closed Primary |
| Massachusetts | Semi-Closed Primary |
| Michigan | Open Primary |
| Minnesota | Open Caucuses |
| Mississippi | Open Primary |
| Missouri | Open Primary |
| Montana | Open Primary |
| Nebraska | Caucuses (Democratic); Primary (Republican) |
| Nevada | Caucuses |

*(continued)*

Table 5.7   (*continued*)

| State | Type of Election—Caucus, Primary, Open, or Closed |
|---|---|
| New Hampshire | Semi-Open Primary |
| New Jersey | Primary |
| New Mexico | Primary (Republican); Closed Caucuses (Democratic) |
| New York | Closed Primary |
| North Carolina | Semi-Open Primary |
| North Dakota | Open Caucuses |
| Ohio | Semi-Open Primary |
| Oklahoma | Closed Primary |
| Oregon | Closed Primary |
| Pennsylvania | Closed Primary |
| Rhode Island | Primary |
| South Carolina | Open Primary |
| South Dakota | Closed Primary |
| Tennessee | Open Primary |
| Texas | Semi-Open Primary and Closed Caucuses |
| Utah | Closed Primary |
| Vermont | Open Primary |
| Virginia | Open Primary |
| Washington | Open Caucuses |
| West Virginia | Closed Primary |
| Wisconsin | Open Primary |
| Wyoming | Caucuses |

*Source*: http://www.diffen.com/difference/Caucus_vs_Primary; and http://www.ncsl.org/research/elections-and-campaigns/primry-types-asps, accessed July 2, 2016.

Table 5.8 presents the top rank-ordered democracies from around the world and the number of political parties active in each. Those countries with a parliamentary/prime minister system tend to have a greater number of active political parties.

**Table 5.8    Top-Ranked Democratic Nations in the World and the Number of Political Parties in Each and Type of National Government System**

| Democracy Rank | Nation | Type of System | Number of Political Parties |
|---|---|---|---|
| 1 | Denmark | Parliament/prime minister | 7 |
| 2 | Finland | Parliament/prime minister | 8 |
| 3 | Sweden | Parliament/prime minister | 9 |
| 4 | Norway | Parliament/prime minister | 8 |
| 5 | Netherlands | Parliament/prime minister | 10 |
| 6 | Switzerland | Parliament/prime minister | 7 |
| 7 | New Zealand | Parliament/prime minister | 7 |
| 8 | Belgium | Parliament/prime minister | 6 |
| 9 | Canada | Parliament/prime minister | 7 |
| 10 | Germany | Parliament/prime minister | 6 |
| 11 | Ireland | Parliament/prime minister | 6 |
| 12 | Australia | Parliament/prime minister | 9 |
| 13 | United Kingdom | Parliament/prime minister | 5 |
| 14 | Estonia | Parliament/prime minister | 6 |
| 15 | United States | President/ Congress | 4 |
| 16 | Austria | Chancellor/ president | 6 |
| 17 | Japan | Diet/prime minister | 8 |

(*continued*)

Table 5.8 (*continued*)

| Democracy Rank | Nation | Type of System | Number of Political Parties |
|---|---|---|---|
| 18 | Uruguay | President/General Assembly | 11 |
| 19 | France | Parliament/prime minister | 15 |
| 20 | Portugal | Parliament/prime minister | 7 |
| 21 | Chile | President/ Congress | 30 |
| 22 | Costa Rica | President/ Legislative Assembly | 9 |
| 23 | Poland | President/ National Assembly | 6 |
| 24 | Lithuania | Parliament/prime minister | 9 |
| 25 | Slovenia | Parliament/prime minister | 8 |
| 26 | Czech Republic | Parliament/prime minister | 7 |
| 27 | Spain | Parliament/prime minister | 4 |
| 28 | Slovakia | President/ National Council | 11 |
| 29 | Italy | Parliament/prime minister | 6 |

*Source*: Data from: http://www.worldaudit.org/democracy.htm, accessed July 14, 2014.

Table 5.9 compares the use of the democratic form of government to the number of countries in the world, showing the ratio of democracies compared to the number of countries in each of the six regions of the world.

Table 5.10 presents data on super-PACs (super-political action committees) as of the 2016 election cycle. Super-PACs are a new type of election committee that have become common

Table 5.9  Worldwide Democracies in Relation to Countries by Region

| Region | Ratio of Democracies (%) | Electoral Democracies | Number of Nations |
|---|---|---|---|
| Asia | 26 | 12 | 46 |
| Africa | 34 | 18 | 53 |
| Oceania | 86 | 12 | 14 |
| North America | 87 | 20 | 23 |
| Europe | 91 | 42 | 46 |
| South America | 92 | 11 | 12 |

*Source*: Freedom House, http://www.democracyw.com/, accessed July 14, 2016.

Table 5.10  Top 10 Super-PACs, 2016 Election Cycle, by Independent Expenditures

| Rank, Group | Supports | Expenditures ($) | Ideology | Raised ($) |
|---|---|---|---|---|
| 1. Right to Rise USA | Bush | 86,817,138 | Conservative | 121,141,408 |
| 2. Conservative Solutions | Rubio | 55,443,483 | Conservative | 60,564,219 |
| 3. America Leads | Christie | 18,578,852 | Conservative | 20,291,894 |
| 4. Our Principles | Anti-Trump | 18,578,852 | Conservative | 18,880,380 |
| 5. Club for Growth | Republicans | 12,407,480 | Conservative | 13,493,218 |
| 6. New Day for America | Kasich | 11,168,205 | Conservative | 15,245,068 |
| 7. Freedom Partners | Republicans | 9,826,904 | Conservative | 12,841,612 |
| 8. Stand for Truth | Cruz | 9,523,814 | Conservative | 11,143,185 |
| 9. Priorities USA | Clinton | 9,445,770 | Liberal | 75,983,220 |
| 10. Keep the Promise | Cruz | 9,110,205 | Conservative | 14,320,691 |

*Source*: Adapted from http://www.opensecrets.org/pacs/superpacs.php?cycle= 2016, accessed June 2, 2016.

(in the hundreds) since the July 2010 Supreme Court decision in *SpeechNow.org v. Federal Election Commission*. Super-PACs are technically known as independent-expenditure-only committees; they can raise unlimited sums from corporations, unions, associations, and individuals and can spend unlimited sums to overtly advocate for or against candidates. The names of their donors are not reported (known as "dark money"). Table 5.10 lists the top 10 super-PACs based on amounts raised and spent and lists their ideological bent. Ninety percent are conservative-oriented PACs.

Table 5.11 presents the election results of the 2012 presidential vote, by selected social group categories and the percentage of the voters in each category voting for President Obama versus Mitt Romney.

Table 5.12 presents the exit poll data for the 2016 presidential vote, by selected social group categories, voting for Secretary Clinton versus Donald Trump.

**Table 5.11   Election Exit Poll Results, 2012 Presidential Vote, by Select Social Categories**

**Group Categories**

*Sex:*

Men: Obama, 47%; Romney, 53%

Women: Obama, 57%; Romney, 43%

*Race:*

White: Obama, 44%; Romney, 56%

Black: Obama, 95%; Romney, 5%

*Age:*

18–29 years: Obama, 62%; Romney, 38%

30–49: Obama, 53%; Romney, 47%

50–64: Obama, 50%; Romney, 50%

65+: Obama, 46%; Romney, 54%

*Education:*

High School: Obama, 54%; Romney, 45%

Some College: Obama, 58%; Romney, 45%

College: Obama 53%; Romney, 47%

*Religion:*

Protestant: Obama, 45%; Romney, 55%

Catholics: Obama, 56%; Romney, 44%

Attend Church Weekly: Obama, 40%; Romney, 60%

*Marital Status:*

Married Men: Obama, 41%; Romney, 59%

Married Women: Obama 45%; Romney, 52%

Unmarried Men: Obama, 60%; Romney, 40%

Unmarried Women: Obama, 71%; Romney, 29%

*Source*: Data from http://gallup.com/poll/139880/Election-Polls:Presidential-Vote, accessed July 15, 2016.

**Table 5.12   Election Results, 2016 Presidential Vote, by Select Group Categories**

*Gender:*

White Men, No College Degree: Clinton 23%, Trump 71%

Men: Clinton 41%, Trump 52%

Women: Clinton, 54%, Trump 41%

*Race:*

White: Clinton, 37%, Trump, 57%

Black: Clinton, 89%, Trump, 8%

Latino: Clinton, 66%, Trump, 28%

Asian: Clinton, 65%, Trump, 27%

*Education:*

High School or Less: Clinton, 46%, Trump, 51%

Some College: Clinton, 43%, Trump, 51%

College Graduate: Clinton, 49%, Trump, 44%

Postgraduate: Clinton, 58%, Trump, 37%

Independents: Clinton, 42%, Trump, 46%

*Age:*

18–29 Years: Clinton, 55%, Trump, 36%

30–44: Clinton, 51%, Trump, 41%

45–64: Clinton, 44%, Trump, 52%

65+: Clinton, 45%, Trump, 45%

*(continued)*

**Table 5.12** *(continued)*

*Gender by Marital Status:*

Married Men: Clinton, 38%, Trump, 57%

Married Women: Clinton, 49%, Trump, 47%

Non-Married Men: Clinton, 46%, Trump, 44%

Non-Married Women: Clinton, 63%, Trump, 32%

*Ideology:*

Liberal: Clinton, 84%, Trump, 10%

Moderate: Clinton, 52%, Trump, 40%

Conservative: Clinton, 16%, Trump, 81%

*Religion:*

Protestant: Clinton, 39%, Trump, 56%

Catholic: Clinton, 48%, Trump, 50%

Jewish: Clinton, 71%, Trump, 23%

None: Clinton, 25%, Trump, 67%

White Evangelicals: Clinton, 16%, Trump, 80%

All Others: Clinton, 60%, Trump, 34%

*Most Important Issue to Voter:*

Economy: Clinton, 52%, Trump, 41%

Immigration: Clinton, 33%, Trump, 64%

Terrorism: Clinton, 40%, Trump, 57%

Foreign Policy: Clinton, 60%, Trump, 33%

*Quality in Candidate That Matters Most to Voter:*

Brings Change: Clinton, 14%, Trump, 82%

Cares about People Like Me: Clinton, 57%, Trump, 34%

Has Good Judgment: Clinton, 65%, Trump, 25%

Has the Right Experience: Clinton, 90%, Trump, 7%

*Residency:*

Small City/Rural: Clinton, 34%, Trump, 61%

Suburbs: Clinton, 45%, Trump, 47%

Cities over 50,000: Clinton, 60%, Trump, 34%

Had Served in the Military: Clinton, 34%, Trump, 60%

*Source*: Data from https://www.washingtonpost.com/graphics/politics/2016-election/exit-polls, updated November 29, 2016, accessed January 13, 2017.

Figure 5.1 depicts, in a stark pie chart view, the relative strength of party identification as of July 2016.

Figure 5.2 depicts presidential popular election results, comparing the data for the two major parties, as they change over time, from 1996 to 2016.

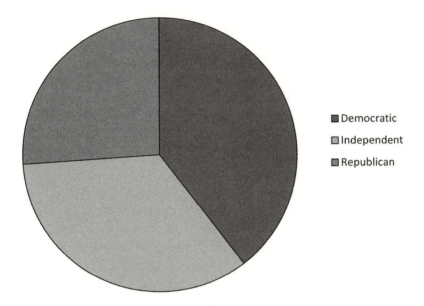

**Figure 5.1   Voter Identification by Party Preference, July 2016**

*Source*: Data from Pew Hispanic Center.

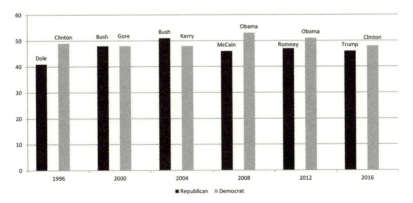

**Figure 5.2   Presidential Election Results, Percentage Total Vote, 1996–2016**

*Source*: Data from http://www.presidency.ucsb.edu, accessed January 13, 2017.

## Documents

*Parts of the Constitution, as amended, as well as numerous laws, Supreme Court decisions, actions by presidents, and political parties have affected the processes of naturalization, the right to vote, and in other ways the development of the party system.*

### Excerpt of Federalist No. 10, on Factions, by Publius (James Madison), November 22, 1787

*James Madison, in Federalist No. 10, written in defense of adoption of the proposed new constitution, argues against faction—his word for parties—and that a virtue of the new form of government to be established by the Constitution is that it will control the damage caused by faction.*

Among the numerous advantages promised by a well constructed union, none deserves to be more accurately developed, than its tendency to break and control the violence of faction. The friend of popular governments, never finds himself so much alarmed for their character and fate, as when he contemplates their propensity to this dangerous vice. He will not fail, therefore, to set a due value on any plan which, without violating the principles to which he is attached, provides a proper cure for it. The instability, injustice, and confusion, introduced into the public councils, have, in truth, been the mortal diseases under which popular governments have every where perished; as they continue to be the favorite and fruitful topics from which the adversaries to liberty derive their most specious declamations. The valuable improvements made by the American constitutions on the popular models, both ancient and modern, cannot certainly be too much admired; but it would be an unwarrantable partiality, to contend that they have as effectually obviated the danger on this side, as was wished and expected. Complaints are every where heard from our most considerate and virtuous citizens, equally the friends of public and private faith, and of public and personal liberty, that our governments are too

unstable; that the public good is disregarded in conflicts of rival parties; and that measures are too often decided, not according to the rules of justice, and the rights of the minor party, but by the superior force of an interested and overbearing majority. However anxiously we may wish that there complaints had no foundation, the evidence of known facts will not permit us to deny that they are in some degree true. It will be found, indeed, on a candid review of our situation, that some of the distresses under which we labour, have been erroneously charged on the operation of our governments; but it will be found, at the same time, that other causes will not alone account for many of our heaviest misfortunes; and, particularly, for that prevailing and increasing distrust of public engagements, and alarm for private rights, which are echoed from one end of the continent to the other. There must be chiefly, if not wholly, effects of the unsteadiness and injustice, with which a factious spirit has tainted our public administration.

By a faction, I understand a number of citizens, whether amounting to a majority or minority on the whole, who are united and agitated by some common impulse of passion, or of interest, adverse to the rights of other citizens, or to the permanent and aggregate interests of our community.

There are two methods of curing the mischiefs of faction: The one, by removing the causes; the other, by controlling its effects.

There are again two methods of removing the causes of factions: The one, by destroying the liberty which is essential to its existence; the other, by giving to every citizen the same opinions, the same passions, and the same interests.

It could never be more truly said, than of the first remedy, that it is worse than the disease. Liberty is to faction, what air is to fire, an aliment, without which it instantly expires. But it could not be less folly to abolish liberty, which is essential to political life, because it nourishes faction, than it would be to wish the annihilation of air, which is essential to animal life, because it imparts to fire its destructive agency.

The second expedient is an impracticable, as the first would be unwise. As long as the reason of man continues fallible, and he is at liberty to exercise it, different opinions will be formed. As long as the connection subsists between his reason and his self-love, his opinions and passions will have a reciprocal influence on each other; and the former will be objects to which the latter will attach themselves. The diversity in the faculties of men, from which the rights of property originate, is not less an insuperable obstacle to an uniformity of interests. The protection of these faculties, is the first object of government. From the protection of different and unequal faculties of acquiring property, the possession of different degrees and kinds of property immediately results; and from the influence of these on the sentiments and views of the respective proprietors, ensues a division of the society into different interests and parties.

The latent causes of factions are thus sown in the nature of man; and we see them everywhere brought into different degrees of activity, according to the different circumstances of civil society. A zeal for different opinions concerning religion, concerning government, and many other points, as well of speculation as of practice; an attachment to different leaders, ambitiously contending for pre-eminence and power; or to persons of other descriptions, whose fortunes have been interesting to the human passions, have, in turn, divided mankind into parties, inflamed them with mutual animosity, and rendered them much more disposed to vex and oppress each other, than to co-operate for their common good. So strong is this propensity of mankind, to fall into mutual animosities, that where no substantial occasion presents itself, the most frivolous and fanciful distinctions have been sufficient to kindle their unfriendly passions, and excite their most violent conflicts. But the most common and durable source of factions, has been the various and unequal distribution of property. Those who hold, and those who are without property, have ever formed distinct interests in society. Those who are creditors, and those who are debtors, fall under a like discrimination. A landed interest, a

manufacturing interest, a mercantile interest, a monied interest, with many lesser interests, grow up of necessity in civilized nations, and divide them into different classes, actuated by different sentiments and views. The regulation of these various and interfering interests, forms the principal task of modern legislation, and involves the spirit of party and faction in the necessary and ordinary operations of government.

**Source:** James Madison. "The Same Subject Continued: The Union as a Safeguard against Domestic Faction and Insurrection." *Federalist No. 10.* From the New York Packet, November 23, 1787. Available at https://www.congress.gov/resources/display/content/The+Federalist+Papers

### Relevant Sections of the Constitution of the United States

*Although the Constitution is silent on the matter of political parties, it has many sections that impact naturalization and therefore the right to vote, many provisions that affect who can run for federal offices, some voting rights and restrictions, and other sections that affect political parties.*

Article I, Section 2. The House of Representatives shall be composed of Members chosen every second Year by the People of the several States, and the Electors in each State shall have the Qualifications requisite for Electors of the most numerous Branch of the State Legislature.

Article I, Section 3. The Senate of the United States shall be composed of two Senators from each State, chosen by the Legislature thereof for six Years; and each Senator shall have one vote. . . .

No Person shall be a Senator who shall not have attained to the Age of thirty Years, and been nine Years a Citizen of the United States, and who shall not, when elected, be an Inhabitant of that State for which he shall be chosen. . . .

Article I, Section 4. The Times, Places and Manner of holding Elections for Senators and Representatives, shall be prescribed in each State by the Legislature thereof; but the Congress may at any time by Law make or alter such Regulations, except as to the Places of choosing Senators . . .

Article I, Section 8. The Congress shall have Power to lay and collect Taxes, Duties, Imposts and Excises; to pay the Debts and provide for the common Defence and general Welfare of the United States . . .

To establish an uniform Rule of Naturalization, . . .

To make all Laws which shall be necessary and proper for carrying into Execution the foregoing Powers, and all other Powers vested by this Constitution in the Government of the United States, or in any Department or Officer thereof.

Article I, Section 9. The Migration or Importation of such Persons as any of the States now existing shall think proper to admit, shall not be prohibited by the Congress prior to the Year one thousand eight hundred and eight, but a Tax or duty may be imposed on such Importation, not exceeding ten dollars for each Person.

Article II, Section 1. The executive Power shall be vested in a President of the United States of America. He shall hold his Office during the Term of four Years, and together with the Vice-President, chosen for the same term, be elected as follows:

Each State shall appoint, in such Manner as the Legislature thereof may direct, a Number of Electors, equal to the whole Number of Senators and Representatives to which the State may be entitled in the Congress; but no Senator or Representative, or Person holding an Office of Trust or Profit under the United States, shall be appointed an Elector.

The Electors shall meet in their respective States, and vote by Ballot for two Persons, of whom one at least shall not be an Inhabitant of the same State with themselves. And they shall make a list of all the Persons voted for, and of the Number of Votes for each; which List they shall sign and certify, and transmit sealed to the Seat of the Government of the United

States, directed to the President of the Senate. The President of the Senate shall, in the Presence of the Senate and House of Representative, open all the Certificates, and the Votes shall then be counted. The Person having the greatest Number of Votes shall be the President, if such Number be a Majority of the whole Number of Electors appointed; and if there be more than one who have such Majority, and have an equal Number of Votes, then the House of Representatives shall immediately chuse by Ballot one of them for President; and if no Person have a Majority, then from the five highest on the List the said House shall in like Manner chuse the President. But in chusing the President, the Votes shall be taken by States, the Representation from each State having one vote; a quorum for this purpose shall consist of a Member or Members from two thirds of the States, and a Majority of all the States shall be necessary to a Choice. In every Case, after Choice of the President, the Person having the greatest Number of Votes of Electors shall be the Vice President. But if there should remain two or more who have equal Votes, the Senate shall chuse from them by Ballot the Vice President.

### Amendments to the Constitution

**Amendment X,** Powers retained by the States and the people

The power not delegated to the United States by the Constitution, nor prohibited by it to the States, are reserved to the States respectively, or to the people.

**Amendment XII,** *Election of the President and Vice President*

The Electors shall meet in their respective states and vote by ballot for President and Vice-President, one of whom, at least, shall not be an inhabitant of the same state with themselves; they shall name in their ballots the person voted for as President, and in distinct ballots the person voted for as Vice-President, and they shall make distinct lists of all persons voted for as President, and all persons voted for as Vice-President, and of the number of votes for each, which lists they shall sign and certify, and transmit sealed to the seat of the government

of the United States, directed to the President of the Senate—the President of the Senate shall, in the presence of the Senate and House of Representatives, open all the certificates and the votes shall then be counted . . .

**Amendment XIV,** *Civil rights*

**Section 1.** All persons born or naturalized in the United States, and subject to the jurisdiction thereof, are citizens of the United States and of the State wherein they reside. No State shall make or enforce any law which shall abridge the privileges or immunities of citizens of the United States; nor shall any State deprive any person of life, liberty, or property, without due process of law; nor deny to any person within its jurisdiction the equal protection of the laws.

**Amendment XV,** *Black suffrage*

**Section 1.** The right of citizens of the United States to vote shall not be denied or abridged by the United States or by any State on account of race, color, or previous condition of servitude.

**Section 2.** The Congress shall have the power to enforce this article by appropriate legislation.

**Amendment XVII,** *Direct election of Senators*

The Senate of the United States shall be composed of two Senators from each State, elected by the people thereof, for six years; and each Senator shall have one vote. The electors in each State shall have the qualifications requisite for electors of the most numerous branch of the State legislatures.

**Amendment XIX,** *Women's suffrage*

The right of citizens of the United States to vote shall not be denied or abridged by the United States or by any State on account of sex.

Congress shall have power to enforce this article by appropriate legislation.

**Amendment XXII,** *Limitation of Presidents to two terms*

**Section 1.** No person shall be elected to the office of President more than twice, and no person who has held the office

of President, or acted as President, for more than two years of a term to which some other person was elected President shall be elected to the office of President more than once. But this Article shall not apply to any person holding the office of President when this Article was proposed by Congress . . .

**Amendment XXIII,** *Suffrage in the District of Columbia*

**Section 1.** The District constituting the seat of Government of the United States shall appoint in such manner as Congress may direct:

A number of electors of President and Vice President equal to the whole number of Senators and Representatives in Congress to which the District would be entitled if it were a State, but in no event more than the least populous State; they shall be in addition to those appointed by the States, but they shall be considered, for the purposes of the election of President and Vice President, to be electors appointed by a State; and they shall meet in the District and perform such duties as provided by the twelfth article of the amendment.

**Amendment XXIV,** *Poll taxes*

**Section 1.** The right of citizens of the United States to vote in any primary or other election for President or Vice President, for electors for President or Vice President, or for Senator or Representative in Congress, shall not be denied or abridged by the United States or any State by reason of failure to pay poll tax or other tax.

**Section 2.** The Congress shall have power to enforce this article by appropriate legislation.

**Amendment XXVI,** *Suffrage for eighteen-year-olds*

**Section 1.** The right of citizens of the United States, who are eighteen years of age or older, to vote shall not be denied or abridged by the United States or any State on account of age.

**Section 2.** The Congress shall have power to enforce this article by appropriate legislation.

**Source:** Charters of Freedom, National Archives.

### Act of March 26, 1790: An Act to Establish a Uniform Rule of Naturalization

*Congress has the power and authority to enact laws that impact elections in various ways and for the purposes of regulating elections for national offices. The following are excerpts from some of those critically important laws enacted by Congress. Among the first such laws was the act to establish a uniform rule of naturalization, which thereby determines the citizen's right to vote.*

Section 1: Be it enacted by the Senate and House of Representatives of the United States of America in Congress assembled, That any alien being a free white person, who shall have resided within the limits and under the jurisdiction of the United States for a term of two years, may be admitted to become a citizen thereof, on application to any common court of record, in any one of the states wherein he shall have resided for the term of one year at least, and making proof to the satisfaction of such court, that he is a person of good character, and taking the oath of affirmation prescribed by law, to support the constitution of the United States, which oath or affirmation such court shall administer; and the clerk of such court shall record such application, and the proceedings thereon; and thereupon such person shall be considered as a citizen of the United States. And the children of such person so naturalized, dwelling within the United States, being under the age of twenty-one years of age at the time of such naturalization, shall also be considered as citizens of the United States. And the children of citizens of the United States, that may be born beyond sea, or out of the limits of the United States, shall be considered as natural born citizens; Provided, That the right of citizenship shall not descend to persons whose fathers have never been resident in the United States; Provided also, That no person heretofore proscribed by any state, shall be admitted a citizen as afore-said, except by an act of the legislature in the state in which such person was proscribed.

**Source:** 1 Stat. 103.

## Act of June 25, 1798, "Alien Act of 1798"

*Responding to fears of the French Revolution, Congress enacted the Alien and Sedition Act of 1798. It required oaths of allegiance from aliens residing in the United States and giving the president extraordinary power to remove aliens deemed to be seditious.*

Be it enacted by the Senate and the House of Representatives of the United States in Congress assembled, That it shall be lawful for the President of the United States at any time during the continuance of this act, to order all such aliens as he shall judge dangerous to the peace and safety of the United States, or shall have reasonable grounds to suspect are concerned with any treasonable or secret machinations against the government thereof, to depart out of the territory of the United States within such time as shall be expressed in such order, which order shall be served to the alien, so ordered to depart, shall be found at large within the United States after the time limited in such order for his departure, and not having obtained a license from the President to reside therein, or having obtained such license shall not have conformed thereto, every such alien shall, on conviction thereof, be imprisoned for a term not exceeding three years, and shall never be admitted to become a citizen of the United States. Provided always, and be it further enacted, that any alien so ordered to depart shall prove to the satisfaction of the President, by evidence to be taken before such person or persons as the President shall direct, who are for that purpose hereby authorized to administer oaths, that no injury or danger to the United States will arise from suffering such alien to reside therein, the President may grant a license to such alien to reside for such time as he shall judge proper, and at such place as he may designate. And the President may also require such alien to enter into a bond to the United States, in such penal sum as he may direct, with one or more sufficient sureties to the satisfaction of the person authorized by the President to take the same, conditioned on the good behavior of such alien during his residence in the United States, and not

violating his license, which license the President may revoke, whenever he shall think proper.

Sec. 2. And be it further enacted, That it shall be lawful for the President . . . whenever he may deem it necessary for the public safety, to order to be removed out of the territory thereof, any alien who may or shall be in prison in pursuance of this act; and to cause to be arrested and sent out of the United States such of those aliens as shall have been ordered to depart therefrom and shall not have obtained a license as aforesaid, in all cases where, in the opinion of the President, public safety requires a speedy removal . . . and if any alien so removed . . . shall voluntarily return thereto, such alien on conviction thereof, shall be imprisoned so long as, in the opinion of the President, the public safety may require.

**Source:** The Alien Act of June 25, 1798 (1 Stat. 570).

## Treaty of Guadalupe Hidalgo, Article VIII, 1848

*In 1848, the United States ended its war with Mexico with the signing of the Treaty of Guadalupe Hidalgo. By this treaty, Mexico ceded to the United States most of its northern territory, which today comprises all or parts of California, New Mexico, Arizona, Nevada, Utah, and Colorado. The treaty grants U.S. citizenship to Mexican nationals remaining in those territories. It is significant because citizen rights, including the right to vote, are thereby granted by treaty, and at the time Mexicans were commonly considered "non-white" and yet were made citizens despite the Constitution's "free white" clause.*

Mexicans now established in territories previously belonging to Mexico, and which remain for the future within the limits of the United States as defined by the present treaty, shall be free to continue where they now reside, or to remove at any time to the Mexican republic; retaining the property which they possess in the said territories, or disposing thereof and

removing the proceeds whenever they please, without their being subjected on this account, to any contribution, tax, or charge whatever.

Those who shall prefer to remain in the said territories, may either retain the title and rights of Mexican citizens, or acquire those of citizens of the United States. But they shall be under the obligations to make their election within one year from the date of the exchange of ratifications of this treaty, and those who shall remain in the said territories after the expiration of that year, without having declared their intention to retain the character of Mexicans, shall be considered to have elected to become citizens of the United States.

**Source:** Treaty of Guadalupe-Hidalgo [Exchange copy], February 2, 1848; Perfected Treaties, 1778–1945; Record Group 11; General Records of the United States Government, 1778–1992; National Archives.

### Abraham Lincoln's Letter to Joshua Speed, 1855

*In 1855, many states, including Illinois, had strong Know Nothing movements, and the party held the balance of power between the two major parties. Abraham Lincoln, in a letter to his friend, Kentuckian Joshua Speed, stated his abhorrence of slavery and nativism. The following excerpt of Lincoln's letter clearly states his opposition to the nativism of the Know Nothing Party.*

I am not a Know Nothing. That is certain. How could I be? How can anyone who abhors the oppression of negroes, be in favor of degrading a class of white people? Our progress in degeneracy appears to me to be pretty rapid. As a nation, we began by declaring that "all men are created equal." We now practically read it "all men are created equal, except negroes." When the Know Nothings get control it will read "all men are equal, except negroes, and foreigners, and Catholics." When it comes to this, I should prefer emigrating to some country

where despotism can be taken pure, and without the base alloy of hypocracy. Springfield, August 24, 1855. A. Lincoln

**Source:** John G. Nicolay and John Hay, eds. 1894. *Abraham Lincoln: Complete Works, Volume 1.* New York: The Century Company, p. 218.

## Millard Fillmore's Speech, June 26, 1856, on the American Party Principles

*In 1856, former Whig president Millard Fillmore ran for president on the American Party (Know Nothing) ticket. He gave a speech in New York, excerpted here, in which he enunciated the principles of the American Party.*

Fellow citizens of Newburgh: Accept my cordial thanks for this hearty greeting. My friend has introduced me as the standard-bearer of the American party, and a friend of the Union. For the former position I am indebted to the partiality of my friends, who have without my solicitation made me your standard-bearer in the contest for President, which has just commenced; but I confess to you that I am proud of the distinction, for I am an American with an American heart. I confess that I am a devoted and unalterable friend of the Union. As an American, occupying the position I do before my countrymen, I have no hostility to foreigners. I trust I am their friend. Having witnessed their deplorable condition in the old country, God forbid that I should add to their suffering by refusing them asylum in this. I would open wide the gates and invite the oppressed of every land to our happy country, excluding only the pauper and criminal. I would be tolerant to men of all creeds, but would exact from all faithful allegiance to our republican institutions.

While I did this, I would, for the sake of those who seek an asylum on our shores, as well as for our own sake, declare as a general rule, that Americans should govern America. I regret to

say that men who come fresh from the monarchies of the old world, are prepared neither by education, habits of thought, or knowledge of our institutions, to govern America . . .

I feel, fellow-citizens, that I need hardly allude to the importance of maintaining this Union. I see the national flag floating from yonder height, which marks the consecrated spot of Washington's headquarters. There was performed an act of moral heroism before which the bravest deeds of Alexander pale, and with which the greatest achievements of Bonaparte are not to be compared. It was there, on that sacred spot, now shaded by the flag of a free republic, that Washington refused a crown. It was there that the officers of the army, after independence had been achieved, made him the offer of a crown, which he indignantly spurned.

**Source:** Frank H. Severance, ed. 1907. *Millard Fillmore Papers, Volume 2*. Buffalo, NY: Buffalo Historical Society, pp. 16–17.

### Act of May 20, 1862: To Secure Homesteads

*Arguably, among the most powerful incentives for attracting immigrants to America and to fill its abundant frontier lands and states, and thereby become citizens and voters and supporters of the two major political parties, was the Homestead Act of 1862, excerpted here.*

Be it enacted . . . That any person who is the head of a family, or who has arrived at the age of twenty-one years, and is a citizen of the United States, or who shall have filed the declaration to become such, as required by the naturalization laws of the United States, and who has never borne arms against the United States Government or given aid and comfort to its enemies, shall, from and after the first of January, eighteen hundred and sixty-three, be entitled to enter one quarter section or a less quantity of unappropriated public lands, upon which said person may have filed a preemption

claim, or which may, at the time the application is made, be subject to preemption at one dollar and twenty-five cents, or less, per acre, or eighty acres or less of such unappropriated lands, at two dollars and fifty-cents per acre, to be located in a body, in conformity to the legal subdivisions of the public lands, and after the same shall have been surveyed; Provided, That any person owning and residing on land may, under the provisions of this act, enter other land lying contiguous to his or her said land, which shall not, with the land so already owned and occupied, exceed in the aggregate one hundred and sixty acres . . .

**Source:** Act of May 20, 1862 (Homestead Act), Public Law 37–64, 05/20/1862; Record Group 11; General Records of the United States Government; National Archives.

### Act of July 17, 1862: Honorably Discharged Soldiers (Re: Naturalization)

*By another act in 1862, Congress granted naturalization to honorably discharged soldiers. It became an important inducement to recruit aliens to serve in the Union Army during the Civil War, and it set a precedent for every war in which the United States was engaged thereafter, to grant speedy naturalization to honorably discharged U.S. soldiers.*

Sec. 2166. Any alien, of the age of twenty-one years and upward, who has enlisted, or may enlist, in the armies of the United States, either the regular or the volunteer forces, and has been, or may be hereafter, honorably discharged, shall be admitted to become a citizen of the United States, upon his petition, without any previous declaration of his intention to become such, and he shall not be required to prove other than one year's residence within the United States previous to his application to become a citizen, and the court admitting such alien shall, in addition to proof of residence and good moral

character, as now provided by law, be satisfied by competent proof of such person's having been honorably discharged from the service of the United States.

**Source:** 40 Stat. 546.

### Act of May 6, 1882: To Execute Certain Treaty Stipulations Relating to Chinese (Chinese Exclusion Act)

*Congress passed the Chinese Exclusion Act in 1882. It "suspends" the immigration of Chinese laborers for 10 years, and, in its Section 14, denies them the right to citizenship by naturalization. Three of its key sections are excerpted here.*

Whereas, in the opinion of the Government of the United States the coming of Chinese laborers to this country endangers the good order of certain localities within the territory thereof: Therefore, Be it enacted by the Senate and House of Representatives of the United States of America in Congress assembled, That from and after the expiration of ninety days next after the passage of this act, and until the expiration of ninety days next after the passage of this act, and until the expiration of ten years next after the passage of this act, the coming of Chinese laborers to the United States be, and the same is hereby, suspended; and during such suspension it shall not be lawful for any Chinese laborer to come, or having so come after the expiration of said ninety days, to remain within the United States.

Sec. 14. That hereafter no State court or court of the United States shall admit Chinese to citizenship; and all laws in conflict with this act are hereby repealed.

Sec. 15. That the words "Chinese laborers," wherever used in this act, shall be construed to mean both skilled and unskilled laborers and Chinese employed in mining.

**Source:** 22 Stat. 58; 8 U.S.C.

### President Grover Cleveland's Veto Message of the Immigrant Literacy Test Bill (March 2, 1897)

*Although the authority to enact laws that affect immigration and naturalization is given by the Constitution to the Congress, presidents have from time to time exercised their veto power against some bills passed by the Congress. An example of such an exercise of power is the veto message of President Glover Cleveland of the Immigrant Literacy Bill, excerpted here.*

To the House of Representatives: I hereby return without approval House bill No. 7864, entitled "An act to amend the immigration laws of the United States." By the first section of this bill it is proposed to amend section 1 of the act of March 3, 1891, relating to immigration by adding to the classes of aliens thereby excluded from admission to the United States, the following.

"All persons physically capable and over 16 years of age who can not read and write the English language or some other language, but a person not so able to read and write who is over 50 years of age and is the parent or grandparent of a qualified immigrant over 21 years of age and capable of supporting such parent or grandparent may accompany such immigrant, or such parent or grandparent may be sent for and come to join the family of a child or grandchild over 21 years of age similarly qualified and capable, and a wife or minor child not so able to read and write may accompany or be sent for and come and join her husband or parent similarly qualified and capable."

A radical departure from our national policy relating to immigration is here presented. Heretofore we have welcomed all who came to us from other lands except those whose moral or physical conditions or history threatened danger to our national welfare and safety. Relying upon zealous watchfulness of our people to prevent injury to our political and social fabric, we have encouraged those coming from foreign countries to cast their lot with us and join in the development of our vast domains, securing in return a share in the blessings of American citizenship. . . .

I can not believe that we would be protected against those evils by limiting immigration to those who can read and write in any language twenty-five words of our Constitution. In my opinion, it is infinitely more safe to admit a hundred thousand immigrants who, though unable to read and write, seek among us only a home and opportunity to work than to admit one of those unruly agitators and enemies of governmental control who can not only read and write, but delight in arousing by inflammatory speech the illiterate and peacefully inclined to discontent and tumult. Violence and disorder do not originate with illiterate laborers. They are, rather, the victims of the educated agitator. The ability to read and write, as required by this bill, in and of itself affords, in my opinion, a misleading test of contended industry and supplies unsatisfactory evidence of desirable citizenship or a proper apprehension of the benefits of our institutions . . .

A careful examination of this bill has convinced me that for the reasons given and others not specifically stated its provisions are unnecessarily harsh and oppressive, and that its defects in construction would cause vexation and its operation would result in harm to our citizens.

**Source:** *Messages and Papers of the Presidents, Volume 13*. 1897. New York: Bureau of National Literature, Inc., pp. 6189–6193.

## *In Re Rodriguez,* District Court, W.D. Texas (May 3, 1897)

*After the Civil War, several states tried to limit the naturalization of Mexicans, and their actions were challenged in federal district court. Notwithstanding the conventional wisdom that citizenship was limited to whites, blacks, and some Native Americans, a federal district court in West Texas affirmed that Mexicans, largely a mixed-race people, were also eligible for naturalization. The following excerpts the summary judgment in the case.*

When all the foregoing laws, treaties, and constitutional provisions are considered, which either affirmatively confer the rights of citizenship upon Mexicans, or tacitly recognizes in them the right of individual naturalization, the conclusion forces itself upon the mind that citizens of Mexico are eligible to American citizenship, and may be individually naturalized . . .

After careful and patient investigation of the question discussed, the court is of the opinion that, whatever may be the status of the applicant viewed solely from the standpoint of the ethnologist, he is embraced within the spirit and intent of our laws upon naturalization, and his application should be granted if he is shown by the testimony to be a man attached to the principles of the constitution, and well disposed to the good order and happiness of the same . . . In the judgment of the court, the applicant possesses the requisite qualifications for citizenship, and his application will therefore be granted.

**Source:** District Court, W.D. Texas (81 F. 337, May 3, 1897).

### *United States v. Wong Kim Ark* (March 28, 1898)

*Birthright citizenship, no matter the citizenship status of the parents, was affirmed by a decision of the Supreme Court, which ruled that a native-born person of Asian (in this case, Chinese) descent was indeed a citizen of the United States despite the fact that his or her parents may have been resident aliens not eligible for naturalization. The decision affirmed an important precedent that all persons born in the United States—no matter their race—were, in fact, native-born citizens of the United States. That central point of the decision is excerpted here.*

The fact, therefore, that acts of Congress or treaties have not permitted Chinese persons born out of this country to become citizens by naturalization cannot exclude Chinese persons born in this country from the operation of the broad and clear words

of the Constitution, "All persons born in the United States, and subject to the jurisdiction thereof, are citizens of the United States."

Upon the facts agreed in this case, the American citizenship which Wong Kim Ark has acquired at birth within the United States has not been lost or taken away by anything happening since his birth . . . The evident intention, and the necessary effect, of the submission of this case to the decision of the court upon the facts agreed by the parties, were to present for determination the single question, stated at the beginning of this opinion, namely, whether a child born in the United States, of parents of Chinese descent; who, at the time of this birth, are subjects of the Emperor of China, but have a permanent residence in the United States, and are there carrying on business, and are not employed in any diplomatic, or other official capacity under the Emperor of China, becomes at the time of his birth a citizen of the United States. For the reasons above stated, the court is of the opinion that the question must be answered in the affirmative. Order affirmed.

**Source:** *United States v. Wong Kim Ark*, 169 U.S. 649 (1898).

### The Federal Election Campaign Laws: A Short History

*In 1979, the Federal Election Commission issued the following short history of Federal Election Campaign Laws, excerpted here.*

The Federal Election Campaign Act of 1971 (P.L. 92–225), together with the 1971 Revenue Act (P.L. 92–178), initiated fundamental changes in Federal campaign finance laws. The FECA, effective April 7, 1972, not only required full reporting of campaign contributions and expenditures, but also limited spending on media limits (such limits were later repealed).

The FECA also provided the basic legislative framework for separate segregated funds, popularly referred to as PACs (political action committees), established by corporations and

unions. Although the Tillman Act and the Taft-Hartley Act of 1947 banned direct contributions by corporations and unions to influence Federal elections, the FECA provided an exception whereby corporations and labor unions could use treasury funds to establish, operate and solicit voluntary contributions for the organization's separate segregated fund (i.e. PACs). These voluntary contributions could then be used to contribute to Federal races.

Under the Revenue Act, the first of a series of laws implementing Federal financing of Presidential elections—citizens could check a box on their tax forms authorizing the Federal government to use one of their tax dollars to finance Presidential campaigns in the general election, Congress implemented the program in 1973, and, by 1976, enough tax money had accumulated to fund the 1976 election—the first publicly funded Federal election in U.S. history.

The Federal Election Campaign Act of 1971 did not provide for a single, independent body to monitor and enforce the law. Instead, the Clerk of the House, the Secretary of the Senate and the Comptroller General of the United States General Accounting Office (GAO) monitored compliance with the FECA, and the Justice Department was responsible for prosecuting violations of the law referred by the overseeing officials. Following the 1972 elections, although Congressional officials referred about 7,000 cases to the Justice Department, and the Comptroller General referred about 100 cases to Justice, few were litigated.

Not until 1974, following the documentation of campaign abuses in the 1972 Presidential elections, did a consensus emerge to create an independent body to ensure compliance with the campaign finance laws. Comprehensive amendments to the FECA (P.L. 93–443) established the Federal Election Commission, an independent agency to assume the administrative functions previously divided between Congressional officers and the GAO. The Commission was given jurisdiction in civil enforcement matters, authority to write regulations and

responsibility for monitoring compliance with the FECA. Additionally, the amendments transferred from GAO to the Commission the function of serving as a national clearinghouse for information on the administration of elections.

Under the 1974 amendments, the President, the Speaker of the House, and the President pro tempore of the Senate each appointed two of the six voting Commissioners. The Secretary of the Senate and the Clerk of the House were designated nonvoting, ex-officio Commissioners. The first Commissioners were sworn in on April 14, 1975.

The 1974 amendments also completed the system currently used for the public financing of Presidential elections. The amendments provided for partial Federal funding, in the form of matching funds, for Presidential primary candidates and also extended public funding to political parties to finance their Presidential nominating conventions.

Completing these provisions, Congress also enacted strict limits on both contributions and expenditures. These limits applied to all candidates for Federal office and to political committees influencing Federal elections.

Key provisions of the 1974 amendments were immediately challenged as unconstitutional in a lawsuit filed by Senator James L. Buckley (R-NY) and Eugene McCarthy (former Democratic Senator from Minnesota) against the Secretary of the Senate, Francis R. Valeo. The Supreme Court handed down its ruling on January 30, 1976, *Buckley v. Valeo,* 424 U.S. 1 (1976).

The Court upheld contribution limits because they served the government's interest in safeguarding the integrity of elections. However, the Court overturned expenditure limits, stating: "It is clear that a primary effect of these expenditure limitations is to restrict the quantity of campaign speech by individuals, groups and candidates. The restrictions . . . limit political expression at the core of our electoral process and the First Amendment freedoms." Acknowledging that both contribution and spending limits had First Amendment implications,

the Court stated that the new law's "expenditure ceiling impose significantly more severe restrictions on protected freedom of political expression and association than do its limitations on financial contributions." The Court implied, however, that the expenditure limits placed on publicly funded candidates were constitutional because Presidential candidates were free to disregard the limits if they chose to reject public financing; later, the Court affirmed this ruling in *Republican National Committee v. FEC.* 445 U.S. 955 (1980).

The Court also sustained other provisions of the public funding law and upheld disclosure and recordkeeping requirements. However, the Court found that the method of appointing FEC Commissioners violated the constitutional principle of separation of powers, since Congress, not the President, appointed four of the Commissioners, who exercised executive powers. As a result, beginning on March 22, 1976, the Commission could no longer exercise its executive powers. The agency resumed full activity in May, when, under the 1976 amendments to FECA, the Commission was reconstituted and the President appointed six Commission members, who were confirmed by the Senate.

In response to the Supreme Court's decision, Congress revised campaign finance legislation yet again. The new amendments, enacted on May 11, 1976, repealed expenditure limits (except for candidates who accepted public funding) and revised the provision governing the appointment of Commissioners.

The 1976 amendments contained other changes, including provisions that limit the scope of PAC fundraising by corporations and labor organizations. Preceding this curtailment of PAC solicitations, the FEC had issued an advisory opinion, AQ 197523 (the SunPAC opinion), confirming that the 1971 law permitted a corporation to use treasury money to establish, operate and solicit contributions to a PAC. The opinion also permitted corporations and their PACs to solicit the corporation's employees as well as its stockholders. The 1976 amendments, however, put significant restrictions on PAC

solicitations, specifying who could be solicited and how solicitations would be conducted. In addition, a single contribution limit was adopted for all PACs established by the same union or corporation.

Building upon the experience of the 1976 and 1978 elections, Congress made further changes in the law. The 1979 amendments to the FECA (P.L. 96–187), enacted on January 8, 1980, included provisions that simplified reporting requirements, encouraged party activity at State and local levels and increased the public funding for Presidential nominating conventions. Minor amendments were adopted in 1977, 1982, 1983, and 1984.

Summary. In one decade, Congress has fundamentally altered the regulation of Federal campaign finances. Through the passage of the Revenue Act, the FECA and its amendments, Congress has provided public financing for Presidential elections, limited contributions to Federal elections, required substantial disclosure of campaign finance activity and created an independent agency to administer and enforce these provisions.

**Source:** *The Federal Election Commission: The First 10 Years, 1975–1985*. Available at http://www.fec.gov/pdf/firsttenyears report.pdf

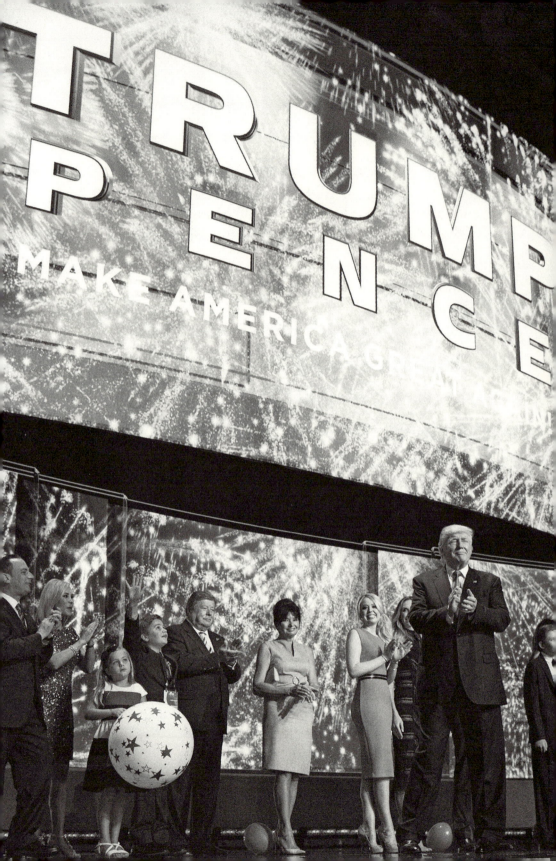

## Introduction

This chapter lists and discusses briefly some major sources of information the reader is encouraged to consult. It begins with print sources: more than 125 scholarly books on the subject are cited and described. It then lists and discusses more than 50 scholarly refereed journals that publish articles pertinent to the subject. Finally, it lists and discusses nonprint sources: more than 25 films and videos that give "life" and faces to the subject, illustrating American political life, elections, and partisan competition depicted in film over time.

## Books

Aldrich, John. 2012. *Why Parties? A Second Look.* Chicago: University of Chicago Press.

> Aldrich goes beyond arguments about whether American parties are in resurgence or decline and reexamines the foundations of the American party system and its role in citizens seeking office, mobilizing voters, and achieving majorities to accomplish policy goals. The book offers a full consideration of the party system, especially the

Donald Trump celebrates his Republican Party nomination for president on the final night of the Republican National Convention in Cleveland, Ohio, on July 21, 2016. In carrying Ohio, a must-win state for Trump, he went on to win the election. (AP Photo/Evan Vucci)

two-party system, and explains why the system is necessary for effective democracy.

Allen, Oliver E. 1993. *The Tiger: The Rise and Fall of Tammany Hall.* Cambridge, MA: Da Capo Press.
    Allen provides a history of America's most notorious political machine—its colorful personalities, scandals, and power brokering—covering its history from 1786 to 1961 into a brisk and entertaining volume.

Anbinder, Tyler. 1992. *Nativism and Slavery: The Know Nothings and the Politics of the 1850s.* New York: Oxford University Press.
    A detailed, authoritative study of the Know Nothing movement showing that their success was linked to their northern members' firm stance against the extension of slavery as well as their attacks against Catholic immigrants.

Bardes, Barbara, and Robert W. Oldendick. 2016. *Public Opinion: Measuring the American Mind.* Lanham, MD: Rowman and Littlefield.
    This text prepares the reader to accurately interpret and analyze data from public polls, with opinion data on such issues as the war in Iraq, Social Security reform, the death penalty, gay rights, and racial issues to enhance the reader's understanding of public opinion and the polling process.

Barone, Michael. 2014. *Shaping Our Nation: How Surges in Migration Transformed America and Its Politics.* New York: Random House.
    The author examines the history of immigration and how past surges influenced American culture, society, and politics, including its past and present impact on political parties.

Bartle, John, and Paolo Bellucci. 2009. *Political Parties and Partisanship: Social Identity and Individual Attitudes.* New York: Routledge.

The authors examine the conceptualization, causes, and consequences of partisanship using comparative empirical research including the United States and Eastern Europe.

Bayor, Ronald, and Timothy Meagher, eds. 1995. *The New York Irish*. Baltimore: Johns Hopkins University Press.
This is the story of the New York Irish as well as the story of American ethnic groups writ large, discussing their impact not just on Tammany Hall but also on unions, race relations, neighborhood development, and the city's culture.

Berinsky, Adam J., ed. 2015. *New Directions in Public Opinion*. 2nd ed. London: Routledge.
This collection of essays brings together leading scholars to provide an accessible and coherent overview of the current state of the field of public opinion covering a wide range of topics using cutting-edge studies as well as the well-established cornerstones of the field.

Bond, Jon R., and Richard Fleisher, eds. 2000. *Polarized Politics: Congress and the President in a Partisan Era*. Washington, DC: Congressional Quarterly Press.
This volume presents a collection of essays discussing how the rise in partisan politics has affected congressional presidential relations, including agenda setting in Congress, lawmaking in an era of hyper-partisanship, and competition between presidents and their parties over defining party identities.

Bowen, Michael. 2011. *The Roots of Modern Conservatism*. Chapel Hill: University of North Carolina Press.
Bowen traces the power struggle emerging between 1944 and 1953 between Thomas Dewey and Robert Taft and how their struggle led to a divide of ideology that determined the party's political identity and what "true" Republicanism means.

Brinkley, Alan. 1995. *The End of Reform: New Deal Idealism in Recession and War.* New York: Alfred Knopf.
> Brinkley shows how New Deal liberalism was transformed during and after World War II and why it fared so poorly in the 1990s.

Burnham, Walter D., et al. 2009. *Voting in American Elections.* Palo Alto, CA: Academia Press.
> Burnham, a leading authority on American elections and voting patterns, brings together some of the best-known quantitative analysis of national trends and patterns in the popular vote, developing the "party system model" and assembling county elections for the entire country.

Burstein, Paul. 2014. *American Public Opinion, Advocacy and Policy in Congress: What the Public Wants and Gets.* Cambridge: Cambridge University Press.
> The author addresses how public opinion and advocacy groups influence policy adoption in Congress using detailed analyses of debates surrounding 60 policy proposals from well-known to obscure and unsuccessful efforts drawn from a random sample of bills from the 101st Congress (1989–1990). He collects available opinion data, articles from hundreds of newspapers and periodicals, and congressional testimony and congressional hearings. He shows that most proposals that have majority support in opinion polls nonetheless fail, with majority preference reflected in the outcome only half of the time, and that the public more likely gets its way when it opposes action.

Campbell, Angus. 1980. *The American Voter.* Chicago: University of Chicago Press.
> This is a classic text on elections, voting, and political parties.

Ceaser, James, and Andrew Busch. 2001. *The Perfect Tie: The True Story of the 2000 Presidential Election.* Princeton, NJ: University of Princeton Press.

The authors continue their study of national elections and their broader implications for American political society, with a penetrating discussion of divided government, independent candidates, party platforms, realignment theory, the Electoral College, and campaign strategies to make sense of the 2008 presidential election.

Chernow, Ron. 2004. *Alexander Hamilton.* New York: Penguin Press.

In this first full-length biography of Hamilton in decades, Chernow tells a riveting tale of a man who overcame all odds to shape, inspire, and scandalize America. Hamilton coauthored the Federalist Papers, founded the Federalist Party and the Bank of New York, and became the first treasury secretary of the United States.

Clanton, Gene. 1991. *Populism: The Humane Preference in America, 18900–1900.* Boston: Twayne.

This volume is a thorough study of the radical left Populist Party that arose in 1890 and, led by William Jennings Bryan, merged into the Democratic Party in 1900. It grew out of the Farmer's Alliance and the People's Party and was a social and political movement that called for government reform.

Clawson, Rosalie, and Zoe M. Oxlay. 2016. *Public Opinion, Democratic Ideals, Democratic Practices.* 3rd ed. Washington, DC: Congressional Quarterly Press.

Clawson and Oxlay examine in 10 literature review chapters linked to underlying normative assumptions and implications in which each asks a few empirical questions, such as are citizens pliable, how do they organize their political thinking, do citizens endorse and demonstrate democratic basics, and what is the relationship between citizens and their government.

Cohen, Jeffrey E., Richard Fleisher, and Paul Kantor, eds. 2001. *American Political Parties: Decline or Resurgence?* Washington, DC: Congressional Quarterly.

> The book addresses two cross-currents affecting American political parties over the past several decades, asking whether the era of party decline is over and the parties are beginning an era of rebuilding, in what direction the parties are headed, and what that means for a healthy and well-functioning democracy. They present historical and contemporary materials on U.S. political parties offering a balanced portrait and a wide variety of views.

Cooper, John Milton. 2001. *Breaking the Heart of the World: Woodrow Wilson and the Fight for the League of Nations.* Cambridge: Cambridge University Press.

> In this engaging narrative, Cooper relates the story of Wilson's battle for the League with sympathy, accuracy, and a deep understanding of the times.

Cooper, John Milton. 2009. *Woodrow Wilson: A Biography.* New York: Vintage.

> Presidential scholar John M. Cooper authors a monumental new biography of the 28th president that seeks to rescue his reputation and restore his place as one of America's finest leaders, one of the greatest legislative leaders ever to serve as president, and a resolute wartime president.

Cox, Gary W. 1997. *Making Votes Count: Political Economy of Institutions and Decisions.* Cambridge: Cambridge University Press.

> Cox examines strategic coordination, covering both legislative and executive elections and both strategic entry and strategic voting, while investigating the consequences of strategic coordination and structural features that shape coordination problems faced by political actors in differing politics.

Dalleck, Robert. 1999. *Flawed Giant: Lyndon Johnson and His Times.* New York: Oxford University Press.

This is a monumental biography of LBJ, who worked his will on Congress like no other president before or since, and an engrossing account of his years in the national spotlight.

De Santis, Vincent P. 1998. *Republicans Face the Southern Question: The New Departure Years, 1877–1897.* Baltimore: Johns Hopkins University Press.

De Santis details the attempts of the Republican Party to regain their position in the South after 1877, focusing on four Republican presidents: Hayes, Garfield, Arthur, and Harrison.

Epstein, David. 2012. *Left, Right, Out: A History of Third Parties in America.* Online. Warsaw: Arts and Imperium Press.

Epstein explores the lesser-told story of American history from its founding to the present: the phenomena that shaped the nation and its politics through the lens of third party politics, whether short lived or long lasting, representing a unique and acute expression of the great social, economic, and political forces that influenced the evolution of the country and the pioneering efforts of third parties and their adherents.

Erikson, Robert S., and Kent L. Tedin. 2014. *American Public Opinion: Its Origins, Content, and Impact.* 8th ed. London: Pearson.

An updated edition, this basic text goes beyond simple presentation of data to include a critical analysis of the role of public opinion in American democracy, providing in-depth analysis of public opinion, its origins in political socialization, the impact of the media, the extent and breadth of democratic values, to its role in the electoral process with survey data from the 2008 elections and the

latest literature on the role of public opinion in policy and politics in America.

Eyel, Yonatan. 2007. *The Young America Movement and the Transformation of the Democratic Party, 1828–1861.* Cambridge: Cambridge University Press.

> Eyel argues that the Young America phenomena of the antebellum period transformed the Democratic Party into an expansionist, economically progressive, and internationally engaged organization, changing the party of Jackson but failing to preserve that character of the party after the Civil War.

Finan, Christopher. 2003. *Alfred Smith: The Happy Warrior.* New York: Hill and Wang.

> Finan describes the meteoric rise and dramatic fall of Al Smith, the brash, Catholic, anti-Prohibitionist politician. Finan writes a full, nuanced study of this engaging and misunderstood politician.

Fink, Leon. 1999. *Progressive Intellectuals and the Dilemmas of Democratic Commitment.* Cambridge: Cambridge University Press.

> In this social history of the progressive movement, Fink examines the means and methods used by twentieth-century intellectuals in the first part of the century, focusing on questions of could and should "the people" prevail? He details the Socialist, Progressive, and New Deal adherents grappling with these questions.

Fiorina, Morris P., Samuel J. Abrams, and Jeremy C. Pope. 2010. *The Culture Wars: The Myth of a Polarized America.* 3rd ed. New York: Longman.

> The authors poke holes in the argument that Americans are deeply polarized and in the concept of a "culture war," showing that on average Americans are moderate in their

views and tolerant in their manner and that moral issues are not among their most serious concerns. They argue that views of them as polarized is not only false but harmful and that recognizing common ground provides a basis for creating a less contentious and more productive approach to government and politics in the future.

Foner, Eric. 1995. *Free Soil, Free Labor, Free Men: The Ideology of the Republican Party before the Civil War.* New York: Oxford University Press.
Foner offers an influential work dealing with the factors that brought the North to fight the Civil War and the struggles of the times.

Fraser, Steve, and Gary Gerstle, eds. 1990. *The Rise and Fall of the New Deal Order, 1930–1980.* Princeton, NJ: Princeton University Press.
This collection of 10 essays by scholars who came of age after the New Deal legacy had been tarnished provides fresh historical perspectives on the period. The book represents cutting-edge historical scholarship of twentieth-century American political life.

Freidel, Frank. 1990. *Franklin D. Roosevelt: A Rendezvous with Destiny.* Boston: Little, Brown.
Freidel offers a solid, scholarly biography of FDR, touching on the high points of his presidency, showing how his governorship of New York prepared him well for the office and focusing on his famous first 100 days.

Galderisi, Peter F., Robert Q. Hertzberg, and Peter McNamara, eds. 1994. *Divided Government: Change, Uncertainty, and the Constitutional Order.* Lanham, MD: Rowman and Littlefield.
This volume is a provocative collection of original essays exploring the complicated nature and implications of divided government in the United States.

Gerring, John. 2001. *Party Ideologies in America, 1828–1996.* Cambridge: Cambridge University Press.
>    Gerring provides a synthesis and analysis of the ideologies of the major political parties, from the early nineteenth century to the present. Its broad view is empirically grounded.

Gerstle, Gary. 2001. *American Crucible: Race and Nation in the Twentieth Century.* Princeton, NJ: Princeton University Press.
>    The volume is a sweeping history of twentieth-century America and its changing and often conflicting ideas of the fundamental nature of American society. Gerstle traces the forces of civic and racial nationalism and shows how they profoundly affected American society.

Gillespie, J. David. 1993. *Politics at the Periphery: Third Parties in Two-Party America.* Columbia: University of South Carolina Press.
>    The author examines third parties and the cultural and structural constraints that relegate them to the periphery of American politics from 1820 to Ross Perot.

Gillespie, J. David. 2012. *Challengers to Duopoly: Why Third Parties Matter in American Two Party Politics.* Columbia: University of South Carolina.
>    Gillespie offers a lively discussion of American third parties, past and present, and is a handy reference of descriptions of the many smaller parties that have enriched the American political scene. He shows that many third parties are driven by a vision of what should be but some are "mean-spirited, nasty, and even downright dangerous."

Gillon, Steven M. 1992. *The Democrat's Dilemma: Walter Mondale and the Liberal Legacy.* New York: Columbia University Press.
>    The author studies Mondale's career from Minnesota politics to his Senate and vice presidential service and his

presidential campaign. Gillon contends that Mondale's failure to create a new Democratic Party underscored its deep divisions. He provides a portrait of the inner workings of the Carter administration.

Glynn, Carroll, and Susan Herbst. 2004. *Public Opinion.* Boulder, CO: Westview Press.
The authors offer a comprehensive and interdisciplinary study of public opinion formation and change, the nature of political and social attitudes in the United States, and how they shape various institutions and the mass media.

Gould, Lewis. 2003. *Grand Old Party: A History of the Republicans.* New York: Random House.
From Lincoln to George W. Bush, Gould traces the evolution of the GOP from its emergence as an antislavery coalition in the 1850s to its current role as champion of political and social conservatism. He brings to life the major figures of the party and the historical forces and issues that shaped it.

Gould, Lewis. 2008. *Four Hats in the Ring: The 1912 Election and the Birth of Modern American Politics.* Lawrence: University Press of Kansas.
One of America's preeminent political historians provides the definitive examination of the 1912 contest and shows how it shaped the major parties for generations to come.

Green, Donald, Bradley Palmquist, and Eric Schickler. 2004. *Partisan Hearts and Minds: Political Parties and Social Identities.* New Haven, CT: Yale University Press.
A detailed analysis of partisan attitudes and identity and how it relates to various social identities (race, class, religion, gender).

Green, Mark. 2002. *Selling Out: How Big Corporate Money Buys Elections, Rams Through Legislation, and Betrays Our Democracy.* Washington, DC: Regan Books (HarperCollins).

The 2001 Democratic nominee for mayor of New York City lost to Michael Bloomberg. Green describes how the millions of dollars in campaign donations shape and corrupt the system and argues that both major parties share in the blame.

Greenberg, Stanley. 1996. *Middle Class Dreams: Politics and Power in the New American Majority.* New Haven, CT: Yale University Press.
     Greenberg, an eminent analyst of public opinion, gives an honest and compelling account of the causes and effects of the middle-class rebellion and why the traditional party strategies produced 30 years of growing party failure.

Gregg, Gary L. 2001. *Securing Democracy: Why We Have an Electoral College.* Wilmington, DE: ISI Books.
     A collection of essays supporting the Electoral College and maintaining it helps reinforce the stability of the two-party system, but the book's overall tone echoes the conservative ethos and seems more concerned with defending the election of George W. Bush's controversial 2000 election.

Groenendyk, Eric. 2013. *Competing Motives in the Partisan Mind.* New York: Oxford University Press.
     The author demonstrates the influence of competing motives in party identification and loyalty, using rational choice theory and empirical data to test hypotheses.

Haas, Garland. 1994. *The Politics of Disintegration: Political Party Decay in the United States, 1856–1900.* Jefferson, NC: McFarland and Company.
     Haas examines the social, economic, and political factors that affected the major parties during a 40-year period.

Hamby, Alonzo. 1992. *Liberalism and Its Challenger: From FDR to Bush.* New York: Oxford University Press.

This volume is a second edition of a classroom text that traces the rise, fall, and continuing evolution of the liberal tradition in America since the Great Depression, focusing on 10 key individuals in lively biographical essays to clarify the ideological bases of American liberalism.

Henderson, David, ed. 2008. *Concise Encyclopedia of Economics*. 2nd ed. Indianapolis: Library of Economics and Liberty.
An online encyclopedia of economics with articles written by economists from different schools of thought and including four Nobel laureates in economics.

Hershey, Marjorie R. 2007. *Party Politics in America*. 12th ed. London: Longman Pearson.
A classic political parties textbook, updated to the 2004 election and the 2006 midterms, it analyzes the components of parties: party-as-organization, party-in-the-electorate, party-in-government, and how they interact in election campaigns.

Holbrook, Thomas. 2016. *Altered States: Changing Populations, Changing Parties, and the Transformation of the American Political Landscape*. New York: Oxford University Press.
A detailed examination of changes in party fortunes in presidential elections since 1972, documenting the magnitude and consequences of changes in party support in the states. Holbrook looks at the ways in which changes in racial and ethnic composition of the states' electorates, migratory patterns, and other key demographic and political characteristics are driving changes at the state level.

Holt, Michael F. 1999. *The Rise and Fall of the American Whig Party: Jacksonian Politics and the Onset of the Civil War*. New York: Oxford University Press.
This is a definitive, comprehensive history of the Whig Party. It gives a panoramic account of the turbulent

antebellum period and how the Whig Party rose and fell, failing to prevent secession.

James, Scott. 2000. *Presidents, Parties, and the State: A Party System Perspective on Democratic Regulatory Choice, 1884–1936.* Cambridge: Cambridge University Press.
James places presidential elections and national party leaders at the center of American regulatory state development from 1884 to 1936 and how and why the Democratic Party coalition of voting blocs drove the party to embrace that regulation.

Johnson, Haynes. 2003. *Sleep Walking through History: America in the Reagan Years.* New York: W. W. Norton.
Johnson, a national best-selling author, provides a political analysis of the Reagan decade. He captures the drama and tragedy of an era nurtured by greed and the morality of the virtue of not getting caught.

Johnson, Haynes, and Dan Blatz. 2010. *The Battle for America 2008: The Story of an Extraordinary Election.* New York: Penguin Books.
A detailed description of the 2008 presidential election, from the early caucuses and primaries through the general election, the book focuses on Hillary Clinton, Barack Obama, Sarah Palin, and John McCain but mentions the other candidates from time to time in typical political reporter style from their daily journals and thereby focuses on minutia most voters really don't care about. However, their mainstream media credentials gained them access to see behind-the-scenes action. It's mostly about the "horserace" aspect of the campaigns.

Judis, John B., and Ruy Teixeira. 2004. *The Emerging Democratic Majority.* New York: Scribner/Simon and Schuster.
The authors argue that current demographic and political trends suggest that a new realignment of political power

is all but inevitable, this time sweeping Democrats to power: such trends as the growth in Asian, Hispanic, and African American populations; the shift to a postindustrial economy producing voters who trend Democratic; and the growing gender gap and increasing electoral clout of women voters.

Kazin, Michael. 1995. *The Populist Persuasion: An American History.* New York: Basic Books.

*The Populist Persuasion* is a thoughtful book that traces the emergence of the populist movements from the nineteenth century to today. Kazin examines the labor movement, the Protestant Crusade, Catholic radio populist Father Coughlin, the New Left, and the recent rise of conservative populism.

Keller, Morton. 2007. *America's Three Regimes: A New Political History.* Oxford: Oxford University Press.

A distinguished political historian weaves a history of America's political development in a colorful narrative tapestry that stresses the continuity as much as the change in an original and compelling account of the entire American polity.

Kleppner, Paul. 1987. *Continuity and Change in Electoral Politics, 1893–1928.* Westport, CT: Greenwood Press.

Kleppner's study attempts to move beyond the older voting studies by questioning their underlying assumptions and analyzing the changes that occurred at the beginning of the twentieth century, showing how party identification changed, responding to short-term fluctuations in the economy and the impact of charismatic candidates.

Kleppner, Paul, et al. 1983. *The Evolution of American Electoral Systems.* Westport, CT: Greenwood Press.

In this now classic work, Kleppner applies the party system model to explain the evolution of the American party system.

Klingemann, Hans-Dieter, Richard Hofferbert, and Ian Budge. 1994. *Parties, Politics, and Democracy.* Boulder, CO: Westview Press.

> This international author team demonstrates the strong link between what parties say they will do in election campaigns and what they actually do when elected. The authors address questions central to the operation of modern democracies.

Landy, Marc, and Sidney M. Milkis. 2000. *Presidential Greatness.* Lawrence: University Press of Kansas.

> The authors claim that we have had no great presidents in the last half of the twentieth century, showing how five presidents, Washington, Jefferson, Jackson, Lincoln, and FDR, set the standards for presidential leadership and achievement.

Lawrence, David G. 1997. *The Collapse of the Democratic Presidential Majority.* Boulder, CO: Westview Press.

> Lawrence questions the classic realignment theory and posits a competing theory of dealignment to make sense of the last half century of American presidential elections, combining analysis of presidential elections with theories of electoral change.

LeMay, Michael C. 1987. *From Open Door to Dutch Door.* New York: Praeger Press.

> This volume is an historical review of immigration policy since 1820, distinguishing four phases, and how they, in the past, influenced major and minor political parties.

LeMay, Michael C. 1994. *Anatomy of a Public Policy.* Westport, CT: Praeger Press.

> This is a detailed case study and analysis of the Immigration Reform and Control Act of 1986 and its impact on Republican and Democratic Party support and on the demographic impact of the law.

LeMay, Michael C. 2006. *Guarding the Gates: Immigration and National Security.* Westport, CT: Praeger Security International.
This book traces the interplay between immigration and national security policies from the nation's founding until the 2000s. It discusses political party actions and platforms for various key elections throughout that history.

LeMay, Michael C. 2007. *Illegal Immigration: A Reference Handbook.* Santa Barbara, CA: ABC-CLIO.
The author examines the flow of unauthorized immigration to the United States since 1970 and policy attempts to grapple with the issue. The book examines unanticipated consequences of the flow, including how the demographic impact has influenced the Democratic and Republican electoral fortunes.

LeMay, Michael C., and Elliott Barkan, eds. 1999. *U.S. Immigration and Naturalization Laws and Issues: A Documentary History.* Westport, CT: Greenwood Press.
This volume summarizes 150 documents covering all the major laws and court cases concerning U.S. immigration and naturalization laws from colonial times to 2000.

Lester, Connie. 2007. *Up from the Mudsills of Hell: The Farmer's Alliance, Populism, and Progressive Agriculture in Tennessee, 1870–1915.* Westport, CT: Praeger.
*Up from the Mudsills* details the Farmer's Alliance, populism, and progressivism in Tennessee from the 1870s to 1915, tracing the development of rural reform from the Grange through the insurgent People's Party.

Leuchtenburg, William. 2001. *In the Shadow of F.D.R.: From Harry Truman to George W. Bush.* Ithaca, NY: Cornell University Press.
The author discusses how FDR's formidable legacy has influenced the office's occupants ever since. It concludes with an analysis of the 2000 election.

Leuchtenburg, William, 2009. *In the Shadow of F.D.R.: From Harry Truman to Barack Obama.* 4th ed. Ithaca, NY: Cornell University Press.

> This updated volume by a leading scholar of FDR looks at the presidency of George W. Bush and the first 100 days of President Obama.

Lippmann, Walter. 1997. *Public Opinion.* New York: Free Press.

> Considered the most important of his books, the late journalist and social critic offers a now classic treatise on the nature of information and communication.

Lowi, Theodore. 2009. *The End of Liberalism: The Second Republic of the United States: 40th Anniversary Edition.* New York: W. W. Norton.

> This modern classic of political science was originally published in 1969, was revised in 1979, and has now been reissued in 2009. The book examines the development of government during the years between the Great Depression and its publication.

Lowi, Theodore, and Joseph Romance, eds. 1998. *A Republic of Parties? Debating the Two Party System.* Lanham, MD: Rowman and Littlefield.

> Lowi and Romance debate the promises and pitfalls of the two-party system and the pro-and-con arguments for it.

Mann, Thomas E., and Norm Ornstein. 2012. *It's Even Worse Than It Looks.* New York: Basic Books.

> The two scholars, one center-left and one center-right, assess the case that the political system is being torn apart and suggest ways to rebuild political bridges and changes that must be made to overcome the current trends.

Mann, Thomas E., and Norm Ornstein. 2016. *It's Even Worse Than It ~~Looks~~ Was.* New York: Basic Books.

The sequel to their 2012 book argues that Republican extremism has no modern political precedent and is making governing and policy making nearly impossible. It describes but also analyzes why the political party system is broken, dysfunctional, and even nonfunctional.

Manza, Jeff, and Clem Brooks. 1999. *Social Cleavages and Political Change: Voter Alignments and U.S. Party Coalitions.* New York: Oxford University Press.

This study is a book-length reassessment and restatement of the sociological approach to American politics that examines the nature of social cleavages and their effect on political identification and voting behavior in the United States since 1950.

Manza, Jeff, and Fay Lomax Cook. 2002. *Navigating Public Opinion: Polls, Policy, and the Future of American Democracy.* Oxford: Oxford University Press.

This volume is a valuable synthesis of the many strands of research examining the connections between public opinion and public policy. Its analysis is broad and its research of high quality.

Marini, John, and Ken Masugi, eds. 2005. *The Progressive Revolution in Politics and Political Science.* Lanham, MD: Rowman and Littlefield.

This volume is a collection of essays that examine progressivism and the premises of the Founder's moral and political thought. The essays provide intellectual guidance to political scientists and political practitioners.

Mayhew, David. 2004. *Realignment: A Critique of an American Genre.* 2nd ed. New Haven, CT: Yale University Press.

In this cogent argument that the essential claims of the realignment theory are wrong, Mayhew examines 15 key empirical claims of the realignment theory and shows why each in turn does not hold up under scrutiny.

Mayhew, David. 2005. *Divided We Govern: Party Control, Law-Making, and Investigations, 1946–2002.* New Haven, CT: Yale University Press.

> In this prize-winning book, a renowned political scientist debunks the commonly held myth that the American national government functions effectively only when one party controls the presidency and the Congress. This new edition brings the historical narrative up to date.

McMath, Robert C. 1993. *American Populism: A Social History, 1877–1898.* New York: Hill and Wang.

> The author interprets the development of the Populist crusade from 1877 to the emergence of the Farmer's Alliance in the 1880s to the founding of the People's (Populist) Party in the 1930s. It is an impressive book about a major social, cultural, and political movement.

McSweeney, Dean, and John Zvesper. 1991. *American Political Parties.* London: Routledge.

> This book is an analysis of the formation, decline, and reform of the American political party system. It seeks to introduce the complexity of the American party system to an international student audience by examining the historical development of the party system and the forces that shaped and reshaped it.

Milkis, Sidney M. 1993. *The President and the Parties: The Transformation of the American Party System since the New Deal.* New York: Oxford University Press.

> This text examines closely the association between the chief executive and the two-party system, shedding light on their connections to other parts of the American political system. By placing the issue in contemporary perspective, Milkis warns of the challenges ahead for a nation struggling to repair its frayed connections between the government and the people.

Milkis, Sidney M. 2009. *Theodore Roosevelt, the Progressive Party, and the Transformation of American Democracy.* Lawrence: University Press of Kansas.

> Milkis revisits the 1912 election and depicts the Progressive Party as a collective enterprise of activists, led by Theodore Roosevelt, pursuing reforms dedicated to direct democracy.

Milkis, Sidney M., and Jerome M. Mileur, eds. 1999. *Progressivism and the New Democracy.* Amherst: University of Massachusetts Press.

> Stressing the reform tradition, the authors consider the extent to which problems at the end of the century resemble those at the beginning and whether roads not taken then could be reexamined now.

Milkis, Sidney M., and Jerome M. Mileur, eds. 2002. *The New Deal and the Triumph of Liberalism.* Amherst: University of Massachusetts Press.

> This volume is a collection of original essays by a distinguished group of political scientists and historians who reevaluate the legacy of the New Deal and modern liberalism.

Mirel, Jeffrey E. 2010. *Patriot Pluralism: Americanization, Education and European Immigrants.* Cambridge, MA: Harvard University Press.

> In this book, a leading historian of education reviews the Americanization movement, showing it was far more nuanced a process shaped, in part, by the immigrants themselves. He retells an epic story of one of the great achievements of American education that has profound implications for Americanization today.

Morris, Edmund. 2001. *The Rise of Theodore Roosevelt.* New York: Random House.

Morris provides a compelling biography of Theodore Roosevelt. The book won a 1980 Pulitzer Prize and is now reissued in hardcover. It is the first of Morris's definitive trilogy on the life of the 26th president.

Morris, Edmund. 2002. *Theodore Rex, 1901–1909.* New York: Random House.
This book is the second volume of the trilogy on the life of Theodore Roosevelt. It is meticulously researched and beautifully written.

Nash, Howard P., Jr., and Morris B. Schnapper. 1959. *Third Parties in American Politics.* Boulder, CO: Public Affairs, Perseus Books Group.
The book stresses the political personalities of the times, but it is weak on their ideals and ideology.

Ness, Immanuel, and James Ciment. 2000. *The Encyclopedia of Third Parties in America.* Armonk, NY: M.E. Sharpe.
This reference volume is an accessible yet comprehensive resource for information about all major and minor third political parties or candidates in U.S. history.

O'Brien, Ruth. 1998. *Worker's Paradox: The Republican Origins of New Deal Labor Policy, 1886–1938.* Chapel Hill: University of North Carolina Press.
O'Brien reinterprets the roots of twentieth-century American labor and politics, arguing that it was not the New Deal but Republicans of an earlier era who developed the fundamental principles underlying modern labor policy.

Patterson, James T. 2007. *Restless Giants: The United States from Watergate to Bush v. Gore.* New York: Oxford University Press.
Patterson has written a concise assessment of the years between the resignation of Richard Nixon and the election of George W. Bush, weaving together the social, cultural,

political, and international developments of the era while exploring the "culture wars" of the times.

Paulson, Arthur. 2007. *Electoral Realignments and the Outlook for American Democracy*. Boston: Northeastern University Press.
Paulson analyzes the impact of ideological polarization on political parties and electoral realignments. It is strong on realignment theory and includes the 2000 and 2004 elections and the outlooks for the 2008 election.

Pickus, Noah. 2005. *True Faith and Allegiance: Immigration and American Civic Nationalism*. Princeton, NJ: Princeton University Press.
This is a compelling account of nationalism and the politics of turning immigrants into citizens and Americans. The author ranges over the fields of political theory, history, and law, arguing for a renewed civic nationalism that melds principles and peoplehood.

Post, Robert C. 2014. *Citizens Divided: Campaign Finance Reform and the Constitution*. Cambridge, MA: Belknap Press.
The author interprets the constitutional conflict over campaign finance reform as an argument between those who believe that self-government requires democratic participation in the formation of public opinion and those who believe that self-government requires a functioning system of representation. One stresses the value of free speech, the other the integrity of the electoral process. He critiques the *Citizens United* decision, showing that the Supreme Court did not clearly grasp the constitutional dimensions of corporate free speech. The book is a blending of history, constitutional law, and political theory.

Rasmussen, Scott, and Doug Schoen. 2010. *Mad as Hell: How the Tea Party Movement Is Fundamentally Remaking Our Two Party System*. Boston: Northeastern University Press.

The authors clarify much about contemporary politics and identify important causes of the current political malaise, showing how economic stagnation and the collapse of equality and opportunity have resulted in a catastrophic decline in confidence in every sort of political institution, including political parties, big business, big labor, the media, and mainline organized religion. They show how past populist movements took root in times of economic stress and were hostile to political elites. Using polling data, political analysis, and on-line focus group input, they offer a guide to the new populism.

Reichley, A. James. 2000. *The Life of the Parties: A History of American Political Parties*. Lanham, MD: Rowman and Littlefield.

Reichley documents the breakdown of political parties from the 1970s to 2000. He traces the decline of parties resulting in divided government and ineffectual political process and shows what it will take to restore the party system to revitalize democracy.

Remini, Robert. 2006. *The House: The History of the House of Representatives*. New York: HarperCollins.

The first-ever nonfiction history of the House of Representatives by an award-winning historian, the book examines the struggle between principle and pragmatism.

Rosenof, Theodore. 2003. *Realignment: The Theory That Changed the Way We Think about American Politics*. Lanham, MD: Rowman and Littlefield.

Rosenof tells the dramatic story of how a new approach to American politics emerged after 1948. The realignment theory holds that critical elections shaped politics for decades to come and shows how the theory emerged as the predominant explanation of electoral change.

Rosenstone, Steven, Roy L. Behr, and Edward H. Lazarus. 1996. *Third Parties in America*. 2nd ed. Princeton, NJ: Princeton University Press.

This volume is a significant contribution to our understanding of minor parties by systematically testing many of the conventional explanations of minor-party politics in America. The authors show that the single-member district plurality system explains two-party dominance and also ensures short lives for third parties that do arise, because to survive longer term, political parties must offer tangible benefits to their supporters.

Rutland, Robert Allan. 1996. *The Republicans: From Lincoln to Bush*. Columbia: University of Missouri Press.

Rutland provides a clear and concise understanding of the Republican Party aimed at the general reader. It is a fast-paced overview of the Republican Party from Lincoln to George W. Bush.

Sabato, Larry, ed. 2006. *Divided States of America: The Slash and Burn Politics of the 2004 Presidential Election*. London: Pearson/Longman.

Sabato looks at the 2004 campaign and election and offers fresh commentary by a team of top election scholars and journalists.

Sabato, Larry, and Bruce Larson. 2001. *The Party's Just Begun: Shaping Political Parties for America's Future*. London: Pearson/Longman.

The authors analyze the 2000 election and the parties' roles. They then analyze the Reform Party and its candidates and use polling data about campaign finance laws and reform efforts to discuss the effects of the impeachment of President Clinton on public opinion of the parties and include survey data before and after the 2000 presidential election.

Salit, Jacqueline. 2012. *Independent Rising: Outsider Movements, Third Parties, and the Struggle for a Post-Partisan America.* New York: St. Martin's Press.

> Salit aims to clear up misunderstandings about independent voters and to clarify the realities of their political power. She examines independent movements past, present, and future through decades of major political developments of third parties and the growth of independents.

Samples, John. 2006. *The Fallacy of Campaign Finance Reform.* Chicago: University of Chicago Press.

> Samples argues that campaign finance reform is not really good for democracy. He finds little evidence that campaign contributions really influence members of Congress and that negative political advertising improves the democratic process. He provocatively argues that crusades against campaign contributions allow public officials to reduce their vulnerability by suppressing electoral competition.

Sanders, Elizabeth. 1999. *Roots of Reform: Farmers, Workers, and the American State, 1877–1917.* Chicago: University of Chicago Press.

> Sanders provides a sweeping revision of our understanding of the rise of the regulatory state, arguing that politically motivated farmers were the driving force behind the Farmer's movement.

Sarasohn, David. 1989. *The Party of Reform: Democrats in the Progressive Era.* Jackson: University of Mississippi Press.

> Sarasohn challenges the assumption that Theodore Roosevelt and Robert LaFollette were the dominant force behind progressivism, describing the role of the Democratic Party as the main party promoting progressive reforms in national politics in this period.

Schlesinger, Arthur M., Jr., ed. 2011. *History of American Presidential Elections, 1789–2000*, 4th ed. 3 vols. New York: Chelsea House.
> This three-volume set is an authoritative, up-to-date reference featuring articles on every presidential election in American history up to 2008, edited by Schlesinger and written by distinguished historians providing a solid history of campaigns, conventions, and candidates.

Shafer, Byron, ed. 2003. *The Two Majorities and the Puzzle of Modern American Politics.* Lawrence: University Press of Kansas.
> Shafer offers a collection of thoughtful, coherently related, and wide-ranging essays on the underlying socio-cultural trends in recent American history.

Shafer, Byron, and Anthony J. Badger, eds. 2001. *Contesting Democracy: Substance and Structure in American Political History, 1775–2000.* New York: Columbia University Press.
> In this collection of essays, scholars address and critique the entire sweep of American political history, focusing on the major policy issues and social forces shaping politics.

Shafer, Byron, and William J. Claggett. 1995. *The Two Majorities: The Issue Context of Modern American Politics.* Baltimore: Johns Hopkins University Press.
> The authors aim to advance an understanding of contemporary partisan realignment but also the structure of American political opinion, the central concern of that opinion, the roots and distribution of preferences, and the gathering and dividing of preferences in partisan ways.

Shafer, Byron, and Richard Johnson. 2006. *End of Southern Exceptionalism: Class, Race, and Partisan Change in the Postwar South.* Cambridge, MA: Harvard University Press.
> The authors challenge the notion of regional distinctiveness and the centrality of race to Southern politics.

Scouring reams of electoral returns, they challenge the notion that the Republican Party is nothing more than a remnant of the old conservative Democratic Party.

Sibley, Joel H. 1991. *The American Political Nation, 1838–1893.* Stanford: Stanford University Press.
Sibley presents a detailed analysis of a unique era in American political history in which political parties were the dominant dynamic force structuring and directing the political world.

Skowronek, Stephen. 1997. *The Politics Presidents Make: Leadership from John Adams to Bill Clinton.* Cambridge: Harvard University Press.
Yale University professor Skowronek's book is an innovative study using historical analysis to show how and why presidents are persistent change agents who sometimes transform the American political landscape, including how their party operates and fares in elections. He effectively catalogs and organizes 200 years of U.S. presidency to elucidate the nature of the American political institution of the office and the pervasive impact of its officeholders.

Skowronek, Stephen. 2008. *Presidential Leadership in Political Time.* 2nd ed. Lawrence: University Press of Kansas.
A classic study of presidential leadership, the author uses historical analysis to examine how some presidents are transformative in their impact. This second edition includes a chapter on Barack Obama. Skowronek details how various presidents influence their respective political parties.

Slayton, Robert A. 2001. *Empire Statesman: The Rise and Redemption of Al Smith.* New York: The Free Press.
This is the compelling story of a trailblazer of America in the twentieth century. Slaton demonstrates in this rich story of an extraordinary man who suffered from

anti-Catholic bigotry in the 1920 and how his reputation suffered but details his eventual redemption.

Sloan, John. 2008. *FDR and Reagan: Transformative Presidents with Clashing Visions.* Lawrence: University Press of Kansas.
Sloan provides a study of how old regimes unravel and new ones are constructed. He analyzes two transformative presidents and how they redefined the nation's fundamental philosophy, priorities, and policies.

Smith, Bradley. 2001. *Unfree Speech: The Folly of Campaign Finance Reform.* Princeton, NJ: Princeton University Press.
Smith argues that the various reforms of the Federal Election Commission and of various state agencies fail to accomplish their stated objectives, instead working to entrench incumbents in office, deaden campaign discourse, burden grassroots activity with needless regulation and distance Americans from an increasingly professional, detached political class—that the legislative cures for the ills of campaign and party financing are sometimes worse than the disease.

Smith, Rodney. 2006. *Money, Power, and Elections: How Campaign Finance Reform Subverts American Democracy.* Baton Rouge: Louisiana State University Press.
Rodney Smith argues that campaign finance reform laws have the opposite of their intended effect, increasing the likelihood that entrenched incumbents in the Congress will be reelected and diminishing the chances that candidates who are not wealthy will be elected; that money buys free speech; and that finance reforms unwittingly unbalanced the checks and balances of the Constitution. He argues for unfettered contributions but complete disclosure of relevant information about campaign donors and the recipients of donations and that all disclosures be available to the media to investigate and report them fully.

Tichenor, Daniel. 2002. *Dividing Lines: The Politics of Immigration Control in America.* Princeton, NJ: Princeton University Press.

> A powerful study of the politics and policies inspired by the struggle to shape America's identity, this book traces the twists and turns of immigration policy and how that struggle impacted the process.

Widmer, Edward. 1999. *Young America: The Flowering of Democracy in New York City.* New York: Oxford University Press.

> This is a study of the meteoric career of a vigorous intellectual movement arising out of the Age of Jackson, proclaiming Manifest Destiny, and is the most complete examination of the movement and its founder, John O'Sullivan.

Wilentz, Sean. 2004. *Chants Democratic: New York City and the Rise of the American Working Class.* New York: Oxford University Press.

> A classic narrative of the rise of labor and of American democracy, this book explores the dramatic social and intellectual changes that came with the early industrialization of New York City.

Wilentz, Sean. 2004. *The Rise of American Democracy: Jefferson to Lincoln.* New York: W. W. Norton.

> This is the definitive study of the period and traces an historical arc, from the earliest days of the nation to the opening shots of the Civil War.

Wilentz, Sean. 2007. *Andrew Jackson: The American Presidents Series: the 7th President, 1829–1937.* New York: Macmillan.

> This text recounts the fiery career of this larger-than-life figure, under whom modern American politics developed and whose legacy continues to the present, written by the preeminent historian of the nineteenth century.

Wilentz, Sean. 2016. *The Politicians and the Egalitarians: The Hidden History of American Politics.* New York: W. W. Norton.

An eminent political historian stresses the commanding role political parties have played in the nation's enduring struggle against economic inequality. He discusses America's egalitarian tradition and political partisanship as a permanent fixture of the American polity. He argues persuasively that every major egalitarian victory in U.S. history has emerged from a convergence of protest politics and the sharp struggles led by political partisans.

Williams, R. Hal. 2010. *Realigning America: McKinley, Bryan, and the Remarkable Election of 1896.* Lawrence: University Press of Kansas.

Williams provides a detailed study of the presidential election of 1896, showing how new voting patterns replaced old ones and how a new majority party came to power in a fresh interpretation of the victory.

Winger, Richard. 1997. "Institutional Obstacles to a Multiparty System," in Paul S. Herrnson and John Green, eds. *Multiparty Politics in America.* Lanham, MD: Rowman and Littlefield.

The authors examine the role third parties have played in U.S. politics and elections, past, present, and their prospects for the future.

Witcover, Jules. 2003. *Party of the People: A History of the Democrats.* New York: Random House.

Witcover traces the evolution of the Democratic Party from its roots to its emergence as today's progressive party of social change and economic justice.

Woodstock Theological Center. 2002. *The Ethics of Lobbying: Organized Interests, Political Power, and the Common Good.* Georgetown: Georgetown University Press.

This study discusses the exponential rise in lobbying, since the 1980s, and its enormous influence on American politics. It seeks to clarify and promote standards and principles for lobbyists and to inform the general public to forestall misunderstanding and misjudgment.

Zaller, John R. 1992. *The Nature and Origins of Mass Opinion.* Cambridge: Cambridge University Press.
Zaller examines the process by which individuals form and express political opinions and the implications that has for public opinion research.

Zolberg, Aristide R. 2006. *A Nation by Design: Immigration Policy and the Fashioning of America.* Cambridge, MA: Harvard University Press.
The late Harvard professor explores American immigration policy from colonial times to the present, describing how it has been used as a tool of nation building, covering policy at the state and local levels, and describing how the oscillating currents of immigration throughout American history shaped the nation and its politics, including major and minor political parties.

## Leading Scholarly Journals

*Administration and Society* is a peer-reviewed academic journal that covers the field of public administration. It was established in 1965 and is published nine times a year by Sage Publications.

*American Journal of Political Science* is a peer-reviewed academic journal published by the Midwest Political Science Association. It is published quarterly since 1973, ranks fourth among political science journals and publishes original research articles in all areas of political science.

*American Political Science Review* is a quarterly peer-reviewed academic journal covering all areas of political science. It is the official journal of the American Political Science Association

and is published by Cambridge University Press. Established in 1906, it is the field's premier research journal.

*American Politics Research* has been published bimonthly for more than 30 years and covers research analysis in all areas of American politics. It is a member of the Committee on Publication Ethics (COPE). It is ranked 77 of 161 political science journals. It is published by Sage.

*American Review of Political Science* is a quarterly peer-reviewed academic journal begun in 1932. It covers significant developments in political science, political theory and philosophy, international relations, political economy, political behavior, comparative politics, public administration, and policy and methodology.

*The Annals of the American Academy of Political and Social Science* was founded in 1889 to promote progress in the social sciences. Today, it is headquartered at the Annenberg Public Policy Center in Philadelphia and offers interdisciplinary perspectives on important social science issues. It is published annually. It ranks 30 out of 161 political science journals and 19 of 95 social science journals.

*City Journal* is a quarterly magazine published by the Manhattan Institute for Public Policy Research. Begun in 1994, it features articles on urban policy for public officials, journalists, and general readers mixing hard-headed practicality with cutting-edge theory.

*Comparative Political Studies* is a quarterly peer-reviewed academic journal published by Sage. It publishes methodological, theoretical, and research articles in the field of comparative and cross-national and intra-national levels. It ranks 12 of 161 political science journals and is a member of COPE.

*Comparative Politics* is an international journal devoted to comparative analysis of political institutions and processes. It communicates new ideas and research findings to social scientists,

scholars, students, the public, and nongovernmental officials. It is published by the City University of New York.

*Congressional Quarterly* is a division of Sage Publications and publishes books, directories, periodicals, and electronic products on American government and politics and on the U.S. Congress, notably *CQ RollCall* and *CQ Weekly*. It was founded in 1945. In 2009, it was acquired by the Economist Group and combined into Roll Call to form CQ RollCall. It publishes news and analysis about the U.S. Congress.

*Electoral Studies* is a refereed international journal covering all aspects of voting and electoral systems and strategies. It publishes research from diverse approaches, both theoretical and empirical, and is published by the Elsevier Publishing Group.

*Federal History* is published by the Society for History in the Federal Government as an open-access, online scholarly journal on the history of the federal government. It has been published annually since 2009. The journal highlights the research of historians working for federal agencies as well as independent scholars.

*Governance* is an international journal of policy, administration, and institutions. It ranks 10th of 161 political science journals. Since 1988, it is published in association with the International Political Science Application's Research Committee on Structure and Organization of Government.

*International Labor and Working Class History* is published semiannually for Columbia University's Department of History by Cambridge University Press for International Labor and Working Class, Inc. Begun in 1976, it explores diverse topics about working class politics. It is an academic journal on comparative and cross-disciplinary research for history, political science, labor studies, and global studies.

*International Political Science Review* publishes peer-reviewed articles in international political science and is a Sage publication ranked 65th of 161 political science journals. It is a member of COPE, published five times per year.

*International Politics* is published by Palgrave Macmillan, UK. It is a peer-reviewed journal of transnational issues and global problems. It is ranked 43rd of 85 journals in the field. Its topics include political science and international relations, development studies, political economy, and foreign policy.

*International Security* is a quarterly peer-reviewed academic journal in the field of international and national security founded in 1976 by the Belfer Center for Science and International Affairs at Harvard University and is published by MIT Press.

*International Studies Quarterly* is a quarterly, peer-reviewed academic journal of international studies, the official journal of the International Studies Association (ISA). Begun in 1959, it is published for ISA by Wiley-Blackwell. It ranks 27th of 161 political science journals and 13th of 65 journals in international relations.

*Journal of American Ethnic History* is the official journal of the Immigration and Ethnic History Society. Since 1981, its articles, review essays, and book reviews are published quarterly. It also publishes special issues that group articles and essays on specific topics or themes. It is published by the University of Illinois Press in print and online.

*Journal of American History* is the official academic journal of the Organization of American Historians. It began in 1914 but changed its name in 1964. It is published quarterly and is a leading scholarly publication published by Oxford University Press.

*Journal of Democracy* is a quarterly academic journal established from 1990 as the official publication of the National

Endowment for Democracy's International Forum for Democratic Studies. It covers studies of democracy, democratic regimes, and pro-democracy movements worldwide for activists and intellectuals. It is one the most cited social science journals and is published by the Johns Hopkins University Press.

*Journal of Information Technology and Politics* is a Taylor and Francis Group publication published quarterly since 2007. Its topics include international politics, politics and international relations, and politics and technology.

*Journal of Politics* is a peer-reviewed academic journal of political science established in 1939 and now published quarterly by the University of Chicago Press for the Southern Political Science Association. It publishes original research studies in all fields of political science and ranks 9th of 161 political science journals.

*Journal of Politics and Society* has been published since 1989 by Columbia University and covers issues concerning law and public policy by undergraduates in a process comparable to that of a peer-reviewed journal.

*Journal of Social History* is a scholarly, peer-reviewed journal that has been published since 1967. It covers social history in all regions and time periods. It is published quarterly by Oxford University Press and is a top-ranked journal in the field of social history.

*Journal of Women, Politics and Policy* has been published since 1980, has been renamed in 2005, and is published for the Institute for Women's Policy Research at George Washington University. It covers new research on politics and policy of special interest to women. It is a multidisciplinary, international journal.

*Legislative Studies Quarterly* ranks 80th of 161 political science journals. It has been published since 1976 by Washington

University and has articles on legislative systems, processes, behavior, parliaments and their relations to other institutions, their functions in political systems, and activity by members. It is a quarterly, peer-reviewed academic journal published by Wiley-Blackwell and is the official journal of the Legislative Studies Section of the American Political Science Association (APSA).

*The National Journal*, based in Washington, D.C., is a monthly magazine about current political environment since 1969 and is now part of the National Journal group and is described as the "premier source of nonpartisan insight on politics and policy."

*National Review* is a semi-monthly magazine founded by William F. Buckley, Jr., in 1965. It is a leading conservative magazine covering news, politics, current events, and culture with analysis and commentary and is described as the "most widely read and influential magazine for conservative news, commentary, and opinion."

*Party Politics* is an international journal for the study of political parties, party systems, and organizations. It is the official journal of the Political Organizations and Parties Section of the APSA. Founded in 1995, since 2009 it has been published six times per year.

*Perspectives on Politics* is a quarterly peer-reviewed academic journal established in 2003 and published by Cambridge University Press. It publishes articles for the political science profession and the broader society. It seeks to nurture political science as a field, publishing important scholarly topics, ideas, and innovations. It ranks 11th of 161 political journals.

*Political Behavior* is an interdisciplinary journal publishing peer-reviewed articles about political attitudes and behavior by individuals and institutions.

*Political Geography* is a journal of the Elsevier Group, the flagship journal of political geography, an interdisciplinary journal for all students of political studies with interest in geographical and spatial aspects of politics. It has been published quarterly since 1992.

*The Political Quarterly* is a British journal founded in 1930, now published by Wiley-Blackwell. It is published quarterly and is a center-left journal publishing articles by a wide range of political thinkers on social and political issues from a progressive point of view by persons of various political affiliations. It is a journal of opinion, ranked 29th of 161 political science journals.

*Political Research Quarterly* is peer-reviewed academic journal covering the field of political science. Founded in 1948, it is a Sage publication for the University of Utah, a COPE publication, and the official journal of the Western Political Science Association.

*Political Science Quarterly* is a double-blind, peer-reviewed academic journal covering government, politics, and policy published since 1886 by the Academy of Political Science. Each issue contains 6 articles and 40 book reviews. It is a journal of public and international affairs ranked 117th of 161 political science journals.

*Political Science Research and Methods* is a Cambridge University Press journal published in print and online since 2013. It is a quarterly journal of the European Political Science Association, a general political science journal publishing original scholarly work in all fields of political science.

*Political Studies* is a peer-reviewed academic journal covering all fields of political science published quarterly by Wiley-Blackwell on behalf of the Political Studies Association and is a British journal of politics and international relations. It has been published since 1963.

*Politics and Gender* is an agenda-setting journal publishing high-quality scholarship on gender and politics. It addresses fundamental questions in politics and political science from the perspective of gender differences. It is the journal of the Women and Politics Section of the APSA published by Cambridge University Press. It is ranked 19th of 41 journals in the Women Studies category.

*Politics and Religion* is published by Cambridge University Press for the Religion and Politics Section of the APSA. It is a peer-reviewed academic journal of original research into all aspects of the relationship between politics and religion all around the world, analyzing the impact of religion on political attitudes, decision making, and public policy. It is multi-disciplinary and international in scope. It publishes book reviews as well.

*Polity* is a Palgrave Macmillan journal published on behalf of the Northeastern Political Science Association since 1968. It publishes articles of original research of general interest to political scientists across all fields. It ranks 92nd of 161 political science journals.

*Presidential Studies Quarterly* is an interdisciplinary journal of theory and research on American presidency by the Center for the Study of the President and Congress published by Blackwell Publishing. Its articles, features, review essays, and book reviews have been published since 1974 in print and now online. It is the official journal of the Presidential Research Section of the APSA.

*PS-Political Science and Politics* is a quarterly peer-reviewed academic journal covering all aspects of contemporary political phenomena and political science published since 1968 and with its current title by Cambridge University Press for APSA.

*Public Choice* is a peer-reviewed academic journal on economics and political science published eight times per year by Springer

Science and Business Media. It ranks 71st of 161 political science journals. It began in 1955.

*Public Opinion Quarterly* is an academic, peer-reviewed journal published by Oxford University Press for the American Association of Public Opinion Research covering communication studies and political science since 1937. It ranks 10th of 76 journals in the field of communications and 23rd of 161 journals in political science.

*Publius: The Journal of Federalism* is the world's leading journal devoted to federalism. It publishes original empirical and theoretical work on federalism and intergovernmental relations. It is published for the Center for the Study of State and Local Government, Lafayette College, Eastern Pennsylvania. It ranks 46th of 161 journals of political science and is the journal of the Section on Federalism of the APSA

*Research and Politics* is a peer-reviewed academic journal of political science and related fields, a Sage publication and member of COPE. It is now an open-access political science journal.

*Social Science History* is an interdisciplinary journal aimed at historians, sociologists, political scientists, anthropologists, and geographers. It has been published since 1976 by Cambridge University Press and is the official journal of the Social Science History Association.

*Social Science Quarterly* is a quarterly journal nationally recognized as one of the top in the field of all social sciences. It is the official journal of the Southwestern Social Science Association. It began in 1919. It is now published by Wiley and Blackwell, since 2004, and publishes an annual special issue.

*Western Political Quarterly* is a quarterly peer-reviewed academic journal of the University of Utah on behalf of the Western Political Science Association published from 1948 to 1992.

It is published by the Salt Lake City Utah Institute of Government as an e-journal/e-magazine.

## Films

*All the King's Men* (2006), Columbia Pictures Corp./Relativity Media/Phoenix Pictures, color, 128 minutes. An all-star cast in a riveting story of a humble man's rise to power and the corruption that leads to his downfall.

*All the President's Men* (1976), Warner Brothers, color, 138 minutes. This is a gripping tale of the Watergate scandal leading to President Nixon's resignation.

*All the Way* (2016), HBO Films/Amblin Entertainment, color, 132 minutes. A TV docudrama on LBJ and the chaotic aftermath of JFK's assassination and Johnson's first year in office.

*The American President* (1995), Warner Brothers, color, 114 minutes. This is a comedy drama about a widowed president and a lobbyist who fall in love.

*Bobby* (2006), Warner Brothers, color, 117 minutes. This story of the assassination of Senator Robert F. Kennedy, with an all-star cast, is a fictionalized account of the hours leading up to the 1968 shooting.

*Born on the Fourth of July* (1989), Universal Pictures, color, 145 minutes. This is a gripping story of a paralyzed Vietnam War vet who becomes an antiwar political activist.

*The Candidate* (1972), Warner Brothers, color, 109 minutes. This Academy Award–winning film starring Robert Redford is a satirical comedy drama that examines the machinations involved in a political campaign.

*Charlie Wilson's War* (2007), Universal Pictures, color, 103 minutes. This is a drama based on Congressman Charlie Wilson

(Tom Hanks) and his covert dealings with Afghan rebels fighting the Soviet Union's army.

*The Contender* (2000), Cinerenta Medienbeteleiligungs KG/Cinecontender, color, 126 minutes. Senator Laine Hanson is a contender for U.S. vice president but information and disinformation about her past threatens to derail her confirmation.

*Dave* (1993), Warner Brothers, color, 110 minutes. This is a comedy about a temporary employment agency manager who is hired to impersonate the president at a fund raiser to cover up the president's extra-marital affair. The president suffers a stroke, and aides convince Dave to continue his impersonation and his enthusiasm revives the president's popularity.

*Election* (1999), Bona Fide Productions/MTV Films/Paramount Pictures, color, 102 minutes. This film is a satirical comedy drama about a high school election.

*Frost/Nixon* (2008), Universal Pictures, color, 122 minutes. A dramatic retelling of the post-Watergate television interviews between British talk show host David Frost and the former president Richard Nixon.

*Game Change* (2012), HBO Films/Playtone/Everyman Pictures, color, 118 minutes. This is an HBO political drama on the events of the 2008 U.S. presidential election campaigns, based on a book written by political journalists John Heilemann and Mark Halperin.

*Good Night and Good Luck* (2005), Warner Independent Pictures. A stellar cast brings to life this drama about a group of professional newsmen who, with surgical precision, removed a cancer from the U.S. body politic—namely, Senator Joseph McCarthy (R-WI).

*JFK* (1991), Warner Brothers, color, 206 minutes. A historical legal-conspiracy thriller, this film is a mixture of fact and speculation about the 1963 assassination of JFK and the

New Orleans district attorney, Jim Garrison (Kevin Costner), adapted from Garrison's book, *On the Trail of the Assassins.*

*The Last Hurrah* (1977), Columbia Pictures Television, color, 105 minutes. A TV Hallmark Hall of Fame film based on the novel by Edwin O'Connor, it depicts the last campaign of a big-city mayor who runs a powerful political machine seeking a fourth term.

*LBJ* (2016), Acacia Entertainment, Castle Rock Entertainment, and Savvy Media Holdings, color, 98 minutes. This drama centers on the political upheaval faced by Vice President Lyndon Johnson, thrust into the presidency by JFK's assassination, through his battles to heal a nation and secure his presidency by passing Kennedy's historic Civil Rights Act.

*Nixon* (1995), Cinergi Pictures Entertainment/Hollywood Pictures/Illusion Entertainment, color, 192 minutes. This is a biographical story of former president Richard Nixon from his youth to his eventual resignation as president. It stars Anthony Hopkins as Nixon.

*Truman* (1995), HBO Pictures/Spring Creek Productions, color, 135 minutes. This is an HBO movie based on David McCullough's Pulitzer Prize–winning book showing Truman's rise from a small town nobody to his decision as president to use the atomic bomb against Japan.

*Wag the Dog* (1997), Baltimore Pictures/New Line Cinema/Punch Productions, color, 97 minutes. This is a dark comedy about a president about to be exposed in a sex scandal creating a fabricated war as a cover-up.

## Videos

*First American Political Parties*, by Ken Kollman, University of Michigan, www.youtube.com/watch?v=GTNYNA AcoVeg. Color, 5.37 minutes.

*Political Parties: Mobilizing Agents*, 30 minutes, color. An Annenberg Learner video about American political parties and their role in politics. Annenberg Learner, P.O. Box 26983, St. Louis, MO 63118.

*Two Party and Multi-Party Systems: Similarities and Differences*, 2012, by Nicole Davis, on Prezi. Study.com/academy/lesson/title.html.

*The Two-Party System: Definition, Advantages, Disadvantages*, an embedded video by Kenneth Mitchell. Study.com/academy/lesson/the-two-party-system.

*What Is American Political Culture?* An embedded video, by Ashby Dugger. Study.com/academy/lesson/title.

## Introduction

*Below is a chronology of major events, including laws and court decisions, which formed or influenced the development of political parties in America from the founding to current times. It includes both the rise and the demise of various major and minor (or third) parties. The minor parties include several types: single-issue, ideological, splinter, racial/ethnic, and regional parties.*

**July 12, 1776** Congress agrees on the Articles of Confederation. National political parties had not as yet developed, but the population was split between loyalists and patriots, prefiguring the Republican-Democrats versus the Whigs of the 1880s.

**1779** The Articles of Confederation are adopted and in force in the 13 states. Political parties were not provided for in the Articles, but some states had organizations that operated like a political party at the state level.

**May 1787** The Constitutional Convention meets in Philadelphia. The Founding Fathers argue over "factions" (what today would be called parties).

---

This two-way signpost depicts the domination of the two major political parties: the Republicans and Democrats, which effectively control the two-party system of American politics. (Roman Milert/Dreamstime.com)

**October 1787**   Publius begins publishing 85 articles of the Federalist Papers, the most famous of which are 10 and 51 (both written by James Madison), defending adoption of the Constitution.

**1788–1789**   In the first quadrennial presidential election, George Washington is elected the first U.S. president, essentially unopposed in the Electoral College. The Federalist Party is established, led by Alexander Hamilton and John Adams. It would disband about 1830.

The Anti-Federalist Party organizes, forming two "proto-parties."

**1789**   The Democratic-Republican Party is established, led by Thomas Jefferson and James Madison. It becomes the major political party in 1800 and establishes an essentially one-party rule until it is disbanded 1824.

**March 1789**   A government begins operating under the new Constitution. There is no provision in the Constitution for political parties. Regular elections are scheduled, but management of elections is left to the states.

**1795**   Naturalization law is changed from two years to five years, thereby affecting electoral participation of naturalized immigrants.

In the first contested presidential election, John Adams, the Federalist Party nominee, wins over Thomas Jefferson.

**1798**   The Alien and Sedition Acts are passed by the Federalist-controlled Congress. Strong reaction to the acts enhances the electoral strength of the Democratic-Republican Party.

**1800**   Thomas Jefferson is elected president and heads the Democratic-Republican Party. The party will be the dominant majority party until 1824.

**1816**   The Toleration Party is established as a single-issue party. It would disband about 1827. The 1816 presidential election has four candidates; none wins majority of Electoral

College votes, so the election turns over to the House of Representatives, which picks John Quincy Adams, the runner-up and Federalist-leaning candidate, over Andrew Jackson, the winner of a plurality of the Electoral College votes.

**1825**    The National Republican Party forms out of the old Federalist Party. It becomes a precursor to the Whig Party.

**1828**    The Democratic Party is organized by New York Albany Regency leaders. It nominates Andrew Jackson, who easily wins the presidency. It is the first "mass party." The Anti-Masonic Party forms to oppose the Jacksonian Democrats. It is the first national party to hold a national nomination convention and to adopt a party platform. It disbands about 1838.

**1830**    The Nullifier Party is established; it would disband about 1839. It exemplifies a single-issue type of third or minor party. The National Republican Party holds its first nominating convention in Baltimore, Maryland. The party disbands about 1833.

**1833**    The Whig Party forms and lasts until 1856, when the slavery issue fractures it. The Whig Party holds its first national convention.

**1840**    The Liberty Party, an example of an ideological party, forms to advocate for abolition of slavery; it lasts until 1848.

**1843**    The American Republican Party is established; it lasts until 1854.

**1848**    The Free Soil Party is founded and lasts until 1855. It exemplifies a single-issue party (anti-slavery), but it is also a splinter-party formed from the Whigs and Liberty Party. The American Know Nothing Party is formed. Another single-issue party, it is disbanded in 1858.

**1854**    The Republican Party is started in Ripon, Wisconsin, as an anti-slavery party. The Democratic Party becomes the pro-slavery party. Whigs dissolve over the slavery issue.

**1858**    The Republicans hold their first national convention.

**1860**   Abraham Lincoln is elected president and heads the Republican Party (the party of the North and the anti-slavery party), forming a new party coalition.

**1861–1864**   U.S. Civil War

The Unconditional Union Party, a single-issue party, is formed and disbanded.

**1862**   Congress passes the Homestead Act, giving 160 acres to anyone who will settle on it and work it for five years. It draws millions of immigrants to America and helps settle the Midwest, which becomes a region strongly supportive of the Republican Party.

Work on the Transcontinental Railroad begins, with the Central Pacific and the Union Pacific railroads linking in Utah. The railroad opens the West to settlement and becomes a strong region for the Republicans.

**1868**   Ulysses S. Grant is elected president on the Republican ticket. The Radical Wing of the Republican Party dominates Congress and the White House.

**1870**   The Readjuster Party is established; it would disband in 1885. It is a single-issue party concerned about reconstruction after the Civil War.

The Liberal Party, a single-issue party, is established. It disbanded in 1893.

**1873**   The Panic of 1873 (a depression or severe recession in today's terms) rocks the national economy and leads to calls for monetary reform.

**1874**   The Greenback Party is founded and lasts until 1884. Another single-issue party, it advocates use of paper money.

**1875**   Congress enacts the Species Redemption Act, imposing the Republican-backed "hard-money" policy.

**1876**   The Socialist Labor Party of America, an ideological party, begins. They use their immigrant supporters as their "grassroots shock troops."

At the end of Reconstruction, the national presidential election is contested and is thrown into the House of Representatives. Although Democrats win the plurality of popular votes, the Southern Democrats join the Republicans to elect a Republican president in exchange for ending Reconstruction.

**1877–1890**  During the so-called Gilded Age, Republicans dominate Congress and "wet-Republicans" splinter off, enabling the Democrats to win the White House with Grover Cleveland.

**1881**  The National Civil Service Reform League is formed to advocate for national civil service reform. The Federal Civil Service System is established by the Pendleton Act of 1882 to work against the spoils system of party patronage.

**1887**  The People's Party (aka Populists) is established, disbanding in 1908.

During this era, the restrictionist groups arise, such as the Workingmen's Party, the Chinese Exclusion League, the Asian Exclusion League, the Ku Klux Klan, the People's Protective Alliance, the Japanese Exclusion League, the American Protective Association, the 100 Percenters, and the Immigration Restriction League.

**1892**  The Silver Party is established as a single-issue party; it disbands in 1902.

**1893**  The Panic of 1893 hits the economy. The Cleveland administration is blamed, enabling the Republicans to regain the White House.

**1896**  William McKinley is elected president in a transformative election.

The National Democratic Party (aka "Gold Democrats") is formed.

**1896–1932**  The Progressive Era of American politics is dominated by the Republican Party.

**1897**  The Social Democracy of America party is established; it disbands in 1900.

**1898**  The Social Democratic Party, an ideological party, is formed; it lasts until 1901.

**1900**  McKinley is reelected but then assassinated in 1901. Teddy Roosevelt assumes the office. Roosevelt launches several progressive reforms, such as breaking up corporate trusts, like the Standard Oil Trust and the Northern Securities Trust. He serves until 1908.

**1901**  The Socialist Party of America, an ideological party, is founded. It lasts until 1972.

**1912**  The Progressive (aka "Bull Moose Party") splinters from the Republican Party. It last until 1914.

Woodrow Wilson is elected U.S. president in part due to the split in the Republican Party. Democrats hold the White House until 1920.

**1913**  The National Woman's Party is established; it lasts until 1930. It advocates for women's suffrage, women's equal property rights, prohibition of the sale of alcoholic beverages, and a federal income tax.

**1915**  The Non-Partisan League is formed as a single-issue movement; it lasts until 1956.

**1916**  Woodrow Wilson is reelected.

**1918**  The Farmer-Labor Party, an ideological party, is established; it disbands in 1944.

The Versailles Peace Conference ends World War I and establishes the Covenant of the League of Nations.

The Great Influenza pandemic of 1918–1919 kills an estimated 50 million people worldwide.

**1919**  The Proletarian Party of America, an ideological party, is established; it lasts until 1971.

**1924**  The Progressive Party is formed.

The Democratic governor of New York, Al Smith, is nominated as the party's candidate for president. He denounces the Ku Klux Klan and causes the split in the Democratic Party over segregation and prohibition, which he opposes.

**1928**  The ideological party Communist League of America is formed. It lasts until 1934.

**1929**  The Wall Street stock market crash sets off the Great Depression.

**1932**  Franklin Delano Roosevelt is elected in a transformative, realignment election. He campaigns on a platform of "relief, recovery, and reform." A New Deal coalition forms and lasts until the 1960s.

**1933–35**  FDR presents his First New Deal package of relief programs.

**1935–38**  In the Second New Deal, policy shifts from relief to structural reform.

**1936**  The American Labor Party, a single-issue party, is formed. It lasts until 1956.

**1939**  World War II begins in Europe.

**1941**  After the Pearl Harbor attack, America enters World War II.

**1944**  The American Party is established as an ideological party espousing nationalism and isolationism; it would disband in 1996.

President Roosevelt dies, Vice President Truman assumes office.

**1945**  World War II ends.

Dixiecrats splinter from the Democratic Party over desegregation.

**1948**  Truman wins reelection. From 1948 to 1952, he proposes the Fair Deal Programs, leading to splintering of the Democratic Party coalition.

Signaling the end of the New Deal coalition, Southern states begin the shift to Republican Party nominees for the presidency.

The Vegetarian Party, a single-issue party, forms and lasts until 1964.

**1950**    The Korean War begins. Truman enters the United States into an "undeclared war," relying on a U.N. Resolution to justify war.

**1952**    The Constitution Party is established, in part as a reaction to the Korean War. It disbands about 1968.

**1959**    The American Nazi Party is formed and lasts until 1967.

The Puerto Rican Socialist Party begins and lasts until 1993.

**1960**    John F. Kennedy is elected president. He reaffirms the Democratic Party majority and announces his "New Frontier" Programs.

The Patriot Party forms, lasting until the 1980s.

**1963**    Kennedy is assassinated; Vice President Lyndon B. Johnson assumes office.

**1964**    LBJ wins in a landslide over Senator Barry Goldwater (R-AZ). He pushes through his "Great Society" programs, trying to match FDR's First 100 Days. His political and economic programs cause the Democratic Party to lose the Solid South to the Republicans.

**1966**    The Black Panther Party forms on ideological, racial, and ethnic lines.

**1969**    The Communist Workers Party forms, lasting until 1985.

The United Citizens Party is established; it disbands about 2008.

The American Party forms, lasting until about 2008. Its platform is nationalist, isolationist, and anti–civil rights policy.

**1970**    La Raza Unida Party forms; it is a racial/ethnic-based party of Hispanic voters.

**1971**    The People's Party forms, lasting until 1976.

Congress passes the Federal Election Campaign Act (FECA).

**1974**    Two parties are formed: the Union Party (until 1976) and the New Union Party (1974–2005).

Congress amends FECA to establish the Federal Election Commission.

**1975** The Concerned Citizens Party is established; it disbands in 1992.

**1979** The Citizens Party (disbanded 1984) and the New Alliance Party (disbanded 1992) are established.

**1980** Ronald Reagan, a transformative president, is elected and establishes a new "conservative" Republican majority.

**1984** The Populist Party (1984–1994) and the Looking Back Party (1984–1996) are established.

**1985** The Republican Moderate Party of Alaska is formed; it lasts until 2011.

**1992** The Natural Law Party (1992–2004) and the New Jersey Conservative Party (1992–2009) are established.

**1992, 1996** Ross Perot funds the Reform Party and runs for president on the third party ticket.

**1995** The American Falangist Party is established; it lasts until 2009.

**1996** The Labor Party is established; it is disbanded in 2007.

**1997** The Supreme Court decides in *Colorado Republican Federal Campaign Committee v. Federal Election Commission* that political parties are not subject to campaign contribution limits.

Congress passes the McCain-Feingold bipartisan bill to close the "soft money" loophole.

**1999** The presidential election between Bush and Gore ends in a virtual tie due to Ralph Nader's third party bid. Florida's vote totals are challenged in Supreme Court, which rules, in *Bush v. Gore*, in favor of George W. Bush.

**2001** The September 11 attacks in New York City and Washington, D.C., lead to President Bush's announcement of the "War on Terrorism."

The USA PATRIOT Act passes Congress in near-unanimity.

**2002**    Congress passes the Bipartisan Campaign Reform Act (BCRA), which is challenged and upheld by Supreme Court in *McConnell v. Federal Election Commission.*

Congress passes the Homeland Security Act, which establishes the new Department of Homeland Security.

**2006**    The Boston Tea Party is established and lasts until 2012. Its members gradually join the national Tea Party movement that in time moves into the Republican Party.

**2007**    The Independence Party of America, an ideological party, begins, lasting until 2013.

**2008**    Barack Obama is elected president on the Democratic ticket; he forms a new coalition, replacing the New Deal coalition.

**2009**    The American Populist Party of America is established; it lasts until 2010.

The Supreme Court overturns some campaign finance reform provisions of the BCRA in *Federal Election Commission v. Wisconsin Right to Life, Inc.*

**2012**    President Obama is reelected, possibly signaling a transformative presidency.

Two court decisions further limit the Federal Election Commission: *Citizens United v. Federal Election Commission* and *SpeechNow.Org v. Federal Election Commission.*

The Wolf PAC is formed in response to the *Citizens United* decision. It calls for an Article V constitutional convention to amend the constitution to override *Citizens United.*

**2013**    In *McCutcheon v. Federal Election Commission*, the Supreme Court rules that aggregate limits on campaign contributions are unconstitutional.

**2016**    Republican Donald Trump wins the presidential election; although he won the Electoral College vote, Democrat Hillary Clinton won the popular vote.

**Albany Regency**  a New York State political organization and model for what became the Jacksonian Democratic Party led by Martin Van Buren.

**American system**  the proposal by Senator Henry Clay, calling for federal funding of internal improvements, high tariffs, and support for a national bank.

**Bloc voting**  racial, ethnic, immigrant, or social class groups voting for one party as a cohesive bloc of voters, providing the winning margin in elections.

**Carpetbaggers**  a pejorative term used by Southerners during the Reconstruction period (1865–1877) to refer to Northerners who moved to the South after the Civil War.

**Chief legislator**  the role of U.S. presidents innovated by FDR, which increased the power of the presidency since 1932 to shape bills and the agenda of congress.

**Civic element of citizenship**  a sense of national allegiance, a more democratic approach to politics stressed by the Jeffersonian Democratic-Republican Party to today's Democratic Party.

**Cold War**  the foreign policy, issues, and conflicts post–World War II with the U.S.S.R. between the West and Eastern Europe.

**Compromise of 1850**  a bundle of laws intended to sort out the slavery issues dividing the nation and states prior to the Civil War.

**Congressional caucus, or "King Caucus"**   groups of legislators who decided whom to support as a candidate for the presidency.

**Demagoguery**   the attempt to shape or mold public opinion by appealing to the base instincts and emotions of ill-informed citizens.

**Direct democracy devices**   progressive reforms in the early 1900s—like direct election of senators, referendum, recall, and primary elections.

**Electoral College**   a constitutional provision that has "electors" selected by the states vote for presidential candidates as a step between the populace and the president to be a check on demagoguery.

**Faction**   the term used in The Federalist Papers for what today would be called a political party.

**Fair Deal**   President Harry Truman's progressive proposals, 1948–1952, modeled on FDR's New Deal programs.

**Federalist Papers**   a series articles published before adoption of the new Constitution, written mostly by Madison and Hamilton, in favor of its ratification.

**Fifth Political System (1932–1964)**   the coalition of FDR's New Deal.

**Fireside chat**   the use of radio broadcasts by FDR to speak directly to the populace urging support for the New Deal.

**First Hundred Days**   the enactment of New Deal's economic recovery reforms.

**Forty-Eighter**   an immigrant, mostly from Germany, fleeing Europe after failed revolutions in 1848.

**The Founders (also The Founding Fathers)**   Washington, Hamilton, Adams, Madison, and Jefferson.

**Fourteen Points**   Wilson's vision for international peace, post–World War I, that included establishment of the League of Nations.

**Gerrymandering**   the process of carving out legislative districts for political advantage. The U.S. Supreme Court has ruled congressional districts must be redrawn every 10 years, after the census, to account for population changes. By shaping the districts in various ways, officeholders are able to affect which voters they will be responsible to on election day.

**Gilded Age (1877 to 1890)**   a time period when Republicans dominated Congress and passed economic policy to expand the economy; it led to the depression of 1896.

**GOP**   the acronym for Grand Old Party, the Republican Party of the 1880s–1890s.

**Grassroots**   organized, political party activity at the precinct level: get-out-the-vote canvassing to register voters, developing party leadership, and dispensing patronage.

**Great Depression**   the most severe economic depression in U.S. history, beginning with the stock market crash of 1929 and ending with World War II.

**The Great Society**   President Lyndon Johnson's programs of integration and economic expansion, attempting to match FDR's First 100 Days.

**Interposition**   the action of a state whereby its sovereignty is placed between its citizens and the federal government.

**Laissez-faire**   an economic system in which transactions between private parties are free from government interference, such as regulations, privileges, tariffs, and subsidies; from French "let them do."

**Likert scale**   a psychometric scale commonly used in research employing a questionnaire. Self-reporting is the most widely used approach to scaling responses in survey research. The term is often used interchangeably with rating scale, or more accurately, with a Likert-type scale, even though the two are not synonymous. The scale is named after its inventor, psychologist Rensis Likert.

**Majority party**   the dominant party of the American two-party system.

**Manifest Destiny**   the belief that it was the God-given destiny that the United States expand from the East to the West Coast.

**Mass party system**   the modern political party system in American politics with two major parties nationally to the grassroots level.

**Minor (or third) party**   a party that has not achieved majority-party status: an ideological, regional, protest, single-issue, or splinter party.

**Minority party**   the subordinate party of the two-party system.

**Monetary policy**   laws governing the monetary system—like the supply of money or currency used, bank regulations, and tariff policy.

**Nationalist element of citizenship**   power at the federal level of government, a deferential approach to government leadership, and skepticism that immigrants were ready for citizenship.

**Partisan realignment**   an election that shifts loyalties and party allegiance, ushering in a new coalition of bloc voting that enables one party to achieve majority status, typically in the election of a "transformative president."

**Partisanship**   the emphasis on loyalty to a political party above all else.

**Party-as-organization**   such aspects of a party as its ability to develop leaders, organize voting blocs, control election of its members to office, raise money for candidates and campaigns, and adopt a party platform at a national convention.

**Party bosses**   party leaders at the local and sometimes state level who control the party-as-organization, typically a "party machine."

**Party machine**   the organization of a party with machine-like efficiency to manage elections and control government and policy making, using patronage and the spoils system and slates of candidates to win the loyalty of ethnic voting blocs.

**Party platform**    a statement of a party's beliefs, goals, values, and public policy, adopted at a party convention.

**Party spoils system**    the systematic distribution of goods, public office, government favors, and benefits to loyalists and to punish the enemy—persons belonging to the other party.

**Presidential franchise**    the right to vote in presidential elections.

**Quintessential**    representing the most perfect or typical example of a quality or class.

**Reagan Democrats**    voters who previously voted Democratic; typically white, union, blue-collar workers attracted to the Republicans by President Reagan.

**Reconstruction**    the period (1865–1876) when Republicans controlled Congress and passed laws to "reconstruct" the southern states of the Confederacy.

**Regime principles**    the values and goals that determine who controls a government—the regime ruling a country—and its form: a monarchy or republic, determining who becomes a citizen, votes, or participates in politics. They may be more deferential to elites (a monarchy) or less deferential and more civic (a republic).

**Republican**    an approach to government favoring neither a monarchy nor a pure democracy, involving widespread participation of citizens voting in periodic elections to select representatives to hold government offices.

**Republican Revolution**    ushered in by the 1994 mid-term elections, the Republican Revolution was led by Newt Gingrich (R-GA) advocating a "Contract with America" as the electoral strategy to regain majority control of Congress.

**Scalawags**    the pejorative term used by Southerners to refer to Southerners who cooperated politically with black freedmen and Northern newcomers, typically supporting the Republican Party.

**Second Party System (1828–1860)**    a new party system ushered in by the transformative presidency of Andrew Jackson.

**Secret Order of the Star-Spangled Banner**    a social movement that became the American Party, or Know Nothing Party, between 1848 and 1854, favoring immigration restriction, a 21-year period of residency for naturalization, and the election of only native-born citizens.

**Social compact theory**    a theory that views society and the natural order of man to be without government and states that governments are formed only when all citizens agree to form one to protect natural rights.

**Solid South**    a period of time between 1876 and 1964 when the Democratic Party controlled the former Confederate States as a solid voting bloc in national elections.

**Square Deal**    the progressive reforms of President Theodore Roosevelt, especially after succeeding to the presidency in 1901 and the early part of his elected term, 1904 to 1906.

**Stagflation**    an economic condition characterized by low economic growth and high unemployment coupled with high inflation rates.

**Swing states**    states that are usually closely divided and contested, and in any given presidential election may shift from one party to another in their presidential vote.

**Switch voters**    independents willing to split their ticket voting between the two major parties in sequential elections or for levels of offices.

**Tammany Hall**    the social club that became the urban political machine of New York City, exemplifying the classic urban machine notorious for political corruption, originally led by the Tweed Ring.

**Tariff**    a duty (fee) or tax imposed on a particular class of imports or exports.

**Teapot Dome scandal**    a period during the administration of President Warren Harding involving national security, big oil companies, and bribery and related corruption in the 1920s.

**Third Political System (1860–1896)** This system was ushered in by the realigning election of Abraham Lincoln, when the Republican Party became the dominant party.

**Tories** people who supported the British side during the Revolutionary War.

**Tracking poll** a type of poll repeated periodically with the same group of people to check and measure changes in opinion or knowledge.

**Transcontinental Railroad** a 2000-mile continuous railroad line built between 1863 and 1869 by the Central Pacific and Union Pacific railroads, from the Mississippi and Missouri rivers, to connect the Pacific Coast at San Francisco Bay with the existing U.S. rail network at Council Bluffs, Iowa.

**Transformative president** a president whose election and administration changes the nation by crafting a new coalition of voters, shifting the majority party of the two-party system, in what is labeled a realigning election.

**Trust busting** the economic reforms of President Theodore Roosevelt that were used to break up big trusts like Standard Oil and the Northern Securities Trust.

**Trusts** businesses using the corporate structure and establishing huge companies to monopolize an industry.

**Two-party system** the Democratic Party and the Republican Party that have won every presidential election since 1852 and controlled Congress since 1856.

**War on terror** post–September 11 policies to combat international terrorism crafted by the administration of President George W. Bush.

**Watergate scandal** the political corruption scandal during the second administration of Richard Nixon that forced his resignation.

**Xenophobia** an unreasonable fear of foreigners.

**Yellow Peril** a xenophobic fear of Chinese and Asian immigration, 1848 to 1929, spurring the Chinese Exclusion Acts and National Origin Quota Acts of the 1920s.

**Note:** page numbers followed by letter *t* in italics indicate tables.

## About the Author

**Dr. Michael C. LeMay** is professor emeritus from California State University–San Bernardino, where he served as director of the National Security Studies program, an interdisciplinary master's degree program, and as chair of the Department of Political Science and assistant dean for student affairs of the College of Social and Behavioral Sciences. He has frequently written and presented papers at professional conferences on immigration. He has also written numerous journal articles, book chapters, published essays, and book reviews. He is published in *The International Migration Review*, *In Defense of the Alien*, *Journal of American Ethnic History*, *Southeastern Political Science Review*, *Teaching Political Science*, and the *National Civic Review*. He is the author of more than a dozen academic volumes dealing with immigration history and policy. His prior books on the subject are *Illegal Immigration: A Reference Handbook*, 2nd ed. (2015, ABC-CLIO) and *Doctors at the Borders: Immigration and the Rise of Public Health* (2015, Praeger). He is the series editor and contributing author of the three-volume series *Transforming America: Perspectives on Immigration* (2013, ABC-CLIO); *Illegal Immigration: A Reference Handbook* (2007, ABC-CLIO); *Guarding the Gates: Immigration and National Security* (2006, Praeger Security International); *U.S. Immigration: A Reference Handbook* (2004, ABC-CLIO); *U.S. Immigration and Naturalization Laws and Issues: A Documentary History*, edited with Elliott Barkan (1999, Greenwood); *Anatomy of a Public Policy: The Reform of Contemporary Immigration Law* (1994, Praeger); *The Gatekeepers: Comparative Immigration*

*Policy* (1989, Praeger); *From Open Door to Dutch Door: An Analysis of U.S. Immigration Policy Since 1820* (1987, Praeger); and *The Struggle for Influence* (1985). Professor LeMay has written two textbooks that have considerable material related to these topics: *Public Administration: Clashing Values in the Administration of Public Policy*, 2nd ed. (2006) and *The Perennial Struggle: Race, Ethnicity and Minority Group Relations in the United States*, 3rd ed. (2009). His most recent Contemporary World Issues series book is *Global Pandemic Threats: A Reference Handbook* (2016, ABC-CLIO). He frequently lecturers on topics related to immigration history and policy and American politics. He loves to travel and has lectured around the world and visited more than 125 cities in 46 countries. He has two works in progress: *Winning Office and Making a Nation: Immigration and the American Political Party System* (under review, coauthored with Scot Zentner) and *From Open Door to Storm Door: The Cycles of Immigration Policymaking* (under review), with three more Contemporary World Issues volumes under contract: *Religious Freedom in America: A Reference Handbook* (2017), *Homeland Security: A Reference Handbook* (2018), and *Reforming Immigration: A Reference Handbook* (2019).